Craft

An American History

Glenn Adamson

BLOOMSBURY PUBLISHING

NEW YORK · LONDON · OXFORD · NEW DELHI · SYDNEY

BLOOMSBURY PUBLISHING
Bloomsbury Publishing Inc.
1385 Broadway, New York, NY 10018, USA

BLOOMSBURY, BLOOMSBURY PUBLISHING, and the Diana logo are trademarks
of Bloomsbury Publishing Plc

First published in the United States 2021

Bloomsbury Publishing Plc does not have any control over, or responsibility for, any third-party websites referred to or in this book. All internet addresses given in this book were correct at the time of going to press. The author and publisher regret any inconvenience caused if addresses have changed or sites have ceased to exist, but can accept no responsibility for any such changes.

ISBN: HB: 978-1-63557-458-6; eBook: 978-1-63557-459-3

LIBRARY OF CONGRESS CATALOGING-IN-PUBLICATION DATA IS AVAILABLE

2 4 6 8 10 9 7 5 3

Typeset by Westchester Publishing Services
Printed and bound in the U.S.A. by Sheridan, Chelsea, Michigan

To find out more about our authors and books visit www.bloomsbury.com and sign up for our newsletters.

Bloomsbury books may be purchased for business or promotional use. For information on bulk purchases please contact Macmillan Corporate and Premium Sales Department at specialmarkets@macmillan.com.

For my brother, Peter

CONTENTS

Craft

Introduction

CRAFT HAS BEEN MANY THINGS in America: a way of making a living, of expressing creativity, of pushing technology forward. It has a potent symbolic status, one so fundamental that it anchors our everyday speech. We talk about forging links, laying foundations, hammering things out, spinning tales. Conceptually, we knit things together and carve them apart. Craftspeople themselves are often seen as representing the best of America. Capable, trustworthy, and self-sufficient, they are the quiet heroes of our national story.

Yet if craft has a prominent place in our language and our imaginations, it has less and less of a role in our everyday lives. Relatively few of us actually perform crafts anymore, or even know the technical basics of how they work. Gradually and inexorably, the United States has become disconnected from the history of its own making. And it is no coincidence that as craft has been increasingly marginalized in the economy, overall levels of social cohesion have also deteriorated. The key role once played by blacksmiths and basket makers has not been replaced. Craft is too central to our culture to be fully dislodged, too essential not to find a place in production. But today, it is most conspicuous as an absence. One of the intentions of this book is to describe what has been lost, and perhaps suggest some ways to get it back.

Crucial to this story is craft's part in a long, agonizing struggle with questions of egalitarianism. One nation, created equal—that is the mythology. In practice, we have never managed to realize it. The inspiring principles upon which the United

States was founded did nothing to stop enslavement, the genocide of indigenous peoples, or the disenfranchisement and often brutal oppression of women. Craft has been an important way of negotiating this essential contradiction, for it is, almost uniquely, a form of independence that also serves communities. Women and Native Americans, African Americans, and immigrants have all relied on handwork for their livelihoods, while also embracing it as a means of group identity. Similarly, it is impossible to understand the American working class without considering the displacement of artisans as they have been steadily shoved aside by the mechanized hands of industry. This book is filled with stories of women and men who were caught up in these power dynamics. For many of them, craft was the best—perhaps the only—possible means to establish security for themselves and their loved ones. With only their skills to survive on, they helped to make the nation, shaping a history that is, as James Baldwin memorably put it, "longer, larger, more various, more beautiful and more terrible than anything anyone has ever said about it."[1]

When I was a graduate student in the 1990s, there was hardly any such thing as craft history. Scholars who wrote about the subject were few in number and concentrated on various narrow aspects of it. Decorative art specialists might study eighteenth-century cabinetmakers or silversmiths. Labor historians focused on the rise and fall of unions and their influence on American life. Anthropologists conducted fieldwork among "folk artists," learning about vernacular traditions. A handful of historians and museum curators devoted themselves to the two great reform projects in American craft, which occurred at the turn of the twentieth century and then again after 1945, the Arts and Crafts movement and the studio craft movement. This compartmentalized approach produced a lot of great scholarship, which I have relied on in writing this book. But it also obscured the common experiences and challenges faced by American artisans of all kinds.

Today, a more mature field of craft studies is emerging. There is more to read on the topic every year, and much of it takes a broad view. There has not, however, been a single overview of craft in America. This book aims to be that history. I have written it with two complementary goals in mind: first, to braid together many different accounts of craft into a single narrative; and second, to tell the story of America through the eyes of its artisans. Of course, I haven't covered everything—not even close. For craft is a vast and varied landscape, difficult to map, especially near the edges. The very definition of the word is much debated. I try to use it in a simple, commonsense way: Whenever a skilled person makes something using their

hands, that's craft. This is, I believe, how most Americans use the word. They do not limit the concept to specific disciplines like pottery and weaving. They know there is craft in a riveted girder, a carved sculpture, and a homemade dress; that craft is practiced by professionals and amateurs alike; that it can be rough or fine. To be sure, the lines sometimes get a little blurry, particularly when it comes to art and technology. Should an excellent painting, skillfully handmade, count as a craft object? Is a nineteenth-century textile mill operative an artisan? How about someone using a 3D printer?[2]

Clearly, there is room for different viewpoints here. But if you ask me, the perspective that should count is that of makers themselves. So, in this book, I have tried to take the words and works of artisans as my guideposts, firmly rooted as they are. After all, craft is an embodied, experiential matter. It cannot be performed well without care or pride in the result. Learning a trade requires time sufficient to occupy much of a person's life. Given that level of commitment, it is no wonder that craft is the repository of deep, sometimes contradictory feelings. It has served as a stable foundation for American culture, a way of holding the past in memory; but again and again, it has been taken up by activists who hope to change the world. If craft represents the best that America has to offer, it is also a way to combat injustice, to reach for better things still. Workshops and factories, dockyards and building sites, parlors and garages—these spaces have always been contested territory. In the story of American craft, then, we see the nation's founding principles meet its foundational problems. We see the idea of America itself taking shape, blow by blow and stitch by stitch.

Chapter 1

The Artisan Republic

H E COULD BE HOLDING A BOOK, a skull, or a prize melon. Instead, he has a
silver teapot. We are face-to-face with an artisan and his creation, witness
not to an act of making, but rather to his reflection on that act, both literally and
figuratively. One skillful hand is doubled in the smoothly polished metal he
holds, while the other props up his clean-shaven chin in a gesture of unhurried
consideration.[1]

Walk into the American galleries at the Museum of Fine Arts, Boston, and you
will see the painting straightaway, in pride of place, dead center on the first wall:
John Singleton Copley's portrait of Paul Revere. The curators have surrounded the
picture with surviving specimens of the smith's handiwork, including his famous
Sons of Liberty Bowl, which pays tribute to the "Glorious Ninety-Two" members of
the Massachusetts House of Representatives, who confronted the British Crown
over punitive taxes. Copley, similarly, supplied Revere with the tools of his trade:
two burins and a needle for engraving, and a sand-filled leather pad on which to
steady the teapot as he worked. These proofs of his profession are practical, unpre-
tentious, so different from the allegorical props that might appear in a painting of an
aristocrat, or a saint. Even the two gold buttons visible on Revere's woolen waistcoat
are likely of his own manufacture. He does, however, sit at a polished table, perhaps
of mahogany. A strange choice for a work surface, it reads instead as artistic license,
affording an opportunity for the painting's most breathtaking passage, the soft
reflected glow of Revere's freshly laundered shirtsleeves.

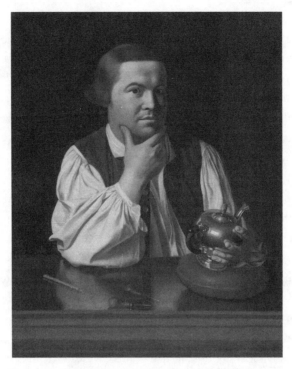

John Singleton Copley, *Paul Revere*, American, 1738–1815. © 1768. Oil on canvas, 89.22 × 72.39 cm (35⅛ × 28½ in.). Museum of Fine Arts, Boston. Gift of Joseph W. Revere, William B. Revere, and Edward H. R. Revere, 30.781.

We don't actually know why Copley painted the portrait, or whether it was commissioned by Revere himself, though that seems likely. But for generations, it has been understood as embodying America's virtues on the verge of the country's independence: clarity, pragmatism, and self-sufficiency. Not incidentally, the picture is also beautifully crafted. Copley's workmanship, as supremely competent as Revere's own, adds to the feeling of solidity and directness, so often seen as defining the national character.

But straightforwardness can be a surprisingly complicated thing, and Copley's portrait of Revere serves as an ideal entry point to the history of American craft precisely because it is not simple. The design Revere is about to inscribe into the teapot is likely a coat of arms, an emblem of aristocracy. In 1768, when Copley painted his portrait, both painter and smith were not only British subjects, but also dependent on elite patronage. Neither could have suspected that a revolution was

soon to come, or known the diametrically opposing parts they would play in it. Copley, married into a family of wealthy loyalists, departed for London. Taking advice from his fellow expatriate artist Benjamin West, he shed his early style for a more cosmopolitan, painterly manner. Revere, of course, would attain legendary status for his midnight ride, alerting townsfolk that the British were coming. By then he'd already stopped making vessels for serving British-imported tea—342 crates of which were sitting at the bottom of the harbor, having been dumped overboard by insurrectionaries dressed as Native Americans. He made coffeepots instead.[2]

During the revolution, Revere had no time to engage in his craft, and in the decades after the war he, too, shifted course professionally, becoming an innovator in industrial techniques. He parlayed his knowledge of metalwork into the mass production of simple items like harness fittings and buckles and the large-scale casting of cannon and bells. Eventually, he operated a furnace and rolling mill, which he used to fabricate copper sheathing for ships. In their different ways, then, these two men were eager to transcend their artisan identities. Copley came to see his early paintings, so carefully delineated and richly detailed, as embarrassingly provincial. In moving to London, he had wanted to escape the status of a painter in America—"no more than any other useful trade, as they sometimes term it, like that of a Carpenter tailor or shoemaker, not as one of the most noble Arts in the world." In this he largely succeeded.[3] Revere, too, elevated himself, at least in his own eyes. In 1781, he had described himself as "very well off, for a tradesman." He wanted instead to be an entrepreneur and merchant, and soon thereafter began describing himself that way on official documents.[4]

As to the proud self-sufficiency of the American craftsman, that, too, is a complex matter. Copley's tools (hog hair brushes, pre-cut canvases, and bladders for storing paint) and pigments (lead white, Prussian blue, vermilion, and more) were all English imports. So, quite likely, were the wool of Revere's waistcoat and the linen of his shirt. (At this date, it is an even bet as to whether these textiles would have been handspun and handwoven or processed with the help of machines.) The silver used to make the teapot might well have circulated in the form of currency, originating in the mines of Potosí (then in the Viceroyalty of Peru, now Bolivia), while mahogany like that in the depicted table came mainly from Honduras. These were both brutal contexts for enslaved workers, some brought there by force from Africa, others indigenous.

Like everything else in Colonial America, then, the painting and its subject matter were situated within an interdependent network of labor, both skilled and unskilled, free and unfree. The portrait can also be taken as a symbol of craft's dual position in American culture—notice how Copley has painted Revere's left hand not once but twice, as actual substance and reflected image. As telling as it may be, though, the painting is a rare exception. Most artisans are unlike Revere simply because they have been forgotten, their faces and names unrecoverable even when the work of their hands is preserved. Half of them have been women; very many have been African American or of Native heritage. Others immigrated to the United States from Asia or Latin America, bringing their skills with them (and often little else). The story of American craft concerns them all.

∼

The historian Gary Kornblith has observed that "the age of handicraft production did not seem so golden to those who experienced it firsthand."[5] Colonial artisans faced difficulties both great and small. Most went bankrupt at least once in their careers. They were at the mercy of large-scale economic trends. They often struggled to acquire and retain materials, tools, and even their own apprentices. Indeed, though it is often romanticized, eighteenth-century apprenticeship is best understood as a system of coercive poor relief. Most who found themselves bound to a master got that way against their will, as orphans, or children of impoverished families. By law, they were then required to stay and work for very low wages, usually for seven years, sometimes up to the age of twenty-one. But this European model faltered in the United States, a wide-open country where labor was scarce. Without craft guilds to exert control over training and standards, both information and people moved around freely. In order to keep up with demand, workshop masters were obliged to impart trade secrets to their apprentices and indentured servants. Once they acquired a basic skill set, young craftsmen found it easier to relocate rather than complete their term of service. They were in a classic seller's market: The colonies were ever short of capable hands.[6]

In rural contexts particularly, flexibility was the rule, as artisans turned their skills to whatever needed doing. The Dominy Shop, for example—which operated over four generations in East Hampton, Long Island, and whose shop equipment, tools, and manuscripts are now preserved at the Winterthur Museum in Delaware—was the site of an array of crafts, among them clockmaking, gunsmithing, joinery and

cabinetmaking, toolmaking, wheelwrighting, horseshoeing, and sundry repair work.[7] The lives of rural artisans were further varied because they were in their shops only part of the year. At planting and harvest times, they worked in the fields among their neighbors and relations. Noah Webster, he of the first American dictionary, contrasted the situation to that in Europe:

> In a populous country, where arts are carried to great perfection, the mechanics are obliged to labour constantly upon a single article. Every art has its several branches, one of which employs a man all his life.
>
> A man who makes heads of pins or springs of watches, spends his days in that manufacture and never looks beyond it. This manner of fabricating things for the use and convenience of life is the means of perfecting the arts; but it cramps the human mind, by confining all its faculties to a point. In countries thinly inhabited, or where people live principally by agriculture, as in America, every man is in some measure an artist—he makes a variety of utensils, rough indeed, but such as will answer his purposes.[8]

This image of the preindustrial artisan as a universal artist is a powerful one, and has served as a touchstone through American history. It is also an exaggeration, because in every artisan's life, there was plenty of repetitive labor to be done. When they were at the anvil, country blacksmiths spent most of their time on a few basic tasks: making nails, sharpening plow blades, repairing chains, shoeing horses, over and over. One-off masterpieces were very rarely called for. In fact, blacksmiths had little choice in what they made. Very few—only 20 percent, by one estimate—even owned their own smithies, instead working as hired hands for the planter who owned the land. In cities, some smiths had opportunities to make decorative work, but many operated within the precincts of dockyards or mills, making chains, anchors, or gears. This was certainly demanding work, requiring high levels of skill, but it was not necessarily inventive. And repetitive labor was routine in other trades, too. Joiners commonly made sets of eight, twelve, or more chairs, all matching, perhaps based on an imported model or a printed pattern "lately from London." Turners speedily fashioned large quantities of identical bowls, stair balusters, or table legs on their foot-powered lathes. Pewterers, many of them itinerant, had even less scope for innovation. Their stock-in-trade consisted of crucibles and molds, which they used to melt down worn or damaged pieces and cast the metal anew.[9]

So, despite later imaginings, preindustrial craft was hardly a stream of constant creativity. Artisans' value lay not in their power of invention, but in their reliability, their *industry*, a term that originally referred not to factories, but to personal work ethic. The Boston silversmith John Coney (who trained Paul Revere's father, the French immigrant Apollos Rivoire) was eulogized on his death in 1712 as "a rare example of industry, a great Redeemer of his Time, taking care to spend not only his Days, but his Hours well, and giving Diligence in his Business." The biblical allusion here—to Ephesians 5:15–16, "See then that ye walk circumspectly, not as fools, but as wise / Redeeming the time, because the days are evil"—alerts us to the religious context for early American craft. A good artisan, a good Christian, was conscientious. The proof of that character was in the work: consistent results, achieved under time pressure despite nonstandardized materials and variable work conditions. And though later commentators liked to imagine the Colonial era as a time of "joy in labor," the Sabbath, a full calendar of holy days, and traditional "Saint Monday" were held as sacrosanct. Artisans were not so joyful that they weren't eager to get off the job.[10]

So, craft production was not idyllic. But it was essential. Whenever and wherever a new town was founded, it required artisans. The first tax assessment for present-day Allentown, Pennsylvania, drawn up in 1762, had only thirteen taxpayers, but they included two carpenters, two tailors, a smith, and a wagoner; two years later, they had been joined by two more tailors, a furniture maker, a mason, a butcher, and a shoemaker who also ran an inn.[11] As specie (hard coinage) was always limited, especially in rural areas, these artisans exchanged their services with other townspeople on a barter system. Work might be done in exchange for food, for other artisans' services, or for raw materials like old iron. Extended lines of credit might be held open for months, or even years. All these informal, face-to-face arrangements helped bind the community together.

This pattern had long been established. Way back in 1608, the year after America's first permanent English settlement was established at Jamestown, the financial backers of the town sent a supply voyage with eight contracted German and Polish craftsmen (who were expert in making turpentine, potash, and glass) and a Swiss miner. The hope was that these men would found industries and train the other unskilled colonists to work them. This reflected an assumption that the colonies would pay off quickly, through resource extraction, a drastic underestimation of the difficulties that living in the New World posed. Dreams of easy riches were quickly

dashed. Many settlers died of disease and starvation. The survivors concentrated on feeding themselves (though remarkably, there is archaeological evidence of an early attempt at glassmaking). John Smith, the swashbuckling sea captain who assumed control of the colony's governing council, saw the continental artisans as the backbone of an otherwise incompetent community: "Only the Dutch-men and Poles, and some dozen others . . . knew what a dayes worke was."[12]

A decade later, the *Mayflower* arrived in the vicinity of present-day Plymouth. Motivated by religious zeal rather than commercial opportunism, these English and Dutch "pilgrims" were delayed on their crossing and so did not arrive until late in the year. By the time they had determined their place of landing, it was December, and most of them were obliged to wait out the winter on board. William Bradford, the chronicler and governor of Plymouth (and a silk weaver by trade), later wrote, "Having past ye vast ocean, and a sea of troubles before in their preparation, they had now no friends to welcome them, nor inns to entertain or refresh their weatherbeaten bodies, no houses or much less towns to repair to, to seek for succor." Come spring, the *Mayflower* sailed away, and the colonists set about building permanent shelters—dirt-floored, clapboard-sided, thatch-roofed. Carpentry was a matter of life and death, but as late as 1623, one of the settlers wrote back to England reporting that just twenty houses had been completed, of which only five were "fair and pleasant."

Fortunately for the colonists, there were excellent makers in the area. One of the settlers' very first expeditions on land yielded a find: in Bradford's telling, "diverse fair Indian baskets filled with corn, and some in ears, fair and good, of diverse colors, which seemed to them a very goodly sight." There was also a metal kettle, obtained through exchange with earlier European traders. The Pilgrims helped themselves to everything they found, intending to use the grain partly for seed. It was a first act of petty theft in a centuries-long pattern of exploitation.

The corn was there for the taking because the people who had inhabited this land for millennia, the Wampanoag (one nation within the wider Algonquian culture of the northeast woodlands) had recently been decimated by disease, contracted from earlier European arrivals (more specifically, shipboard rats). The majority of the population had died in this epidemic, mostly between 1615 and 1619, a tragedy that repeated itself wherever cultural contact occurred between Europeans and Native Americans. By the time Bradford and his brethren arrived, the Wampanoag

community had withdrawn from the coastline, leaving not just handmade baskets full of corn, but cleared land and even burial pits, which the colonists used to inter their own numerous dead. Another result of this depopulation was that, even at this point of initial contact with Native peoples, it was already possible for Europeans to see them as figures receding into the past. This was part of the mix of fear, disdain, and idealization that allowed the settlers to justify their own actions. We ourselves should not make the mistake of idealizing Native culture; brutal violence was hardly introduced to the Americas by European settlers. Indigenous nations were both diverse and rivalrous, and had been engaging in both trade and warfare for millennia. The colonists, however, were all but blind to this complex history. They tended to view Native people simply as both uncivilized brutes and "nature's gentlemen," both pitiable and pure—and in any case, fated to disappear.[13]

Craft assumed an important place within this racist—indeed, genocidal— attitude. One of the most common leitmotifs of commentary on Native people was that they lacked rational understanding. As Alexander Pope wrote in his 1734 *Essay on Man*, "Lo, the poor Indian! whose untutor'd mind / Sees God in clouds, or hears him in the wind; / His soul proud Science never taught to stray." Now, every European settler, struggling to survive in what seemed a hostile wilderness, was struck by the Natives' practical skills. Wampanoag adults were expected to be self-sufficient, attending to their own food, clothing, and shelter. This meant mastering the skills of hunting, fishing, leatherwork, basketry, wood carving, stonework, pottery, and more. Fire was a key technology, used for warmth and cooking, to hollow out dugout canoes, and to fell enormous old-growth trees (far easier than using a metal axe, as the colonists tried to do).[14]

Rather than seeing this omnicompetence as something to be emulated, however, Europeans tended to juxtapose it with true understanding. The French Jesuit priest Pierre-François Charlevoix, who traveled widely in North America in the 1720s, wrote of Native peoples that "everyone must acknowledge, that they have a wonderful Genius for Mechanics: They have scarce any Need of Masters to excel in them, and we see every Day some who succeed in all Trades without having served an Apprenticeship." All the same, they were "not fit for the Sciences, which require much Application, and a Course of Study."[15] This dynamic runs through the history of American craft—a declared preference, among the cultural elite, for knowing *that* over knowing *how*. This attitude, which first enters the story through European

commentary on indigenous populations, would be deployed to denigrate particular kinds of people (Blacks, the working class, women, immigrants) and the value of their skills for centuries.

A case in point is beadwork, which was and is used for myriad purposes by Native people, but attracted most interest among European colonists in the form of wampum, a medium of both communication and exchange. The Wampanoag shaped wampum beads by hammering the hard, brittle shell into small pieces, which were then ground into the desired form with a stone. The stringing channel inside each bead was made using a bow or pump drill, historically tipped with a sharpened stone bit; when metal became available after contact, they used reworked iron nails and awls, or simply imported European drills.

Two different shell materials are used in wampum making: the core spiral of white whelks and the distinctive purple inner surface of quahog clamshells. These are rich with association. For a people who have always derived much of their livelihood from the sea, shellfish are not only a staple food but also deeply imbued with social and spiritual significance—sustenance taken up from the unseen depths into the human realm. (Some present-day Wampanoag return shells to the water after consuming their meat, as an offering of gratitude.) Shells are also extremely hard and durable, surviving archaeologically in burial middens for many centuries, and so represented a temporal dimension beyond, yet intertwined with, the span of human life.[16]

The binary color scheme of wampum is ideal for creating graphic patterns, which can be arranged on a simple loom strung with milkweed or other plant fibers, the terminations finished with leather or gut. These configurations (triangles or figures in silhouette, for example) had symbolic import, and were variously interpreted as signifying peace and war, or light and darkness. At diplomatic sessions, they were literally read out, point by point; a missionary named David Zeisberger claimed that Native people "are so accustomed to this that when they communicate the contents of a message, merely in private conversation, they cannot do so without something in their hands, a strap, a ribbon or a blade of grass."[17] At the conclusion of a council, the wampum was often handed over to mark agreement, a procedure that Europeans likened to the signing of a contract. In one very early instance, a wampum belt with two parallel lines in purple was used to mark a treaty between the Haudenosaunee and the Dutch in 1613, signifying that the peoples would travel together into the future, like vessels on the same river, neither attempting to steer the other. Much

later, in the momentous year of 1776, a group of Shawnee sent a delegation to the town of Chota, in what is now Tennessee. They brought with them a nine-foot-long belt of purple wampum, serving as a declaration of war. In case its meaning was not sufficiently clear, a spokesman explained (in words recorded by a British agent present at the scene) that the "red people" had once been "Masters of the whole Country," but now they "hardly possessed ground enough to stand on." The whites had made it plain that "there was an intention to extirpate them." [18]

Europeans understood Native beadwork's diplomatic content, but they mainly viewed it quantitatively. Because they had seafaring experience, they tended to measure wampum by the fathom (six feet), a length requiring about three hundred beads total. That might have taken a skilled Native about a week to fashion, with longer and more complex belts representing commensurately more labor—examples with more than ten thousand beads are known. The Europeans certainly understood wampum as currency; when Carl Linnaeus gave quahog clam its taxonomic name, he called it *Mercenaria mercenaria*. Even so, they were perplexed by Native attitudes to its value. John Lawson, an English naturalist who conducted early explorations in the Carolina interior, commented in 1714 on the difficulty of making the beads ("smaller than the small end of a tobacco pipe, or a large wheat straw") and then drilling them ("very tedious work"). So tedious, in fact, that when Englishmen tried to make wampum, effectively an attempt to mint the American coinage, "it proved so hard that nothing could be gained." "The Indians are a people that never value their time," Lawson explained, "so that they can afford to make them, and never need to fear the English will take the trade out of their hands." [19]

Too little value, too much time. This formula, too, would come to haunt American craft after the advent of industry. Once there were machines, making things by hand simply could not be justified—at least not on narrow economic grounds. But machines were not the issue yet, in 1714 (nor would they be in 1814). Rather, the question was one of attitudes to labor. Lawson and other European observers saw the production of Native peoples as misapplied, irrational. And what constituted rationality? Increasingly, there would be one and only one answer to that question: the market. In 1776, just as the revolution ignited in the colonies, Adam Smith published *The Wealth of Nations*, whose argument is there in its very first line: "The greatest improvements in the productive powers of labour, and the greater part of the skill, dexterity, and judgment, with which it is anywhere directed, or applied, seem to have been the effects of the division of labour." Over the course of his book,

in patient, unrelentingly logical prose, Smith explained just why "skill, dexterity and judgment" must be controlled by the imperative of efficiency, with tasks broken up into smaller and smaller parts. Smith's passage on pin making is best remembered. He reported on a factory that, through subdivision of labor, was able to produce 48,000 pins in a single day, with only ten workers. "If they had all wrought separately and independently," Smith notes, "they certainly could not each of them have made twenty."

Smith argued that a worker's dexterity would actually increase with specialization—a blacksmith who only made nails would do it better and faster—and he pointed to the time saved in shifting from one task to another. An artisan who also farmed, as most did in eighteenth-century England and America, was inherently inefficient. ("A man commonly saunters a little in turning his hand from one sort of employment to another.") In making this argument—the exact antithesis to that proposed by Noah Webster—Smith was by no means insensible to the importance of personal skill. He just thought of it in totally instrumental terms, without any attention to its psychological or social aspects ("consumption is the sole end and purpose of all production"). And he believed that skill should be tightly circumscribed in order to ensure maximum value creation. This could best be done simply through the unfettered operations of the market itself. He famously wrote of the economy as self-guiding, directed, as it were, by an "invisible hand." Left to their own devices, individual workers and consumers, "without intending it, without knowing it, advance the interest of the society."

This is exactly what Native peoples did not do. In practical terms, their generalist approach, in which everyone knew how to perform many needful crafts for themselves and those in their close community, was not incompatible with the way that rural colonists worked. The problem, from the European perspective, was that they did their work without regard for the laws of supply and demand. As the Irish trader James Adair wrote in his *History of the American Indians*, published just one year prior to *The Wealth of Nations*, the Natives exchanged wampum "at a stated current rate, without the least variation for circumstances either of time or place; and now they will hear nothing patiently of loss or gain, or allow us to heighten the price of our goods, be our reasons ever so strong."[20]

This was exasperating to the colonizers. But they did figure out a workaround, importing glass beads from Italy and Bohemia to replace the indigenous shell. Native people across the continent adopted this new medium and achieved brilliant

results with it. They adapted patterns originally achieved with shell or porcupine quills, and adapted their skills, too, just as they had when adopting metal tools. Benjamin West, the American-born painter who advised Copley to follow him to London and there shed his provincial technique, amassed a small collection of these glass beadworks to use as models for his paintings. We can see them, for example, in *The Death of General Wolfe* (1770), which also features a tattooed and pensive Native warrior, who has often been interpreted as the very type of the "Noble Savage," contemplating the sight of death with equanimity.[21]

Interestingly, one early biographer reported that Benjamin West's first painting instructors were Native Americans who taught him to prepare red and yellow pigments. The tale is almost certainly apocryphal, yet it captures a truth that colonists hardly dared admit from the time they first set foot in the Americas. For all that they disparaged Native people as ignorant savages, and excused their own acts of violent destruction as a means of expanding civilization, the Europeans had less to teach than they had to learn.[22]

~

Benjamin Franklin, ever willing to be skeptical about his countrymen's easy assumptions, captured this truth in an anecdote told in his *Remarks Concerning the Savages of North America*, written while he was living in France, in 1784. Almost uniquely for its day, the slim publication argued for a relativistic attitude to Native American culture: "Savages we call them, because their manners differ from ours, which we think the Perfection of Civility; they think the same of theirs." As an example, he

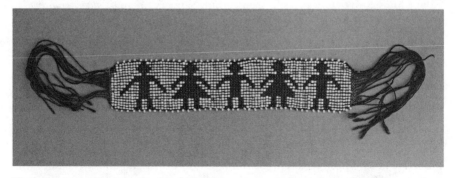

The loom-woven garter in glass beads, imitating wampum, that is depicted in Benjamin West's painting *The Death of General Wolfe* (1770). © The Trustees of the British Museum.

recalled an exchange that had occurred forty years earlier, when a delegation from the six Haudenosaunee nations had met with a contingent of white military men in Lancaster, Pennsylvania. The main business was to draw up a treaty, but at one point during their exchange, the Native group made a magnanimous offer: "Several of our young people were formerly brought up at the Colleges of the Northern Provinces; they were instructed in all your sciences; but, when they came back to us, they were bad Runners, ignorant of every means of living in the Woods, unable to bear either Cold or Hunger, knew neither how to build a cabin, take a Deer, or kill an Enemy, spoke our language imperfectly, were therefore neither fit for Hunters, Warriors, nor Counsellors; they were totally good for nothing." The Haudenosaunee concluded: "If the Gentlemen of Virginia will send us a dozen of their Sons, we will take great Care of their education, instruct them in all we know, and make Men of them."[23]

Regular readers of Franklin—and there were many by the 1780s—would have recognized the irony in this tale. He loved to take a notion, in this case that of the American "self-made man" that he himself had done so much to invent, and turn it on its head. This crafty bit of rhetoric aside, though, he was no advocate of the unhurried way of life commonly associated with Native people. For if anyone was more convinced than Adam Smith that time was money, it was Ben Franklin. *Poor Richard's Almanack*, his annual bestseller of helpful information and homespun advice, brimmed with injunctions about frugality and industry. (It was later compiled into the even better-selling book, *Way to Wealth*, which, for Franklin, it was.) Among Poor Richard's pearls of wisdom: "Diligence is the mother of good luck." "He that hath a trade, hath an estate." "Learn of the skillful—he that teaches himself, hath a fool for his master." "God helps those who help themselves." (Franklin helped himself to that line; it's from Algernon Sidney's 1689 *Discourses Concerning Government*). Mark Twain later quipped that this aphoristic onslaught had brought untold suffering to generations, "being held up for the emulation of boys forever—boys who might otherwise have been happy." Early to bed, early to rise, makes the man healthy, wealthy, and wise? "The sorrow that that maxim has cost me through my parents' experimenting on me with it," Twain wrote, "tongue cannot tell."[24]

Twain's grousing aside, Franklin did become a paradigm for later Americans, the living embodiment of the low-born artisan made good. He was born in Boston in 1706, one of seventeen children, the son of a soap maker and tallow chandler who initially planned to bring his youngest son into his own trade. When young Franklin resisted this idea, finding the work noxious (as indeed it would have been), his father

had an inspired idea. He took the boy on a sort of walking tour of the city's craft shops (joiners, bricklayers, turners, braziers) to see if anything caught his imagination. Seemingly, everything did. When Franklin recounted the story in his *Autobiography*, he commented, "It has ever since been a Pleasure to me to see good Workmen handle their Tools."

In the end, in recognition of his evident bookishness, Ben was apprenticed as a printer in the shop of his elder brother James. Making newspapers and pamphlets was certainly better business than making soap, and of higher status. But it was still a manual craft. In an age when clean hands were the sign of a gentleman, Franklin's were perpetually smudged with ink. He learned both sides of the trade: the skills of the compositor who set up the type, which required dexterity and accuracy; and those of the pressman, demanding strength and endurance. At the same time, he began writing satirical essays, signed with the pseudonym Silence Dogood. These were published in his brother's paper, the *New England Courant*, which had the slogan "Jack of All Trades," suggesting alliance with an artisan readership. Consistent with this, Franklin mocked class pretensions, advancing the implicitly radical notion that opinion should be weighed for its own merits, not the station of the person who voices it, whether "poor or rich, old or young, a Scholar or a Leather Apron Man."

When Franklin wrote that line in 1722, he was in fact poor, young, and wearing a leather apron—the reliable sartorial indicator of the craftsman. A year later he launched himself on a course of independent self-improvement, one that never really ended. Though still apprenticed to James, he ran off, taking advantage of the absence of guilds in America. ("It was not fair in me to take this Advantage, and this I therefore reckon one of the first Errata of my Life," he wrote in his *Autobiography*, employing a printer's metaphor.) After trying his luck in New York, the teenage Franklin moved on to Philadelphia, where he quickly found work with one of that city's few printers, Samuel Keimer. This man apparently had no scruples about how his new workers had learned their trade and, anyway, not much of a shop:

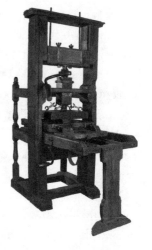

Printing press said to have been used by Benjamin Franklin in England in 1726. Division of Work and Industry, National Museum of American History, Smithsonian Institution.

just an "old shatter'd Press, and one small worn-out Fount of English." Franklin found lodging nearby in the home of a "plain carpenter," John Read, whose daughter Deborah would some years later become Franklin's wife. And he set to work.

Thus, Franklin's early years were thoroughly saturated in artisan culture of the middling sort. This upbringing, related in his *Autobiography* as a parable, forever after secured his identity as America's most democratic founder. He is our great self-made man, our prime paragon of social mobility. Yet it is not so easy to square his complex character with a single class identity, or indeed a single identity of any sort. The widow Silence Dogood was only the first of many guises he would assume over the course of his writing career, more than a hundred in all, each associated with a particular point of view—plain old Homespun; Anthony Afterwit, the beleaguered husband; Alice Addertongue, the gossip; and of course "Poor" Richard Saunders, the American Everyman whom Franklin was not, quite.[25]

In 1724, Franklin sailed for London, initially to secure better printing equipment, but ultimately staying for nearly two years. During this first British sojourn, he found himself in conflict with traditional craft ways, at first over alcohol. The abstemious Franklin sought in vain to persuade his fellow printers not to drink beer all day, thus saving their money and clearing their heads. This won him few friends, as might be expected. Things got worse when he refused to pay a so-called *bienvenu*, a round of drinks for all hands, traditionally paid by new workers. "I stood out two or three Weeks," Franklin recalled, "was accordingly considered as an Excommunicate, and had so many little Pieces of private Mischief done me, mixing my Sorts, transposing my Pages, breaking my Matter, &c. if I were ever so little out of the Room." Eventually he paid up, "convinc'd of the Folly of being on ill Terms with those one is to live with continually."

Once back in Philadelphia, Franklin remained firmly involved in the printing trade, initially at Keimer's shop and then out on his own, though at an increasing distance from the shop floor as he became more successful. He finally closed his shop in 1748, at the age of forty-two. That early retirement was possible because he had also become a highly successful entrepreneur, flogging his almanacs, setting up paper mills, and creating an innovative franchise of printshops nationwide. Historians differ on whether Franklin wanted to escape his tradesman roots, as Copley and Revere did, or remained proud of his artisan identity.[26] In theory, he was definite on the point: "Labouring and Handicrafts Men [are] the chief Strength and Support of a People."[27] Yet much of his biography suggests otherwise. When he founded a

group for self-improvement and debate, which posed itself discussion questions such as "Have you lately heard of any citizen's thriving well, and by what means?," it was initially called the Leather-Apron Club. But when an actual gentleman joined, it was renamed the Junto (a Spanish term for a legislative assembly).

As he became wealthy, Franklin also did things of which few other artisans would have conceived. He became an amateur naturalist, conducting the scientific experiments with electricity that won him worldwide fame, and an avid inventor, designing an efficient stove that bore his name. He had himself painted by the artist Robert Feke; in the portrait he wears not an apron, but a smart velvet coat. He aspired to public office. And he purchased slaves, not for his workshop (as many other master mechanics did), but as household servants—a married couple named Peter and Jemima; their son, Othello; and three others, George, John, and King—though in later life he came to repudiate slavery, even serving as the president of an early abolitionist society.[28]

Franklin's increasingly elevated social position did not prevent other artisans from embracing him as one of their own. In 1765, during the crisis over the Stamp Act, which imposed a wildly unpopular tax on printed paper goods, Franklin's hard-won property was at risk. He was in England at the time, and widely perceived to be a loyalist. (That was entirely accurate; Franklin remained conciliatory with the British government right until the eve of revolution.) It was only through the defensive action of a group of ship carpenters called the White Oaks that his house was protected from a furious mob. When the Stamp Act was repealed the following year, this same artisan society constructed a new fishing boat to celebrate, and christened it the *Franklin*.[29] It was the first of many such tributes, and they did not go unreciprocated. On his death, Franklin bequeathed a princely two thousand pounds to set up endowments that would make small business loans to craftsmen. These funds were later used to create the Benjamin Franklin Institute of Technology, in Boston, and the Franklin Institute, a science museum

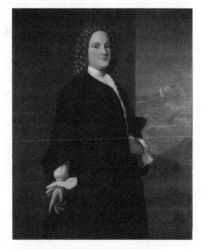

Robert Feke, *Portrait of Benjamin Franklin*, c. 1746. © President and Fellows of Harvard College, Accession Number H47.

in Philadelphia. In the codicil to his will that outlined this gift, the man who had run away from his older brother's shop so long ago explained his benevolent intentions: "I have considered that, among artisans, good apprentices are most likely to make good citizens." The printing trade, after all, "was the foundation of my fortune, and all the utility in life that may be ascribed to me."

With this final generous act, Franklin reclaimed his craftsman identity even as he played the role of a great philanthropist. He both encouraged and enabled other artisans, other citizens, to rise above their humble stations, just as he had. His story was unique, not least in its being so well told. But the trajectory from artisan to entrepreneur was one that arced through the American imagination in the years and decades following the revolution.

The revolution itself was a big part of the reason. From its very beginnings, the patriot cause was rooted in craft communities. "Mechanics" (the commonest term for artisans at the time) were the best organized, most committed, and most physically courageous of the revolutionary activists. In the periodic uprisings of the 1760s and '70s, the ship carpenters who protected Franklin's house were the exception. Usually the artisans were the ones burning things down.

Consider the Boston Tea Party, which took place on December 16, 1773, and resulted in the destruction of a whole shipload of tea belonging to the East India Company. (Franklin, still in peacemaker mode, argued that the merchants should be compensated in full.) Among the participants were coopers, masons, carpenters, and blacksmiths. Paul Revere was there. A decorative painter and japanner (that is, a specialist in imitation lacquer), the appropriately named Thomas Crafts, likely made the "Mohawk" disguises for the group. Francis Akeley, the only person among the several hundred involved who was unfortunate enough to be imprisoned, was a wheelwright. George Robert Twelves Hewes, a diminutive shoemaker who had also been present at the Boston Massacre, where he was hit by a rifle butt, blackened his face with coal dust from a blacksmith's shop beforehand. (He lived long enough to be treated with nostalgic awe as a surviving witness to the event, and though he lived in penury his whole life, he was nonetheless praised for his Franklinian "habits of industry, integrity, temperance and economy.")[30] Nathaniel Bradlee, a housewright, was one of the main planners of the raid; his sister Sarah Bradlee Fulton is said to have come up with the idea for the Native costumes, and prepared a pot of hot water for the protestors to clean their faces with afterward.

Costumes aside, the Tea Party was a typical proto-revolutionary riot, both led and executed by artisans. The pattern first emerged when the hated Stamp Act was passed in 1765. In Boston, protests were coordinated by a group calling themselves the Loyal Nine; Thomas Crafts was one of them, along with two distillers, two jewelers, two braziers, and a printer, as well as a ship captain. In New York, a loyalist decried the way that "Cobblers and Tailors" were taking over politics, dislodging "the loyal and sensible inhabitants of the city and province of New York."[31] In Philadelphia, the tailor Joseph Parker put himself forward for elected office, breaking into a realm of public life previously reserved for his social betters. And in all three cities, artisans erected "liberty poles," put effigies of Colonial administrators to the torch, and posted placards signed VOX POPULI.[32]

All this political activism was premised on a Franklinian ideal of individualism, personal merit, and hard work; as the historian Charles Olton has observed, "mechanics appear to have been less interested in erasing barriers based on class than in crossing them."[33] This was no class war, with proletarians facing off against a bourgeoisie. Indeed, independent artisans found much in common with small merchants. Though they did find themselves on opposite sides of certain policy questions—craftspeople favored tariffs and boycotts to protect domestic manufactures, for example, while merchants opposed them, as they cut into profits—they both wanted to see trade prosper. We easily forget that urban artisans made many of their goods for export; even gravestone carvers in Boston shipped their work all the way down the East Coast to Charleston, and occasionally as far as the Caribbean.[34] It's also worth remembering that the prerevolutionary master artisan was a capitalist, of a sort. A printer could not operate without presses and type, a joiner without tools and stores of timber, a glassmaker without a furnace. They were property owners. It was this, as much as their skills, that distinguished masters from the mass of journeymen and apprentices, indentured and enslaved laborers. In the more highly capitalized crafts, equipment was an important legacy left from parent to child, promoting family lineages within a trade.[35]

One of the most powerful binding agents for the mercantile and artisanal elite was the institution of Freemasonry. This network of secret societies had evolved from stoneworkers' guilds in Britain, which took on outside members to bolster their numbers during the seventeenth century, when guild membership was in decline. By 1717, when the first Grand Lodge was founded in London, very few members of

the fraternity were actually stonemasons. Only a minority constituted craftsmen of any sort (in Colonial America, estimates hover at about 10 percent). But the symbolism of the organization was saturated in craft imagery. Freemasons constructed a mythic history for themselves, going back to the building of Solomon's Temple in biblical times. At "the lodge" (usually held in a tavern or coffeehouse), a Freemason wore an apron, made of clean lambskin rather than durable leather, but still emblematic of artisan identity. Membership rituals and iconography featured the mason's compass, square, level, and plumb line, representing guidance, honesty, equality, and upright-ness. Lodge degrees mirrored those of a traditional craft guild, rising from "entered apprentice" to "fellow craft," and finally to "master." A Freemason was most likely to be a merchant, lawyer, or physician, but at least playacted the role of mechanic.[36]

The Great Seal of the United States features masonic symbolism to this day; turn over a dollar bill, and you'll see a perfectly built stone pyramid, with an all-seeing eye

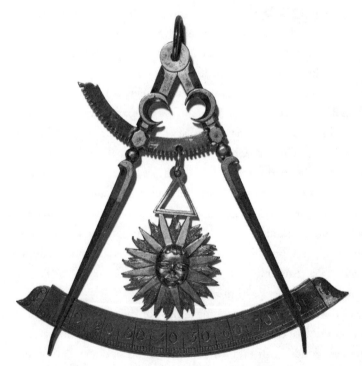

Masonic Past Master's Jewel, New York, 1804. This medal belonged to Mordecai Myers, a Jewish merchant in New York City who served in the War of 1812. Division of Cultural and Community Life, National Museum of American History, Smithsonian Institution.

hovering at its apex. This reflects the enthusiasm that the revolutionary generation had for fraternal societies. Franklin was a member of America's first masonic lodge, founded in Philadelphia in 1730. Revere was a Freemason, as was Thomas Crafts; they plotted along with other Sons of Liberty at the Green Dragon Tavern, which was owned by St. Andrew's Lodge and briefly operated as "the Masons' Arms." Also in Boston was Prince Hall, a free Black minister who had been born in Barbados. Manumitted from slavery in 1770 by his owner, William Hall, a tanner, he took up leatherwork as his trade. Five years later, he and fourteen other African Americans appealed to a masonic lodge of Irishmen who were attached to the British Army then encamped at Bunker Hill. The soldiers, apparently overcoming whatever racial prejudices they may have held, agreed on the spot to initiate them into the fraternal order—though they asked twenty-five guineas apiece for the privilege. Hall and his supporters then promptly organized Provisional African Lodge No. 1, the first Black masonic organization in America, with Hall as its first worshipful master.[37]

Prince Hall Freemasonry expanded with the rest of America. (In its bicentennial year of 1975, it would boast as many as three hundred thousand members nationwide, and a proud history of activism within the civil rights movement.)[38] But first there was a revolution to fight. With the onset of war, Hall unsuccessfully lobbied the Massachusetts legislature to commit to the abolition of slavery. His brother masons also turned him down, the all-white Grand Lodge of Massachusetts refusing the African Lodge's application for a charter. He could have been under no illusions as to the racial attitudes of his countrymen. But Hall remained an optimist. Feeling that Black soldiers would be the best possible argument for future emancipation, he advocated that they be allowed to enlist in the patriot army. He is thought to have fought for the patriot cause himself, possibly returning to Bunker Hill for the famous battle there, and to have made leather drumheads for the military. And in later speeches to his fellow African American masons, he counseled the same path of self-improvement that was central to white artisanal culture: Whenever "one of our members is at a drinking house, or at a card table, or in some worse company, this brings disgrace on the Craft." Above all, he counseled patience, realizing that the road to racial equality in America would be a very long one: "Patience, I say, for were we not possess'd of a great measure of it you could not bear up under the daily insults you meet with in the streets of Boston."[39]

~

There are striking parallels in the lives of Benjamin Franklin and Prince Hall, two artisans born into unpromising circumstances who rose to prominence through their own merit and counseled others that they could do the same. There the likeness ends, however, for there is no comparing the experiences of white and Black craftspeople in eighteenth-century America. If a white artisan's social position was anchored in ownership of property, enslaved Blacks did not legally own even their own bodies, and free Blacks were in a perpetually precarious position, their rights to live and work constantly under assault. For any African American, the possession of craft skill was more important than it could possibly have been for a white person.

In the plantation economy of the South, a minority of enslaved people (particularly those of mixed race) were put to work as house servants, a relatively secure position, if still a dehumanizing one. The vast majority was forced into agriculture fieldwork, which meant unrelenting labor and the constant threat of physical torture. Even in that brutal situation, the enslaved were sometimes valued for their skills, as with those who arrived with knowledge of West African rice or indigo propagation. But the surest way to escape the fields was to learn a trade, such as blacksmithing, carpentry, and boatbuilding (for men), or spinning and weaving (for women). In plainest terms: Skilled people were just too valuable to work to death.

The financial investment in buying an enslaved artisan, or training one from childhood, was considerable. For an owner, it had to pay off. This could be achieved not only through direct enforced labor, but also by hiring out, for a day, a week, a season, even a year. This usually meant that enslaved craftspeople were sent to other plantations or to the nearest town, where they would work alongside an existing population of whites and free Blacks. Many of these enslaved artisans were required to carry at all times a small impressed-metal badge, marking their ownership and occupation. They readily realized, however, that this represented a degree of freedom: The more distance they could maintain from a master, the better. Some took the opportunity to escape, taking their tools with them (as with Dick, a "good carpenter" who left a plantation near Richmond in 1794 with a "band saw, jack and long plane"). But they also stayed: Blacks, free and bonded, accounted for between one quarter and one half of the construction workforce in southern cities. The Charleston attorney Timothy Ford wrote in his diary in 1785, "I have seen tradesmen go through the city followed by a negro carrying their tools . . . in fact many of the [white] mechanicks bear nothing more of their trade than the name."[40]

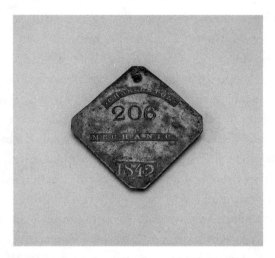

The badge of an enslaved mechanic from Charleston, South Carolina, 1842. Courtesy of Old Salem Museums & Gardens.

Nor was the slave trade just a southern phenomenon. Its profits helped build cities like Newport and Bristol, in Rhode Island, the primary slave ports in the north, where Blacks were forced to make the very vessels that were used in human trafficking. In the dockyards, they made ropes, masts, and sails, or worked as ship carpenters and caulkers (who sealed the hull with a mixture of hemp fiber and pine tar). These were difficult, sometimes dangerous, and for the most part relatively unskilled jobs. But there were also many Black coopers and printers, furniture makers and metalsmiths, both free and unfree. In total, enslaved people actually outnumbered both apprentices and indentured servants in the North. When we are faced with an eighteenth-century teapot or high chest in a museum, it is usually impossible to know whether or not it was made partly with enslaved labor. But newspaper advertisements—selling people, and offering rewards when they escaped—attest that African Americans as young as fifteen could be highly valued for their skills. Master mechanics' inventories also attest to the presence of enslaved artisans, for they were itemized as property. The cooper John Butler, for example, had four enslaved workmen in his shop; one of them, a man named Boston, for the city where he lived, was valued at five hundred pounds, which implied he was very skilled indeed.[41]

Such trace evidence—a single name in a runaway notice here, an inventory listing there—is as close as we can normally get to the identities and perspectives of enslaved artisans. It can be similarly challenging to recover female experience in the eighteenth century, as is suggested by the feminist slogan "Anonymous was a woman."[42] But a generation of scholars has done pioneering work in this regard, and some of these historians (e.g., Rozsika Parker, Laurel Thatcher Ulrich, and Marla Miller), have focused particular attention on women with craft skills. Occasionally, female artisans ran their own enterprises in fields such as printing and cabinetmaking because they had been widowed. In such exceptional cases, it is likely they worked mainly in a management role. Where every eighteenth-century American woman did get hands-on, though, was in the discipline of textiles. Basic needlework was virtually universal, taught to young girls as a matter of course, and it could be developed into myriad advanced techniques. At a time when textiles were extremely costly—the densest concentration of wealth in most homes—and ready-made clothes were unknown, it was vitally important to be able to mend fabric and, when necessary, repurpose it.

Sewing was also a discipline in another sense: Learning it well required patience, physical endurance, and attention to detail. Girls were instructed to make samplers with the alphabet and numerals, and sometimes an additional legend: LYDIA DICKMAN IS MY NAME AND ENGLAND IS MY NATION AND BOSTON IS MY DWELLING PLACE AND CHRIST IS MY SALVATION. IN THE THIRTEENTH YEAR OF MY AGE, 1735.[43] These demonstration pieces, or "accomplishments," the thread equivalent to a penmanship exercise, attested to their makers' literacy and also implied a readiness to take on household duties—and hence to marry. With their formulaic execution and inscriptions, samplers can seem somewhat disheartening, not so much evidence of young women's creativity as the lack of options that lay before them. Yet, once the stitches were learned, embroidery could be turned to ends as imaginative as any painting. A well-known example is Prudence Punderson's needlework picture *The First, Second, and Last Scene of Mortality*, completed in the early days of the revolution, when she was about eighteen. This compellingly self-referential image shows its own maker seated at a tea table working at her craft. A pewter ink stand and pen are beside her on the tabletop. At one end of the room is Punderson again, as an infant; at the other is her own future coffin, marked PP. The Black child rocking the cradle is possibly a representation of an enslaved girl described as "Wench Jenny" in the will of Punderson's father. The empty chair in the picture may signal Punderson's

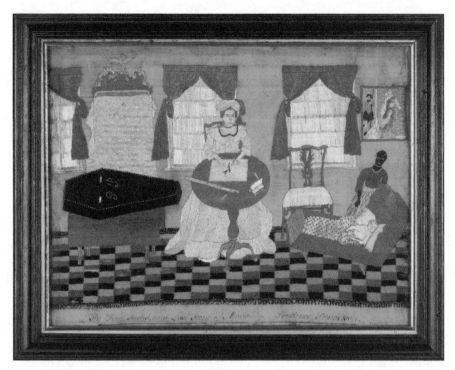

Prudence Punderson, *The First, Second, and Last Scene of Mortality*, 1770s. 1962.28.4,
The Connecticut Historical Society.

then-unmarried status, though she did later wed her cousin. In an eerie fulfillment
of her own future portrait, she bore a daughter, Sophie, in 1784, and died less than a
month later, only twenty-six years old.[44]

Complex allegories like Punderson's are rare in American needlework. But for
many women, sewing really did become a means to secure an independent living.
One possibility was to open a home school, offering private tutorials in dress-
making or other marketable skills. One woman who chose this path, a Mrs. Armston
of Norfolk, must have been a craft polymath of extraordinary ability. According
to her advertisements in the *Virginia Gazette*, she was capable of teaching "Petit
Point in Flowers, Fruit, Landscapes, and Sculpture, Nuns Work, Embroidery in Silk,
Gold, Silver, Pearls, or embossed, Shading of all kinds, in the various Works in
Vogue, Dresden Point Work, Lace, Catgut in different modes, Muslin after the Newest
Taste, and most elegant Pattern, Waxwork in Figure, Fruit or Flowers, Shell ditto, or
grotesque, Painting in Water Colours and Mezzotints."[45] Less ambitiously but far

more commonly, women worked part time in a cottage industry (weaving fabric, knitting stockings, spinning yarn, making straw bonnets and hats) or in a branch of the sewing trades. Within this system, one end of the spectrum was the almshouse. These institutions presaged later industrialized factories, employing impoverished girls and women to perform unskilled tasks like carding wool and picking oakum (that is, untwining frayed ropes into separate hemp fibers to be used in ship's caulk). The broad middle ground was represented by home workers in artisan and farm families. These women gained much-needed supplementary income for the household—Laurel Thatcher Ulrich has described them as "deputy husbands"—and often they were involved in a stage of the family trade, for example, stitching the leather uppers of shoes. Spinning, easy to pick up and put down, was so common that half of rural households had wheels for the purpose.[46]

At the upper end of the spectrum of homeworkers were makers of suits and gowns. For both genders, everyday dress was comparatively simple to make, typically constructed from rectangular panels with straight seams and held together with drawstrings and pins. But more formal dress, worn regularly by the elite and as "Sunday best" among less wealthy families, demanded a wide technical repertoire. A man's bespoke suit (coat, vest, and breeches) had tight tailoring, numerous buttonholes, and trim. And a gown maker had to exercise great care in cutting, lest expensive fabric be ruined. So, while the barrier to entry for a seamstress was low in terms of equipment—all that was needed was needles, shears, thimbles, and pins—the advanced skills required would have kept most out of the craft.[47]

Come the revolution, women put their craft in the service of the cause. Both before and during the war, there was an intense need for increased domestic textile production, initially to fill the void resulting from patriotic importation bans. In one early and much-publicized incident, eighteen young women in Providence, Rhode Island, responded to the Stamp Act by gathering together with their spinning wheels and proclaiming themselves Daughters of Liberty. They swore not to drink tea or buy foreign goods, and also declared that they would not "admit the addresses of any gentlemen" of loyalist sympathies. Further, they committed to spin and weave a fine piece of linen, which would be given as a premium to the most successful flax grower in the region: domestic industry used to promote home manufacture.[48]

Then there was Betsy Ross, easily the most famous craftswoman in American history. The thing everyone knows about her—that she designed the flag of the

United States—turns out to be uncertain at best, and perhaps an invention from whole cloth, put about by overenthusiastic descendants. The version of events that used to be taught to every schoolchild is certainly a fabrication. It has George Washington himself visiting Ross's upholstery shop, together with the leading patriot financier Robert Morris and Betsy's uncle George Ross. This "secret committee" is supposed to have asked her to design a flag for the new nation, with thirteen six-pointed stars. With a nifty fold of some paper and a pair of scissors, Ross showed them that it would actually be a lot easier to cut five-pointed stars. Suitably impressed, they left her to it, and the rest is history.

It is a great story, but unfortunately, all we know for sure is that she worked in an upholstery shop. As her biographer Marla Miller has commented, "the Betsy Ross story is usually treated as a matter of design, but it is not—it is a story of production." Ross was born Elizabeth Griscom, to a Quaker artisan family. Most of her male

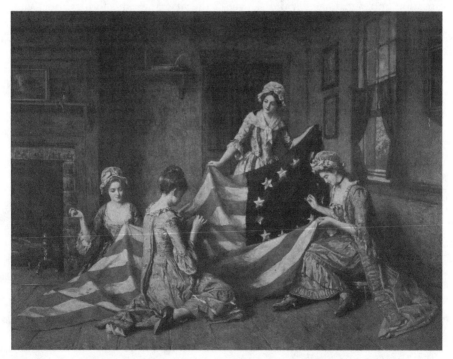

Henry Moser's *The Birth of the Flag*, 1911. The painting exemplifies the fictional ideal later associated with the historic upholsterer Betsy Ross. Lambert, Archive Photos/Getty Images.

relations worked in the building trades, her brother became a silversmith, her aunt made corsets, and her cousin was a dressmaker. From 1767 to 1773, Ross trained with John Webster, who had recently arrived from London—an advantage in this luxury trade, as the newest styles from Britain were highly sought after. She worked for Webster for six years, then eloped with a fellow apprentice, against the wishes of her family. (Her new husband was a patriot, but not a Quaker.) The young couple set up their own upholstery shop, but then her husband died, leaving her widowed at twenty-four. She would marry again, twice, but for now, she persisted with her trade. This involved making not just furniture padding and covers, the kind our current use of the term *upholstery* might suggest, but also a wide range of other useful textiles, such as curtains, bed linens, carpets, and even umbrellas.[49]

Ross also did make flags. These were far from difficult for a trained upholsterer to produce, though they were made of heavy fabrics that required strength and steadiness in the sewing. It is not surprising that there was considerable call for this service, as Philadelphia was a port city, and flags were widely used on ships for identification and signaling. But did she make the first Stars and Stripes? Surviving documentation does indicate that her shop was commissioned to make flags for the war effort on an ongoing basis, and one bill indicates that she was paid for "making ship's colours" just six weeks before the Continental Congress passed a resolution on June 14, 1777, specifying that the new national flag would have "thirteen stripes, alternating red and white," and "thirteen white stars in a blue field representing a new constellation."[50] So . . . maybe. More important is the fact that there were women like Ross, who not only were professionalized, but also found themselves working independently at the highest level of their craft through force of circumstance. She may or may not have had a hand in the creation of the U.S. flag. But in a society that little rewarded women's enterprise, she stayed in business for over fifty years, finally retiring at the age of seventy-six. That's an American story.

American artisans started the war, and also did much to win it. But this would be only the first of their many battles against long odds, and they would rarely be so successful again. The end of the American Revolution coincided with the advent of many interrelated processes referred to collectively as the Industrial Revolution. The basics are familiar enough. First, a factory system was established, based on economies of scale and mass production. Second, the new factories were proving grounds

for technology, designed to replace hand processes. Third, a powerful capitalist class emerged, at first from the ranks of craft masters, but increasingly distant from the shop floor. Fourth, ever-falling production costs resulted in a rising tide (eventually, a torrential flood) of cheap consumer goods. And finally, an unprecedented extraction of natural resources wrought widespread environmental destruction. These transformative changes are still under way today on a global basis, and so widespread that we may struggle to imagine life without them.

At first, industrialization had little impact on average Americans. As they did come to experience it, however, most found themselves on its receiving end, as subject to its dictates as they had been to those of the British Parliament. Over the course of the nineteenth century, "industry," no longer a personal virtue but instead an impersonal abstraction, would overwhelm artisan culture. This occurred slowly and unevenly, but nonetheless, inexorably. Industrialization is the most important dynamic in the story of American craft, a development made all the more fascinating because it was artisans who made it possible.

The Revolutionary War provided employment for many craftspeople, but it also presented challenges. The combination of years-long military service, naval blockades, and currency devaluation put pressure on small shop owners, particularly in cities. During the conflict, animosities with merchants periodically flared into the open, particularly around issues of hoarding. In Philadelphia, as traders stockpiled their goods in the hope of selling high to the military, artisans complained bitterly. "We had better be without trade," they said, "than exposed to the consequences it has hitherto produced." They argued that merchant wealth was ultimately based in the value created by working people. No carpenters, no riggers, no caulkers? No ships. In the interest of the whole community, then, prices and wages should be fixed at levels that permitted tradespeople to make a decent living, perhaps using prewar rates as a benchmark. In effect, these artisans were making the case for *fair trade*, as opposed to *free trade*. It was an ethical appeal that would be renewed many times by American craftspeople, and hardly ever heeded.[51]

Artisans eyed another development with concern: the creation of America's first large factories. Centralized bulk production was not in itself a new phenomenon. Water-powered sawmills, gristmills for grain meal and flour, tanneries, ironworks, and foundries had been lynchpins for Colonial towns since the seventeenth century. Such facilities represented a concentration of what would later be called "capital" in the hands of their proprietors. But they did not employ a large number of workers,

and those who were employed tended to be highly skilled. Even by the time of the revolution, not a single craft had been significantly affected by mass production, though the factory system was already well entrenched in the North of England, in cities like Birmingham and Manchester.

The first departures from this small-shop system occurred just after the war. In 1790, a young Englishman named Samuel Slater came to America, direct from a Derbyshire factory outfitted with water-powered spinning frames (which had been invented by Richard Arkwright about twenty years prior). In flagrant violation of British laws prohibiting the export of such technology, he went into business with a group of Rhode Island merchants and set up a cotton mill at Pawtucket Falls. Slater was a skilled machinist, and he was assisted by a local blacksmith named David Wilkinson. But artisan solidarity was of little concern to him. As soon as the facility opened, he hired nine children as cheap, docile factory hands, repeating a practice he had experienced in England. By 1801, there were more than one hundred children working in his Pawtucket mill. It was the first of many instances in which artisans created the tools of American industry, leading directly to the exploitation of other, unskilled workers. In another sign of things to come, the technically knowledgeable Slater came into regular conflict with his technically ignorant merchant investors, who nonetheless set up their own rival concern (having taken careful measurements of his equipment beforehand). Even so, he was a success, as were the other mills set up in direct imitation of his methods.[52]

Slater's mill, which still stands today, is a textbook example of the early shops of the Industrial Revolution. Long leather belts transfer power from the low waterfall rushing outside to squat black machines inside, capable of producing spool after spool of identical cotton thread. Just looking at the sight, you can imagine spinning wheels all over New England being retired to dusty attics. Yet, at first, mechanized spinning technology was actually beneficial to artisans. The sudden availability of inexpensive yarn—not primarily from the small concerns in Rhode Island, of course, but the large quantities imported from England—had the effect of lowering materials costs and promoting hand weaving. A visitor to eastern Connecticut remarked in 1815 that there was a new mill every few miles, and "yarn is furnished to every female available to weave in the vicinity."[53] But this wouldn't last long. Once powered looms were introduced by the merchant Francis Cabot Lowell in 1814 (he, too, was assisted by a skilled machinist, Paul Moody), independent weavers' ranks were

swiftly decimated. Only in cities such as Philadelphia, a center for highly specialized textiles, did skilled weavers continue to flourish.

It's worth reflecting on how arbitrary this process must have seemed to artisans. The logic of machinery, and hence the likelihood of a certain craft being mechanized into obsolescence, would initially have been completely foreign to most people. It was a phenomenon whose effects were hard to predict. Spinners and weavers were disrupted a decade apart, even as most trades remained thoroughly artisanal. Well into the nineteenth century and beyond, certain crafts survived because they were site-specific (plastering, masonry), involved expensive raw material (silversmithing, tailoring), or were simply very difficult to automate (making window glass, gilding with metal leaf). And machine making itself was among the most specialized and skill-intensive of all crafts. It demanded both precision and flexibility, a combination that only an excellent artisan could provide.

As a result of these difficulties, economic change during the decades after the American Revolution came slowly, and primarily not through machines at all. Rather, the first wave of industrialization involved new ways of organizing the workforce—just as Adam Smith had predicted. Shoemaking is a paradigm case. Though it would not be mechanized until the 1850s, with the introduction of the sewing machine, the trade nonetheless underwent a dramatic transformation in the postrevolutionary years. A high tariff on imported shoes and boots, passed in 1789, essentially eliminated international competition, and opened the way for entrepreneurial manufacturers to achieve economies of scale. What had been a bespoke craft carried out by itinerants or, literally, in cordwainers' kitchens, was swiftly reorganized into a new spatial hierarchy. The new system, pioneered in Lynn, Massachusetts, was based on a tripartite division of cutting, binding, and finishing. Shoes were no longer made to measure, but according to set patterns, and were sold ready-to-wear. A craft that had always been conducted face-to-face now involved bulk commodities shipped over great distances.

The first step in making the shoes, cutting, was done by cordwainers in small sheds called "ten-footers"—typically in teams of three, perhaps a master and two journeymen. These men's wives, and perhaps their children, too, would then stitch together the leather uppers. This family labor was unwaged, simply subsumed into the male-dominated household economy. Finally, assembly of the components and other finishing processes were carried out in central shops. These factories were

owned by "masters" who no longer touched the product, though they did bookend the whole operation, providing leather to their outworkers and wholesaling the completed articles to market. Every component of every shoe was still made by hand, but in ever-larger quantities and at ever-greater speed. And so, the average artisan's negotiating position was ever weaker. This was what division of labor looked like, at first: not a single factory with parallel assembly lines, but a system of pieceworkers scattered across town. By 1800, Lynn was producing one pair of shoes for every five American citizens. And as an industrial center, it was just getting started.[54]

One man who watched these developments with approval was the Philadelphia merchant Tench Coxe. An opportunist through and through—during the revolution, his sympathies had shifted from loyalist to patriot along with news from the front—Coxe emerged after the war as a successful arms dealer. In 1790 he became assistant secretary of the treasury, a promotion that made him Alexander Hamilton's right-hand man. Both men saw manufacturing as essential to America's security as well as its prosperity. Accordingly, they set about encouraging large-scale industry wherever possible. Coxe was the sort who could stare unblinking into the headwind of history. He predicted that the "combination of machines with fire and water" would produce a rapid expansion in American manufacturing, and he further foresaw that this would attract unprecedented numbers of immigrants from Europe. Worries about the human consequences of all this he brushed aside. Mechanization might well be "unfavorable to the health of the people," but it was not, after all, as bad as clearing swamps, growing rice, or raising indigo (all tasks done mainly by slaves, a fact he did not mention). As for child labor, it was actually desirable as a way to curb "idleness and rambling," temptation, and vice. In an influential collection of papers entitled *A View of the United States in 1794*, Coxe pointed to Lynn, Massachusetts, as a model to follow, citing one family there that had shipped over ten thousand pairs of shoes to the Philadelphia market in a single year.[55]

Hamilton and Coxe worked together to support consolidated enterprise. Among the policy levers they devised were a central bank, which gave loans to entrepreneurs while largely ignoring artisans; cash premiums awarded directly to promising industrialists; and most innovative, a hybrid public-private investment body called the Society for Establishing Useful Manufactures, intended to promote industry along the Passaic River in New Jersey. Artisans were quick to criticize these measures, with shoemakers among the most vocal. In 1792, a twenty-eight-year-old Connecticut

cobbler named Walter Brewster initiated a petition drive against his state's tax system, eventually gathering more than fourteen hundred signatures. In articles signed "A Mechanick on Taxation," he attacked such ventures as the Society for Establishing Useful Manufactures, as well as government investment in a Hartford woolen mill. This was tantamount, he wrote, to "planting a Birmingham and Manchester amongst us."[56]

In 1794, Philadelphia witnessed the founding of the Federal Society of Journeymen Cordwainers, one of the first American trade unions. Its name indicated an important shift. Prior to the war, journeymen had been relatively few in number, and were legitimately in training to become masters. Less skilled jobs were performed by apprentices, indentured servants, or enslaved workers. But in the 1790s, the overall population of journeymen began to increase, as upward mobility within a shop faltered. Few now had a hope of becoming so-called masters because they lacked the capital to set up large shops with many employees. They also avoided traditional apprenticeships, acquiring their skills through new technical manuals and on the shop floor. The journeymen bounced from one master to another, often being paid on a piecework basis. They were becoming a new thing among white Americans: a skilled underclass.

Eventually, the Philadelphia shoemakers began a series of protest actions against low wages. They took their case directly to the public through newspaper advertisements and pasted-up broadsides. They established their own journeymen-operated shops, competing directly with those owned by masters. They wrote constitutions for themselves, then staged boycotts against any master who violated their provisions. And as a last resort, they went on strike.[57]

After nearly a decade of conflict, this running labor dispute ended up in court. In the case, *Commonwealth v. Pullis*, there were more than clashing interests at stake; the two sides voiced competing ideals as well. The masters appealed to a traditional view in which the interests of the manufacturing community were paramount: "Will you permit men to destroy [the trade], who have no permanent stake in the city; men who can pack up their all in a knapsack, or carry them in their pockets to New-York or Baltimore?" Lawyers for the journeymen dismissed such claims. They proclaimed that labor itself "constitutes the real wealth of the country," and that the journeymen should have the right to negotiate a fair price through collective bargaining. As it was, masters were getting rich quick, while workers were poorly compensated. That was true enough, but it didn't matter. The jury found the

journeymen guilty of "combination." For the first time, but by no means the last, the industrialist's thumb rested heavily on the scales of justice, and the position of the artisan dipped just a bit lower.[58]

~

In this contest between struggling shoemakers and emergent capitalists, we can hear the echo of a larger clash of ideas, one that defined American politics in the years before and after 1800. Historians tend to frame this as a battle between federalism and republicanism, embodied respectively by Alexander Hamilton and Thomas Jefferson. Hamilton saw American fortunes as tied to urban manufactures, and therefore lent his support to innovative entrepreneurs and merchants. Having absorbed Adam Smith's concept of the division of labor, Hamilton argued for regulated workplaces that avoided "frequent transition from one operation to another." To this principle he added a thinly disguised elitism: Divided labor, he said, would give "greater scope for the diversity of dispositions which discriminate men from each other"—by which he meant that people better suited to management would be rewarded.[59] He also held a more general conviction that a strong central government was strategically necessary for the young nation.

Jefferson disagreed in every particular. He preferred dispersed power structures: states' rights rather than federal authority. With the model of the ancient Roman Republic fixed in his capacious mind, he upheld the small farmer as the ideal American. He disliked large cities, seeing them as engines of European-style decadence and corruption. In any case, he frankly doubted that his countrymen would willingly quit their land, even if given every encouragement: "Such is our attachment to agriculture, and such our preference for foreign manufactures, that be it wise or unwise, our people will certainly return as soon as they can, to the raising of raw materials, and exchanging them for finer manufactures than they are able to execute themselves." And in fact, not only was this wise, it was nothing less than providential: "We have an immensity of land courting the industry of the husbandman. Is it best then that all our citizens should be employed in its improvement, or that one half should be called off from that to exercise manufactures and handicraft arts for the other?" he asked. Definitely not, for "those who labour in the earth are the chosen people of God."[60]

What did unite Hamilton and Jefferson, and other leading political figures of their day, was their passionate dedication to the concept of liberty. They saw the

ideal American citizen as leading a free, self-reliant, and virtuous life, equal in rights to every other citizen. Of course, they also saw this ideal citizen as a white man. Like the other so-called Founding Fathers, neither gave much thought to the rights of women, and their egalitarianism had no room in it for equality of race. Jefferson was notoriously a slave owner, and while Hamilton was nominally an abolitionist, he pragmatically accepted the South's position on slavery. Within the narrow bounds of their concern, however, both were staunch individualists. The question was what kind of individualism they supported. For those of Hamiltonian inclination, liberty tended to be positively defined, freedom *to*—the right to pursue personal entrepreneurship, and expect government support. Jefferson, who had after all drafted the Declaration of Independence, tended to emphasize a negatively defined freedom *from*—the right not to be interfered with, not to be tyrannized.

These differences of opinion have divided American politics right down to the present day. And they have, as their corollary, two different views of craft—not necessarily incompatible, but certainly in tension with each other. Hamilton cared about artisans only insofar as he wanted to keep them hard at work. They were dangerous, a potential source of political disorder, but also important as subsidiary contributors to an economy of perpetual improvement. Jefferson, by contrast, viewed handicraft principally as an adjunct to agriculture and, in this context, a means by which Americans would safeguard their own liberties. In Hamilton's top-down, capitalistic perspective, craft is instrumental. Artisans either produce economic value or they are dispensable. In Jefferson's bottom-up, agrarian worldview, craft is foundational. It is part of an ethical value system rooted in the land, and in that respect, it is essential.

Neither man considered professional artisans to occupy the central place in American society—they reserved that position either for the entrepreneur (Hamilton) or the farmer (Jefferson). And yet both needed artisan votes. Hamilton's Federalists had the harder job of persuasion. After all, they were allied with merchants and proto-industrialists, who were already emerging as artisans' natural political opponents. The Federalists did win support from those in the craft community, particularly in New York and Boston. Many urban artisans embraced their economic program, hoping that overall growth would result in greater opportunity, and perhaps even upward mobility, for themselves. They were far from the bottom of the social ladder, and even if there were already signs that large-scale enterprise might be bad for workers, those who stood to lose most were the unskilled.

Jefferson's Democratic-Republicans, meanwhile, had the easier task of painting their opponents as class enemies. One of the most effective advocates in this cause was William Duane, who had inherited Benjamin Franklin's mantle as the most active political printer in Philadelphia. Born to Irish immigrants in upstate New York, Duane already had a well-developed reputation as a troublemaker with a taste for radical politics by the time he joined Franklin's grandson Benjamin Franklin Bache in editing *Aurora*, an anti-Federalist journal. After Bache died two years later, Duane married his former partner's wife, Margaret, who had inherited the paper, and continued to use it as Republican platform, vigorously attacking rival Hamiltonian publications like the New York *Evening Post* (which he said was not just wrong on the issues, but "weary, stale, and flat"). In a series of articles entitled "Politics for Farmers and Mechanics," published in 1807, he espoused the view that had been already voiced by Philadelphia's shoemakers in *Commonwealth v. Pullis*, that economic value originates in skilled labor. Duane waxed lyrical about "the self-respect which every mechanic should feel, as forming part of that great basis upon which society is erected," and condemned "idle and imbecile" speculators. As to the machinery wielded by the new capitalist class, he reminded his readers that it, too, was "a production of labor and of mechanical rules of art; and that even in its most perfect state, labor is necessary to its operation, as well to contrive and make, as to keep in order and put it in motion." And he expressed a clear preference for small-scale manufactures, such as could be performed by just "one, two, or three artists, working with simple tools," and preferably sold by the maker rather than entrusted to a "third person for sale." America would be an artisan republic, an advanced economy without hierarchy: "a new thing on earth."[61]

That dream would remain, and it would also remain elusive. By 1800, the volatile currents that would alternately propel and submerge American craftsmanship had all been unleashed. The new nation had fully embraced an ideology of individualism, of liberty above all things; now it needed to work out what that would mean in practice. Mechanization was only in its infancy, but division of labor and concentration of capital were already well under way. The accompanying shift to a wage-labor system led to a situation in which only men were directly compensated, positioning women in a more economically dependent role than ever before.

Meanwhile, in 1794, a Massachusetts-born mechanic named Eli Whitney was awarded a patent for an "engine" that cleaned short-staple cotton. It was a simple enough device: a wooden cylinder with teeth for removing seeds and a rotating wire

brush to gather the fiber. Any competent artisan could build one, which was too bad for Whitney. Though he did go into business manufacturing his cotton gin, it proved impossible to enforce his patent. He got almost nothing as it proliferated across the American South. Yet, within a few short years, in conjunction with automated spinning and weaving, his invention transformed the economic calculus of the plantation system. As the cost of processing cotton into finished goods plummeted, the profits of cultivating it soared, helping to entrench mass enslavement in the South, and with it, the ethical and political conflict that laid so much of the foundation for the Civil War that would explode decades later. Like the other groundbreaking machines of its time, the first cotton gin was a handmade object, executed with skill and ingenuity. It may not be the first thing we picture when we think of American craft in the late eighteenth century. But maybe it should be.

Chapter 2

A Self-Made Nation

I N 1822 A YOUNG BLACKSMITH called James Pembroke, aged about fifteen, made himself a pen of steel. He walked the chicken yard looking for the best feather to complete the quill. He gathered berries and crushed them to make a weak ink. He pored over the workshop's order book every Sabbath Sunday, matching the marks on the page to customers' names he had overheard. He compared the numbers in the right-hand column to the ones he knew from his "common mechanic's square." Eventually, he managed to lay his hands on some paper and at last began teaching himself how to write. He had to do all this secretly, for Pembroke was Black, and enslaved.

Shortly thereafter he would escape his servitude and shed his master's surname, rechristening himself James W. C. Pennington. He would become the first Black man to attend classes at Yale University, the first to write a history of "colored people" in America.[1] He would establish himself as a leading abolitionist and popular Congregational minister, in Hartford, Connecticut. And he would author a memoir entitled *The Fugitive Blacksmith*, in which he detailed his harrowing childhood experiences and desperate flight to freedom. Most of all, he wrote of the great evil of slavery, of which he was not just victim and witness but also analyst. "My feelings are always outraged," he said, by talk of "kind masters, Christian masters, the mildest form of slavery." There can be only one outcome when some people are treated as chattel: "the cart-whip, starvation, and nakedness." "Talk not then about

kind and Christian masters," Pennington wrote. "They are not masters of the system. The system is master of them."[2]

Pennington learned several trades as a boy, first as a hireling for a nearby mason. Once he learned the essentials of building with stone, he was set to work by his owner constructing a new smithy, then as a blacksmith himself, and subsequently as a carpenter. He learned to make a great range of products, taking particular interest in fashioning tools and weaponry: guns, penknives, hammers, hatchets, sword canes. At night, after long hours of work, he assisted his father in making straw hats and willow baskets, which the family could sell to get at least a little money. He took great pride in his developing skills, but one day something in him snapped. On the flimsiest of pretexts, his father, Bazil, was beaten with a cowhide lash by the master of the plantation. Pennington was at the scene, close enough to "hear, see, and even count the savage stripes." From then on, he said, in his heart, he would never be a slave. A short time later, he himself was assaulted. Pennington was shoeing a horse. When he finished and straightened up, he accidentally caught the eye of his master, who flew "into a panic of rage; he would have it that I was watching him. 'What are you rolling your white eyes at me for, you lazy rascal?' He came down upon me with his cane, and laid on over my shoulders, arms, and legs, about a dozen severe blows."[3]

That incident happened on a Tuesday. The next Sunday, Pennington was gone. It meant never seeing his family again. It meant the risk of capture and violent punishment. He went all the same. Following the North Star, he made his way from the plantation in Washington County, Maryland, striking out for Philadelphia. When asked his business on the road, he claimed to be a freeman, but near Baltimore he was accosted by a white man who demanded to see his papers. Though Pennington had no weapon, he seriously considered resorting to violence: "This was a desperate scheme, but I could think of no other, and my habits as a blacksmith had given my eye and hand such mechanical skill, that I felt quite sure that if I could only get a stone in my hand, and have time to wield it, I should not miss his knee-pan." But then the man shouted for help. A shoemaker emerged from a nearby shop, "girded up in his leather apron, with his knife in hand." Pennington was trapped. He tried to talk himself out of it—which meant lying, of course, but he considered that "facts in this case are my private property," and "these men have no more right to them than a highway robber has to my purse." He claimed to have been kidnapped by a slave trader who'd subsequently died of the smallpox—a clever ruse, as the men

quickly concluded they would much rather be rid of him. He reached Pennsylvania and had the good fortune to be taken in by a family of Quakers, who abhorred slavery. When asked if he could read, he demonstrated the few letters he'd managed to learn: *a, b, c, l, g.* His hosts replied, "We can soon get thee in the way, James." At last he was free.[4]

In later years, Pennington reflected on the important role that craft had played in forming his identity. "Feeling a high degree of mechanical pride," he reflected, was the "one thing that had reconciled me so long to remain a slave."[5] But that same pride, perhaps, was what emboldened him to escape, and to have confidence that he would be able to survive as a freeman. In 1844, now a prominent minister, he wrote an extraordinary letter to his former owner, declaring the quality of the work he had performed—"in the very best style, a style second to no smith in your neighborhood"—and asserting his rights. "I never regarded you as my master," he wrote. "The nature which God gave me did not allow me to believe that you had any more right to me than I had to you, and that was just none at all."[6]

Meanwhile, he preached mightily from his Hartford pulpit on the hypocrisies of white supremacy: "The men who have sent out the Washingtons, the Jeffersons, the Madisons, the Monroes, the Jacksons, the Calhouns, the Clays, &c., are they too much in the dark to be judged by the light?" Legally speaking, Pennington was still a fugitive. Given his prominence, he could have raised the money to buy his freedom, but that, he declared, was no way to end slavery. Before it was finally undone, there would need to be a great storm: "The last half of our present century will be our great moral battle day. I go to prepare for that."[7] He would see those words proved. Pennington lived to 1870, long enough to see the Civil War, and emancipation.

~

Few enslaved artisans had a story like Pennington's, but they did all have stories. Most are lost to us. Some, like his, are preserved in narratives that attested to the depravities of slavery, while also thrilling readers of abolitionist sympathies with their tales of daring escape. One of the most exciting of these, *Running a Thousand Miles for Freedom*, related the experiences of the aptly named William and Ellen Craft. Brother and sister, carpenter and seamstress, they slipped away from a plantation in Macon, Georgia, and then made their way north by train in full light of day. Ellen was sufficiently light-skinned to pass for white on their journey, and adopted

the guise of a man traveling with "his" servant, having sewn herself a full set of men's clothes beforehand.[8]

Other skilled African Americans resolved to fight instead of run. Slave revolts were frequently led by artisans, for the same reason that white craftsmen had played a key strategic role in the revolution—they were known and trusted in their communities. Those who were hired out from plantations to cities were particularly effective networkers; in the words of the historian Douglas Egerton, they gained "a glimpse into a world of mobility and prosperity that even their masters could scarcely understand."[9] Egerton's studies of court records show that African Americans put on trial were almost always craftsmen (carpenters, coopers, blacksmiths, rope makers, painters, masons, wheelwrights, and ship caulkers), suggesting a high correlation between artisan identity and active resistance. One prominent example was the literate blacksmith Gabriel, who had been hired out from his plantation to foundries in the Richmond area. In 1800 he laid plans for an armed rebellion, but was betrayed and hanged, along with twenty-five of his followers.[10]

The same fate lay ahead for the ship carpenter and lay the preacher Denmark Vesey, also known as Telemaque, who tried to engineer a revolt in Charleston, South Carolina, in 1822. This was an ideal place for insurrection, as African Americans outnumbered whites in the region by a three-to-one ratio, the result of the city's role as a nexus in the slave trade. And Vesey was the ideal leader. An intimidating man by all accounts, of towering height and immaculate dress, he was also an unusually cosmopolitan figure. Born in about 1767 on the island of St. Thomas (at that time a Danish colony, hence the name he later chose for himself), in his teenage years he had worked as a translator on a slave ship in the Caribbean. At the age of thirty-two, now in Charleston, he won a city lottery and was able to buy his freedom. It was then he took up the carpentry trade. He could have gone north, but his family was still in bondage. So, he stayed, and plotted, using the city's African Methodist Episcopal congregation as his base. He and his allies planned their rising for Bastille Day, intending to commandeer a ship and make for Haiti, which had staged a successful revolt beginning in 1791. Once again, though, word reached the white authorities. One hundred thirty-one enslaved and free Blacks were arrested; many were tortured to extract confessions. Vesey was executed, along with thirty-four others. The white citizenry pulled down the African Church itself in vengeance. Vesey's son Robert, also a skilled carpenter, remained in bondage for four decades; in 1865, at the end of the Civil War, he helped rebuild that church.[11]

Against these courageous instances of resistance must be placed other, perhaps more complicated stories, in which free African Americans worked peaceably within the antebellum system. Sometimes they even owned slaves themselves. Thomas Blacknall, a bell maker and blacksmith in North Carolina, purchased his freedom upon the death of his former master in 1820, then set about buying his own family members from their masters. At first he was able to simply liberate them, but as changes in the law code made this more difficult, he eventually was obligated to "own" his own children.[12] James Boon, an itinerant free Black carpenter, was married to a literate woman called Sarah who was the property of another man. As far as we know, she never gained her freedom. Yet Boon was successful enough that he could hire white, free Black, and enslaved men to assist him in house construction. He earned lower wages than a white craftsman of equivalent skill, charging $1.25 per day for his services—just twenty-five cents more than he was obliged to pay for the work of an enslaved carpenter.[13]

Native Americans were also implicated at all levels of the slave system. The Cherokee chieftain James Vann had more than a hundred Black people working on his plantation, a sign of his status and cultural assimilation.[14] This was highly exceptional. For the most part, African Americans and Native people suffered the effects of white oppression together. Intermarriage was common. And as southern tribes such as the Cherokee, Choctaw, and Chickasaw had their land stolen from them, they had little choice but to serve the economic regime of King Cotton, working in the fields, setting up looms and spinning wheels. The passage of the Indian Removal Act in 1830 triggered a rise in the forced relocation of Native peoples off their ancestral lands—including the infamous "Trail of Tears," in which fully one quarter of the Cherokee perished. A less-well-known part of this tragedy is that its victims included mixed-race and enslaved African Americans who were part of the Native community.

Still more complex is the life of John Carruthers Stanly, also known as "Barber Jack." The son of a white landowner and an Igbo woman who had been captured in present-day Nigeria, he was apprenticed while young to the barbering trade, which was dominated by African Americans at that time. In 1798 he was liberated by his master, the slave ship captain who had brought his mother to America. Stanly opened his own barbershop in New Bern, North Carolina, and seems also to have acted as a currency broker there. He soon earned enough money to purchase two men, named Brister and Boston, whom he trained in the "tonsorial art." Eventually,

he accumulated enough wealth and land that he had no less than III enslaved people under his direct control (either through ownership or hiring out). Dismayingly, he is known even to have sold a child away from its parents.[15] Yet "Barber Jack" also used his influence to make New Bern a relatively welcoming place for other free Black artisans. Among them, according to a nineteenth-century local historian, were John C. Green, "a bright mulatto, always dressed in the latest fashion, making his own figure an advertisement of his proficiency," and a "copper-colored" bricklayer and plasterer named Donum Mumford, who was also a slave owner: "Whenever a job was to be done expeditiously, he was apt to be employed, as he could always throw upon it a force sufficient for its rapid execution."[16]

The success of such men was always precarious. In the South, things got harder than ever after Denmark Vesey's failed rebellion, which alarmed whites and prompted greater restrictions on free Blacks' movement and rights. The cotton boom also compromised Black artisans' autonomy, as it increased the relative value of agricultural work, eroding the economic leverage they had due to their skill.[17] The challenges of navigating these turbulent waters can be seen in the life of Thomas Day. Born free in 1801, the son of a Quaker-educated Black cabinetmaker, he followed the family trade. By the 1820s, he had established an independent shop right on Main Street in Milton, North Carolina, with an integrated workforce, eventually including at least three slaves. The clientele for his expensive mahogany furniture and architectural woodwork was made up principally of whites who were enriched by slave-harvested tobacco.

For a time, Day was successful at winning the support of his fellow artisans, regardless of their skin color. In 1829, when he married a woman called Aquilla Wilson, he was forced to petition for her right to move from Virginia to join him in North Carolina. The document Day submitted to the state General Assembly described him as "a first-rate workman, a remarkably sober, steady, and industrious man, a high minded, good and valuable citizen," and was signed by his customers and business associates, as well as a local chairmaker, silversmith, carriage maker, and tailor, all of whom were

Thomas Day, newel, Glass-Dameron House, North Carolina, 1855. Tim Buchman.

white—a remarkable instance of craft solidarity.[18] Over the succeeding decades, however, this collegial regard was not enough to insulate Day from hardship. His later work bears physical evidence that he was getting stretched beyond his means; he reused packing crate panels and old, weathered boards for the backs and interiors of his furniture. Perhaps he was facing increasing competition from white cabinet-makers, or declining custom from white clients. Whatever the reasons, Day declared bankruptcy in 1860 and died a year later, just as the Civil War was beginning. This does not detract from his fundamental achievement: a successful craft business built in the face of pervasive prejudice. For Day, the fact that his objects had no race—that they could be detached from their maker and be valued in themselves—was itself empowering.[19]

Thomas Day was exceptional in many ways, not least in the human decency he was shown by his fellow tradesmen. For the most part, African American artisans were bitterly resented by their white competitors, particularly when opportunities for work were scarce. Henry Boyd knew that well. Born into slavery in Kentucky, he earned enough spare money while hired out at a saltworks that he was able to buy his freedom. He learned how to make furniture, and then traveled north to Cincinnati in 1826, arriving virtually penniless. Despite his talent and skill, every cabinetmaker's door in the city was slammed in his face. At one point a recently arrived English joiner offered him employment, but the white journeymen in the shop refused to work alongside him, and he was sent packing.

For a while Boyd was reduced to work as a stevedore, unloading pig iron from the holds of ships. But then an opportunity presented itself: A carpenter who had been hired to build a merchant's counter showed up too drunk to do the job. Boyd stepped in, and acquitted himself so well that he began to get more work, then still more, through word of mouth. Finally, he saved up enough to establish a small factory. There he manufactured bedsteads of his own invention, built with "swelled rails" and wood screws at the corners to increase efficiency, stability, and ease of assembly. Boldly stamped H. BOYD, they sold well. Yet he still faced discrimination and worse. As an African American, he was not able to take out a patent, so he was forced to register his bedstead design under the name of a white associate. A credit report on his business noted that "being a colored man, [he] has to submit to unusual exactions on the part of his white employees," suggesting the difficulties he must have faced as a manager. Worst of all, there were at least three incidents of arson at Boyd's factory; he closed it down in 1860.[20]

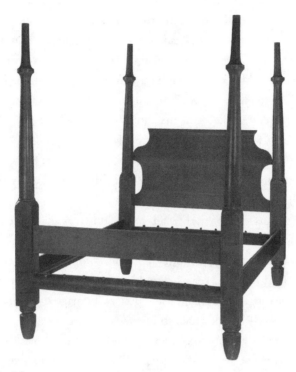

Henry Boyd, bed frame, 1802–86. Collection of the Smithsonian National Museum of African American History and Culture.

The hostile attitudes that Boyd faced were widely shared prior to the Civil War. White artisans might work shoulder to shoulder with African Americans on a construction scaffold while remaining intensely racist, and they were perfectly willing to engage in repressive politics when they felt their own livelihoods threatened.[21] In 1851, for example, a group of North Carolina mechanics petitioned their state assembly, requesting that taxation be used to curb Black participation in the building trades: "Free negroes are with us a degraded class of men, living in a condition but little better than that of the brute creation . . . They idle away their time and only labour when more dishonest means fail them and hunger oppresses them, and then, at prices regulated entirely by the circumstances."[22] This complaint did have one grain of truth in it: African Americans really did exert downward pressure on wages. But that was simply because employers could get away with paying them less.

White artisans also profited directly from the institution of slavery. William Price Talmage began his career as a blacksmith in New Jersey, a state that was

increasingly turning to industrial iron production. He struggled for work, and in 1834, at the age of twenty-one, he headed south. At this point he began keeping an almanac journal, perhaps thinking of Benjamin Franklin's *Autobiography* as a model. In this manuscript (which remains unpublished but has been studied by the historian Michele Gillespie), he recorded his various setbacks and successes, as well as noteworthy occurrences (like seeing the public hanging of a "Negro"). He first went to Athens, Georgia, following his elder brother John, who was also a blacksmith and had spent time as a missionary among the Cherokee. The next few years were difficult. Talmage tramped constantly in search of steady work, at one point returning north but finding opportunities no better there.

Eventually, he was able to put the skills he'd acquired as an itinerant wage earner to good use, opening a machine shop in Athens. The railroad had just arrived in town, and with it, textile mills. Both trains and looms created demand for the services of a skilled metalworker who could make and repair machine parts, saw blades, pumps, gearing, steam engines, and boilers. Talmage also branched out into iron fences and gates—one of which still serves as an entrance to the University of Georgia. Like so much else of the Old South, it was built partly with enslaved labor. In 1843, Talmage bought his first slave, a man called George, for $450; a decade later he owned five more people. By the time of the war, he'd become a wealthy man.[23] Boyd and Talmage are mirror images: a Black man who went north and a white man who went south. In the early nineteenth century, that geographical divide was becoming the frontier of a culture war. And as these two men's stories suggest, artisans were swept along in it, even as they helped to shape it.

In his great observational work *Democracy in America*, Alexis de Tocqueville described his voyage through the young nation in the year 1831. As he sailed down the Ohio River, nearing its junction with the great Mississippi, he reflected on the differences between the land of the free, to his right, and the land of the enslaved, to his left. He was traveling, as he put it, "between liberty and servitude." On one side lay the state of Kentucky, where "from time to time one descries a troop of slaves loitering in the half-desert fields; the primaeval forest recurs at every turn; society seems to be asleep, man to be idle, and nature alone offers a scene of activity and of life." On the other was Ohio, where "a confused hum is heard which proclaims the presence of industry; the fields are covered with abundant harvests, the elegance of the dwellings announces the taste and activity of the laborer, and man appears to be in the enjoyment of that wealth and contentment which is the reward of labor."[24]

Though exaggerated for effect, the contrast that Tocqueville draws in this passage does capture the increasing economic divergence between the still-agrarian South and the industrializing North. As late as 1849, a visitor to a textile mill in Augusta, Georgia, wrote to a friend expressing amazement: "I was sorry when I got there I did not have you and Lou with me to see the gretest sight I ever saw. There is about 100 gales [girls] and grown females all employed and such sistem I never saw [*sic*]."[25] By that time, though, the North had become well accustomed to the reality of children's and women's labor. What had started in a few mills in Pawtucket had grown into the unprecedentedly gargantuan factories of Lowell, Massachusetts. By the 1830s, this new industrial center had five thousand operatives at work—over 80 percent of them young women, the so-called mill girls. They labored twelve to fourteen hours a day, beginning with the morning bell at four thirty A.M.[26] Those were farming hours, too, to be fair. But the work was extremely repetitive, the noise ceaseless, and the air lint-filled and fetid, particularly in the wintertime, when candles and oil lamps provided illumination into the long evenings.[27] Incidents were recorded in which

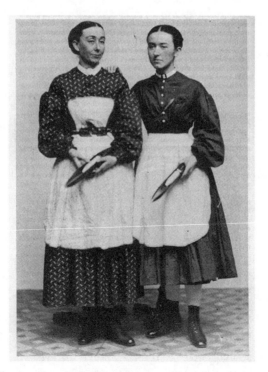

Tintype of two weavers, 1860. American Textile History Museum.

the factory clock was purposefully run slow, to trick the operatives into working even longer.[28] Owners promoted their factories as moral, orderly, and sociable. The reality was different.

Even the *Lowell Offering*, an industry-backed periodical that functioned principally as propaganda aimed at the workers—"sweet are the uses of adversity"—occasionally betrayed the dire working conditions.[29] One item, entitled "A Weaver's Reverie," posed the question "Why is it that the factory-girls write so much about the beauties of nature?" The answer: "Why is it that the desert-traveler looks forward upon the burning waste and sees pictured before his aching eyes, some verdant oasis?"[30] Soon enough, cracks began to appear in the system. In 1834, having just been handed a 15 percent wage cut, the female operatives went on strike. (They also coordinated a run on the local banks, hitting the owners where it really hurt.) In 1836, they walked out again, singing:

> Oh! isn't it a pity, such a pretty girl as I
> Should be sent to the factory to pine away and die?
> Oh! I cannot be a slave, I will not be a slave,
> For I'm so fond of liberty,
> That I cannot be a slave.

Then, in 1842, came the "stretch-out." Operatives were suddenly asked to mind not the usual two, but three or even four power looms at once. Initially intended as a temporary measure, this quickly became the new normal—which, ironically, led to a higher premium on workers' experience, as only a skilled hand could manage such a furious work rate. The Yankee "mill girls," who had generally been a transient population, were gradually replaced by another exploited group: immigrants newly arrived from Ireland, then entering the Great Famine.[31]

Lowell represented all that artisans most feared when they looked at the factory system. The mill operatives often likened themselves to African American slaves—as in the 1836 strike song or in a complaint written at the height of the stretch-out: "All that have toiled within the factory walls must be well acquainted with the present system of labor, which can properly be termed slavery."[32] Some opponents of wage labor even proclaimed it to be worse than the plantations, on the grounds that masters were at least obligated to feed their bonded workers. This was an argument that southerners were happy to make, too; the pro-slavery apologist George Fitzhugh,

in a racist tract entitled *Cannibals All!*, wrote, "Capital exercises a more perfect compulsion over free laborers than human masters over slaves; for free laborers must at all times work or starve, and slaves are supported whether they work or not."[33]

These comparisons now ring horribly false, but they were consistent with the overall pattern in early nineteenth-century labor, in which each echelon of the working class feared slippage into the condition of the tier below. That defensive posture was assumed in its most militant form by white male artisans, whenever and wherever they faced the prospect of their own replacement—not typically by a machine, as we tend to imagine today, but by lower-paid African Americans, women, children, convict labor, or increasingly, immigrants. Members of all these demographics did frequently have craft skills. Even among the most desperate of them, the Irish who came in huge numbers during the late 1840s, over one third of men had some form of manual trade. But their social standing gave them little leverage. Even an accomplished immigrant woodworker was unlikely to be hired into the well-paid position of a ship carpenter, cabinetmaker, or coachmaker.[34] This can lead to confusion. Terms such as *skilled*, *semi-skilled*, and *unskilled* were primarily reflections of trade status. They did have some correlation to experience and expertise, but only in an approximate and subjective way. The tendency has long been to drastically overrate the proficiency of American-born adult white men and undervalue the skills of other workers. In the early nineteenth century, we see that dynamic taking on its modern form.[35]

~

It is easy to understand why professional artisans wanted to maintain their status as a labor aristocracy. More complicated is the question of how they pursued that goal. Certainly, the situation was different from that in Britain and Europe, where workers were taking regularly to the barricades and developing a politicized class consciousness. Americans did not head down that path. One might think they didn't need to, as they already enjoyed the constitutional rights that Europeans were rioting to win. Indeed, when Americans did see an abuse of power, they were quick to cry despotism, summoning the specter of the European regimes.

Another factor that reduced working-class cohesion was mobility. As the stories of men like William Talmage show, when economic times got tough, it was always possible to pick up and go somewhere else, north, south, or, increasingly, west. Later, in the 1890s, Frederick Jackson Turner would famously draw a contrast between the

singular American frontier, which beckoned wave after wave of enterprising migrants, and the many frontiers of Europe, each one "a fortified boundary line running through dense populations." In Turner's view, the putatively wide-open West had functioned as a kind of social safety valve, providing a natural encouragement toward pragmatic individualism. American settlers developed an "inventive turn of mind, quick to find expedients," a "masterful grasp of material things, lacking in the artistic but powerful to effect great ends," and "withal, that buoyancy and exuberance which comes with freedom."[36] This thesis doubtless had a measure of truth to it; Tocqueville had made a similar observation on his travels, noting of the American homesteader that "the resources of his intelligence are astonishing, and his avidity in the pursuit of gain amounts to a species of heroism."[37] As late as the 1960s, this ideal of self-sufficiency, tested and proved at the frontier, would be embraced as a core value of American craft.

Between them, democracy, geography, and individualism help explain the slow development of class-based solidarity in America. Even so, the early nineteenth century did see the emergence of an artisanal identity politics. So much is clear from the most famous image of a craftsman from the period, a portrait of the Scottish immigrant blacksmith Patrick Lyon. Painted in two very similar versions by John Neagle, a former coachman's apprentice, it was an immediate sensation when exhibited at the Pennsylvania Academy of the Fine Arts in 1827.[38] Unlike Copley's portrait of Paul Revere, which depicts him in contemplative mode and clean surroundings, Neagle's picture plunges us right into the heat of Lyon's forge. Cheeks flushed, hammer in hand, he wears artisan garb (a loose white shirt and long leather apron) and is accompanied by a young assistant. He regards us proudly, blue eyes twinkling, cheeks flushed.

Lyon commissioned the portrait as the capstone to a long-running campaign to reclaim his honor. Back in 1798, the Bank of Pennsylvania had been robbed of over $160,000, then an absolute fortune. Lyon happened to be in Delaware at the time of the theft, but he had recently worked on a set of iron doors for the bank, and was held on suspicion of being an accessory to the crime. The charge was baseless, but he was nonetheless incarcerated for three months. Upon his release, he was infuriated to find that he was unable to sue for damages; and so, the aggrieved craftsman set his case before the public. In his version of events, Lyon claimed that he had informed the bank that their locks were totally inadequate, more well suited to a ship's cabin than a vault. He strongly implied that the bank had had him imprisoned only to

prevent him from reporting their negligence.[39] To this self-justification he added a fistful of political observations, declaring that "the great when they have power, will often make a wrong use of it, and those who are inferior in rank, have very little chance of justice."[40] He was still prosecuting his case thirty years later, when he commissioned the portrait. The jail where he was held appears in the upper left-hand corner, as if in a thought bubble. He purportedly told Neagle, "I wish you, sir, to paint me at full length, the size of life, representing me at the smithery, with my bellows-blower, hammers, and all the et-ceteras of the shop around me . . . I do not wish to be represented as what I am not—*a gentleman*."[41] You can imagine him spitting on the ground as he said it.

Considering the particularity of Lyon's perspective on class conflict, it is striking how popular his portrait became, not only in exhibitions but also in reproduction, even appearing on a banknote in far-off Augusta, Georgia. So, while it is certainly an image of staunch individualism, the self-esteem it projects is based firmly in class identity. In fact, the portrait strongly echoes the era's most commonly circulated artisan emblem: a flexed arm gripping a hammer, accompanied by the legend BY HAMMER AND HAND ALL ARTS DO STAND. Originally created as the armorial crest of the Worshipful Company of Blacksmiths in London, this insignia had been widely adopted by trade organizations founded in America in the years after the revolution. Such "friendly societies" did not engage in collective bargaining, as labor unions later would. But they did aim to achieve solidarity in other ways. They provided uplift to their members through the provision of libraries. They encouraged moral behavior, including abstention from drink, part of a temperance movement that attracted considerable support among artisans at this time. And they participated in civic parades, carrying banners with pictures of their two holy texts, the Bible and Benjamin Franklin's *Autobiography*, and proud slogans like the one that a group of rope-makers marched behind in 1825, on the occasion of the completion of the Erie Canal: "Our hemp is good, our cordage neat / We will supply the American fleet."[42]

Underneath the good feelings, though, there was a rising surge of anger. Patrick Lyon was not alone in condemning "the great" for their misuse of power. The year 1825 saw not just celebrations in the streets, but also a push by Boston carpenters to have their workday limited to ten hours, and a strike among women tailors in New York—America's first industrial action by female workers, preceding even those at Lowell. The practices of "outworking" that had been pioneered by the master

shoemakers of Lynn were now advancing into many other trades. The word *sweat-shop* entered American parlance.

These were also the years of the so-called American system, which Senator Henry Clay and his allies in the Whig Party implemented following the War of 1812—a tripartite combination of protectionist tariffs, a national bank, and government funding for internal improvements such as roads and canals. This strategy was essentially a reintroduction of the policies pursued by Alexander Hamilton and Tench Coxe, and it had a similar result, greatly contributing to the growth of industry while also concentrating wealth in the hands of a small class of northern manufacturers and financiers, to the great discontent of urban artisans and southern planters. Improvements in transport were the least controversial aspect of the American system, but they may have had the greatest long-term effect. Rural artisans were increasingly forced into competition with centralized manufactories, a dynamic that intensified following the introduction of railroads in the 1830s.[43] As Sean Wilentz, a leading labor historian of this period, has put it, "the cardinal 'artisan republican' virtues of independence, cooperation, equality and virtue were all upended by the new social order—replaced by contingencies, competition, and insecurity."[44]

For skilled workers, the most pressing concern was the division of labor. In some cases, this took the form of a pyramidal workforce, with a tiny group of artisans at the top supported by a much larger number of low-wage outworkers. This was the situation in the tailoring industry: Custom tailors and dressmakers continued to have secure employment, and in the ready-to-wear sector, cutters reigned supreme; they knifed through many layers of cloth, guided by premade iron patterns, producing stacks of identical pieces. A single mistake could ruin a large amount of fabric, so their skills were highly valued, and they were compensated accordingly. But the vast majority of garment workers were stitchers and finishers, paid barely enough to live on.

In other trades a broader stratification emerged, with one sector devoted to standardized production, and a much smaller sector oriented toward the luxury trade, which used labor-intensive and skilled techniques. Cabinetmaking is a good example of this bifurcation. As the piecework system began to proliferate in the furniture trades, most woodworkers—over 90 percent of them, by one estimate—found themselves stuck in "botch," or "butcher," shops, which might focus on just a single chair or table form, made through divided labor. This specialized approach

not only increased efficiency, but also eliminated the necessity for thorough training. As the *New York Herald* noted of furniture making in 1853, "those who have had an experience in the trade say [it] is almost impossible to obtain a complete practical knowledge of it."[45]

At the other end of the spectrum were fine cabinetmakers such as Duncan Phyfe, a Scottish immigrant who arrived in New York City by 1792. A decade later, he had become successful enough that he was able to buy property on Partition Street, in a newly built uptown neighborhood near the Hudson River docks. Soon he owned much of that city block. He steadily concentrated his production in-house, eventually even setting up his own upholstery department. Phyfe's brand of neoclassicism, balancing expanses of figured mahogany with passages of tight carving, made him much in demand—in 1816, one potential client reported to a friend, "it is with difficulty now, that one can procure an audience even of a few moments; not a week since I waited in company with a dozen others, at least an hour [in] his cold shop

Shop and warehouse of Duncan Phyfe, Fulton Street, New York City, c. 1816. Metropolitan Museum of Art.

and after all was obliged to return home, without seeing the great man."[46] By that time, Phyfe had probably stopped making anything himself, though he is still thought to have been the shop's head designer. Certainly, his elegant work seems a world away from the debased piecework being made elsewhere in the city. And yet, the two sides of the trade did touch one another. Alongside his high-end production, Phyfe had a sideline in subcontracting "butcher" furniture; and during an economic downturn in 1819, his own journeymen staged a walkout in protest of a wage cut. They set up their own shop, intentionally undercutting Phyfe's prices. This is what independence meant for them: standing together against what they considered to be unfair practices.

It's easy to imagine that mechanization further compromised craft integrity during this period, but this actually occurred only in a few areas, principally in textiles. New woodworking machinery was too expensive for the average "botch" shop, but it arguably helped a fine cabinetmaker such as Phyfe, because it greatly reduced the time his workmen spent in arduous and repetitive procedures like cutting veneer or roughing out identical blanks for chair legs; they could concentrate on more skilled tasks. In other fields, technology was more profoundly transformative. One example is gunsmithing. All the way through the Revolutionary War, this strategically vital craft had been carried out in small shops capable of producing perhaps twenty muskets a month; many patriot soldiers fought with their own weapons from home rather than waiting for ones issued by the government.[47] The custom trade continued to turn out firearms, some of them beautifully wrought, but that was not what the U.S. military wanted.

This began to change around the turn of the century. In 1798, Eli Whitney boldly asserted that he could produce ten thousand muskets in two years, and also arrive at the holy grail of mass manufacturing: true interchangeability of parts, which would dramatically increase production efficiency and also greatly simplify subsequent repair. He failed to deliver on both counts, partly because he was busy waging an unsuccessful struggle to enforce the patent for his cotton gin. But once the goals of scale and interchangeability were in view, experiments unfolded at the Springfield Armory in Massachusetts, and elsewhere, employing improved gauges, jigs to guide hand-finishing, and replicating lathes for wooden gunstocks—a good example of skill being displaced, no longer applied to finished products but instead to automated tools.[48]

A parallel story unfolded in clockmaking. When the Connecticut entrepreneur Eli Terry first started out, he was selling handmade brass clock movements door-to-door. His sales with rural customers were not brisk, though, because the movements were too expensive (all the more so because they required custom-built cases). As an apprentice, he'd had some experience with cheaper wooden movements, and it was there that he began to focus his efforts. Eventually he was up and running in a water-powered mill, using a circular saw to cut gears out of cherrywood. In 1806 he took on a commission to manufacture four thousand wooden clock movements. Unlike Whitney, he pulled it off, in just three years—one to set up the machinery, one to make his first one thousand clocks, and one to finish the order. Finally, in 1814, he began selling his own fully finished shelf clocks in great numbers, mainly via peddlers traveling the same circuits he had once ridden. Though he was achieving nothing like the precision that firearms required, Terry was probably the first American to

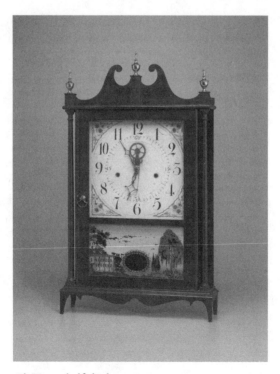

Eli Terry, shelf clock, 1816–25. Yale University Art Gallery.

manufacture truly interchangeable parts. In 1983 a historian brought together a group of surviving unassembled components, sourced from different shops in Terry's network, and put them together. They worked just fine.[49]

Manufacturing efforts of this sort did not necessarily push artisans out of employment, because they were aimed at consumers who had previously been unable to afford bespoke craftsmanship. But with its enormous scale and rapidly improving transport links, America was fast becoming a mass market: a land of quantity rather than quality. Tocqueville saw this as a material expression of the nation's politics: "The democratic principle induces the artisan to produce with great rapidity many imperfect commodities, and the consumer to content himself with these commodities." Was this a good or a bad thing? On this point, Tocqueville was ambivalent. "When none but the wealthy had watches, they were almost all very good ones. Few are now made that are worth much, but everybody has one in his pocket."[50]

∼

To an artisan frustrated with this state of affairs, Andrew Jackson must have seemed like a man riding to the rescue. The first president to hail from the West, and the first to be born in a log cabin, he had vaulted to national prominence in the War of 1812, winning the Battle of New Orleans just at the end of the conflict. He then prosecuted a bloody campaign against the Creek and Seminole nations, who lived in parts of what are now Alabama, Georgia, and Florida—it was the first time, but by no means the last, that Jackson would undertake brutal assaults on Native lands and peoples. He was also a slaveholding plantation owner, and a lifelong opponent of abolitionism. But for white Americans, his military exploits made him a hero—a true man of the people. Jackson's men called him "Old Hickory" for his toughness. In 1824 he ran for the presidency, winning the popular vote but not the election, as a "corrupt bargain" engineered by Henry Clay put John Quincy Adams into the White House instead. Four years later it was no contest: Jackson and his new Democratic Party swept to a landslide victory, backed by both northern craftsmen and southern farmers. His inauguration was a remarkable scene. "Uncouth" constituents carried a log cabin down the street, packed into the White House, and raised their punch in toasts, men carrying hickory walking sticks, women wearing hickory nut necklaces.[51]

If the Jacksonian era has a lesson, though, it is this: Beware of demagogues. Even as he stocked the White House and his own Nashville residence, the Hermitage,

with an unprecedented quantity of silver (good employment for Tennessee's smiths, at least), Jackson's combative anti-elitism led him to veto Congress's regular rechartering of the national bank, the primary instrument of Clay's American system.[52] "The rich and powerful too often bend the acts of government to their selfish purposes," Jackson said when dissolving the bank, and "the humble members of society, the farmers, mechanics, and laborers, who have neither the time nor the means of securing like favors to themselves, have a right to complain." He also declared war on paper currency, which was seen as a tool of speculators and capitalists, decreeing that land on the frontier would now have to be bought in specie. Artisans cheered him on.

But in 1837, with Jackson's handpicked successor, Martin Van Buren, just a few weeks into his presidency, the folly of these policies became evident. A shift in British interest rates triggered a lending crunch in the United States. The newly decentralized banking system, low on cash and without a stabilizing mechanism,

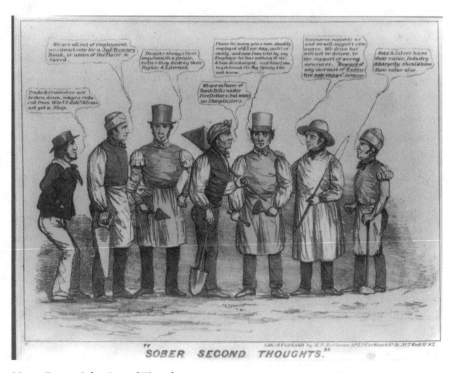

Henry Dacre, *Sober Second Thought*, 1838–39. Cartoon Prints, American collection, Prints & Photographs Division, Library of Congress, LC-USZ62-19197.

suffered a cascade of failures. The price of cotton dropped, with disastrous results for northern merchants and the southern economy as a whole. The political cartoonist Henry Dacre mocked artisans who had supported the Democrats, showing a line of them in their smocks and carrying the tools of their trades, expressing their "Sober Second Thoughts" about Jackson and his program. One of them says, "Despots always first impoverish a people, before they destroy their Rights & Liberties." Another is preoccupied with his own problems: "I am told by my employer he has nothing to do, and I am discharged, and how I am to get bread for my family I do not know."

Like the Great Depression a century later, the Panic of 1837 delivered a shock wave that reverberated beyond the economy. It struck at America's image of itself as a land of opportunity, at a time when upward mobility was already faltering. It says a lot about the country that the general response was not to abandon individualism, but to double down on it. Rather than turning toward collective solutions, Americans continued building a mythology of the self-made man. At the very moment that the crisis was settling in, one of the most popular books in America was Rev. Thomas Hunt's *Book of Wealth*, which had been published the previous year. A trim 119 pages, and subtitled *In which it is proved from the Bible that it is the duty of every man, to become rich*, the book is a continuous, sanctimonious exhortation against idleness. Hunt assured his readers that God was sure to reward their honest toil—and not just in the hereafter. He particularly encouraged readers with a manual bent—"many a fine mechanic by nature, who might have been happy and useful with his talents turned into their proper channel, has led a miserable, useless life, as a lawyer, a physician, or clergyman." The fact that artisans all over America were already working every daylight hour and longer, and staying poor while doing so, went unmentioned.[53] This hypocrisy replicated itself like a bad cold in books like John Frost's *Self-Made Men of America* (1848), which held up eleven paragons of virtue for admiration. Most of them had craft roots, among them John Jacob Astor, then the wealthiest man in America. He made his money principally as a real estate speculator, but in Frost's telling, Astor's fortune was inevitable from the moment he was "initiated into the mysteries of his craft" as a furrier. By midcentury, there were many such self-made man narratives in circulation, among them the popular poor-boy-makes-good tales of Horatio Alger, such as *Ragged Dick* (1868). The message of every one of them was the same: The best sort of man works hard and rises high "by his own unaided efforts."[54]

Despite the thin evidentiary basis for this claim, it appealed to many Americans. It dovetailed neatly with the Protestant notion of a "calling," in which work performed dutifully was considered service rendered to God; it was also compatible with a developing stereotype of masculinity, which gravitated toward raw strength and risk-taking (which were newly necessary in certain industrial settings, like iron foundries). Men with "soft hands" were scorned, the "manly hardihood" of west-bound pioneers celebrated.[55] The sociologist Ava Baron has pointed out that the ideal body type for men changed over the course of the nineteenth century, from "lean and wiry to bulky and physically powerful," citing that muscular hammer-wielding arm in the mechanics' emblem as one example.[56] So, the self-made man myth cohered with certain other notions that were widely shared among workers. But it was also propaganda aimed from the top of the social ladder at the bottom.

In fact, the term *self-made man* was first put into circulation by none other than Henry Clay, who said in an 1832 Senate address, "In Kentucky, almost every manu-factory known to me, is in the hands of enterprising and self-made men, who have acquired whatever wealth they possess by patient and diligent labor."[57] (Ironically, the speech was given in support of a protective tariff, the opposite of self-help in policy terms.) The term was quickly adopted across the political spectrum. Jackson's Democrats made the concept their own, celebrating their man for his humble origins, a rebel with his own cause, beholden to none. Then, in 1840, after Van Buren's disastrous presidency, Clay was edged out as the nominee for the Whigs, who instead opted for the sixty-seven-year-old William Henry Harrison. When he was taunted as a senile has-been—perhaps he could be persuaded to "sit the remainder of his days in a log cabin," drinking from "a barrel of hard cider"—Harrison's party ingeniously adopted both these motifs as emblems for their campaign. They wheeled horse-drawn cabins around the country, distributing free mugs of cider as they went. Harrison died just thirty-one days into his presidency, famously felled by pneu-monia contracted while delivering his inaugural address without an overcoat; but the log cabin was in American politics to stay. Abraham Lincoln, of course, but also Ulysses S. Grant, James Garfield, Calvin Coolidge, and in later years Jimmy Carter—all were celebrated for their lowly upbringings in buildings of rough timber.[58]

As it happens, log cabins were somewhat more sophisticated than this rhetoric might suggest. Some were made of round, partly debarked trees—as the Lincoln Log toys of later years would lead one to believe—though often the timbers were squared. Either way, the buildings would have required a large construction team to

included in the Harper's volume could not reasonably have been construed as self-made—Henry Clay had already inherited two slaves when he was four years old—Burritt certainly was. Born in 1810 in New Britain, Connecticut, the son of a shoemaker, he earned the sobriquet "the learned blacksmith" for his prodigious self-education, depicted in *Self-Made Men* by way of a quoted diary entry: "*August 18. Forged 16 hours—read Celtic 3 hours—translated 2 pages of Icelandic, and three pages of German.*" In the hagiographic account that follows, Burritt comes across as the perfect union of mind and hands, capable of "welding sentences and cartwheels with equal facility."[62]

We don't have his cartwheels to judge, but Burritt's sentences certainly stand the test of time. Known widely as an abolitionist and pacifist, he was also an acute observer of the onrushing tide of industry, sensitive to the human beings caught in its currents. In a book of essays entitled *Sparks from the Anvil*—composed, he said, "during my hours of relaxation from arduous manual labour"—he evocatively captures the worker's perspective otherwise so absent in the period's literature. In one set piece, he imagines a complex of arsenal buildings at the end of a war, falling swiftly into ruin: "There they stand in haggard desolation, like things built before the sun was made, and unable to bear its light ... And Labour, wan, dejected Labour, at whose veins the monster fed, runs up and down the green hills exulting to see the curse removed." In another essay, he conjures a train steaming its way along a New England mountainside. Emphasizing that it is the product of free, rather than enslaved, labor, he writes, "I love to see one of these huge creatures, with sinews of brass and muscles of iron, strut forth from his smoky stable." But what really fires Burritt's imagination is the "little sober-eyed, tobacco-chewing man in the middle ... For, begrimed as he may be with coal diluted in oil and steam, I regard him as the genius of the whole machinery."[63]

When *Sparks from the Anvil* was published, in 1847, Burritt was in the midst of a tour through England's furnace-fueled industrial districts, "black by day and red by night." He went to Birmingham, to view the city's light metals factories. He went to Kidderminster, to see carpet weaving on great looms. He went to Oldbury, to see the Brades Iron and Steel Works, which had taken so much coal out of the ground nearby that the village had sunk eleven feet from its original level. The factory there was filled with smiths working "with remarkable tact and celerity," he reported, manufacturing 99 out of every 100 trowels wielded by masons back home in America.[64] At all these sites, Burritt felt that he was seeing "specimens of handicraft ...

like a string of beads of infinite variety of tinting and texture." In other words, he could see what eluded so many others, then and since—that industry and skill may have been opposed in theory, but they were not incompatible in practice.[65]

To the extent that Burritt is remembered today, it is mainly in connection with Henry Wadsworth Longfellow. The two men were frequent correspondents on topics ranging from abolitionism to Burritt's school for women in New Britain.[66] In 1840, Longfellow invited Burritt to stay with him in Cambridge. The learned blacksmith respectfully thanked him, but declined to leave his forge. That same year, Longfellow's famous poem "The Village Blacksmith" was first published; it seems likely that their friendship played some role in its conception.[67] This said, Burritt's sophisticated view of modern industry is completely absent from the poem, which is instead the ultimate paean to the independent craftsman:

> Under a spreading chestnut-tree
> The village smithy stands;
> The smith, a mighty man is he,
> With large and sinewy hands;
> And the muscles of his brawny arms
> Are strong as iron bands.[68]

Longfellow clearly thought that he was describing life as it ought to be lived, simple and steady. He did conclude with a stanza linking the "sounding anvil" to generative "deed and thought"—a very Burritt-esque conceit—but apart from this final flourish, the poem presents the blacksmith in purely instinctive terms, wholly without intellectual proclivities. (Though he once likened himself to a "Rhyme-Smith," Longfellow quickly added, "Think not that thus I degrade the Poet's high vocation into a base handicraft.")[69]

The smith also lives, in a sense, outside history. His every day is the same: "Each morning sees some task begin / Each evening sees it close." As in the self-made man literature of the day, labor offers its own sure reward. Most important, the smith is free and completely autonomous:

> His brow is wet with honest sweat,
> He earns whate'er he can,
> And looks the whole world in the face,
> For he owes not any man.

This individualistic ideal circulated like life-giving sap in Longfellow's poetry. And it was equally vital to his associates, the Transcendentalists. This learned group of New Englanders (which included Ralph Waldo Emerson, Henry David Thoreau, Nathaniel Hawthorne, and Margaret Fuller) placed individualism at the core of their thought, often using the skilled artisan as an exemplar. The name of the group may be slightly misleading; it does not indicate a disdain for the physical realm, but, on the contrary, the group's shared conviction that material experience was the only means to higher ("transcendental") truths. Their logic here was simple: The sensible world is God-given; therefore, it is the pathway to the divine. Understanding that connection was not, however, a passive process, as in the traditional Christian concept of revelation. It required constant action. Emerson, in his influential long essay *Nature* (1836), wrote of the "hand of the mind," which restlessly searches and tests reality to form concepts.[70]

The following year, he expanded on this figure of speech in a lecture entitled "Doctrine of the Hands," a sustained argument for the practical foundation of knowledge. "A man is no worse metaphysician," Emerson said, "for knowing how to drive a nail home without splitting the board." Lacking skill in a craft is not just "unmanly," he wrote; it is also an impediment to true understanding. Evidence comes from the mouths of artisans themselves: "A carpenter, a farmer, a blacksmith do not choose their words and correct their sentences; their attention is so fastened on the thing that their speech is very simple and very strong." A man who trades only in words can bend the truth to suit himself, can "affect to know what he knows not," but in craft there is no place to hide: "If the fire is not directed to the right spot, the iron will not melt; if the hammer do not fall at the right instant, the iron will not bend, though he should talk a year."

Of course, Emerson himself was neither carpenter, nor farmer, nor blacksmith. It was an incongruity that his friend Henry David Thoreau set out to resolve, over the course of two years and two months spent in a log cabin he'd built himself, on Emerson's land. Thoreau put his fellow Transcendentalists' ideas into practice, seemingly proud of "not having many communicable or scholar-like thoughts" as he did so. The book he went on to write about this experience, *Walden, or, Life in the Woods*, published in 1854, is an American classic—a masterpiece of nature writing, an aspirational text about living in harmony with the environment, in complete self-sufficiency, "by the labor of my hands only." It is a foundational text of American craft.

It is also a bundle of contradictions and hypocrisy. The writer Kathryn Schulz has pointed out that Walden Pond in Thoreau's day was "scarcely more off the grid

than Prospect Park is today," and that he routinely depended on outside help to get him through his supposed seclusion—including regular visits to his mother's house, about a twenty-minute walk away.[71] Most damning of all is her assessment of his disdainful attitude toward his fellow human beings, summed up in *Walden*'s most famous line, "the mass of men lead lives of quiet desperation." In order to embrace the natural world, he felt it necessary to reject society.

It is hard to argue with any of this. Yet Thoreau needs to be read in context, and there is still something extraordinary in the way that he overturned the prevailing ideology of American individualism. *Walden* is in some ways paradigmatic of the self-made man myth. Asking, "Shall we forever resign the pleasure of construction to the carpenter?," Thoreau built his cabin with his own hands. (Admittedly, he did it with a borrowed axe, bought another family's shack, whole, to use for planks, and had help in raising the house's timber frame.) In one of his most celebrated metaphors, Thoreau compares the shelter he built in the woods not to other people's houses, but rather to nests built by the birds all round. "Who knows but if men constructed their dwellings with their own hands, and provided food for themselves and families simply and honestly enough, the poetic faculty would be universally developed, as birds universally sing when they are so engaged?" Thoreau not only adopted period ideas of self-reliance, but also exaggerated them into a kind of performance. He even took care to move into his cabin on the Fourth of July.

He made no promises that *Walden* would be a "way to wealth"; indeed, as he put it, "my greatest skill has been to want but little." In the first section of the book, pointedly entitled "Economy," Thoreau tells an anecdote about a Native American who goes door-to-door trying to sell his handwoven baskets. When the man makes no sales, he wonders, "What? Do you mean to starve us?"—"Thinking that when he had made the baskets he would have done his part, and then it would be the white man's to buy them."[72] The parable echoes earlier American commentary on Native people, who had supposedly failed to grasp the inevitability of supply and demand. But the lesson Thoreau draws is quite different: "I too had woven a kind of basket of a delicate texture, but had not made it worth any one's while to buy them. Yet not the less, in my case, did I think it worth my while to weave them, and instead of studying how to make it worth men's while to buy my baskets, I studied rather how to avoid the necessity of selling them." He exulted in saving time and money simply by ignoring middle-class propriety. All he had for warmth was a small cook-stove, and he was happy to wear thin, patched clothing. "Some of my friends," he

said, "spoke as if I was coming to the woods on purpose to freeze myself." And Thoreau needed no curtains, having "no gazers to shut out but the sun and moon, and I am willing that they should look in."

Thoreau may have been, by disposition, a misanthrope. But it is not society in general that he rejects in *Walden*, but its specifically modern form. He was uniquely attuned to the privations of the nineteenth-century laborers who made up his potential audience. For these men and women, he recognized, free time was of necessity "borrowed or stolen"—every hour a reader spent with his book was an hour not spent keeping the creditors at bay. Likewise, he knew that not all hard labor was equally valuable. Work on one's own terms was satisfying above all things, but that was far from being the case in the factory system. "Where is this division of labor to end?" he asked. "And what object does it finally serve? No doubt another may also think for me; but it is not therefore desirable that he should do so to the exclusion of my thinking for myself."

Walden was not a bestseller like Franklin's *Autobiography* or Rev. Thomas Hunt's *Book of Wealth*. The book had only one printing, of two thousand copies, of which less than half initially sold. Within a few years it was out of print.[73] Readers who did encounter it were sometimes puzzled, wondering whether Thoreau was actually encouraging his readers to follow his example and go live in a forest. Horace Greeley, editor of the *New-York Daily Tribune*—he coined the phrase "Go West, young man," and inspired the joke "Yes, he is a self-made man, and he worships his Creator"—advised his readers that Thoreau was not, as he might seem, an enemy of sociability, or insensible to the virtues of "helping-each-other-along." He had simply presented "his brother aspirants to self-culture, a very wholesome example, and shown them how, by chastening their physical appetites, they may preserve their proper independence without starving their souls."[74] It would not be until the twentieth century that this message found its audience. When it did, however, the influence was both wide and deep. In *Walden*, later generations would discover a new way to think about craft: an expression of individualism not in the service of modern society, but in opposition to it.

～

In retrospect, we can see that the biggest problem with the mythology of the self-made man was that it left out women—almost entirely. Thoreau himself was quite open to the idea that a woman might follow his example, and in fact he found a

prospective candidate in Kate Brady, a young home seamstress of his acquaintance. He noted in his journal that she planned to live in a "lonely ruin" belonging to her family, and there support herself through keeping a flock of sheep, spinning, and weaving: "There, she thinks she can 'live free.' "[75] And Thoreau's fellow Transcendentalist Margaret Fuller, who edited the group's journal, the *Dial*, before moving on to work with Greeley at the *Tribune*, made the same argument for all womankind. In her pioneering feminist manifesto, *Woman in the Nineteenth Century*, she argued that self-reliance was just as urgent for women as for men—even more so: "Women must leave off asking [men] and being influenced by them, but retire within themselves, and explore the ground-work of life till they find their peculiar secret."[76] Fuller attracted a far greater readership than Thoreau. But in advocating complete equality of the genders, she was challenging conventional wisdom even more provocatively than he was. American men who prized individual liberty for themselves very rarely considered women's right to the same. This was particularly true of male working-class leaders, who saw their wages as threatened by cheap female labor. Instead of solving this problem by pushing for equal pay, they sought to block women from the workplace, presenting them as victims who needed protection. A lady's fit and proper place, they said, was in the home.[77]

This last message came at women from every direction in nineteenth-century America, accumulating into what historians have called a cult of true womanhood—the unequal opposite, as it were, to the mythology of the self-made man. The closest most female readers would have had to a "book of wealth" were texts like William Alcott's *The Young Wife*, which intoned, "Let her be industrious for the sake of the good mental and moral effects which industry produces, and because it is the will of God."[78] A particularly impressive example of this pedantic genre is Catharine Beecher's *Treatise on Domestic Economy*, first published by Harper and Brothers in 1841. Beecher was a minister's daughter, born in East Hampton, New York, in 1800. (Harriet Beecher Stowe was her younger sister.)[79] In 1823, Beecher opened an academy for young women in Hartford, Connecticut, and went on to publish on diverse topics, including abolitionism (which she was against), calisthenics (which she was for), and religion. But it was the *Treatise*, and her other works on home economics, that made her famous.

Leaving no room for misunderstanding, Beecher opened her book with the Declaration of Independence—"all men are created equal"—and then quickly added that for the general good, it was necessary that "certain relations be sustained, which

involve the duties of subordination." Paramount among these relations, in her view, was that of a wife to her husband. After lengthy quotations to support this view from a male authority—none other than Alexis de Tocqueville—Beecher then proceeded to the matter at hand, an intricately detailed account of keeping house, 350 pages of solid obligation. "Economy," as mandated by Beecher, was the antithesis of that advocated by Thoreau. Her book is all about appearances: Never buy a cheap carpet, particularly for a room much used. A dining table should be set with geometric precision. Cutlery should have weighty handles, so that when laid down, knife blades and fork tines will not touch the table. Housework is to be done as efficiently as possible, on the theory that a proper life is a well-disciplined life: "Wise economy is nowhere more conspicuous, than in the *right apportionment of time* to different pursuits." The strangest thing about her seemingly practical book is that it would have been all but impossible to follow all its injunctions—a trait it shares with many other aspirational how-to guides.[80]

Beecher's militaristic code of conduct was clearly aimed at the mistress of the house—here and there, she pauses for an aside about the inevitable laxity of servants—but she certainly expected her reader to be hands-on. Her chapter on laundry, for example, unfolds at impressive length. She gives step-by-step-by-step instructions across four categories ("flannels," "coloreds," "coarse whites," and "fine clothing"), with supplementary advice on making soda, lye, soap, and starch from scratch. Her version of dusting the parlor requires four separate implements (dust brush, feather brush, painter's brush, and a piece of silk). Making the bed begins with sculpting the feather mattress just so; proceeds through a dizzying array of maneuvers with sheets, covers, and pillows; and finally concludes with this disheartening comment: "A nice housekeeper always notices the manner in which a bed is made; and in some parts of the Country, it is rare to see this work properly performed." Her chapter on sewing—the only domestic craft she discusses—is equally relentless, with particular attention paid to keeping a neat workbasket. At no time does Beecher hint that any of this labor might give pleasure, apart from the pleasure of making oneself useful.

It is never a good idea to take advice literature at face value, and just because many women owned copies of the *Treatise*, it does not mean they followed its advice to the letter, nor in the spirit in which it was intended. For that matter, Beecher herself was a curiously contradictory figure, having become nationally prominent precisely by advocating meek subordination. Yet the "Cult of True Womanhood," of which she was a leading celebrant, was indeed powerful, giving shape to lives from

girlhood on. Another of its delivery mechanisms was *Godey's Lady's Book*, which began publishing in 1830. The most widely circulated periodical in America prior to the Civil War, it was edited, from 1837, by Sarah Josepha Hale, who also gave the world "Mary Had a Little Lamb." Advertised as "instructive and entertaining," the *Lady's Book* offered a variety of contents, including essays, poetry, short stories, and piano scores for home performance—a popular activity among women in an age before recorded music. Most visually arresting were its hand-tinted fashion plates, accompanied by garment patterns with instructions for home sewing. There were also frequent features on other crafts, such as crochet, quilting, and a type of lace-making called tatting, which was described as a good activity for "odd moments, in the dusk, and when visiting; it is particularly suitable work for mothers." In such women's publications, craft did have a prominent place. But its role was symbolic, never professional, and, at least in the pages of the *Lady's Book*, slathered with senti-mentality: "What little girl does not recollect her first piece of patchwork, the anxiety for fear the pieces would not fit, the eager care with which each stitch was taken."[81] No longer a productive economic unit, as it had been in the eighteenth century and earlier, the home was now seen as the antithesis of a workplace. It was a refuge and, given the competitive nature of the capitalist economy, which was supposedly shut out at the front door, a site of moral redemption.[82]

Not every woman was prepared to accept these terms, of course. In one of her poetic fragments, Emily Dickinson, that most private of writers, recorded a subtle yet powerful rejoinder to the cult of femininity's coercions:

> I'm ceded—I've stopped being Theirs—
> The name they dropped upon my face
> With water, in the country church
> Is finished using now,
> And they can put it with my dolls,
> My childhood, and the string of spools,
> I've finished threading too.

In this deft sketch of female self-making, Dickinson likens her abandonment of sewing to an assumption of adulthood—and by implication, her identity as an artist. Craft is not a means to self-realization, but a binding that needs to be cut.

Then there were the public faces of resistance: women like Frances "Fanny" Wright. When Catharine Beecher was twenty-three, she opened her own school in Hartford. That was pretty ambitious. But when Fanny Wright was twenty-three, she set off to see America, eventually journeying thousands of miles over nearly two years, unaccompanied apart from her younger sister, Camilla. It was the first of many things she would do that seemed, to most people, extraordinary, even unthinkable. Wright was born in Dundee, Scotland, in 1795, the daughter of a linen manufacturer. Orphaned young, she used her inheritance to get an education, reading widely on history and politics. Eventually she would be attacked by her enemies as a "man woman" and a "priestess of Beelzebub," and described even by her friend Frances Trollope as "the advocate of opinions that make millions shudder, and some half-score admire."[83]

Name an ideological conflict of the time, and Wright was on the progressive side of it. She was an abolitionist feminist secularist, an opponent of capital punishment, and an advocate of birth control. After the published account of her travels, *Views of Society and Manners in America*, vaulted Wright to fame, she became intimate with the Marquis de Lafayette, hero of both the French and American revolutions. On one occasion, she wrote to him to say this: "I dare say you marvel sometimes at my independent way of walking through the world just as if nature had made me of your sex instead of poor Eve's. Trust me, my beloved friend, the mind has no sex but what habit and education give it."[84]

During her travels to the American West, Wright, like Tocqueville, was deeply impressed by settlers' practical aptitude and ingenuity, their "dexterity in all the manual arts," and by the way that the whole family pitched in: The husband "wields the axe, and turns up the soil, his wife plies the needle and the spinning-wheel, and his children draw sugar from the maple, and work at the loom."[85] This image of frontier self-sufficiency clearly stayed with her. Wright had formed a very high opinion of America, particularly in comparison to the tyrannical monarchy of her own country. But in this new land of freedom, there was one glaring exception—and she was determined to do something about it. In 1825, Wright began purchasing slaves and housing them at a community in Tennessee, on land that had been occupied by the Chickasaw nation until Andrew Jackson forced them off their ancestral ground. (In fact, it was through Jackson, whom Wright contacted via Lafayette, that she acquired the property.) She called it Nashoba, the Chickasaw word for "wolf,"

after the nearby Wolf River. There, she planned to educate the relocated African Americans. She also hoped to pay them for their work, enough to eventually buy their own freedom and that of one other enslaved person. In an essay entitled "A Plan for the Gradual Abolition of Slavery in the United States, without Danger of Loss to the Citizens of the South," Wright pressed Congress to do the same. If her simple scheme were adopted generally, slavery could be eradicated without bloodshed. She figured it would take about eighty-five years.[86]

Clearly, Wright had set herself some unrealistic expectations. First, she persuaded herself that most white southerners were looking for a way out of the slave system. In her great admiration for Americans, perhaps she was unable to imagine that any of them could be as racist and inhumane as they in fact were. Second and more urgently, she underestimated the practical challenges that her project would entail. Partly under the influence of Robert Owen, an even more wildly optimistic visionary than she—he was establishing his own utopian settlement at New Harmony, Indiana, at this time—she assumed that the settlers at Nashoba would be able to support themselves on the land, with a surplus.[87] In fact, this proved far from being the case. Though she did seek financial support from friends, both to purchase slaves and to operate the colony, little was forthcoming. In 1827, after bringing just a handful of enslaved African Americans to the community—only thirty would ever live there— Wright contracted malaria and returned to Europe to recover. In her absence, the community struggled to stay afloat. It also earned a notorious reputation for rumored experiments in interracial "free love" (that is, nonmarital sex). In 1830, five years into the experiment, Wright finally admitted defeat. She emancipated the men, women, and children of Nashoba, chartered a ship, and sent them off to Haiti.

Wright at Nashoba makes for a fascinating counterpoint to Thoreau at Walden Pond. Both saw something deeply immoral in the society of their time and set out to demonstrate that things could be done otherwise. Thoreau pursued a completely individualistic path, attending to nothing but his own needs and desires. Wright's methods, by contrast, were philanthropic and communitarian. True, she achieved far less than she intended. And what she did achieve was extremely paternalistic; she was arguably America's first exponent of what the writer Teju Cole has called the "white-savior industrial complex."[88] Yet, for all these shortcomings, Nashoba was at least an attempt—indeed, for thirty people, a life-changing one—to intervene in a horrific state of affairs.

It is also easy to overstate Wright's impracticality. She knew very well what Nashoba was. In a commentary published in 1830, she described the community as offering "only a life of exertion, and, at the present time, one of privation: rough cabins, simple fare, active occupation." With this in mind, though she invited any to come who might be of help, she requested only those with a useful trade and requisite tools: "All must bring hands as well as heads." And Wright, a woman of considerable wealth, was willing to sacrifice her own comforts. She, too, lived in a rudimentary log cabin, a setting indelibly recorded by her friend Trollope in 1827: "The rain had access through the wooden roof, and the chimney, which was of logs, slightly plaistered with mud, caught fire, at least a dozen times in a day; but Frances Wright stood in the midst of all this desolation, with the air of a conqueror." Wright herself was more concise. "The step between theory and practice," she conceded, "is usually great."[89]

~

Even as Nashoba collapsed, Wright was already turning her attention to a new cause in a new setting: the rough-and-tumble of urban politics. In 1829, at a high tide of populist sentiment—it was the year Jackson assumed the presidency—a new Working Men's Party was founded in New York City. Drawing its support from mechanics' societies and journeymen's associations, the "Workies," as they were often called, were a striking anomaly in the political landscape. Enthusiastic collectivists, they attempted to unite both skilled artisans and unskilled laborers in a single reformist movement. This put them far to the left of the Democrats—who in any case were rapidly becoming a corrupt political machine in New York, run by the notorious bosses of Tammany Hall. The contrast is clear in the two parties' platforms on education. The Democrats supported universal schooling for men because it would help the economy and provide opportunity for advancement. The Workies backed it, too, but for a very different reason: They hoped to "remove the veil of ignorance by which the poor who suffer are prevented from penetrating into the mysteries of that legislation of the rich, by which their sufferings are produced."[90]

Wright arrived in New York on New Year's Day 1829 and quickly formed an alliance with other agitators. As an upper-class outsider and a woman, however, she was not seen as a candidate to lead the new party. The political center of gravity instead settled on Thomas Skidmore, a machinist, amateur inventor, and blazing

radical. He led the Working Men's Party into the upcoming assembly elections, running on the demand of the ten-hour day. The emblem of the Hammer and Hand was printed at the head of its ballot. But Tammany Hall was hard to beat. Just one Working Men's candidate (a journeyman carpenter) won office, and that marked the height of the party's electoral success.

For many observers, the most memorable thing about the brief rise and fall of the Workies was Wright herself, draped in a muslin tunic (the rationalist garb that the Owenists had adopted in New Harmony), shouting to the rooftops. "The eyes of the people," she cried in her Scottish brogue, had been opened: "I say *of the people*—of that large and, happily, sounder part of the population who draw their subsistence from the sweat of their brow, and whose industry constitutes at once the physical strength, and the moral prop of the nation." This country, she said, this "revolutionized America," may have left the scaffold and the dungeon behind. But it still needed to win victory over the "tyranny of ignorance, and the slavery of the mind."[91] Out there in the audience, among thousands of others, were a Quaker carpenter called Walter Whitman and his ten-year-old son, known as Walt. Many years later, the poet would remember the shock of seeing Wright speak: "We all loved her, fell down before her; her very appearance seemed to enthrall us."[92]

Meanwhile, about two hundred miles to the southwest, another boy of about ten years old—he never learned the true date of his birth—was just learning to read and write. His name was Frederick Augustus Washington Bailey, and he had been born into slavery. By 1829 he was living in Baltimore, but as a small child he had already witnessed plantation life and its viciousness—"the blood-stained gate, the entrance to the hell of slavery, through which I was about to pass."[93] In 1833, his worst fears were realized. He was sent back out to the country to be a field hand. There he experienced for himself the full horror of the slave system: constant hunger, hard labor all day and into the night, biting cold in the winter, whippings so severe that they raised "ridges on my flesh as large as my little finger." There was no respite. In 1836 he was hired out to a city shipbuilder, working as an unskilled laborer in an integrated crew. The pace was frantic—he felt he needed a dozen pairs of hands—but the workplace was at least peaceable—until, suddenly, "the white carpenters knocked off, and said they would not work with free colored workmen. Their reason for this, as alleged, was, that if free colored carpenters were encouraged, they would soon take the trade into their own hands, and poor white men would be thrown out of employment." Though young Frederick was not himself a skilled carpenter, the conflict

spilled into more general violence, and he was once again severely assaulted, this time by four white apprentices.

It was at this point that his luck finally turned. His master sent him to a different shipyard, where he was trained in hull caulking. This represented an immediate improvement in his status. Now, he said, "I sought my own employment, made my own contracts, and collected the money which I earned. My pathway became much more smooth"—so smooth, indeed, that he was able to escape. In 1838, with the help of a free Black woman he had met named Anna Murray, he passed himself off as a sailor on a northbound steamboat. Once he reached safety, Murray joined him, and they married, settling in the whaling town of New Bedford, where he would have plenty of work as a caulker. He also adopted a new name, shedding that of his former master: Now and forever, he would be Frederick Douglass.

Soon established in abolitionist circles as a brilliant orator, he proceeded to write the story of his life; it was published in 1845. He continued speaking, stunning audiences both Black and white with his account of what slavery was really like, and what it portended. In an address first delivered to an antislavery sewing circle in 1852, he asked, "What to the Slave Is the Fourth of July?" His answer was that it reveals, "more than all other days in the year, the gross injustice and cruelty to which he is the constant victim. To him, your celebration is a sham; your boasted liberty, an unholy license ... There is not a nation on the earth guilty of practices, more shocking and bloody, than are the people of these United States, at this very hour."

These words are justly famous today. But in Douglass's own lifetime, his best-known speech was another, first delivered a few years later, in 1859. Its title: "Self-Made Men." Unlike so many other books, pamphlets, and lectures on that theme, Douglass chose it, much as he had chosen the Fourth of July, in order to fundamentally transform its meaning. "Properly speaking," he began, "there are in the world no such men as self-made men. That term implies an individual independence of the past and present which can never exist. We have all either begged, borrowed, or stolen." There is but one lesson normally associated with the concept of the self-made man that was worth holding on to: "WORK! WORK!! WORK!!! Not transient and fitful effort, but patient, enduring, honest, unremitting and indefatigable work into which the whole heart is put." For a moment, the ghost of Benjamin Franklin rose once again—only to be banished, a few minutes later, as Douglass reached his culminating theme: "How will this theory affect the Negro?" It was a question Franklin had never thought to ask, nor Jefferson, nor Emerson or Thoreau, nor even

Frances Wright. But Douglass offered a simple reply: "Give him fair play and let him be." Meaning this: "Throw open to him the doors of the schools, the factories, the workshops, and of all mechanical industries . . . He well performed the task of making bricks without straw: now give him straw. Give him all the facilities for honest and successful livelihood, and in all honorable avocations receive him as a man among men."

Through five years of blood, a hundred years of legal segregation, and down to the present day, Douglass's call has yet to be fully answered. In the meantime, debates about the place of craft in Black lives would continue to rage. On that topic Douglass, who had won first his livelihood and then his freedom with the humblest of tools, the mallet and irons of a ship caulker, had one piece of advice for his fellow African Americans: "It is idle, yea even ruinous, to disguise the matter for a single hour longer; every day begins and ends with the impressive lesson that free negroes must learn trades, or die."[94]

Chapter 3

Learn Trades or Die

I T IS A SULTRY DAY aboard the *Pequod*. The unpredictable flow of the whale hunt, prolonged monotony punctuated by bouts of bloody ferocity, is at low ebb. The sea is the color of lead. On deck, Ishmael and Queequeg are "mildly employed" weaving a mat. Once finished, it will be lashed to one of the ship's harpoon boats as a protective sheathing. Ishmael feeds a woof of marline (a type of light tarred rope) through the shed formed by the alternating splay of the warp yarns. After each pass, Queequeg beats the woof down with a blade carved of oak. Their joint rhythm is listless, and Ishmael slips into metaphysical reflection: "I say so strange a dreami- ness did there then reign all over the ship and all over the sea, only broken by the intermitting dull sound of the sword, that it seemed as if this were the Loom of Time, and I myself were a shuttle mechanically weaving and weaving away at the Fates." It occurs to him that the irregular slide and thump of Queequeg's wooden beater into the dense mat work—"sometimes hitting the woof slantingly, or crook- edly, or strongly, or weakly, as the case may be"—is an apt metaphor for the happen- stance nature of life. "This savage's sword, thought I, which thus finally shapes and fashions both warp and woof; this easy, indifferent sword must be chance—aye, chance, free will, and necessity—nowise incompatible—all interweavingly working together."[1]

Like so many passages in Herman Melville's *Moby-Dick*, published in 1851, this extraordinary vignette draws on an ancient well of metaphor—in this case, the asso- ciation of textiles and fate—while also speaking urgently to its own moment. The

friendship between the South Sea Islander and the white American, which here and elsewhere in the novel edges into homoeroticism, is also meant to be read politically. Out in the ocean, the racial divisions that prevail upon land are to some extent suspended. Black and white hands combine to do what needs to be done. In some interpretations, this is a part of the grand metaphor that drives the whole novel: the *Pequod* as isolated ship of state. The dictatorial Captain Ahab stands precariously at its head, the officers and sailors his tyrannized, hard-laboring subjects. The fellowship shared by the men is their only solace, their sole pleasure.

In long, lavishly descriptive passages, based on Melville's own experiences as a whaleman in the early 1840s, *Moby-Dick* records the many incidental details of shipboard life, including its maritime crafts. One of its memorable characters is an unnamed carpenter, who grumbles and fumes constantly, but is competent not just in "the ancient and outbranching trunk" of woodworking, but also in "those thousand nameless mechanical emergencies continually recurring in a large ship, upon a three or four years' voyage, in uncivilized and far-distant seas." He even fashions a peg leg for Ahab from a sperm whale's jawbone. Melville portrays this artisan with a strange mixture of awe and condescension. At one point, he even compares the carpenter to a Sheffield knife, with innumerable tools and contrivances within its case ready to pop out and be used. "He was a pure manipulator," Melville writes. "His brain, if he had ever had one, must have early oozed along into the muscles of his fingers." Is this man a mechanic or a mechanism?

A similar question had occurred to many observers of the emerging American industrial system, not least those who worked in it. *Moby-Dick* was published near the peak of the whaling industry, and Melville well knew that the ships he described were much like floating factories. Whalemen did more jobs than the average textile worker, many of them skill-intensive; they also practiced individualistic craft pursuits, such as the famous scrimshaw carvings they made in their copious spare time. Yet, when a whale was caught and its blubber had to be boiled down into oil, they might as well have worked in an iron foundry. One of Melville's most famous chapters, "The Try-Works," describes the process: the enormous pots, cleaned and hand-polished until they "shine within like silver punchbowls"; the unctuous fatty flesh shoveled into the pots; the hellish fire of the masonry hearth beneath; the hot, stinking, smoking oil splashing over the vessels' edges with every roll of the ship. It could not be more of a contrast with the quiet moment of the mat weaving, making the *Pequod* a seagoing outpost of the defining American conflict between modest craft and sublime industry.

Scrimshaw with an American eagle motif, c. 1850. Museum of Fine Arts, Boston, Harriet Otis Cruft Fund, 64.2176.

The ethnic diversity of *Moby-Dick*, too, is based on fact. The very name of the *Pequod* refers to the Pequot nation, the historic inhabitants of present-day Connecticut and Rhode Island. And while there is much exaggeration in Melville's rendering of Queequeg and his fellow harpooneers Daggoo (who is from Africa, we aren't told where) and Tashtego (an Aquinnah from Martha's Vineyard)—they are

sometimes primitive caricatures, sometimes a trio of superheroes—their presence does reflect the reality of the industry. Whaling was difficult and extremely dangerous, and a "greenhand" on his first voyage made very little, if anything at all, after his expenses were deducted. If he survived, he did receive greater pay as he became more experienced, a debased version of an apprenticeship system. These terms were obviously not attractive, and many who ended up as whalemen had few other economic options. Native Americans, who had been whaling off the coast of New England long before European colonization, were particularly important to the industry, as were African Americans and immigrants from Cape Verde.

The stereotypes, both positive and negative, that Melville ascribed to the harpooneers were in general circulation: Native Americans were renowned for their keen eyesight in the crow's nest and their athleticism at the point of attack, while the more managerial aptitudes they brought to the work, though well documented in logbooks kept by Native officers, were overlooked. Native and Black workers were also heavily involved in the dockland crafts that kept the ships moving: sail and rope making, carpentry, coopering, block making, and hull caulking, the trade Frederick Douglass practiced as a young man. Off ship, the *Pequod's* home port of New Bedford was crowded with industrial facilities for processing the harvested oil into lamp fuel (inspiring the town motto, *Lucem diffundo*, "I pour forth light") and lubricants, candles, and soap. There were also workshops for shaping baleen (thin, bony ridges from the whales' mouths) into ribs for umbrellas and corsets. And then there were the town's financiers, the banks and insurance companies who managed the enormous capital that flowed through the port.[2]

In its knotty tangle of handwork and industry, then, its proximity of an exploited multicultural workforce and monied interests, whaling truly was a microcosm of the nation. This was becoming the general way of things. In 1855, with Fanny Wright's oratory still echoing in his ears, Walt Whitman wrote a "Song for Occupations," enumerating scores of different trades bumping noisily along like logs rolling down a hillside:

> House-building, measuring, sawing the boards,
> Blacksmithing, glass-blowing, nail-making, coopering, tin-roofing,
> shingle-dressing,
> Ship-joining, dock-building, fish-curing, flagging of sidewalks by flaggers,
> The pump, the pile-driver, the great derrick, the coal-kiln and brick-kiln,

Coal-mines and all that is down there, the lamps in the darkness, echoes,
 songs, what meditations, what vast native thoughts.

And so on, stanza after stanza: caulking and cotton, fireworks and flour, brewing and butchery, glue and ice, silk and glass, a single great cavalcade. For Whitman and others of his generation, there was still no absolute distinction between craft and industry. There was simply production, and increasingly, it defined America. "You may read in many languages, yet read nothing about it. You may read the President's message and read nothing about it there," Whitman wrote. "Or in the census or revenue returns, prices current, or any accounts of stock." All the same, it was there, everywhere you looked. And it was awesome to behold.

~

When war finally did come, this massive complex of making turned on itself and became the most destructive force the world had ever seen. Both sides—but particularly the North, which had the advantage both technologically and in sheer weight of numbers—achieved unprecedented standardization in their production of war matériel. A huge explosion of demand for standard goods, along with an improved railway system and economies of scale, encouraged centralization of manufacture. Even if they could have competed, most adult male artisans were otherwise occupied: They'd joined the army. There they encountered a life that was similar to factory work in many respects. Soldiers experienced task specialization, hierarchical structure, time regulation (with the bugle and drum taking the place of the factory's morning bell), and, above all, the uneven contest of human bodies and inhuman technology. Artillery is an exemplary case. Previously it had been the most artisanal branch of the military, and generally the most well paid, with a strong culture of apprenticeship. It had not been all that long since Paul Revere transitioned smoothly from silversmithing to cannon casting, and gunners had intimate knowledge of their own weapons. But by the end of the Civil War, field pieces and shells were made to a factory standard, and were also much more lethal. Early in the war, using weapons of mass destruction such as mines and torpedoes was criticized as dishonorable—"the most murderous and barbarous conduct," in the words of the Union general George McClellan. By 1864, they, too, were being mass manufactured by both sides.[3]

A similar shift in scale occurred in all aspects of war production, even innocuous ones like sewing. Isaac Merritt Singer had taken out his first patent for a sewing machine

in 1851 and achieved some success, using marketing methods similar to those Eli Terry had pioneered with his wooden clocks. The company sold machines door-to-door, offering purchase plans for payment over time. They bought back old models to encourage the purchase of new ones. At the same time, as had already happened with shoes, ready-made (rather than bespoke) clothing began to gain acceptance among consumers in the 1840s. A new "proportional measurement" system in men's clothing allowed for the purchase of garments according to size; the age of cheap, imperfectly fitting clothing that is still with us today had begun. This was expedited to some degree by the advent of sewing machines, but the impact was not immediate. The high unit price dissuaded many individual buyers, and early machines were challenging to use. One early customer wrote in her diary, "I was once told, if I owned a sewing machine, I should have nothing to do for a great part of the time. Had I been poetical enough to have imagined such a reality, I should have been

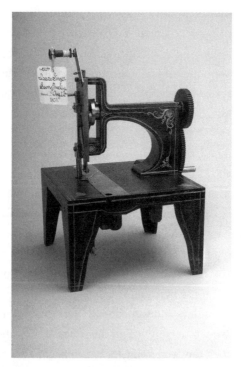

Isaac Singer, sewing machine patent model, 1851. Division of Cultural and Community Life, National Museum of American History, Smithsonian Institution.

woefully disappointed."[4] Potential buyers were also put off by the industrial look of the early machines, a problem that manufacturers corrected through the addition of painted and cast ornament. An 1860 puff piece in *Godey's Lady's Book* promoted one model as "so light and graceful, and the finish so beautiful, that one is prepossessed by its appearance before understanding any other of its excellencies."[5]

Then came the war. Sewing machines were suddenly in huge demand, to make uniforms, tents, blankets, flags, and other supplies. One machine operative—usually a woman—could do as much finishing as six working by hand. In response, manufacturers dramatically expanded production of the machines, implementing the method of mass-produced, interchangeable parts that had been pioneered in the gun industry. A few statistics tell the tale: In 1853, Singer made only about eight hundred units, all handcrafted, retailing for three hundred dollars each. In the late 1860s, after the end of hostilities, they produced more than forty thousand sewing machines annually, retailing for about sixty dollars each. (They also spent over a million dollars annually on advertising.)[6]

The Civil War, then, was mass slaughter powered by mass production. The first war to be extensively photographed, it was also covered by the mass media. Yet it was experienced by individuals, who had to adapt to circumstances as best they could. Military leadership laid plans, soldiers improvised. Every time an army made camp, the ideal layout prescribed by regulations—a neat grid of huts with straight alleys between them—was adjusted to available set-up time and local terrain. Some nights, the troops might simply sleep on a rubber mat and a folded tent laid on the ground. At a more long-term encampment, they might construct a log or plank-sided cabin, or even a round, tipi-style tent. The construction of fortifications, field battlements, railway lines, and other military structures similarly required on-site inventiveness.

Commanders were well aware of this unpredictability, and tried to ensure that each regiment (typically, between five hundred and eight hundred men) had a skilled woodworker, bricklayer, and mason among its ranks. Specialist "artificers," paid more than rank-and-file infantrymen, were particularly concentrated in cavalry and artillery units, working as blacksmiths, saddlers and harness makers, or engineers. Other artisans were stationed in cities, where they were assigned to shipyards, wagon works, or armories.[7] But over the course of the conflict, every soldier needed to pitch in as and when needed. One Union cavalryman wrote, "Nearly every man has suddenly become a mason or a carpenter, and the hammer, the axe and the trowel

are being plied with the utmost vigor, if not with the highest skill. Many of us, however, are astonished at the ingenuity that is displayed with this department."[8]

Back on the home front, too, craft was an important aspect of the war effort. Immigrants flocked to northern cities, attracted by high wages brought about by a sudden demand for labor. "These are golden times for craftsmen, workers, and soldiers," one German cabinetmaker wrote to his family in 1863, reporting that his wages had doubled.[9] Mothers, sisters, and daughters made clothing for the enlisted men in their families. Everywhere, both north and south, homemade flags were sewn and flown. The inventor Samuel Morse, who bitterly opposed the war, proposed a Peace Flag bisected on a diagonal from upper left to lower right. One triangle was to be flown in the North, the other in the South. If a truce could be reached, the two halves "would clasp fittingly together."[10] This suggestion went nowhere. Instead, flags attained a new degree of nationalistic attachment, which they have retained ever since. In Richmond, in 1861, the prominent writer Constance Cary Harrison, the so-called Betsy Ross of the Confederacy, collaborated with two of her cousins to sew the first version of the "Stars and Bars" battle flag, which remains one of the most controversial emblems in American life to this day. Up in New York, following the attack on Fort Sumpter, two ship riggers raised an enormous Star-Spangled Banner atop Trinity Church in New York City, as the crowds poured into the streets: "Broadway was almost hidden in a cloud of flaggery. Nothing but red, white and blue, red, white and blue, greeted the eye, turn which way it would."[11]

Caroline Cowles Richards, born in 1842 near the Canadian border in upstate New York, had begun keeping a diary at the age of ten. It details her involvement with community sewing projects, including "album" quilts in which the members of her sewing circle contributed squares to one another's marriage blankets. When the war came, Richards was swept up in the fervor. "The storm has broken upon us," she wrote, "how strange and awful it seems." But it was stirring to see the boys marching off, singing, "Oh, 'tis sweet for one's country to die." Along with the other women of the town, she made garments for soldiers, tucking notes into the seams for them to discover. Her sewing circle agreed that if any of their husbands went off to war, they would band together to make that man's wife a flag-themed bed quilt, with a contributor's name on each star.[12]

There is a persistent myth that, both before and during the war, African Americans used quilts to even greater purpose—as a signaling device on the Underground Railroad. According to this theory, a "log cabin" quilt left hanging from a washing

line signified a safe house, while a pattern called "drunkard's path" was actually an escape route map. Unfortunately, these claims have no historical evidence supporting them (and surviving "drunkard's path" quilts actually postdate the Civil War).[13] Wishful thinking aside, the most striking thing about the African American craft experience during the conflict was how continuous it was with prewar patterns— until suddenly, it wasn't. At first, Black laborers and artisans adapted their plantation and urban labor roles directly into military provisioning. They were a vital part of the war effort on both sides, making boots for soldiers, wheels for wagons, saddles for horses. Carpenters and blacksmiths were particularly in demand. Many of these workers were simply carrying on in trades they had long practiced. African Americans in the South, with an experience of enslavement, were valued for the flexibility and multiple skills they had learned through the hiring-out system. Provisioning officers commented on this; a Confederate supply inspector at a strategic depot in Lynchburg, Virginia, emphasized the importance of providing medical care to Black artisans there: "The workmanship in every branch is very fine, and all materials economized, and worked up to the best advantage . . . the negroes are of great service, and their health is of grave importance."[14] Perhaps surprisingly, mixed-race work crews, including both enslaved and free Blacks, were common in the South all the way through the war's end.

Up north, meanwhile, an army report on the contributions of free Blacks, both as combatants and craftspeople, simply read, "We could never get enough of them."[15] The Union was well aware how vital African American labor was to the Confederate effort, too, and this formed a powerful practical argument for emancipation. "Strike from the rebellion the support which it derives from the unrequited toil of these slaves," a New York gubernatorial candidate said in 1862, "and its foundations will be undermined."[16] He was proved exactly right. In the early stages of the war, some African Americans were able to escape past the northern lines and then performed critical roles as scouts and spies. Others signed up and fought. These few brave men and women were the forerunners of a great wave of change. When the Union Army swept through the South, they liberated thousands from plantations and manufactories, crippling the Confederacy's supply lines. In the same moment, they opened up the question of these newly free Americans' legal and social status. That question would not be resolved for a very long time.

One African American artisan experienced her war far from the front, in the parlors of the White House itself. This was Elizabeth "Lizzie" Keckley, a seamstress

whose story is recounted in her autobiography, *Behind the Scenes*. "My life has been an eventful one," she begins. "I was born a slave—was the child of slave parents—therefore I came upon the earth free in God-like thought, but fettered in action." She was born in Virginia in 1818, the daughter of a white plantation owner and a literate house slave named Agnes. Her growing-up years were all too typical of enslaved women's experiences: family separations, vicious beatings, and an enforced sexual relationship that endured for four long years. All the while, she sewed, both for the household's use and to earn them extra money. Eventually, Keckley was taken to St. Louis, where the family that owned her fell on hard times. "With my needle," she recalled with pride, "I kept bread in the mouths of seventeen persons." At last, in 1855, she managed to buy her freedom with the support of a network of white patrons she had established through her work as a bespoke dressmaker.[17]

Once free, Keckley moved back east and became known in Washington society as a seamstress of exceptional skill. In 1860, on the eve of the war, she was engaged as "modiste" by Varina Davis, wife of Jefferson Davis, then a senator for Mississippi. Keckley recalled that southern politicians came and went frequently as she worked on fittings, discussing the "prospects of war" freely in front of her, as if she were not there. That Christmas, at the stroke of midnight, she completed a dressing gown in "changeable silk," drab-colored, intended as a gift for the senator from his wife. "I have not the shadow of a doubt," Keckley wrote in her autobiography, that "it was worn by Mr. Davis during the stormy years that he was the President of the Confederate States." Varina Davis would also have been turned out in Keckley's fashions during that time. The same was true of another client, Mary Anna Custis Lee—a direct descendant of Martha Washington and also the wife of General Robert E. Lee. Throughout the Civil War, these two leading ladies of the Confederacy wore gowns made by a formerly enslaved African American woman.

This picture is made all the more extraordinary by Keckley's close relationship with Mary Todd Lincoln. When originally published in 1868, *Behind the Scenes* was of public interest not because it unveiled the story of a Black craftswoman, but for the intimate view it provided of the White House and of Mrs. Lincoln in particular. During the war years, Keckley not only made her ball attire—a glorious ensemble in purple velvet piped with white satin survives in the Smithsonian collection today—but also served as a personal assistant and confidant. In her memoir, Keckley claims that when the president was assassinated, Mary Todd Lincoln wanted to see no one but her. She subsequently gifted Keckley several relics of Lincoln: the comb that

Keckley herself had used to "brush down his bristles"; a glove; even the cloak, stained with blood, that he had worn to Ford's Theatre. Most of these she donated to Wilberforce College, recently formed in Ohio for the education of African Americans. Keckley lived nearly to the age of ninety, still supporting herself with needle and thread. A quilt of her making, preserved at Kent State University, is said to date from these later years, and perhaps even to incorporate scraps of material associated with Mary Todd Lincoln's wardrobe. Its central square shows an eagle in flight, with seven letters stitched under its wing: LIBERTY.

~

If Keckley's quilt speaks volumes with that single word, how much more articulate are the works of Dave the Potter? Today, he is nearly as well known as she is: Keckley has been the topic of a novel and a play, and appeared as a character in Steven Spielberg's film *Lincoln*, while Dave has been the subject of several museum exhibitions and even a children's book. Yet the two could hardly be more different. Dave left no memoir; scholars have had to piece together his biography from scattered newspaper mentions and business records. These place him not at the center of political power, but in a rural district called Edgefield, South Carolina, where he was born in 1800 and seems to have lived out all his days, mostly in obscurity.

He would have stayed there—in obscurity, that is—had he been only a potter. Although his wheel-thrown and coiled jars are handsome, and sometimes large in scale (over two feet high), many craftspeople both African American and white created similar objects, and their names are now lost to history. What has preserved Dave's memory are the short verses he quickly scratched into some of his pots before they were glazed and fired. Each is accompanied by a date and his own name, in a bold, scrolling hand. The earliest surviving example, from 1834, riffs on the gallon capacity of the vessel it inscribes: PUT EVERY BIT ALL BETWEEN / SURELY THIS JAR WILL HOLD 14. Two poems, of 1840 and 1857, voice reservations about money, that great necessity that is also the root of all evil: GIVE ME SILVER OR EITHER GOLD / THOUGH THEY ARE DANGEROUS TO OUR SOUL and I MADE THIS JAR FOR CASH / THOUGH ITS CALLED LUCRE TRASH. Others mention Bible reading, storing lard and meat, constellations of stars, and celebrations on the Fourth of July. Most notably, at a place and time when literacy itself was illegal among the enslaved, he addressed his own condition of bondage. In 1840, having recently been sold to a new owner, he recorded the fact: DAVE BELONGS TO MR. MILES / WHERE THE OVEN

David Drake, storage jar, 1857. Metropolitan Museum of Art.

BAKES & THE POT BILES. And in 1859—some years after a woman named Lidy and two boys from his household, perhaps his wife and sons, were transported west to Tennessee—he leaned over a jar and scratched in these heartbreaking words: I WONDER WHERE IS ALL MY RELATIONS / FRIENDSHIP TO ALL, AND EVERY NATION.

Lewis Miles's pottery, where Dave worked, was a sizable concern, valued at five thousand dollars in the 1860 U.S. Industrial Census, with an annual output of fifty thousand gallons' worth of vessels—perhaps as many as two thousand pots per year. (Firing was done in low-slung "groundhog" kilns, built partly into the ground, with a chimney at one end to suck through the air, heat, and smoke.) Of that large production, fewer than one hundred fifty works attributable to Dave survive today. For all his fluency as both a maker and a writer, his story, like that of nearly every person born into American slavery, is primarily one of erasure. Yet what we do have to read about him, primarily from his own hand, suggests a man of humor and dignity. One local newspaper item, a nostalgic tour of Edgefield published in 1859, mentions him as a local curiosity: "Do we not still mind how the boys and girls used

to think it a fine Saturday frolic to walk to old Pottersville and survey its manufacturing peculiaristics? to watch old DAVE as the clay assumed beneath his magic touch the desired shape of jug, jar, or crock, or pitcher?" When the Civil War came, and then emancipation, Dave continued to work for Lewis Miles, though making few of the large jars for which he has become posthumously famous. Perhaps this was due to his advancing years, or the wartime collapse of the plantation economy. The last of his inscriptions, vibrant with Christian faith, is dated 1862: I MADE THIS JAR ALL OF CROSS / IF YOU DON'T REPENT, YOU WILL BE LOST. Nothing is heard from Dave after this, though we do know that he took his final owner's name, Drake, as a surname after the war. That is how he was recorded in an 1870 census, as a "turner." And that is the last word. Whether he reunited with Lidy or not, we do not know. His pots and words remain, however, a union of making, thinking, and feeling.[18]

Dave's silent years take us into the period that historians know as Reconstruction. This was a time of initial optimism for African Americans, but it ended in harsh disappointment. At issue were the rights of the formerly enslaved, which were swiftly enshrined in the Constitution after the war, only to be eroded through a campaign of terrorism and state oppression carried out by white supremacists. Black representatives appeared in the U.S. Congress and in legislatures all over the South, only to be banished again through techniques of voter suppression. When other forms of social control failed, whites resorted to lynching, a practice that became only more common as the decades passed.[19]

All through this tragic series of events, craft was a central topic of debate. Before the Civil War, Frederick Douglass had counseled his brothers and sisters to "learn trades, or die." In a culture that treated African American lives and property with complete disregard, he argued that the best safeguard of liberty was a manual skill, which could never be taken away. This calculus ought to have altered significantly after 1865, as African Americans gained the right to enter "white-collar" professions. Instead, the great fear for many reformers was that Blacks would remain a permanent underclass, performing only manual labor.

Prior to the war, about 70 percent of the South's enslaved people were plantation hands. Only about 13 percent were skilled artisans (most of them men). The remainder were employed in service, as drivers or house servants, or as unskilled laborers in laundries, factories, and warehouses. In the immediate aftermath of the war,

government officials, well aware that the southern economy had been completely shattered, encouraged all these people to continue in their previous lines of work, in order to prevent further upheaval. For the minority of formerly enslaved people who were already skilled artisans, this was typically a decided improvement. They transitioned smoothly from the hiring-out system and were now paid wages directly. Former field workers, however, faced a grim economic reality. Most owned no property—no land, no tools, few material resources of any kind. Radical Republicans in Congress wanted to make them some form of restitution—"forty acres and a mule," as the saying went—but that goal was never achieved. The bitter result was that the vast majority of Blacks in the South were forced into sharecropping. While no longer exposed to some of slavery's worst aspects, they were still subject to white oppression, often imposed through the device of credit extended for equipment, seeds, and livestock. These arrangements involved a lien against the future earnings of the sharecropper, on terms dictated by the landowner or merchant lender. This was a legal means to continue exerting control over Black workers' lives.[20]

As the possibility of a more equitable political settlement faded from view, only one remedy presented itself: education. There had been scattered attempts to construct a school system for African Americans for decades, both north and south. Courageous work was done by white abolitionist missionaries such as Rev. John Fee, who in 1855 opened a one-room schoolhouse in Kentucky (then a slave state), promising "an education to all colors, classes, cheap and thorough." This was the origin of Berea College, the first racially integrated higher education institution in the South. Black intellectuals, too, had long identified education as a primary goal. In 1840, the "fugitive blacksmith" James Pennington had urged the founding of African American schools: "Who lays this stone in a masterly manner, can surely lay another on the top of it, another of the top of that, and so onward, can he not? A man who did not need process, was never known."[21] But with the end of slavery came new urgency, and new questions. Should education efforts focus on vocational training? Or should Black children be offered the same general education as whites? Proponents of the first approach emphasized immediate economic benefit. But others saw vocational education as a trap, one that would only reinforce the racial caste system. America had always had Black artisans, they argued. What it needed was Black businessmen, lawyers, ministers, and politicians. In period terminology, the choice was between "industrial" and "liberal" education; in strategic terms, between

short- and long-term thinking; in philosophical terms, between pragmatism and idealism.[22]

This difficult dilemma would continue to be debated for decades. During the Reconstruction period—from 1865 to 1877—the liberal option was in the ascendancy. A Freedmen's Bureau, set up by the Republican-dominated federal government immediately after the war, was charged with improving conditions for Blacks across the South. Though chronically short of funding, the bureau boasted an impressive range of accomplishments, particularly in the areas of health care and legal assistance. Its most lasting achievement was to supervise a network of schools across the South—more than four thousand of them by 1870, serving a quarter million students—and to support the founding of universities like Fisk, Atlanta, and Howard (named for the commissioner of the Freedman's Bureau, General Oliver Howard), all of which were established in the late 1860s. These higher educational institutions were initially focused on training teachers. The objective was to staff the rapidly expanding school system, where curriculum was designed along "liberal" lines—perhaps with a class or two in home economics, but also the full range of other subjects: Latin, history, geography, music, mathematics, and government.

Unsurprisingly, these efforts faced strong opposition from whites. W. E. B. Du Bois put it simply: "The South believed an educated Negro to be a dangerous Negro. And the South was not wholly wrong; for education among all kinds of men always has had, and always will have, an element of danger and revolution, of dissatisfaction and discontent."[23] In particular, white community leaders worried that liberal education would make African Americans unwilling to work in manual occupations. The solution they settled on was to teach them crafts instead. Rutherford B. Hayes, elected president in 1876 (in the so-called corrupt bargain that spelled the end of Reconstruction), was also a founding trustee of the John F. Slater Fund, which provided financial support to southern Black schools. "This is the gospel of salvation for the colored man," he wrote in his diary. "Let not labor be servile, but in manly occupations like those of the carpenter, the farmer, and the blacksmith."[24]

A man named Samuel Chapman Armstrong agreed. Born in Hawaii to a family of Christian missionaries, he had fought for the Union in the Civil War, defending against Pickett's Charge at the Battle of Gettysburg, and subsequently commanding a unit of African American soldiers. After the war, he joined the Freedmen's Bureau,

and in 1868, he founded the Hampton Normal and Agricultural Institute—now Hampton University—in Virginia. Like other universities founded under the aegis of the bureau, Hampton was mainly devoted to teacher training. But Armstrong placed unprecedented emphasis on industrial education. Though he saw himself very much as a "friend of the Negro," as the phrase then went, he was also infused with missionary spirit, which had a strongly paternalistic cast. He believed that African Americans were socially inferior and would likely remain so for the foreseeable future: "Too much is expected of mere book-knowledge; too much is expected of one generation."[25] Vocational training, to him, seemed the only sensible path forward. It would create a prosperous and moral Black populace, at a safe remove from politics, dedicated to agriculture and artisanship.

Accordingly, the pedagogical emphasis at Hampton was almost entirely on manual skills. This curriculum was modeled on a missionary school that Armstrong had known as a child, the Hilo Manual Labor School for Native Hawaiians, which he approvingly described as turning out "men less brilliant than the advanced schools, but more solid."[26] All Hampton students worked on the school farm. Young men also were trained in blacksmithing, shoemaking, machine building, and carpentry, while women studied cookery and sewing, including dressmaking. An illustrated monthly was published at the school called the *Southern Workman*. From Armstrong's perspective, this emphasis on trades had several advantages. It would build character, respect for the dignity of labor, and an aptitude for self-help. It would give his newly minted teachers concrete skills, making them immediately employable. And it would also create an income stream: Schools could defray their own costs through the sale of student craftwork. Armstrong did make space for intellectual development; for example, basic geometry could be learned through dressmaking or furniture construction. There was also time given to Bible reading and some textbook-based subjects. But if it was a choice between the classroom or the workshop—well, the workshop it would be.

Hampton's impact on African American history would prove to be profound, principally because of an eighteen-year-old coal miner who showed up at the door one day in 1872: Booker T. Washington. He had been born into slavery on a plantation in Franklin County, Virginia, and of course received no schooling there of any kind. "From the time that I can remember anything," he wrote in his autobiography, *Up from Slavery*, "almost every day in my life has been occupied in some form of labor." He was struck, by contrast, with the general uselessness of the white people

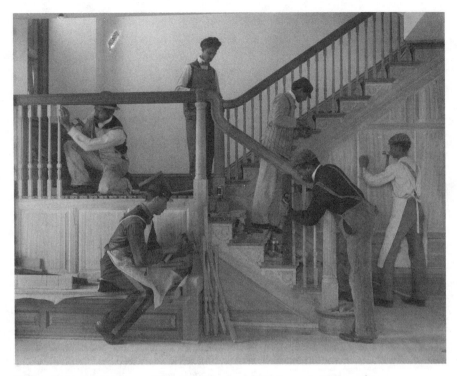

Frances Benjamin Johnston, *Students at Work on the Treasurer's Staircase*, from
The Hampton Album, 1899–1900. Digital Image © The Museum of Modern Art/Licensed by
SCALA/Art Resource, NY.

he observed on the plantation. All physical work was left to the enslaved Blacks, who
had no personal interest in improving the property. "As a result of this system," he
said, "fences were out of repair, gates were hanging half off the hinges, doors creaked,
window-panes were out, plastering had fallen but was not replaced, weeds grew in
the yard." This portrait of disarray tells us something about its author. For
Washington, slavery was not just a brutal assault on human life and liberty; it was
also an affront to the dignity of the Black race. He spent his life trying to win that
dignity back.[27]

Following emancipation, Washington's family made its way to the newly consti-
tuted state of West Virginia, where he was able to attend a small local school, mainly
at night. He also found employment as a child laborer in a salt furnace, and then in the
difficult and dangerous work of coal mining. He first heard mention of Hampton in
an overheard conversation between two other miners, who spoke of "a great school for

colored people somewhere in Virginia." Washington immediately determined to make his way there as soon as he could. At last, a year and a half later, he set off on a five-hundred-mile journey, which he completed mostly on foot, taking odd jobs along the way to earn enough money to survive. By the time he arrived, he was exhausted and hungry. He had not slept under a roof for some time (and for that matter, had never in his life slept on a bed with two sheets on it). No wonder Hampton's three-story brick edifice impressed him: "The largest and most beautiful building," he said, "that I had ever seen." After passing an initial test—he was asked to sweep a room clean, and did so with exaggerated enthusiasm—he was taken on as a student.

In many ways, Washington never lost the idealism of his arrival at Hampton. He heroized Armstrong in particular, describing him as superhuman and Christlike, "the rarest, strongest, and most beautiful character that it has been my privilege to meet." He also fully accepted the white philanthropist's pious version of the self-help doctrine. At Hampton, Washington earned his keep by serving as the school janitor, and then as a brick mason. "I learned to love labor," he said, "not alone for its financial value, but for labor's own sake and for the independence and self-reliance which the ability to do something which the world wants done brings." After graduating, he found work as a teacher elsewhere, but was then invited back by Armstrong to join the faculty at Hampton. Initially, this was to participate in an experimental undertaking: to help "civilize" a group of Native Americans who had been taken prisoner in the West and transported to an army base in Florida, before being shipped to Hampton. Now Washington had his own prejudices to overcome. In his autobiography, he described the new arrivals as "wild and for the most part perfectly ignorant Indians." Yet he came to feel that they were "about like any other human beings," in that they profited from being taught trades. (Armstrong, for his part, described Native Americans as "grown up children," adding, "we are a thousand years ahead of them in the line of progress.")[28] Just one year later, in 1879, the man who sent this group of Native people to Hampton, Captain Richard Henry Pratt, would set up the Carlisle Indian Industrial School in Pennsylvania. As we will see, it applied the principles pioneered at Hampton with greater coercive force, employing craft as a means of pacification rather than supposed empowerment.

Meanwhile, down in Alabama, a bargain was being struck. An African American community leader named Lewis Adams, formerly an enslaved metalsmith and leather-worker, negotiated a fateful agreement with the local Democratic Party (the party of white supremacy). If he rallied voters to its support, it would approve funding for

a new school for African Americans, in the town of Tuskegee. The white Democrats agreed, went on to narrowly win the election, and soon systematically disenfranchised Black voters across the state. They did, however, uphold their end of the deal: Funds for a new school were appropriated in early 1881.[29] Adams asked Armstrong to recommend a principal, and Armstrong sent him Washington, who arrived eager to extend the "Hampton idea." Astonishingly, he claimed to find relations between Blacks and whites in that part of rural Alabama to be "pleasant," but was discouraged to find that the money appropriated for the school covered only teacher salaries, without any provision for buildings or equipment. This was, he said, like being asked to "make bricks without straw"—an echo, intentional or not, of Frederick Douglass's "Self-Made Men" speech. Even so, the Tuskegee Institute opened on the Fourth of July of that year, in a deconsecrated church.

As with other Black universities in the South, the emphasis at Tuskegee was on teacher training and manual processes. Like his mentor Armstrong, Washington dismissed autodidactic book learning, which some of his students had cultivated prior to their arrival at Tuskegee—"the bigger the book and the longer the name of the subject, the prouder they felt of their accomplishment." Cognizant of white people's fears that newly educated Blacks would abandon their farms for opportunities in the cities, he gave agriculture a prominent place in the curriculum. Students were set to work constructing the school's buildings and even constructed their own furniture, "making their own beds," as Washington said, "before they could lie on them." (He meant it literally; students slept on the floor until they were able to complete a frame and a hand-sewn mattress.) A kiln was indeed constructed to fire bricks—successfully enough that the school was soon manufacturing sufficient quantities to sell them, raising badly needed money. Eventually, pageants were staged for the benefit of Washington's white patrons, in which the students would dutifully demonstrate their various craft skills.[30]

Washington was successful with those patrons because he was willing to mirror their preconceptions. His strategy was to disprove racist assumptions by positive example, on an individualistic basis. As soon as the school was on its feet, he expanded his efforts to support Black schools, farms, and small businesses. For white philanthropists like John D. Rockefeller Jr. and Andrew Carnegie, Washington was the ideal partner, willing to abide by what seemed to them natural limits to African American ambition. "The black man," Washington said, "can sooner conquer southern prejudice than Yankee competition." That was of course music to their ears. Eventually, the

political network he built—W. E. B. Du Bois called it "the Tuskegee machine"—extended all the way up to the White House. His conciliatory approach culminated in an infamous speech delivered in 1895, often known as the Atlanta Compromise address, in which he explicitly disavowed confrontation with racist Jim Crow laws and seemed even to sanction segregation. "The agitation of questions of social equality is the extremest folly," he said. Blacks must accept that "we shall prosper in proportion as we learn to dignify and glorify common labour, and put brains and skill into the common occupations of life." Addressing the whites in the audience, he offered a craftsmanlike analogy for his political philosophy: "In all things that are purely social we can be as separate as the fingers, yet one as the hand in all things essential to mutual progress."

How should we think about Washington's Tuskegee, and the turn from liberal to industrial education more generally? Many observers have been extremely critical, seeing the embrace of craft as tantamount to perpetuating white supremacy. The first, and arguably still the most sophisticated, expression of this view came from Du Bois, who was significantly younger—he was born the same year that Hampton was founded. At first, the intellectual and historian was very supportive of Washington's approach, and even considered joining the faculty at Tuskegee.[31] But as Du Bois studied the question of vocational training in detail, he came to feel that Washington had made a huge mistake. In 1906, speaking at the Hampton Institute itself, he attacked the "soothing syrup attitude toward the race problem," a barely veiled allusion to Washington's rhetorical style. "If we are to be trained grudgingly and suspiciously; trained not with reference to what we can be, but with sole reference to what somebody wants us to be," Du Bois said, "then my fellow teachers, we are going to fail, and fail ignominiously, in our attempt to raise the black race to its full humanity."[32] Elsewhere, he was still more direct, accusing Washington of forging an "indissoluble link" between industrial education on the one hand and "submission and silence as to civil and political rights" on the other.[33] Later civil rights activists would take up this critique; in their 1967 book, *Black Power*, the activists Stokely Carmichael and Charles V. Hamilton devoted a whole chapter to Tuskegee, arguing that it embodied "the politics of deference."[34]

Recent historians have been more mixed in their assessments. For some, "Washington and Tuskegee were Armstrong and Hampton in blackface," paternalism personified.[35] Others more sympathetically note that the ideology of self-help, of which Tuskegee was an expression, was very widespread in this period, embraced by

W. E. B. Du Bois, infographic prepared for the Exposition Universelle in Paris, 1900.
African American Photographs Assembled for 1900 Paris Exposition, Prints & Photographs
Division, Library of Congress, LC-DIG-ppmsca-33879.

whites as well as Blacks. They also point to the forces arrayed against African
Americans with the rolling back of Reconstruction. This was, after all, a time when
whites routinely lynched Blacks who dared to resist, and the government did
nothing to stop it. Against this grim backdrop, Washington's cautious conservatism
is somewhat easier to understand.[36] In *Up from Slavery*, he recalled the laying of his
school's cornerstone with particular pride. Only sixteen years after the abolition of
slavery, a group of white local officials gathered to celebrate the occasion with a
group of Black people (teachers, students, and family), some of whom they had
previously owned. "That spring day at Tuskegee was a remarkable one," Washington
commented. "I believe there are few places in the world where it could have taken
place." Unfortunately, he was right about that.

In a way, the most damning assessment of Tuskegee and other "industrial educa-tion" programs of its era had to do not with racial politics per se. Rather, it was that these programs were not industrial *enough*. Du Bois was again a pioneer in this respect. A series of Atlanta University reports on "the Negro artisan," to which he contributed substantial research, concluded that (as Fanny Wright had already discovered in the 1830s) it was all but impossible for school workshops to be econom-ically self-sufficient. While students might well benefit from such training in some subjective, character-building way, there was nonetheless an inherent conflict in the very premise of vocational education: "It was found that it was possible to teach a boy a trade mechanically without giving him the full educative benefit of the process, and vice versa, that there was a distinct educative value in teaching a boy to use his hands and his eyes in carrying out certain physical processes, even though he did not actually learn a trade."[37]

This critical evaluation would be further developed by Carter G. Woodson in his 1933 book *The Mis-Education of the Negro*. A carpenter's son who had studied at the integrated Berea College in Kentucky, Woodson was all for craft entrepreneurship among African Americans—in fact, he was among the first to write about Black artisans such as Thomas Day and Henry Boyd. Yet he argued that industrial education of the kind prescribed by Armstrong and Washington had been a false hope, as the workshop provision at these schools was so completely inadequate. Even institu-tions like Tuskegee, which had external financial support, could not hope to match "all the experience with machinery which white apprentices trained in factories had," Woodson wrote. "Such industrial education as these Negroes received, then, was merely to master a technique already discarded in progressive centers; and even in less complicated operations of industry these schools had no such facilities as to parallel the numerous processes of factories conducted on the plan of the division of labor." Teaching boys to make shoes and girls to sew dresses was pointless, because those trades had been debased by a combination of machine production and low-paid piecework. And of course, even African Americans who emerged from schools with marketable skills faced a wall of prejudice erected at the hiring line. Nor was this just a southern issue; as another early twentieth-century Black educator put it, there was "an increasing tendency to exclude Negroes everywhere from skilled industrial pursuits," so that even in the North, "any considerable group of Negro carpenters, masons, apprentices or skilled artisans of any kind in any of the great indus-trial establishments would create a public sensation." In short, while craft-based

education may have been well intentioned, it had resulted in several generations of African Americans who lacked both the benefits of a general education *and* realistic job prospects. In a verdict dishearteningly similar to that made by Frederick Douglass before the Civil War seventy-five years earlier, Woodson concluded, "Now the Negro is facing the ordeal of either learning to do for himself or to die out gradually in the bread line in the ghetto."[38]

As Woodson's analysis implies, the late nineteenth century saw a dramatic further erosion of America's artisan manufactures. Before the Civil War, the factory system had been the exception, encountered only in a few manufacturing sectors. Now, thanks partly to the effects of the war itself, it was fast becoming the norm. This pushed craft into three distinct roles. The first was the most well established: the luxury trade. Furnishing objects to the elite, the "privileged and rich classes," as Woodson put it, had long been a job for American artisans, and that was still the case. In this context, the very things that made craft noncompetitive, its inefficiency and variability, were valued as guarantors of quality and uniqueness. The second role for craft was nearly opposite to this: as a tool of philanthropic uplift. As the story of Tuskegee shows, this impulse was nominally democratic, but paternalistic in practice. For white patrons, craft seemed an ideal way to transform Black people, Native Americans, and immigrants into productive, "normal" American citizens. Then there was a third role: amateurism, work done for pleasure alone—which was particularly, though by no means exclusively, the province of female makers.

Each of these three conditions for craft, in its own way, was economically marginal. Taken together, they indicate that artisan labor could no longer compete in the mass market. But otherwise, they had little in common. Was craft elite or populist? Ethical or aesthetic? Done by highly trained, well-paid white men, or by ethnic minorities and women for little or no compensation? These questions would frame debate for decades to come. There was an increasing urgency, too, because the gradual dismantling of the artisan class had left a hollow at the center of the social hierarchy. Eventually, it would be replaced by a largely suburban and white-collar middle class; but that development was decades away. The result was pervasive inequality. In 1873, Mark Twain coined the phrase "the Gilded Age," a crafty play on the notion of a "Golden Age."[39] With this figure of speech, Twain intended to highlight a certain fraudulence in American life, a disparity between surface appearances and underlying reality—like a piece of mass-manufactured costume jewelry cast in base metal with only the thinnest layer of precious gold plated on top. It was also an

apt metaphor for a society with a tiny number of rich capitalists standing atop a vast population of the less well off.

Ironically, this era of ferocious class conflict, in which artisans would play a key role, both symbolic and practical, was ushered in by the greatest pageant of optimism the country had ever seen. This was the Centennial Exposition of 1876, marking the nation's one-hundredth birthday. It was staged at Fairmount Park in Philadelphia, with multiple pavilions sprawling over a 250-acre site. "To say that the Exposition is gigantic," noted the *Manufacturer and Builder*, "fails to express it." Press reports staggered under the weight of statistics: The buildings, constructed in just eighteen months, comprised nearly 4,000 tons of iron and 250,000 square feet of glass, and over 1 million square feet of tin roofing. Machinery Hall alone enclosed fourteen acres. In Agricultural Hall, one exhibitor showed three hundred varieties of potato. Over in the Colorado Building, an amateur scientist, one Mrs. Maxwell, presented no fewer than five hundred hand-prepared taxidermy specimens. The *American Farmer* magazine ran a quick calculation: "Five minutes spent over each object in the Centennial would require a life-time of sixty years."[40] Over its six-month run, the Centennial was attended by almost ten million people— equivalent to 20 percent of the U.S. population at the time. Many of these visitors came from abroad, however, as there were twenty-seven countries represented in the displays, mostly European nations, but also Brazil, China, and Japan. And yet, for all its profusion and diversity, the exhibition conveyed one principal message: America, after a century of independence and a decade of peace, had entered a new and spectacularly productive era.[41]

As with other World's Fairs (most important, the Great Exhibition of 1851, in London's Crystal Palace), there was a spirit of intense competition at the Centennial. Businesses and nations alike kept score, boasting of their superiority whenever possible and expressing frank apprehension about their perceived shortcomings. America's cut glass was hailed as superb, for instance, while its ceramics were seen as sadly lacking—it was shocking to admit that better wares were being made in Brazil, a country even younger than the United States.[42] Such lapses were largely excused, however, because of the herculean display of American industry. New inventions were unveiled, including the Remington typewriter and Alexander Graham Bell's telephone. A classical folly was constructed entirely in sheet metal and pressed zinc, sponsored by the aforementioned *Manufacturer and Builder*. (Its competitor, the *American Architect and Building News*, described it as the "most offensive building

on the grounds.")[43] The Cataract, a water spectacle in Agricultural Hall, was powered by hydraulic pumps.

Then there was the unrivaled centerpiece of the Exposition, an enormous steam engine made by the Providence, Rhode Island, firm of George Corliss, which was used to power innumerable devices across Machinery Hall. Much of the engine, comprising over six hundred tons of steel and iron, was recycled from horseshoes—a potent metaphor of technological displacement if ever there was one.[44] In a widely read review of the Centennial, William Dean Howells, editor of the *Atlantic Monthly*, professed himself baffled by the sheer quantity of contrivances on display in Machinery Hall: "A whole half-mile of sewing machines seems a good deal. And is there so very much difference between them?" But he was flabbergasted and unnerved by the Corliss engine, describing it as "an athlete of steel and iron with not a superfluous ounce of metal on it." In a racially charged comment, he imagined the machine destroying the sole engineer who was nominally its master, like a "slave who could crush him past all semblance of humanity with his lightest touch." And yet, he concluded, "of such things the Machinery Hall is no place to speak, and to be honest, one never thinks of such things there. One thinks only of the glorious triumphs of skill and invention."[45]

In the wake of the Civil War, this sort of triumph had clear political overtones. While the states that had joined the Confederacy were certainly represented at the Centennial—Mississippi, for example, constructed a "rustic cottage" built from the different timbers native to the state—the southern consensus was that the whole event was nothing but a "Yankee Swindle," a federally funded propaganda exercise for northern industrialists "on the make." Nor were these southern critics entirely mistaken. The Centennial's organizers did see it as an investment that would pay immediate dividends. "There will be a tremendous shaking up of the people," *Scribner's Monthly* reported, "a great going to and fro in the land, a lively circulation of money, and a stimulation of trade."[46]

Craft did have a major presence at the Centennial, but in guises that suggested its superfluity. Most commonly, it was encountered in the form of intensely made luxury goods, showpieces that had no real purpose other than to demonstrate their makers' skills. Some critics dismissed these as indulgent, particularly if they were foreign. A Chinese ivory carving depicting a miniature city on a miniature hillside, for example, was described in one paper as "a monument to wasted energy."[47] But mostly, visitors were entranced. A writer for *Appleton's Journal*, faced with a

"picturesque chaos" of Brazilian feather work, Italian wood carving, Japanese porcelains, and innumerable other specimens of exquisite workmanship, homed in on a jewelry box from Switzerland. When it was opened, out popped a one-inch-long mechanical bird that sang, flapped its wings, and swiveled from side to side. Marveling at this little wonder, he thought of the artisans who had made it: "Oh, aching eyes, benumbed fingers, and patient care!"[48] American luxury manufacturers, not to be outdone, showed off their technical prowess in monumental objects laden with allegorical ornament. The most celebrated was Gorham Silver's "Century Vase," a hundred years of history compressed into 2,200 ounces of sterling silver: a pioneer and a Native American, Ben Franklin and his printing press, a bison, and in a reminder of recent events, the Genius of War, accompanied by a shell-shattered tree and a broken caisson wheel. The Brooklyn-based Union Porcelain Works took a similar approach. Its own "Century Vase" had shallow-relief scenes of Penn's treaty with the Lenape, the Boston Tea Party, and a frontier log cabin.

As prestige objects like these indicate, craft at the Centennial also served as a symbolic carrier for the American past, in direct juxtaposition to the technological present. The Corliss Engine had its opposite number in an "Old Mill," purportedly constructed in 1776, that stood at the heart of Agricultural Hall. A modern kitchen was set up next to a kitchen evoking Colonial New England, which included a seventeenth-century cradle, a gateleg table, and other antiques.[49] This being Philadelphia, one of Ben Franklin's hand presses was on display, as was a replica of the Liberty Bell made from the melted-down metal of Revolutionary and Civil War cannon—a gesture analogous to beating swords into plowshares. In fact, Elihu Burritt, the "learned blacksmith" and prominent pacifist, now in his mid-sixties, was invited to do just that, at a forge set up for the purpose. He declined, however, fearing that it would come across as a "burlesque," and a deeply hypocritical one at that: "For there were never so many furnaces, forges and arsenals at work, turning out the latest improvements in the machinery of war, as at the present moment, and no mind and hand more busy and ingenious in the invention and manufacture of such weapons as the American."[50]

Amateur craft also was present at the Centennial, in the Women's Building—an exposition within the exposition. It had originated when the Centennial's all-male Board of Finance appointed a women's auxiliary committee, hoping that it would help raise advance subscriptions and increase attendance. Under the leadership of

Elizabeth Duane Gillespie, a great-granddaughter of (who else?) Benjamin Franklin, the group set to work raising funds and planning a women's display for the fair's Main Exhibition Building. When this space was withdrawn to make room for international exhibitors, the women's committee, angered but undeterred, raised even more money and built its own separate pavilion. It was cruciform in shape, with the legend LET HER OWN WORKS PRAISE HER IN THE GATES spelled out in gilt lettering, in a different language on each doorway—Spanish, German, French, and English.

Visitors who entered the building found a separate feminine sphere, as they might have expected, but one that showcased women's achievement.[51] The message bears comparison to Booker T. Washington's on behalf of African Americans: The exposition showcased female excellence, but in service to the conservative argument that a woman's place was in the home. This idea was borne out through extensive displays of domestic handicraft: "Fine needlework, laces light as gossamer and as delicate in design as any ever spun by Arachne herself, paper and wax-flowers, and wax fruits that are works of art, with a bewildering array of other productions of woman's skill and genius." Amateur work was sent in from cities across the nation—tiles from Boston, wood carving from Cincinnati—and from abroad. There was an

Women's Building at the Philadelphia Centennial, 1876. Universal Images Group/Getty Images.

impressive display from the Royal School of Art Needlework in London, even a linen damask made of thread spun by Queen Victoria herself. Alongside the crafts was a selection of paintings and sculptures, and seventy-four scale patent models of inventions. These examples of expertise did offer a subtle challenge to gendered stereotypes, though the fine art works were on suitably decorous themes and the inventions nearly all concerned domestic improvements: a blanket washer, window fasteners, a frame for dyeing lace curtains.[52] The genteel tone of the proceedings was captured in a newspaper printed up for the occasion, entitled the *New Century for Women*, which described the pavilion as filled with "the rich fruits of earnest thought and toil—of busy brain, and gentle heart, and fair, skillful hand."[53]

The fact that there were women all over America whose brains, hearts, and hands were captive within a system of exploitative sweatshop labor went unmentioned, perhaps unsurprisingly, in the Women's Building—not unmentioned at the Centennial, though. At one of the event's most prominent celebrations, held on the Fourth of July, Susan B. Anthony strode to the stage and handed the presiding officer a copy of the Declaration of Rights of the Women of the United States. Other activists distributed the same document through the hall. Anthony then exited the stage, mounted a nearby speaking platform, and proclaimed "articles of impeachment against our rulers," which enumerated the many aspects of women's oppression in a sexist society, including the fact that in the workplace, "the fact of sex, not the quality or quantity of work, in most cases, determines the pay and position." Anthony and her allies also boycotted the Women's Building, arguing that it "was no true exhibit of woman's art" because it did not represent the products of industrial labor or protest against "political slavery."[54]

The question that divided women at the Centennial—what was an appropriate form of female aspiration?—found test cases in two special exhibitors at the Women's Building, both of whom attracted considerable attention from the press. The first was the engineer Emma Allison; the second, an artist named Caroline Shawk Brooks. Allison's role was to operate and explicate a small Baxter steam engine, which was used to drive a printing press—it turned out copies of the *New Century for Women*—and other machines on display. The *New Century* reported predictions that the pavilion would be "blown to atoms, and it would be discovered that the female engineer had lost herself in some interesting novel when she ought to have been watching the steam-gauge."[55] Male journalists offered patronizing compliments to "the perfect neatness of the mechanism and its fair attendant," who tended her "iron pet" in her Sunday best. Yet they also had praise for Allison's mechanical know-how and

occasionally hailed her turn at the fair as a major step forward: "The ease with which she accomplishes the management of her busy machine, the care of which has hitherto been deemed to lie essentially within man's province, marks a decided epoch in female labor."[56]

Brooks, the other exhibitor in the Women's Building who excited the public, was a thirty-six-year-old from an Arkansas farm. She was a talented sculptor, but that was not what garnered attention—there were plenty of works by women artists at the Centennial. (Particularly noteworthy was *The Death of Cleopatra*, by Edmonia Lewis, a sculptor of African American and Ojibwa heritage.)[57] Nor was her work's romantic subject matter, *Dreaming Iolanthe*, especially arresting. What did interest people about Brooks's bas-relief was its medium: carved butter—nine pounds of it, to be exact, displayed in a tin milk pan. The artist stood by her creation in the Women's Building, attending to the ice that prevented it from melting, giving autographs, and answering questions. Word got around, and in October she was invited to sculpt another *Iolanthe*, in Judges Hall, with a large audience in attendance. The butter had been freshly churned that morning in the fair's dairy. After this triumph, her work was moved to Memorial Hall and placed alongside that of eminent artists such as Winslow Homer. And when the fair closed, Brooks launched a road show, making likenesses of Washington, Lincoln, and characters from Dickens, all set to accompanying music and poetry recitals. (She also worked in marble, less successfully.) Writers, of course, loved all this. One attributed to her sculptures "a richness beyond alabaster." Another reflected "how much better off New York would be, artistically, if three-fourths of its public sculptures had been made of the same perishable material."[58]

Jokes aside, Caroline Shawk Brooks was the perfect counterpart to Emma Allison. Both were clearly skilled—Allison with her mechanic's tool kit; Brooks with her knife and wooden paddle. Both stepped outside the normal strictures of female achievement, and both were simultaneously celebrated and belittled for doing so. Both stood right at the edge of acceptability, the subtle demarcation line between craft (a woman's realm) and something more serious—art, or industry. Their parallel stories map the contours for women's craft at the time. To some extent, they were met with condescension. Yet it was also through craft that they, and the many other women who showed in the pavilion, were able to be seen. This contradictory pattern would hold for many years to come.

～

Caroline S. Brooks and her sculpture in butter during a public exhibition at Armory Hall, 1877. The New York Public Library, The Miriam and Ira D. Wallach Division of Art, Prints and Photographs: Photography Collection.

There was one invention that loomed over all the other novelties at the Centennial: America itself. Henry Pettit, an architect and engineer who had helped design the Main Exhibition Building and laid out the installation plan for much of the fair, made an important observation: "Although rare industrial art and opportunities for instruction were present in the exhibits on all sides," he said, "the *most* interesting thing to the people was the people themselves."[59] In all their throngs, visitors to the fair were able to tell themselves that they'd seen the whole nation, as if in a looking glass. Of course, that image was quite distorted: It took northern industry as its shining center, without recognizing the associated human costs of the factory system. Organized labor was sidelined. So were women. And the event was over-whelmingly white. Though Black southern schools did have a display in the educa-tion section of the Main Exhibition Building, African Americans were hardly in evidence otherwise, except in alarming caricatures (as in the quartet of cigar rollers

hired by a tobacco company, who demonstrated the process while singing spiri-
tuals). Black workers had also been pointedly excluded from the more skilled jobs
in the construction phase of the fair, prompting one Philadelphia journalist to
lament that they would have no role "save that of a menial, the water-drawers and
hat-takers, to the assembled races now to be found there."[60]

When it comes to blind spots, though, perhaps the most glaring was this: In
celebrating the nation's one-hundredth birthday, the Centennial all but ignored the
Native history that had come before. The celebratory picture of America painted
across the broad landscape of the fair had only one supporting role for indigenous
people, and that was as a foil to the technological progress everywhere else on
display. In 1876, the West was still an active theater of warfare between whites and
Native Americans. The famous Battle of the Little Bighorn occurred in June of that
year, followed by a reprisal massacre of the Lakota Sioux and Cheyenne, at the Battle
at the Red Fork, in November. The "Indian" displays at the Centennial alluded to
this ongoing violence only obliquely, through the inclusion of a plentiful amount of
weaponry and some papier-mâché figures of fierce-looking warriors. Visitors thrilled
to the sight of Sioux leader Red Cloud, with raised tomahawk and scalps at his belt;
and of the Cheyenne warrior Tall Bull, displayed in the very attire in which he had
been killed at the 1869 Battle of Summit Springs.[61] Spencer F. Baird, assistant secre-
tary of the Smithsonian Institution, was charged with the task of mounting a large
presentation of Native artifacts. These were mixed together without regard for
the diversity of different peoples, regions, and traditions. Carved totem poles
from the Pacific Northwest, painted tipis from the Plains, various pottery and stone
tools, beadwork and basketry—all were placed into a single exhibition hall, a "vast
collection of Indian curiosities, idols and weapons of war and the chase, curiously
carved and colored."[62]

The display positioned Native people firmly on the bottom rung of the great
ladder of civilization, pointedly excluding any representation of assimilated commu-
nities in favor of those that retained their "original style and form." There was just
one exception: a small display devoted to educational efforts produced under the
auspices of the reservation schools. These included specimens of handwriting, and
craftwork such as quilts, aprons, and pleated garments of European style. "You may
hold in your hand a bit of patch-work sewn by an Apache girl," wrote one reviewer,
and reflect that "a year ago, the women of her tribe, sunk in savage squalor and apathy,
knew no finer art than the fashioning of skins with strings of sinew, and bone

needles pushed in and out after the manner of an awl."[63] The extraordinary skill required to prepare a buckskin, gut thread, and bone needles—much less to fashion exquisite leather garments of the kind elsewhere on display at the Centennial—went unmentioned.

The Centennial's treatment of Native craft was a double bind. Objects considered authentic were treated as signs of savagery, while evidence of successful assimilation was met with self-congratulation and condescension. This contradictory dynamic was certainly nothing new. Back in 1832, the Cherokee spokesman John Ridge had said, "You asked us to throw off the hunter and warrior state. We did so. You asked us to form a republican government. We did so—adopted your own as a model. You asked us to cultivate the earth, and learn the mechanic arts, we did so."[64] Cherokee lands were taken away nonetheless, and the people driven west. Their situation, and that of other Natives confined to the reservations, soon became desperate. Poverty and hunger were rampant. The reservations were intentionally set on poor land, difficult or impossible to farm, and little thought was given by the authorities to any other means of livelihood. The great western buffalo herds, which had been the mainstay diet and artistic material for Plains cultures such as the Cheyenne, Crow, and Lakota, were exterminated. The animals' hides were used to make belts for industrial machinery, their skulls and bones crushed to make fertilizer—though the great majority was simply gratuitously killed and left to rot in the sun. Those Natives who did survive military assault and forced removals were reduced to the status of state dependents, kept alive on meager government handouts.

Finally, an organized opposition began to form. In 1881, the writer Helen Hunt Jackson published a book whose title offered a riposte to the Philadelphia exposition's triumphant narrative: *A Century of Dishonor*. It catalogued innumerable instances in which treaties with Native nations had been agreed to, and in some cases even upheld by the U.S. Supreme Court, and then blithely ignored. Jackson showed beyond any doubt that the steady march into Native lands had been accompanied by deception at every turn. She also included an appendix of supporting documents; of particular interest is one by a Northern Paiute woman called Sarah Winnemucca. She was born Thocmetony ("Shell Flower"), in an area that would later become Nevada, to a family that was relatively well disposed to arriving settlers. Fluent in English from a young age, she was educated at a Catholic school in California. When a war broke out between the Paiute and the whites, she served as an interpreter and scout on behalf of the U.S. Army. This was controversial

among some Natives, who considered her actions traitorous, but following the war, Winnemucca became a prominent voice for reform. In the letter reprinted in *A Century of Dishonor* (originally written to an army officer in 1870), she argued in terms calculated to sound reasonable to a white audience. If not encroached upon and given the advantages of learning, she wrote, "I warrant that the savage (as he is called today) will be a thrifty and law-abiding member of the community fifteen or twenty years hence."[65]

Winnemucca went on to write her own manifesto for Native rights, *Life Among the Paiutes: Their Wrongs and Claims*, published in 1883 with the support of philanthropists in Boston.[66] She also lectured widely, wearing traditional costume, including elaborate beadwork, as a way to claim attention. The press dubbed her the "Paiute Princess," a title that had no basis in fact, but seemed to capture her splendidly handcrafted appearance: "Richly and fantastically attired, her dress of buckskin, short-sleeved and of moderate length, [is] trimmed with an abundance of sparkling beads and wampum."[67] It was a canny performance, calculated to thread the needle of white curiosity and disregard. Winnemucca played to tradition while also manipulating the media to get her message across; not for nothing have historians referred to her as a "newspaper warrior."[68] In 1885, again with philanthropic support, she founded the Peabody Indian School (also called Peabody's Institute), devoted to teaching language— not just English, but Native tongues as well. Manual crafts associated with ranching and housekeeping were also a part of the instruction. The school "shall not be, as is usual, a farce," she wrote; nor would it separate children from their parents. She accepted whole families, and students of all ages.[69]

Winnemucca's school was never large, and lasted only a few years—it was shut down under the federal Dawes Act of 1887, which mandated that Native children could be taught only in white-run, English-language schools. This was a victory for supporters of Captain Richard Henry Pratt, a Civil War veteran who set the template for Indian education in these years. Pratt was born in 1840 and moved with his family to Indiana at the age of six. Soon after, his father headed farther west to join the gold rush, where he struck it rich—only to be ambushed, robbed, and murdered by a rival prospector. To support his family, young Richard went to work in a printshop, then became an apprentice tinsmith; he might have remained a tradesman had the war not come and set him on a path of military service. After the conflict, Pratt joined a cavalry unit made up of other white officers and Black soldiers (some recently emancipated). For about a decade, he fought both against and alongside

Native American bands, in the shifting tides of alliance that marked this period of conflict. It was he who escorted a group of Native prisoners to an old Spanish fort in Florida, spent three years imposing discipline and "civilization" on these young men, and finally made contact with Samuel Chapman Armstrong, who agreed to take the prisoners on as students at Hampton Institute—where they were taught by a young Booker T. Washington. Inspired by Armstrong's work, Pratt decided to follow in his footsteps. He would create a school that did for Native Americans what Hampton had done for Black students—that is, make upstanding citizens of them though craft-based education. He located an abandoned army barracks in Pennsylvania and, in 1879, opened the Carlisle Indian Industrial School. Its first intake included about two hundred students from twelve different indigenous nations.

The legacy of this institution is a complex and painful one. The students at Carlisle had been forcibly taken from their homes and families. Some parents were coerced into yielding their sons and daughters by having rations withheld. Other children were simply kidnapped by soldiers or police. When they arrived, their hair was shorn into European-style cuts and their bodies put into stiff uniforms and hard leather boots. No language but English was permitted. As at Hampton and Tuskegee, students were taught artisan trades: ironwork and tinsmithing, wagon making, carpentry, tailoring, and farming for boys; sewing and cookery for girls. The school also had its own printing press and newspaper, called the *Red Man and Helper*. In the summertime, instead of being returned to their families, students were sent to work on "outings" to nearby white farms. "I am a Baptist," Pratt wrote. "I believe in immersing the Indians in our civilization and when we get them under, holding them there until they are thoroughly soaked."[70]

Students at Carlisle experienced extreme disorientation, and sometimes worse—smallpox and other diseases ravaged them. All this was exactly what Sarah Winnemucca had tried to avoid in setting up her multilingual and culturally inclusive school; yet it was Pratt who was widely imitated. From 1880 to 1900, Indian industrial schools on the Carlisle model opened nationwide at the rate of about one per year. Some later became notorious for abuse. Suicide among the students was not unknown. But Pratt's vision was, quite literally, on the march. At the World's Columbian Exposition held in Chicago in 1893—the successor to the Philadelphia Centennial, this time marking the four-hundredth anniversary of Columbus's mythologized "discovery" of America—he led a parade of Carlisle students, each holding emblems of their craft trades.

The tin shop at the Carlisle Indian School, 1880s. Left to right: Charles Oheltoint, Richard Henry Pratt, Henry Roman Nose, Paul Black Bear, J. H. Curtain (instructor), Ernest, and Koba. Cumberland County Historical Society.

Pratt's methods—summarized in his infamous phrase "Kill the Indian in him, save the man"—were exactly in line with national trends in white philanthropy. Annually from 1883, a group of well-to-do patrons gathered at Lake Mohonk in the Hudson River Valley, discussing among themselves what should be done about the "Indian problem," as defined by the conference's president Merrill Gates: "How shall we educate these men-children into that great conception of the reign of law, moral, civil, and political, to which they are now strangers?" While much more enlightened than actual government policy, these self-appointed "advocates" were still extremely hostile to Native cultures. They wanted to see the reservation system dismantled, but would never even have considered the return of ancestral lands and traditions. Rather, they pushed for complete assimilation, with manual training as a principal mechanism. Citing Armstrong's precept that "the way to the head and the heart is through the trained right hand," Gates argued that the way to deal with Natives was to turn them into American-style capitalists. "Discontent with the tepee, and the starving rations of the Indian camp in winter, are needed to get the Indian

out of the blanket and into trousers—and trousers with a pocket in them, and with a pocket that aches to be filled with dollars!"[71]

This sort of rhetoric—which, we should remember, was comparatively progressive for its day—marks the difference between whites' attitudes toward Native Americans and their attitudes toward African Americans. It is a difference to some extent disguised by the strong connections between Carlisle and Hampton. For centuries, Black workers had been a servile class. They were forced to take on jobs that whites did not want to do, either as slaves or, if free, for lower wages than whites were willing to accept. These roles were played by Natives, too—in the whaling industry, for example. Primarily though, indigenous people had not been seen as useful tools, but impediments to ever-expanding settlement. The tendency, therefore, was to try to keep Blacks "in their place," while attempting a complete erasure of Native culture through a combination of extermination and absorption.[72] This distinction, segregation versus assimilation, had important implications for craft. Skilled Black artisans were tolerated, so long as they did not threaten white jobs—which is why Booker T. Washington's emphasis on deference was so welcome, and why individual makers like Thomas Day, Elizabeth Keckley, and Dave the Potter have been celebrated for their aesthetic achievements only recently. The craftwork of Native Americans, by contrast, was seen as firmly located in the past, the relic of a dying race—where it obviously presented no threat.

These are sweeping generalizations. But they do help to explain trend lines that would take shape over the ensuing decades, including the way Black workers were treated by the strengthening labor unions of the late nineteenth century; and the reception for Native baskets, pottery, weaving, and silversmithing within the Arts and Crafts movement. Luther Standing Bear, a Lakota Sioux boy born in 1868, was the first member of his nation to enter the Carlisle Indian School. Many years later, he wrote an autobiography in which he vividly recounted his time there. When he was taken from his parents and brought east, he assumed he would be killed. He had seen the crackdown on the Lakota following the Battle of the Little Bighorn, and could not imagine what else a group of white people might want to do with him. Instead, when he arrived at Carlisle, he was forced into a uniform and boots, which he found agonizing. "We longed to go barefoot, but were told that the dew on the grass would give us colds," he wrote. "That was a new warning for us . . . I remember as a child coming into the tipi with moccasins full of snow." Though he

had been known as Ota K'te ("Plenty Kill") as a boy, having helped to bring down a buffalo at a young age, he was asked to pick a new name off a blackboard: Luther.

Standing Bear was on the receiving end of Pratt's full battery of assimilation. He trained in the workshops, went on his outing, marched on parade, was photographed in his uniform, even got an internship at the department store Wanamaker's in Philadelphia. But later, when he wrote his autobiography, he said, "While I had learned all that I could of the white man's culture, I never forgot that of my people. I kept the language, tribal manners and usages, sang the songs and danced the dances . . . no coat that I have ever worn can take the place of the blanket robe." After leaving Carlisle, he went on to become an actor and extra in silent films—his first, in a strange coincidence, was based on a novel written by Helen Hunt Jackson, author of *A Century of Dishonor*—and also a prominent Native rights advocate. He recognized that his life had been shaped by Carlisle. But he learned a very different, and deeper, lesson than Pratt could possibly have imagined: "We went to school to copy, to imitate; not to exchange languages and ideas, and not to develop the best traits that had come out of the uncountable experiences of hundreds and thousands of years living upon this continent . . . while the white people had much to teach us, we had much to teach them, and what a school could have been established on that idea!"[73]

Chapter 4

A More Perfect Union

Isaac newton youngs was a perfectionist's perfectionist. Born in 1793, the youngest of ten children, he was trained in clockmaking by his uncle. He could put one together by the age of six, and "knew the time of day," he said, "before I could talk plain." His uncle and his parents were recent converts to the Shaker religious sect. As a boy, Youngs grew up in surroundings that were neat as a pin. Plain yet precise in all they did, the separatist Shakers edged their village streets with level paving stones—at a time when sidewalks were rare even in cities—and used the community sawmill to cut their firewood to standard lengths. Their clothing, gardens, furniture, buildings—everything was bare of ornament but beautifully proportioned. As the historian of American utopian communities Chris Jennings has written, "As they built, Shaker carpenters and masons believed that they were working with heavenly blueprints."[1]

Even in this elevated environment, Youngs's craftsmanship stood out. The Shakers were radical egalitarians, but they specialized in their work, making their settlements far more efficient than was typical for America at the time—a divinely inspired version of divided labor. Youngs, however, managed to be a jack-of-all-trades. After learning clockmaking, he apprenticed as a tailor, and also turned his hand to masonry, tinsmithing, and toolmaking. He made things small and large, from clothespins and buttons, which he turned out by the thousand, to a whole schoolhouse. Also, like the famous scientist for whom he was named, he had a passion for invention. He

Isaac Newton Youngs, box for labels, 1833. Shaker Museum | Mount Lebanon, New Lebanon, NY.

fashioned a five-nibbed pen in brass to draw staves for sheet music, and a threading machine to carve the handy wooden screw pegs that lined Shaker rooms.

Youngs also wrote, prodigiously. Four thousand manuscript pages in his hand survive. His diary is a remarkably candid document; it records his struggles with feelings of lust—Shakers were meant to be celibate—and his frank judgments of brethren who did not quite measure up to the community standard. Measuring, indeed, was an abiding passion for him. He precisely noted his own height (five foot eight and a quarter inches in his shoes), traced his hands on the covers of one of his journals (left hand on the front, right hand on the back) and tracked the heights of fellow Shakers as they aged, to see how much they were shrinking. He printed numerals on tinted paper, snipped them into little squares, and then pasted them on to furniture, brooms, and other items—"which helps much to keep things in their place"—and made an immaculately dovetailed pine box to store the labels.

Youngs was aware of his own obsessive tendencies, but also took a modest pride in his own mechanical ingenuity. His humorous autobiography, written in doggerel verse, includes the lines "Blacksmithing, Tinkering, mason work. When could I find

a time to shirk? An endless list of chores and notions, to keep me in perpetual motion."[2] As this last turn of phrase suggests, it was Youngs's first vocation, clock-making, that probably suited him best. He even kept track of the time it took to keep time, carefully tabulating the hours expended in making six wall clocks, complete with cases (382 total, a little less than 64 hours apiece). This was an apt fixation for a man raised in a millennial faith. The Shakers—officially, the United Society of Believers in Christ's Second Appearing—believed in a cosmic consummation. They held that the first Messiah, the son of a carpenter, found his successor in "Mother" Ann Lee, the daughter of a blacksmith. She preached that her own appearance was a harbinger of the end, and after her death in 1784, the sect readied itself for the apocalypse. When this did not transpire, they simply carried on, within constant sight of ultimate redemption, living by Mother Ann's famous injunction, "Put your hands to work, and hearts to God."

By the time Youngs himself died in 1865, the Shakers had seen their best days. Over the decades, as the world kept failing to end, their proscription against sex became a strategic weakness. Every new member had to be a convert. In the industrialized economy of the post–Civil War era, their home industries faltered; communities found it increasingly difficult to attract adherents. From their peak in the 1840s, when they had about six thousand members nationwide, they saw a swift decline. Communities fell into debt. Believers died, never to be replaced. Others abandoned the villages. Arrivals seemed more opportunistic than devout: "tramps, the off-scrowering of creation," in the stern judgment of one elder.[3] By the turn of the century, there would be fewer than nine hundred Shakers left.

The utopian impulse in America, however, continued. So did its close involvement with craft. Workmanship, virtue, and control—these intertwined values, which had been so completely embodied by the Shakers, were shared by many other activists in the late nineteenth century, among them Arts and Crafts advocates, industrial "scientists," labor unions, and educational reformers. Though extremely diverse, sometimes even bitterly opposed, in their ideas and methods, these groups had much in common. In the spirit of the Progressive Era, they shared the conviction that life and work could be greatly improved, even perfected, through the implementation of standards. They developed theories, then tried to put them into practice. The story of American craft in the late nineteenth century is largely the story of these true believers, their conflicts with one another, and their headlong collisions with reality.

As new tracks for craft reform were laid, older utopian communities continued on in their quiet way. In addition to the Shakers, there had been many other separatist groups active in America prior to the Civil War. The followers of George Rapp, a German weaver and mystic, had settled in Harmonie, Indiana, in 1814; a decade later, the visionary philanthropist Robert Owen bought the town from the Rappites, rechristened it New Harmony, and attempted to construct an ideal society there. There were also the Fourierist phalanxes, inspired by the voluminous visionary writings of an eccentric Parisian Communist; the Amish and Mennonite communities of Pennsylvania; and the Perfectionists (in this case, the term refers to the eradication of sin), led by John Humphrey Noyes.

Generally speaking, the more these groups brought artisans into their ranks, the more successful they were. Owen had amassed his wealth as a textile manufacturer in the North of England; but in Indiana, he struggled to keep his community going because it attracted mainly intellectuals and unskilled laborers. The Shakers, by contrast, achieved prosperity by making unadorned yet beautiful furniture and other goods and selling them to "the World," as they described outside society. The Perfectionists were infamous for their doctrine of "complex marriage," by which all men and women in the community engaged freely in sexual relations. But in practice, their closely knit, gender-equal community was an economic dynamo. They developed a highly successful artisan business at their collective household in Oneida, New York. After first focusing on custom-designed animal traps, they eventually went into manufacturing silver flatware, a business that still exists today.

Quite apart from its commercial importance to separatist communities, craft also served their immediate needs, both utilitarian and symbolic. A famous example is the scrap quilting undertaken by the Amish, particularly Amish women, in the decades after the Civil War. Contrary to popular belief, this was a new craft for them, not an inheritance from Colonial days, though they did adopt it partly because it matched their traditional self-image. Ironically, too, quilts might never have caught on in the famously technology-resistant community if it were not for the availability of cheap industrially made fabrics. Even so, quilting was a way to bind the community together. As in many other American communities, the collaborative stitching of a quilt top to its fulling and backing (an event often called a "quilting frolic") was a highlight of the social calendar. Quilts also built connections between friends and family, through gift giving and the passing of bedspreads from one generation to another.[4]

At the end of the nineteenth century, one of the most thriving American religious settlements was the "Community of True Inspiration," at Amana, Iowa. Founded in 1842 by a group of dissenters who had fled Germany, the group was initially led by a carpenter, Christian Metz. In community terminology, he was considered a *Werkzeug*, "a tool in the hands of God." After Metz died in 1867, he was succeeded by the seventy-two-year-old Barbara Landmann, another German immigrant, who led the Amana settlements with stern discipline for fifteen years. Even as the Shaker villages were disintegrating, the Inspirationists thrived, in large part thanks to their printed wool textiles, leather goods, and other products. Communist in their internal dealings, they were praised by outsiders as "fair-dealing and cash-paying," and highly adept at their trades. "Nowhere," reported a newspaper all the way out in San Francisco, "can be found a class of operators more skillful and intelligent than those at Amana."[5]

In some ways, the community was like a factory run on self-imposed discipline. Each day's work regimen was marked out by the village bell. Every man wore an identical broad-brim hat and butternut jeans; every woman, the same sunbonnet and checked apron. For outsiders, Amana was a puzzle and a challenge. The people there seemed totally lacking in individualism. "Frivolity seems to have been crucified, and ambition walled up in the tombs," a Chicago journalist wrote. "There is here no spur to ambition, no incentive to industry, no incitement to exertion." Yet, somehow, the community enjoyed peace and prosperity. Economically, the Inspirationists should have been the envy of any American town; ideologically, they were every-thing the rest of America was not.[6]

In 1890, a twenty-year-old daughter of Czech immigrants made her first trip to the Amana settlement. She lugged with her a large-format box camera, given to her as a birthday present, and a supply of five-by-eight-inch glass plates. It was to be the first of many visits. Over the next decade, Bertha Horack Shambaugh returned again and again to take pictures of the Inspirationists, finally publishing an account of their community in a 1908 book. She beautifully captured their lifelong devotion to craft—children learning how to knit, an octogenarian watchmaker "still at his post as regularly as the sun rose." And she was quietly awestruck by the daily routines of Amana life: the cushioned chair in the mill, for workers to rest "between times"; the fresh-cut flowers decorating the loom frames; the psalms hummed by the elders as they worked; the steady creak of the two-wheeled oxcart, which contrasted with the distant sound of a train's whistle; the equal treatment of all, regardless of

Bertha Shambaugh, *Boys Learning to Knit at Amana*, c. 1898. Courtesy of Amana Heritage Society.

experience or skill. "It is not the Inspirationist's way to take his allotted labor as an affliction," Shambaugh wrote. "He works less rapidly than his brother in the world; but he lives longer." The women, working their spinning wheels, reminded her of "pilgrim foremothers." The people of Amana, she concluded, had figured out something essential about life—something that other Americans had long forgotten.

~

In her book about the Inspirationists, Shambaugh made one other, more contemporary comparison: "The product of the Amana mills comes as near what William Morris called 'the expression of a man's joy in his work' as can be found anywhere."[7] She was referring, of course, to the great figure of the English Arts and Crafts movement. And she was right to invoke his name. With its communism, unswerving work ethic, and behind-the-times approach to existence, Amana was like a scene from Morris's utopian novel *News from Nowhere* brought to life. But when Americans read that book, and his other writings (as many did), they certainly did not imagine

a religious sect operating a textile mill. They did not even embrace Morris's commitment to socialism, the radical aspect of his challenge to the status quo. Rather, they drew lessons that were altogether less provocative.

It was easiest to agree with Morris's diagnosis of the problem. Modern labor had become intolerable. Lives and souls were ground to dust in the gears of the factory system. Even white-collar workers, though relatively fortunate, faced an existence of meaningless paper pushing. And the goods disgorged by this dehumanizing economy were cheap, in every sense: affordable, yes, but intrinsically worthless, because they lacked the spark of human creativity. Drawing on earlier writers such as Thomas Carlyle and John Ruskin, Morris put his finger on a central contradiction in modern life, one that was especially pronounced in the United States. A culture supposedly devoted to individualism had in fact produced the exact opposite. Propagandists might peddle the dogma of self-help, but real, live working people were imprisoned in a vast mechanical structure whose operations lay far outside their control. Everyday things, once enlivened by the artisan's touch, had been degraded into a state of deadened sameness. Morris's answer was a "revival of handicraft." This meant rolling back the false progress of the preceding century. Divided labor must be reintegrated. Machines, though doubtless useful for rote tasks, should be abandoned wherever they interfered with the creative process. Beauty— the organic, unselfconscious beauty of old things, and old ways of making—must be retrieved, not for its own sake, but as an inevitable accompaniment to building a better world.

These powerful ideas spread like living vines, not only through England and America, but also across Europe, and eventually to Japan and India.[8] Yet it was difficult to take Morris whole. Many on the political left agreed with him that modern industry was alienating and dehumanizing. A smaller, though still significant group responded to his call for a craft movement dedicated to restoring "joy in labor." Comparatively few, however, were willing to embrace socialism as a means of achieving this goal. Morris had explicitly warned against "elegant little schemes for trying to withdraw ourselves" from the commercial economy, "none of which can have more than a temporary and very limited success."[9] Yet this is what most Arts and Crafts initiatives were: elegant little schemes. To be fair, one could level the same accusation at Morris himself. He devoted his seemingly inexhaustible energies to the socialist cause, speaking widely before working-class audiences. But was he really calling for a revolution? If so, why did he spend so much time on extravagant

craft projects such as tapestry weaving and letterpress printing? Morris's elite, anti-quarian craftworks were (and remain) hard to square with his democratic impulses.

The same is true of the Arts and Crafts movement as a whole. Particularly in America, it was a top-down affair, led by professors rather than provocateurs; social-ites rather than socialists. Among these leaders were Irene Sargent and Oscar Lovell Triggs, who taught art history at universities in Syracuse and Chicago, respectively; and wealthy women like Maria Longworth Nichols, founder of the Rookwood Pottery Company in Cincinnati. All were inspired by Morris's ideas, but none was a social radical. On the contrary, Sargent worried that repetitive labor resulted in an empty head where the mind should be, "a resting place for destructive and chaotic ideas." At worst, the worker might become an "insurrectionist, perhaps even a pervert and a criminal."[10] Triggs, who helped found the William Morris Society in Chicago, took the great man's ideas to mean that "the time has come to estimate the genius of an individual or of a people by capacity to control materials." But for him this meant advanced technology, inventions (e.g., electricity) that could be bent to human will. He was dubious about the prospects for working-class activism, and saw labor unions as inherently illogical: "An industrial structure can never be laid upon a political or legal foundation, industrial democracy being a co-partnership of men and not a government of laws."[11] Sargent and Triggs did believe strongly in the morally uplifting potential of craft, but they saw it in apolitical terms.

These principles were put into practice in workshops such as Rookwood, founded by Nichols in 1880. Initially she had fairly modest goals: "While my prin-cipal object is my own gratification, I hope to make the Pottery pay expenses." She did far more than that, establishing Rookwood as a nationwide model for what came to be called "Art Pottery." Nichols had first gotten involved with ceramics as a china painter, an amateur craft that (along with wood carving) had become extremely popular among Cincinnati's elite women. This typically involved deco-rating an existing "blank," biscuit-fired at a commercial pottery, rather as an amateur painter might work on a prepared canvas. Given this prior experience, it was perhaps natural for her to think of Rookwood as a decorating enterprise rather than a manu-factory. Even as the company's fame grew, largely on the strength of its Standard Ware line—its deep-brown palette and chiaroscuro effects were somewhat reminis-cent of Old Master paintings—Rookwood's marketing emphasized the unique brush-work of every piece. Its painters were "given the utmost freedom in the choice and character of their designs. The results obtained are entirely distinct from mechanically

decorated ware."[12] The company also featured particular artists, notably the Japanese-trained master Kataro Shirayamadani, as a way of emphasizing individuality and originality. Exceptional pieces were entered into international expositions, further raising Rookwood's profile. All the while, the company continued to turn out a more commercial range, like a fashion brand making both couture and ready-to-wear.

Art Pottery found its most ambitious exponent in Adelaide Alsop Robineau, born in 1865, the daughter of an engineer. She, too, started out as a china painter, teaching herself from manuals. In 1899, together with her husband, a Frenchman who collected Chinese porcelains, she founded a new journal entitled *Keramic Studio*, aimed primarily at other amateur decorators. Soon after, she began throwing her own shapes on the wheel, and also made a huge technical leap from china painting to high-temperature stoneware and porcelain—"about as rational and as possible a vocational change," as her friend and colleague Frederick Hurten Rhead said, as a shift "from dentistry to cello playing."[13] She experimented with crystalline and flambé glazes, and other spectacular effects. After studying in a new ceramics course at Alfred University, in upstate New York, she relocated to nearby Syracuse. It was here that she made the *Scarab Vase*, also known as *The Apotheosis of the Toiler*, completed in 1910, one of the most extraordinary feats of craftsmanship ever realized in America. Robineau spent more than a thousand hours making the carved porcelain vase, only for it to crack in its initial firing. She persisted, filling the tiny fissures with a paste of ground porcelain and firing it again, this time successfully. She also selectively glazed the piece, to highlight its delicate openwork structure. Robineau had essayed various revival styles previously, and here employed a rather unusual Egyptian idiom, occasionally seen in architecture at the time but virtually unknown in ceramics. The vase's name derives from its prominent use of scarab beetle iconography, which accounts for the strange crowning motif. These insects gradually roll manure into a perfect sphere, which then becomes a food source. Robineau affixed a carved orb to the vase's lid, representing a ball of dung. As her allegorical subtitle for the piece suggests, she intended this as an emblem of patient labor.

In its crisp linear detailing, the *Scarab Vase* is quite different from the painterly pots made at Rookwood. But it makes an even greater claim to art status simply by virtue of the time and skill invested in it. As Robineau's teacher from Alfred University, Charles Fergus Binns, wrote, "only those who have faced the difficulties of the *grand feu*"—high-temperature kiln firing—"can have any conception of the patience and enthusiasm and the indomitable perseverance amid repeated and

discouraging failures which lie beneath such work as this. Even with skilled workmen at command a manufacturer may well hesitate before attempting elaborate works, and yet Mrs. Robineau has successfully overcome the difficulties." Given this complete mastery, Binns had no hesitation in asserting that her work "should find a resting place in every museum of art."[14]

Clearly, the *Scarab Vase* is a long way from simple "joy in labor." Rather, Robineau's expenditures of time and skill are transformed in it, as if by an alchemist, into something approaching perfection. Her use of the religious term *apotheosis* in the vase's alternate title is apt; the vase floats up, up, and away from the realm of coarse commerce. As she would later write in *Keramic Studio*, "we have shown a steady movement [to] a much higher plane."[15] In this sense, Robineau exemplified something intrinsic about the Arts and Crafts movement: a characteristic desire to ascend to a pure, enlightened aestheticism, escaping the brutal reality of economics. That reality is simply put: The finer the craftsmanship, the more expensive the object. Every maker has to face a hard bargain between democracy and quality, a dilemma that Robineau regarded with lofty indifference.

Arts and Crafts advocates tried to slip this logical noose however they could, but in the end, they always felt it tighten around them. Exemplary in this regard are the careers of Candace Wheeler and Gustav Stickley, two of the movement's best-known protagonists. Wheeler was born on a New York farm in 1827 and brought up in an atmosphere of rural self-sufficiency. Her grandmother was a seamstress, her parents made hats, and the whole family earned extra money by making cheese, butter, candles, and various preserved foods. Her father, a staunch abolitionist, set them all to spinning and weaving linen for their own use, so they would not have to wear slave-made cloth. It was, she said, like being raised "a hundred years behind the time."[16] After studying at a local academy, Wheeler married advantageously and moved to New York City, where she fell into an artistic circle that included some of the leading landscape painters of the day. And in 1876, she was among the millions who attended the Centennial Exposition in Philadelphia.

There, Wheeler took in the display of the Royal School of Art Needlework in Memorial Hall, and was not too impressed: The embroidery there was "a very simple sort of effort," she thought, and "easily within the compass of almost every woman. It required far less ability than painting china." But she could also see craft's promise as a way to help people. For some years, she had been assisting friends—"gentlewomen in distress," many of them war widows—by quietly selling examples of their needlework.

(One of her recruits to this scheme was Elizabeth Custer, whose husband had just been killed at the Battle of the Little Bighorn.) Now she saw an opportunity to do the same out in the open, in the name of fine craftsmanship. There was a subtle but significant feminism at work in her thinking: "It was the unwritten law that women should not be wage-earners or salary beneficiaries," she said, "but necessity was stronger than the law." [17]

And so, supported by a group of luminaries that included Louis Comfort Tiffany and Lockwood de Forest, Wheeler founded the Society of Decorative Arts. The plan was simple: Take on needlework commissions for weddings, churches, and domestic upholstery, and sell work on consignment in the society's showroom. A loan exhibition was also organized in December 1877, to provide positive exemplars of workmanship. A committee on design—all male, as even Wheeler was excluded—was put in charge of judging submissions. Though embroidery was the main focus, the SDA also offered instruction in other arts and crafts practical for the home, such as china and tile painting, wood carving, and panel painting. Very quickly, Wheeler realized that there would be a conflict between charitable intention and artistic ambition. Her colleagues were interested primarily in elevating the level of public taste; she still wanted to help women in "untoward circumstances."

In the end, she did both. Together with Tiffany and de Forest, she started a decorating firm that furnished some of the grandest interiors in the country, including Mark Twain's home in Hartford, several rooms in the White House, and the Veterans Room at the Park Avenue Armory, still intact today and described on its opening as "undoubtedly the most magnificent apartment of the kind in this country." [18] On the other hand, Wheeler founded a new venue for the display and sale of craft, the New York Exchange for Woman's Work. Here all pretense of exclusivity was abandoned. The goods were largely utilitarian linens and garments, rather than ornamental embroideries. Only those with financial need were invited to contribute; and of 17,566 items submitted for its inaugural fair, only 37 were rejected. [19]

Wheeler clearly realized what many of her fellow craft reformers did not: that beauty and practicality did not always go together, and were often in conflict. Like so many others in this era, she did speak of "the duty of self-help." But she was most unusual in actually taking steps to make self-help possible. In 1883, Wheeler formed her own textile and upholstery firm, Associated Artists, in which only women were employed. A decade later, she designed the interiors of the Women's Building at the Columbian Exposition in Chicago—successor to the one at the Philadelphia

Candace Wheeler, Samuel Colman, Lockwood de Forest, and Louis Comfort Tiffany, Veterans Room of the Park Avenue Armory, 1881. Park Avenue Armory.

Centennial. Filled with domestic craft (carefully juried, in this instance), it also featured, running under the dome of the central Hall of Honor, a frieze inscribed with "the golden names of women who in past and present centuries have done honor to the human race."[20]

By the turn of the century, Wheeler's lively and encouraging writings on interior decoration helped to displace the grim commandments found in books like Catharine Beecher's *Treatise on Domestic Economy*. She continued to advocate for home industries, of the kind she herself had undertaken as a farm girl, while recognizing the challenges presented by an age of factories and sweatshops. There is a genuine tug of regret when she writes, in her 1900 book *How to Make Rugs*, that it had become a "positive economy to push the spinning-wheel out of sight under the garret eaves and chop up the bulky loom for firewood."[21] And yet this same book, as a reviewer in *House Beautiful* noted, could well have had the subtitle "How to Make Happiness and to Awaken Social Consciousness."[22] Wheeler continued to believe there was money to be made in craft, and that aesthetics should not be the concern only of a narrow elite, but of every household. Though she had a hand in some of the era's most lavishly appointed rooms, she nonetheless maintained that the simplest cottage could be more pleasing than the grandest palace: "Beauty, like education, can dignify any circumstances, from the narrowest to the most opulent."[23]

If Wheeler helped to usher in the Arts and Crafts movement, Gustav Stickley presided over its zenith and eventual decline. He was born three decades later than she, in 1858, in a small Wisconsin town, the eldest of six brothers. His parents were German immigrants—his name at birth was Gustavus Stoeckel—and he was trained from childhood in his father's trade of stonemasonry. From this modest background, Stickley rose to become America's preeminent Arts and Crafts furniture manufacturer and, for a brief time, the captain of a commercial empire, with his own publications, department store, and even a home-building service. His introduction to the trade came through an uncle who owned a chair factory in Pennsylvania. From there Stickley moved to upstate New York and launched into business independently, initially in partnership with two of his brothers. Their first product was a chair based on the Shaker model, fashioned with a simple lathe bought from a broom handle maker. The power to drive it, and the other simple machines they had, was transmitted from another workshop next door via a rope.

Stickley later idealized these humble beginnings: "The very primitiveness of the equipment, made necessary by lack of means, furnished what was really a golden opportunity to break away from the monotony of commercial forms."[24] This was a typical expression of his thinking. Like Wheeler, he prized simplicity, seeing it as a way to solve the uneasy equation of craft, in which quality and affordability tend to conflict. After a few years making revivalist and utilitarian furniture—one of his largest clients was a local prison—Stickley traveled to England, in 1895 and again in 1896. There he met with leading lights of the Arts and Crafts movement, and he returned to America full of ideas and energy, determined to arrive at an ideal solution to the problem of modern living.

It took him just five years. By 1901 he was making furniture possessed of deep gravitas: massively proportioned, totally unadorned, and usually constructed from white oak, a timber often used in medieval joinery, but in Stickley's day, more associated with house construction than fine furniture. Boards were quartersawn, a way of cutting a log that exposes a striking pattern of rays and flecks, a sort of naturally occurring ornament. He used exaggerated construction details such as through tenons (which poke all the way through their mortises and out the other side), sometimes with additional wedges anchoring them in place. Upholstery was of leather, with oversize brass tacks. He used long strap hinges and faceted handles of wrought iron. Rough hammer marks were left visible on the surfaces of these metal fittings. A historic smith like Paul Revere would have considered this bizarre, if not

incompetent, but Stickley intended it as proof of the artisan's touch. Every aspect of his furniture, in fact, was slightly contradictory: a calculated expression of authenticity.

Also in 1901, Stickley began publishing his celebrated journal, the *Craftsman*, arguably the most influential publication of the American Arts and Crafts movement. It was designed along the lines of William Morris's productions at the Kelmscott Press, and the first issue's main feature, written by Irene Sargent, was a study of Morris's life, work, and influence, including his socialist thought. At this early, idealistic moment in Stickley's career, he wrestled with the English theorist's politics. The sixth issue of the *Craftsman*, published in March 1902, carried an opinion piece by Algie M. Simons, editor of the *International Socialist Review*. "Any movement toward the revival of the beautiful, the pleasant, and the good—in short, of the artistic—which does not connect itself with the great revolutionary movement of the proletariat," Simons declared, "has cut itself off from any hope of realizing its own ideal."[25] And in 1904, Stickley published an editorial that initially seemed to espouse this political platform. He proclaimed the twentieth century "an Age of the People," and argued that the salvation of the country lay "with the workers, rather than with the possessors of hereditary culture, or of immense wealth and the power attendant upon it." Yet he immediately softened these revolutionary-sounding words; what he had seen in Morris was "a revelation in which the socialism of the reformer clothed itself in a mild, beneficent aspect." This would be "a socialism of art—art made homely and brought within the reach of all."[26] Something slippery is going on here, a sleight of hand in which the craft revival is nudged away from outright class conflict. Just a couple of years later, Stickley sounded an even more conciliatory note, writing that the *Craftsman* "is in no sense a socialist, nor even a sociological magazine."[27] Thus Stickley came to think principally in terms of aesthetics and personal morality, rather than politics. This arguably blinded him to the realities of the actual "simple life"—i.e., poverty—but it helped him reach a middle-class audience, whom he encouraged to view their homes as ethical platforms.

If Wheeler had directed her efforts mainly at women, Stickley adopted an equally gendered approach, devoting himself increasingly to the moral improvement of men and boys.[28] This was a time when masculinity was much on the minds of Americans. Throughout his political career, President Theodore Roosevelt had cultivated an image of hardy independence based on his own "Rough Rider" military stint and his reputation as a fearless outdoorsman. The cult of machismo that he helped to propagate found its holy writ in his 1899 speech, "The Strenuous Life." Roosevelt

bristled with hostility against the notion that a peaceful life was best. Male Americans must instead exert themselves, leading virile lives of "toil and effort, of labor and strife." If they did not, the nation would fall into effeminacy and decay—here he veered into racist caricature—like the once-great China, "and be content to rot by inches in ignoble ease within our borders, taking no interest in what goes on beyond them, sunk in a scrambling commercialism."

Stickley reprinted portions of "The Strenuous Life" in the *Craftsman*, and increasingly devoted himself to its principles. One writer in the magazine even compared Roosevelt's "square deal" (the promise that every American man should have the same opportunity to improve himself) to the lines of Stickley's furniture. In 1910, with his magazine at peak circulation (over 22,000), he announced a new initiative, a "school for citizenship" that would teach boys not out of books, but through "the practice of doing something useful with brains and hands." To some extent, this project echoed the approach that Booker T. Washington had taken at Tuskegee, and Richard Pratt at Carlisle. But Stickley's emphasis was entirely on character building, not vocational training. Instruction would be done outdoors whenever possible, and devoted to the sole objective of instilling manly, independent virtues among the students: "I want the boys to learn here to *stand on their own feet*," Stickley wrote, "to develop independence of thought and creative initiative."[29] A supportive article in the *Craftsman* was more blunt: "A child of twelve able to recite Homer and discuss philosophy is about as useful to society as Halley's comet."[30]

Ultimately, Stickley was unable to achieve his pedagogical dreams. In 1913, even as he was laying plans for the school, he opened an establishment called the Craftsman Building in Manhattan. This was an even more ambitious project, with multiple sales floors, a visitable craft workshop, and a food hall with farm-fresh produce. It was remarkably forward-looking, anticipating today's experiential retail culture and organic dining. Unfortunately, it also proved to be a money sink. The Craftsman Building closed after just three years, its stock of furniture taken to the nearby (much more traditional) Gimbels Department Store and sold for bargain prices.[31] Was this failed retail venture the ultimate verdict on Stickley's philosophy, a crushing confirmation of what happens when craft is understood as its own reward? Or should his iconic furniture, which has remained influential to this day, be considered the true proof of his ideas?

The protagonists of the American Arts and Crafts movement asked themselves similar questions, and the spectrum of their opinions was wide. At one end was the

entertainingly self-aggrandizing Elbert Hubbard, who had started his career as a soap salesman in Buffalo, New York, and then launched into a career as a writer, settling in the nearby town of East Aurora. In 1894, he traveled to England, where he probably did not meet William Morris—though he liked to claim otherwise—but did acquaint himself with Arts and Crafts thinking. On his return, he founded a press in direct imitation of Morris's Kelmscott, which he called Roycroft. (The name was meant to approximate medieval English for "king's craft"). "Roycroft began as a joke," he said, "but did not stay one; it soon resolved itself into a commercial institution."[32] In 1899, Hubbard hit it big with a pamphlet called *A Message to Garcia*, a Rooseveltian tale of an intrepid American soldier who braves the jungled mountains of Cuba to deliver a secret missive from President McKinley to an insurgent army leader. A total fabrication presented as fact, it sold millions of copies. On the strength of this and other light fare, he fashioned himself into a high priest of self-help, "Fra Elbertus," and in 1900 launched Roycroft Industries, which made some domestic furniture and a great deal of what amounted to Arts and Crafts kitsch, including busts of Morris, Walt Whitman, and of course Hubbard himself.

Hubbard produced an oak furniture line that was stylistically imitative of Stickley's, falsely claiming that every piece was custom-built by a single craftsman, when actually he relied on divided labor and mechanized production techniques.[33] He also found success with small metal wares, lamps, and leather goods, all impressed with the distinctive Roycroft trademark (which he swiped from a medieval illuminated manuscript). He waved the craftsman banner for all it was worth; there was such a steady stream of tourists to see the workshops in East Aurora that he built an inn to house them. He did employ some talented makers, too, notably an investment banker turned coppersmith named Karl Kipp and the young designer Dard Hunter. And Hubbard made room in his pantheon for Thoreau's *Walden* and Booker T. Washington's Tuskegee (which he described as "an ecstasy in brick and mortar").[34] Ultimately, though, he was most interested in himself. He died in 1915 on the RMS *Lusitania* when the ocean liner was attacked by an experimental German submarine. Legend has it that as the ship was going down, Hubbard turned to his wife and said, "Think of it, Alice—tomorrow the headlines will say, Elbert Hubbard killed on the Lusitania!"

Meanwhile, out in Pasadena, California, brothers Charles and Henry Greene were also creating furniture under the influence of Stickley's *Craftsman* magazine. Like Hubbard, and Stickley himself, Charles had direct experience of the Arts and

Crafts movement in England, where he had gone on his honeymoon in 1901. Greene and Greene initially relied on local millwork companies, but then joined forces with another pair of brothers, the Swedish immigrants Peter and John Hall. The skills of these highly trained cabinetmakers were put to work in the development of a unique design idiom, realized fully in the houses that Greene and Greene produced for the Blacker and Gamble families, designed in 1907 and 1908, respectively. The softened contours of the furniture and interior woodwork in these projects attest to the Halls' Scandinavian training and to the influence of Japanese joinery and archi-tecture. The luxurious materials (mahogany and ebony) and custom workmanship of the buildings' every inch, meanwhile, indicated the wealth of Greene and Greene's patrons. Though these houses are now seen as the quintessential examples of West Coast Arts and Crafts style, there was nothing democratic about them: They were a Californian spin on the Gilded Age mansions of New York City and Newport, Rhode Island.[35]

Private patronage also made possible an Arts and Crafts experiment called Byrdcliffe, founded by Ralph Radcliffe Whitehead, the son of an English textile mill owner, and his wife, Jane Byrd McCall. Whitehead had studied with Ruskin and, like Robert Owen before him, conceived the idea of investing his factory-derived wealth into a utopian community in America. The couple purchased a large prop-erty in the Catskill Mountains, near Woodstock, New York, and transformed it into an art colony. Like Owen's New Harmony, the project was fleetingly idyllic, attracting a range of intellectuals, craftspeople, and artists. There was a pottery, a metal studio, and a woodshop. Byrdcliffe was particularly inviting to women, who found a creative freedom there unimaginable in most of America at the time. Zulma Steele, a creative polymath who mastered the skills of painting, pottery, print-making, and furniture, collaborated with her long-term romantic partner, Edna Walker, on a ceramic line called "Zedware" (derived from their first names, just as "Byrdcliffe" was derived from its founders' middle names). They inserted carved and painted panels into simple cabinets and chairs that Whitehead had designed—an approach similar to that used for Rookwood's conventionally shaped but lushly painted vases, quite literally "applied art." Unfortunately, the colony proved short-lived. Whitehead and McCall lacked Hubbard's flair for promotion; having only the couple's patronage to support it, Byrdcliffe began to break apart in 1907 in a blaze of recriminations. Several of the artists involved remained in the area, however,

and their bohemian imprint would echo down all the way to the 1960s, when Woodstock became synonymous with the counterculture.[36]

All these manifestations of the Arts and Crafts movement—the calculated commercialism of Hubbard, the bespoke elegance of Greene and Greene, the boutique experimentalism of Byrdcliffe—resulted in objects that are treasured today and shown in museums, inspirational relics for successive generations of craftspeople. At the time, though, some considered these artifacts proof of misplaced idealism. One of the most articulate skeptics was Mary Ware Dennett, a leading light of the Society of Arts and Crafts in Boston. She stands at the opposite end of the Arts and Crafts spectrum from Hubbard: If he approached the movement basically as a marketing opportunity, for Dennett it was a deadly serious business. The Society of Arts and Crafts, founded in 1897 and still in existence today, was among the first and most ambitious organizations associated with the movement. Its primary activity, following the lead of London's Arts and Crafts Exhibition Society, was to present its members' work in group shows. It also produced a journal entitled *Handicraft*, comparable to Stickley's *Craftsman*, to which Dennett was a frequent contributor. Though she supported the society's overall goals, she was soon disillusioned by its emphasis on display. "Something is wrong when the members are busy mainly at making the trifles and extras of life, rather than the important first necessities," Dennett wrote. She pointed out that in a holistic, craft-based economy, the makers would also have to be the consumers. But in practice, society members often could not afford one another's work, and instead sold their products up the social ladder. This seemed to her an obviously untenable model, for it could never expand beyond its narrow base of philanthropic clientele.

Dennett was also dubious about another declared goal of the society: elevating public taste in the hope that this would create broader demand for well-crafted objects. As she rightly pointed out, "the enterprising manufacturer or merchant" could easily imitate a craftsman-produced item and sell it at half the price. She doubted that the general public could be taught to distinguish spurious from genuine. And even if this were possible, a program limited to aesthetic reform could only produce "a passive, negative, merely harmless art, which could hardly be called art at all, being simply the omission of ugliness." The fundamental problem was that the Arts and Crafts movement was obsessed with "things—their beauty, their sale, their increase," when its primary interest should have been "the man—his

freedom—his industrial and economic independence." Eventually, Dennett gave up on convincing her colleagues of this. Instead, she focused on women's rights, advocating for birth control and against prostitution and joining a Woman's Peace Party when the First World War came.[37]

Dennett's criticism of the Arts and Crafts movement was echoed by other observers—among them, the prominent Chicago sociologist Thorstein Veblen, originator of the theory of conspicuous consumption, who derided the craft revival as sentimental, "romanticism with a smear of lackadaisical aestheticism across its face."[38] But Dennett was especially clear-sighted in highlighting the tension between products and process—on the one hand, "things," aesthetically gratifying but politically inert; and on the other, political reform leading to a more just society. The Arts and Crafts movement, in all its variety and intermittent splendor, focused primarily on the first of these. It never paid more than lip service to the project of empowering the skilled worker. But there was another movement abroad in the Progressive Era that did just that: the cause of organized labor.

They called her "the most dangerous woman in America." Mary Harris Jones was born in County Cork, Ireland, in 1837, and emigrated with her family during the Great Famine that ravaged the countryside. Safely in North America, she and her relations led itinerant lives, first in Canada, then in Michigan, then Memphis. Harris supported herself as a seamstress, having learned the craft at a convent school. She married a man named George Jones, a skilled metalworker who was also an organizer for the International Union of Iron Molders (its motto: "Equal and exact justice to all Men, of whatever state or persuasion"). Then tragedy struck. The family lived on low-lying land in the fork of a bayou, ideal conditions for the spread of yellow fever. In 1867, the disease claimed the lives of Harris's husband and all four of their children. She herself was spared, though, and moved on to Chicago, where she opened a dressmaking shop, only for yet another unthinkable calamity to befall her four years later. The city was consumed in flames—the Great Fire of Chicago— and her business with it. Jones was luckier than some, though; her skills permitted her to find work with some of Chicago's wealthiest families. "I had ample opportunity to observe the luxury and extravagance of their lives," she recalled in her autobiography. "Often while sewing for the lords and barons who lived in magnificence on the Lake Shore Drive, I would look out of the plate glass windows and see the

poor, shivering wretches, jobless and hungry, walking along the frozen lakefront. The contrast of their condition with that of the tropical comfort of the people for whom I sewed was painful to me." Animated by this sense of injustice, she took up her late husband's role as a union organizer, joining up with the Knights of Labor. And so, she embarked on a career in radical politics, becoming a full-time agitator— a career that would eventually earn her the nickname Mother Jones.[39]

Jones staged her greatest feat as an activist in 1903. A massive strike of 75,000 workers, about equally divided by gender, was under way in the Kensington neighborhood of Philadelphia, then a center for the American textile industry. Among their grievances were the use of underage labor and extraordinarily dangerous working conditions—a horrific combination. "Every day," Jones said, "little children came into Union Headquarters, some with their hands off, some with the thumb missing, some with their fingers off at the knuckle." She assembled a group of them to parade together through industrial districts. Everywhere they went, massive crowds turned out in support. Jones brought the young factory workers up on platforms to display their mutilated limbs: "Philadelphia's mansions," she cried, "were built on the broken bones, the quivering hearts and drooping heads of these children." She marched them up to New York City, and in Coney Island, she went so far as to display them in animal cages as a metaphor for their treatment at the hands of their employers. Then she pressed on to Long Island, to the summer home of Theodore Roosevelt. She would show him what the "strenuous life" really looked like.[40]

The contrast between Mother Jones's tactics and those of the Arts and Crafts reformers was vivid, to put it mildly. Her emphasis, in the terms proposed by Mary Ware Dennett, was entirely on "industrial and economic independence," the quality of labor, not its products. And she sought to remedy the worst forms of exploitation, which meant standing side by side with the most oppressed workers, paying little mind to elite artisans. Yet she and her fellow labor activists did think seriously about questions of skill. And these were difficult questions. The Knights of Labor, the pioneering union that formed the context for Jones's early activism, was the descendant of earlier fraternal organizations, as its medieval-sounding name suggests. Founded in 1869 as a secret brotherhood, it grew into a nationwide movement representing "producers" of all types, whose interests were juxtaposed to "nonproducers" such as bankers and lawyers. It sought goals that would be beneficial to all its members, both skilled and unskilled: a legislated eight-hour workday, the end of child labor, and greater safety regulations. The Knights also pushed for equal pay

between men and women, and they admitted African Americans into their ranks. This solidarity was not to last, however. The labor movement suffered a series of setbacks, including the dramatic events that occurred in Haymarket Square in Chicago on May 4, 1886. During a strike at the local McCormick Reaper plant, union protestors clashed with police, with loss of life on both sides. Public opinion turned against the bomb-throwing "anarchists" who were believed to be at fault, turning the tide in the war of words between management and unions.

In December of that year, a rival workers' association called the American Federation of Labor (AFL) was formed to pursue a different strategy, which ultimately came to be known as "craft unionism." It was not necessarily more conciliatory in its methods than the Knights had been—strikes nationwide nearly tripled in the 1890s, partly as a result of an economic depression that settled over the country in the middle of the decade.[41] But instead of the centralized, big-tent approach of the Knights of Labor, the AFL was structured as a coalition of trade-specific unions, which restricted their membership based on standards of skill. This approach proved effective for those it protected, but left other workers exposed. In 1889, for example, an AFL affiliate called the Journeymen Tailors' Union of America staged a successful strike to protest reduced wages and domestic outsourcing. The union position was that a tailor should "sit among men and make work," and that the home should not be used as a workshop. The victory maintained income for male workers, but it effectively sidelined female pieceworkers. The AFL presided over a similar marginalization of African American and Chinese American interests. In the railroad industry, labor was organized narrowly according to specialization, with thirteen separate unions (electricians, blacksmiths, oilers, boilermakers, carpet layers, and so forth) by 1901. These skilled workers had terrific leverage because they could shut down so much economic activity with a strike. Yet they did nothing to help manual laborers in the industry, who were more likely to be Black or Chinese—and, on the contrary, turned against the latter viciously, accusing them of undermining the "integrity" of the craft. This was a classic "labor aristocracy," one that looked down on unskilled workers as a threat to be suppressed, rather than as allies to be supported.[42]

To the extent that craft unionism had a single architect, it was the AFL's founding president Samuel Gompers, who remained at its head almost continuously for nearly forty years until his death in 1924. Born to a poor Jewish family in London in 1850, he immigrated with his family to New York City at the age of thirteen and was set to work assisting his father as a cigar roller. This was one of the infamous

tenement trades of the city. Manufacturers often owned whole houses and rented them out to their workers, an arrangement that gave them complete control over their employees' lives. Yet Gompers looked back on his early days with fondness. "The craftsmanship of the cigarmaker," he wrote, "was shown in his ability to utilize wrappers to the best advantage to shave off the unusable to a hairbreadth, to roll so as to cover holes in the leaf and to use both hands so as to make a perfectly shaped and rolled product. These things a good cigarmaker learned to do more or less mechanically, which left us free to think, talk, listen, or sing." One among the crew was often selected to read aloud to the others, and given a share of the cigars as a form of payment: "I had earned the mind-freedom that accompanied skill as a craftsman."[43]

The cigar trade also gave Gompers his introduction to organized labor. A union was formed in New York in 1869 to resist the use of bunch-breaking machines and molds that allowed unskilled workers to replace highly trained rollers. Mechanization produced an inferior grade of cigar, but nonetheless a salable one, and the unions were unable to prevent its adoption. By 1873, Gompers was working at one of few remaining high-grade producers, David Hirsch and Company—which, not coincidentally, was also one of the only cigar shops in the city with a unionized workforce. Many of these artisans were immigrants, well read in current European political theory, "men of keener mentality and wider thought," according to Gompers, "than any I had met before." He listened to what they had to say, and was even handed a copy of Marx and Engels's *Communist Manifesto* in translation. Ultimately, though, he sided against its radical ideas. Particularly following the Haymarket incident, he believed that a centrist political stance would result in more gains. In this sense, he did for the skilled working class what Booker T. Washington was doing for African Americans, pressing for advantage but only in a limited way, while trying to lay hold of backroom levers of power. To socialists, he had this to say: "Economically, you are unsound; socially you are wrong; industrially you are an impossibility." Eugene Debs, the most widely recognized socialist in America, responded in kind: "We have to educate and organize the workers industrially and politically, but not along the zigzag craft lines laid down by Gompers, who through all of his career has favored the master class. You never hear the capitalist press speak of him nowadays except in praise and adulation."[44]

This debate was not happening against a static backdrop. The Progressive Era was a time not just of unprecedented class conflict in America, but also of intensive

industrialization and corporate growth. The AFL's attempt to impose skill-based standards, what Gompers called "trade autonomy," was vigorously opposed by a growing managerial class with its own sense of what constituted proper standards of work. This set of principles came to be known by the misleading term "scientific management," more accurately "time and motion studies," or simply, "Taylorism," after its leading promoter, Frederick Winslow Taylor. It was a pseudo-science at best. Taylor, born in 1856 to a wealthy Philadelphia family, is as close as American craft history has to a cartoon villain. He was a sort of craft activist in reverse, a man who devoted his life to the merciless control of bodies and minds: joylessness in labor. Ironically, Taylor began his career as a skilled artisan, working as an apprentice machinist and patternmaker in a pump factory. (He also did a six-month stint at the 1876 Centennial Exposition, as a representative of a machine tool manufacturer.) For whatever reason, this early experience convinced him not of the importance of shop floor solidarity, but on the contrary, that most workers were wasting time, and therefore their employers' money.

Taylor first had a chance to test these suspicions when he was promoted to gang boss over a group of lathe operators at Midvale Steel, a Philadelphia producer of high-quality metal products. He was the proverbial foreman from hell. Taylor felt that the men should be producing about three times as much as they did, and that they were "soldiering" (working deliberately slowly) to hold down expectations. They called him a "damn hog." Two or three years of bitter conflict ensued, with Taylor eventually hiring a whole new team and training them to work to his dictates. If they could not keep up, he said, "I have not any mercy on you." As a means of further developing control, he began keeping track of the workers' every movement with an exactitude that would perhaps have pleased Isaac Newton Youngs, the perfectionist Shaker, but was infuriating to those who had to endure it. The modular unit of his system was the "task"—which "should not in the least degree be vague nor indefinite, but should be circumscribed carefully and completely, and should not be easy to accomplish." A set amount of time should be allotted to the task, based on measured observation. Workers who completed the task on time and consistently were to be paid well. Those who failed to do so were to be penalized, and eventually fired.[45]

Anyone who has ever done work of any kind can immediately spot the flaws in this logic. First, nothing happens in a vacuum. Even in a large factory, a worker must contend with irregularities in materials, tools, work flows, and many other variables.

Time saved at one step of a process results in lower quality, and hence greater ineffi-ciency down the line. To this Taylor had a simple answer: Standardize everything. Each machine tool, each piece of raw material, and above all each iteration of each step of the manufacturing process had to be identical. People, too, had to be care-fully sorted. The first step in Taylorism was "selection," getting the right worker for the job (classified by endurance, strength, and skill level) and then holding them to their maximum output. (The next steps were "repetition, obedience and reward.") Even if this highly ambitious scenario were to be accomplished, there was another obvious problem. Management has a vested interest in shortening the time for a "task," effectively making it cheaper. The worker has the opposite motivation. So, who should decide how long a task will take? Again, Taylor had a ready response: Management would. But they would be *scientific* about it. By establishing targets fairly and implementing them without deviation, they would increase the efficiency and profitability of the workplace. The resulting windfall could then be shared between owners and workers.[46]

Taylor and his supporters felt sure that labor unions would embrace his princi-ples as advantageous to all. Instead, they concluded, as William B. Wilson of the United Mine Workers put it, that this "new idea of peace and cooperation" between management and labor would "be very much like the lion and the lamb lying down together with the lamb inside."[47] For one thing, as the historian Harry Braverman has noted, when Taylor calculated the output of a fair day's work, he "tended to define this level of activity at an extreme limit, choosing a pace that only a few could maintain, and then only under strain."[48] An infamous example, described in Taylor's bestselling book *Principles of Scientific Management*, came from his time as a consul-tant at the Bethlehem Steel works. In studying the pig iron handlers there, he concluded that they were doing only about one third as much work as they should; he reckoned transferring forty-seven tons per day to be about right. To prove this, he selected a man called Schmidt, whom he described as "mentally sluggish . . . of the type of the ox," and set about dictating every aspect of his work: the size of his shovel, the number of steps he took from one position to another, the quantity of iron per shovelful, even the arc he should use when emptying it. Schmidt was watched over all day by a man with a stopwatch, told when to work and when to rest. Taylor claimed that, in this way, Schmidt did indeed perform a "proper day's work." As it happens, Taylor probably made up "Schmidt" and everything he said about him.

But even in this thought experiment, the scales were weighted against labor: Taylor reports that "Schmidt's" wages went up—by half, for three times the work.

∼

Like many crazy, dangerous ideas, Taylorism did contain a spark of genuine insight. One could even say that Taylor was ahead of his time. The hyperrationalist, quantified approach to manufacturing he espoused, and even his fantasy of a totally pliant labor force, would ultimately be realized in robotic automation. But in his own day, and as applied to actual people, Taylorism was little more than a paper-thin justification for the brutal exercise of power. Schmidt with his shovel was easy enough to turn into a mathematical formula. But this was impossible in the case of complex craft processes. If a nonspecialist (e.g., a management consultant) could not fully comprehend a job, much less compartmentalize it into discrete, measurable "tasks," it was a problem. This was the flip side of craft unionism, as promoted by the AFL. Highly trained workers were difficult and expensive to replace, so there was no choice but to negotiate with them. And negotiation with labor, just like every other inefficiency lurking in the manufacturing system, was something managers were determined to eliminate. This was the true logic hiding behind Taylor's supposed standards, the dystopian antithesis of the Arts and Crafts ideal: total subjection to the profit motive, with skill factored out of the equation. From Taylor's point of view, irreplaceable artisans were the worst kind of workers a company could have.

In the popular imagination, Taylorism had its day of triumph in 1913, when the first Model T rolled off a fully integrated assembly line. Henry Ford had put the car into production five years earlier, relying on conventional coach-building techniques. With the assembly line, he was able to reduce the time to completion by something like 90 percent. This cost-effectiveness proved such a huge advantage commercially that within a few years, fully half of new American cars were Model Ts. Ford's competitors all introduced the assembly line, too; their only other option was to go out of business (and many did). It is common to construe this success as a direct application of Taylor's ideas. In fact, about all that Taylorism and Fordism had in common was an obsession with efficiency and a complete disregard for workers' quality of life. There was no manager with a stopwatch standing over Ford's employees, because there didn't need to be. The pace of labor was controlled by the assembly line, about which there is nothing "scientific." To quote Braverman again, it is "merely a primitive device for hauling the work past the worker."[49] Ford did not indulge in

Chevrolet cars on a production line, c. 1920. Heritage Images, Hulton Archive/Getty Images.

the Taylorist delusion that there is a single, optimal way of performing a task, which could be studied, taught, and enforced. He simply applied the much older idea of Adam Smith, the division of labor, to the fullest extent humanly possible.

Or, many would have said, inhumanly. The Chicago writer Julian Street, in his 1914 book *Abroad at Home*, recorded an indelible impression of the brand-new Ford plant as wholly alien: "Of course there was order in that place, of course there was system—relentless system—terrible 'efficiency'—but to my mind, unaccustomed to such things, the whole room, with its interminable aisles, its whirling shafts and wheels, its forests of roof-supporting posts and flapping, flaying, leather belting, its endless rows of writhing machinery, its shrieking, hammering and clatter, its smell of oil, its autumn haze of smoke, its savage-looking foreign population—to my mind it expressed but one thing, and that thing was delirium."[50] In the first year of the assembly line, so many workers walked out of the Ford plant in disgust that more than 52,000 had to be hired just to maintain a constant labor force of 14,000. Though the company had massively deskilled the process of assembly, each new

employee still had to be trained. This was an inefficiency Ford had not counted on. Famously, he raised wages to five dollars per day, far above the industry norm, just to keep workers on the job. Later this was spun as a brilliant maneuver to help his own employees afford Model Ts, turning them into consumers. It was actually a means of coping with a self-inflicted management crisis. In any case, Ford did not have to pay these high wages for long. As the entire industry shifted to the assembly line—and then other sectors of the economy followed suit—workers had little choice but to submit to the new manufacturing techniques.

Between them, the ideology of Taylorism and the implementation of Fordism marked the most explicit and concerted assault on artisan autonomy in American history. It is a striking fact that this occurred just as the Arts and Crafts movement was in full flourish, and equally noteworthy that the new techniques of mass production were themselves the work of artisans. As the sociologist Thorstein Veblen observed in 1914, it was craftsmen's "own technological mastery that furnished the means of their own undoing."[51] Ford, like Taylor, had been a machinist's apprentice when he was young, at the Dry Dock Engine Works in Detroit, and also earned extra money as a repairman in a jewelry shop. He even considered becoming a full-time watchmaker. He saw these experiences as instrumental in the development of his techniques: "Machines are to a mechanic what books are to a writer. He gets ideas from them, and if he has any brains he will apply those ideas."[52] Ford's assembly line was constructed by machinists and toolmakers like William "Pa" Klann and C. Harold Wills. Even the device by which autoworkers clocked in and out was invented by an artisan. This was William Legrand Bundy, who first made his living as a jeweler and watchmaker in Cayuga County, New York. In the 1880s, he built a mechanical marvel that he called the "Thousand Year Clock," with 3,100 parts, as a showpiece for his shop. He then patented a much more prosaic timekeeping device, to record employees' arrival and departure from their places of work. The Bundy Manufacturing Company, founded in 1889, was so successful that it had offices nationwide by the turn of the century. Over time, it merged with other businesses in the time-recorder industry, then branched out into calculators and other punched-card technology. Eventually, it was rebranded as International Business Machines, better known as IBM.

Quite apart from these captains of industry, the very tools of mass production remained dependent on artisan labor. A perfect example is the profession of the steel mill puddler. This was an extremely demanding craft, requiring fine judgment

and material intelligence, tremendous physical strength and endurance—and all the while performed at the lip of an infernal pool of molten metal. The puddler's job is to refine pig iron (hauled over, presumably, by a handler like Schmidt) from the blast furnace into workable wrought iron. Individual "pigs" of the unrefined metal (so named because they have a rounded shape, which could be seen as porcine given sufficient imagination) are melted in a furnace. This liquid mass is then manipulated with a long iron rod, as the puddler pushes bits of pure iron to the bottom, where they gradually accumulate into a mass. The impurities are poured off as waste slag, and the iron is shaped into rough balls, which are hoisted out with tongs. Other workers then refine the metal further by working it with rollers, removing more slag and getting it into a workable flat bar. This is as difficult as it sounds. James J. Davis, a Welsh immigrant who began his work life as a teenage puddler's assistant in Pittsburgh, recalled the importance of tacit knowledge in his training: "None of us ever went to school and learned the chemistry of it from books. We learned the trick by doing it, standing with our faces in the scorching heat while our hands puddled the metal in its glaring bath."[53] Davis became a union organizer and, later, secretary of labor in the Harding and Coolidge administrations. Even then, he was known as "Puddler Jim."

Davis was unusual in his rise to political prominence, but his start was very typical: He was an immigrant in a difficult and dangerous job, acquiring his skills on the shop floor. Industrial artisans like these, wherever in the world they came from, knew well the distance between their own lives and the caricatures of Taylorism. This can be seen not only in their increasing involvement in labor unions, which built solidarity within trades between different immigrant groups, crossing lines of language and religion, but also in the folklore generated among factory workers. One fascinating tale imagines a Pittsburgh steel man called Joe Magarac, whose heroic stature and feats echo those of nineteenth-century workers' myths such as the lumberjack Paul Bunyan and the "steel-driving man" John Henry. Though not attested in print until 1931, when a version of the legend was printed in *Scribner's Magazine*, the legend of Joe Magarac seems to have circulated among eastern European immigrants years earlier. He was literally made of steel, seven feet tall, with arms the size of smokestacks; he could take molten metal in his hands and fashion it into perfect train rails. In the end, though, he was undone by his own productivity. Driven by a compulsion to work ever harder, he eventually created an oversupply of rails, and his mill shut down. His purpose in life gone, he hurled

himself into the furnace, producing the highest grade of steel imaginable. Strangely, this story was embraced by steel companies in the 1940s as a way to motivate workers—historians have called their version "fakelore." Yet it clearly began as satire, an allegory about the soul-destroying drive to overwork that would consume even the most conscientious if they fell for it. *Magarac*, it turns out, means "jackass" in Croatian.[54]

~

"You do not know what life means when all the difficulties are removed! I am simply smothered and sickened with advantages. It is like eating a sweet dessert first thing in the morning."[55] This is how Jane Addams, looking back over a life of philanthropy, pictured herself as a young girl. She was born in 1860 in northern Illinois, the daughter of a wealthy businessman—a founder of the state's Republican Party (and thus a close ally of Abraham Lincoln) who had investments in the railroad, timber, and woolen trades. Conscious of her cushioned youth, Addams was determined to turn her wealth to some social purpose. She found her model in London's East End, in Toynbee Hall, an early and influential "settlement house." The term referred to university students and other middle-class volunteers who would temporarily settle there—"city missionaries," Addams called them—and conduct charitable works among the poor. Addams had traveled to Europe with Ellen Gates Starr; they became activist colleagues and, for a time, domestic partners. Upon their return to Chicago in 1889, they founded Hull-House (named for Charles J. Hull, a millionaire who bequeathed his mansion to this charitable use). From the beginning, Addams considered her venture to mark a departure from its British precedent. While Toynbee Hall was organized by "university men," Hull-House would be run by women, in an egalitarian spirit. Reflecting on the class consciousness, and class condescension, she had perceived on her travels in England, Addams wondered, "Why should an American be lost in admiration of a group of Oxford students because they went out to mend a disused road, inspired thereto by Ruskin's teaching for the bettering of the common life, when all the country roads in America were mended each spring by self-respecting citizens"?[56]

This democratic impulse coursed through every aspect of Hull-House. It was located in the midst of a densely populated Italian American neighborhood, but as the organization's programming expanded, it reached immigrants from Greece, Poland, Russia, Germany, Ireland, and elsewhere. In the 1920s it would become a

Jane Addams, c. 1900. Bain Collection, Prints & Photographs Division, Library of Congress, LC-DIG-ggbain-12065.

northern outpost of craft-based Mexican identity politics, or *mexicanidad*, as migrant potters came to work at the Hull-House Kilns.[57] For this polyglot community it served as an all-purpose school, fitness center, orphanage, theater, and hospital, providing services in response to needs. And craft was right at the center of it. Far from insisting on assimilation, as was frequently the case when Progressive Era reformers sought to help immigrants, Addams was concerned that her constituents' children, embarrassed by Old Country ways, were losing touch with their cultural inheritance. She saw traditional artisan techniques—particularly what she called "women's primitive activities"—as a valuable corrective. In 1900 a Labor Museum opened at Hull-House, offering classes and public demonstrations in textiles, bookbinding, and metalworking. An extraordinary miscellany of equipment was put on display: spinning wheels from Colonial America, but also Syria; not just industrial weaving equipment, but also Navajo, Hindu, and Japanese

handlooms. Immigrant women were invited to participate, not as passive students force-fed a diet of Americanism, but as teachers passing on their own knowledge and skills.

The unprecedented diversity of the Labor Museum was the result of Addams's and Starr's firm convictions. "Art must be of the people if it is to be art at all," wrote Starr. "It is only when a man is doing work which he wishes done, and delights in doing, and which he is free to do as he likes, that his work becomes a language to him." These words could have appeared in any Arts and Crafts manifesto, and to some extent Starr did fit the profile of the movement's many other reformers. She trained as an ornamental bookbinder, was staunchly opposed to machine production, and networked with other well-to-do Chicagoans to found a Society of Arts and Crafts. But she was also active as a labor organizer among the city's garment workers. In fact, the just-cited quote comes from a fascinating volume published by Hull-House in 1895, which also included "wage maps" of Chicago showing the extent of poverty in the city.

The same book contained a deeply researched investigation into tenements, prepared by Mary Kenney O'Sullivan and Florence Kelley, Hull-House participants who were also labor activists. (Kenney was an ally of Samuel Gompers in the AFL, while Kelley would go on to be a leading suffragist and co-founder of the National Association for the Advancement of Colored People.) Significantly, Starr titled her contribution to the Hull-House book "Art and Labor," two concepts she and Addams always considered in light of one another. At Hull-House, pure aestheticism was rejected as hollow; craft reform was backed by political action. As Starr memorably put it, "It is a feeble and narrow imagination which holds out to chained hands fair things which they cannot grasp—things which they could fashion for themselves were they but free."[58]

As inspiring as it is, the story of Hull-House suggests the difficulty of welding together a fully integrated progressive vision for craft. After all, it was only Addams's inherited wealth, and the philanthropy of other rich Chicagoans, that made it possible. And though there were other, similar attempts to utilize artisan workshops as instruments of social reform—the Paul Revere Pottery in Boston, which grew out of a weekly training session for immigrant women known as the "Saturday Evening Girls," is an excellent example—even these endeavors tended to have a paternalist cast. And, of course, they had only a tiny economic footprint in comparison to the awesome power of Fordism.[59] All the currents in craft reform that swept through America at the turn of the twentieth century had their blind spots. The AFL tried to

make a fortress of skill, but in so doing, it shut out women, African Americans, and immigrants. The Arts and Crafts movement created objects of extraordinary conception and resolution, but these often ended up decorating the homes of the rich, or else were copied in degraded form by commercial interests. Gustav Stickley's own brothers made versions of his designs using efficient mass-production techniques, and proudly announced the fact in terms that Taylor would have approved: "The work of L. and J. G. Stickley, built in a scientific manner, does not attempt to follow the tradition of bygone days."[60]

Even the utopian community at Amana, which seemed to Bertha Shambaugh such a complete realization of William Morris's ideals, was a fragile construction. When the Great Depression hit, young Inspirationists began drifting away from the settlement, unconvinced that it could provide for them. In 1932, the aging leaders of the settlement made the difficult decision to set aside their communal way of life. They called it the Great Change. Though the church remained, the local industries were now set up as a private firm called Amana Society Inc. The following year, Prohibition was repealed, and spotting an opportunity, a man called George C. Foerstner started making beverage coolers in the corner of one of the local furniture shops. The Amana Society purchased his company, and he built it into one of America's most successful appliance manufacturers. In 1965 it was purchased by Raytheon, and today it is part of the Whirlpool Corporation. Needless to say, its appliances are built on assembly lines. Online employee feedback describes the factory experience at Amana in terms that would have been familiar to autoworkers a century ago: "Very fast paced environment. Repetitive work, same thing over and over. Very physically demanding." There are apparently good benefits, though, thanks to union backing.[61]

Craft has often served as an armature for idealism, and never more so than in America at the turn of the century—whether in the aestheticism of Adelaide Alsop Robineau, the radical visions of Mother Jones, or even the mechanical hyperrationality of Frederick Winslow Taylor. All were people of their time, and there is much to learn from their achievements and their failures. But if the complex narrative of Progressive Era craft reform has one simple lesson, it is that we don't live in a perfect world. An artisan knows this more deeply than anyone else: Every craft project is a reckoning in which time and cost, tools and materials, skill and invention are all in play. It is this very balancing act that makes it such a subjective human endeavor. Craft—like politics, like life—is a matter of give-and-take.

Chapter 5

Americana

FIRST CAME THE PLAINS INDIANS, dimly illuminated in the blue light of two electric bulbs. Then the Spanish explorers, "armored and grim." Next the French Missionaries, the Virginia Cavaliers, and the Puritans in their gray cloaks and peaked hats. Some soldiers of the revolution marched out, and finally, a group of hardy pioneers. When all were assembled, they greeted one another with poetry:

> Grateful to all who sailed the seas before us
> Glad to claim a kinship with New England's lofty names
> Ancestral in our turn, we raise this inland temple
> And hopefully confront the challenge of your flames.

The setting for this strange event, at which all of American history was condensed into a costume party, was Chicago. The date was January 1909, and the occasion, the first meeting of an organization called the Cliff Dwellers Club. Actually, there were no Native Americans among them, no more than there were Puritans or pioneers. Those in attendance were all white, all male. They comprised the city's premier arts club, a group of writers, artists, and collectors. Among their members were Charles L. Hutchinson, the founding chairman of the Art Institute of Chicago, and the architects Louis Sullivan, Frank Lloyd Wright, and Daniel Burnham.[1]

It was Burnham who designed the Orchestra Hall where they met, towering a then-dizzying ten stories or so above street level. But that is not why they were called

the Cliff Dwellers. Nor was it because the membership inhabited the skyscraping offices and upper-tier penthouses of the city. Rather, the organization's name was an honorific allusion to the ancient Puebloans of the American Southwest (then typically referred to as the Anasazi) who made their homes in rock architecture. Puebloan artifacts had been prominently featured at the Chicago Exposition in 1893, attracting much interest. The club called its meeting room atop Orchestra Hall the "kiva," after the ceremonial space at the heart of Puebloan culture.

The Cliff Dwellers loved their pageantry. A year after their inaugural event, they commissioned one of their members, an Arts and Crafts movement silversmith named Robert Riddle Jarvie, to fashion a punch bowl for the club's use. Horizontally ribbed with an inset diamond pattern, it closely imitates "corrugated" Puebloan pottery, which was in turn based on handwoven basketry. This round-bottomed form is set atop a curved base, elevating it, much as Burnham's tall building elevated the Cliff Dwellers' gatherings. In salute to Jarvie's bowl, another poem was recited, which bizarrely likened the modern businessman to a Puebloan brave:

> Warriors are we, but in another fashion,
> Rivals for wealth and happiness and fame.
> Down in the city's deeps we meet in savage fashion
> And play as best we may the selfish, sordid game.

Playacting of this kind, in which people and objects alike were dressed up in the garb of the past, was becoming all the rage in 1910. The nation, though more outward-looking in certain respects than it had been, was also becoming obsessed with its origins. In 1918, the literary critic Van Wyck Brooks lamented the state of American culture. "The present," he said, "is a void." The only solution, in his eyes, was to look backward. "Discover, invent a usable past we certainly can," Brooks wrote. "That is what a vital criticism always does."[2] This was exactly the spirit in which the period's craft revival unfolded: a self-conscious production, compounded of diverse historical material. Increasingly seen as a relic of the past, craft became an essential prop in the self-conscious performance of American identity.

This cult of authenticity brought about a dramatic shift in attitudes toward Native Americans. The same year that Jarvie made his close copy of an Anasazi pot, Gustav Stickley's magazine, the *Craftsman*, proclaimed, "The only handicraft this country knows [is] that of the Indian." Every other aspect of American culture had

been imported from somewhere or other. Only Native traditions had sprung from this soil, this land. And only in Native communities, undisturbed by industry and the other trappings of modernity, was craft still intrinsic to everyday life. Already in 1904, Stickley had visited an Indian School at Fort Yuma, California, where he urged instructors not to impose "the white man's way" on the children and to respect traditional Native skills such as basketry and pottery.[3]

A sense of urgency accompanied this reevaluation, for as the *Craftsman* also explained, the "fast-vanishing race" was easily corrupted by outside influence. This concern led directly to a double standard: "The white craftworker can hardly escape from the suggestion of secondhand ideas, but the Indian who is affected by them must have degenerated sadly under the influence of civilization, so that his work as a craftsman is hardly worthy of the name." The about-face was bitterly ironic, too, for it was only now, after doing their very best to destroy and displace the Native cultural universe, that whites made a fetish of it. The Dakota author and physician Ohiyesa, also known as Charles Eastman, wrote in 1902 that it was already too late. Those seeking Native Americans in their "natural and free" condition would never find them: "Those remnants which now dwell upon the reservations present only a sort of tableau—a fictitious copy of the past."[4]

Yet Native artisans, sizing up the situation, strategically embraced the idea of authenticity, as a way of both articulating their own identity and positioning their work in new markets. Among the first and most prominent makers to adopt this complex position was the potter Nampeyo (Nung-beh-yong, translated as "Sand Snake" or "Harmless Snake"). She was born in about 1860 to a Hopi father and a Tewa mother, in what is now the state of Arizona. The Hopi, along with the Zuni and Acoma peoples, consider the ancient Puebloans to be their ancestors. And Nampeyo was indeed an inheritor of tradition. She learned to make pottery from her paternal grandmother, and already at the age of fifteen she was photographed at her home on First Mesa by visiting geographical surveyors—the first of many times that her image would be captured and reproduced as an emblem of Hopi culture.

At about the same time, a Cornishman named Thomas Keam arrived in the area. Like Richard Henry Pratt, founder of the Carlisle School, he was a veteran of the Civil War—he had fought for the Union—and ensuing battles against the Plains Indians. Keam was nonetheless an admirer of Native culture. He married a Navajo woman, learned to speak the Hopi and Navajo languages, established a boarding school for Native children, and in 1879, opened his first trading post.[5] He asked the

Edward Curtis, *Nampeyo Decorating Pottery*, c. 1900. Edward S. Curtis Collection, Prints & Photographs Division, Library of Congress, LC-USZ62-48396.

Hopi artisans nearby to make commercial versions of *tithu*, popularly known among whites as "kachina dolls," figures carved in cottonwood root representing deities, the *katsinam*.[6] These objects previously had an exclusively ceremonial use and were considered symbolic gifts from the supernatural realm. Keam, however, sold them as curiosities, alongside pots by Nampeyo and other Hopi makers.

Keam's business was exploitative, at least by today's standards. But his timing was excellent. The Santa Fe Railway was just completing its first route into the Southwest, and with it came tourists by the thousands. The Fred Harvey Company, a hospitality chain of restaurants and hotels, was founded in 1876 to cater to them. In their advertisements, these commercial interests began to construct a picturesque stereotype of the Southwest, and Native people were a part of the branding effort. Instead of bitter enemies, they were now recast as quaint remnants. And their crafts made the perfect souvenirs: baskets so finely made that (as virtually every journalist who

wrote about them seems to have mentioned) they could actually hold water; striped Navajo blankets, ideal for an Arts and Crafts bungalow. Back east, at Lake Mohonk, the self-appointed "Friends of the Indian" made optimistic sounds about the economic opportunities for Native artisans. One member of the Board of Indian Commissioners imagined Yuma, Arizona, as "the hive of as busy an industry as Trenton, with a forest of smoking furnace stacks, and producing a style of pottery characteristic, unique, and meritorious."[7]

The smokestacks never materialized, but trading posts certainly did, typically situated along the railway and in the vicinity of army bases. Keam, the first to sell Pueblo and Native products to the tourist trade, remained the most influential of the early merchants. He and an assistant had discovered shards of ancient pottery at a ruin called Sikyátki, at the base of First Mesa. The fragments they found probably date from the fifteenth and sixteenth centuries, and are distinguished for their polychrome decoration. Keam showed them to the Pueblo potters, including Nampeyo, and encouraged them to make contemporary versions for sale. In 1895 a formal excavation was conducted at Sikyátki, under the auspices of the Smithsonian, and Nampeyo's husband was on the crew. Through these connections, she had ample opportunity to study the ancient pots, which she treated as an aesthetic quarry for her own innovations.

For the most part, Nampeyo retained the techniques she had learned in her youth. Her earthenware pots, coiled rather than thrown, were coated in a thin white kaolin slip, which she calibrated to the clay body to avoid surface cracking. Once it was fired, she decorated the pot using mineral pigments, in a visual language of her own creation. Nampeyo borrowed motifs from those she saw on Sikyátki shards and from other contemporaneous Pueblo potters such as the Zuni. Over time, her compositions departed from the interlocking geometries conventional to the tradition. She placed stylized bird forms on the shoulders of her forms, crisply delineated swirls floating on an off-white ground. Nampeyo also made technically challenging shapes such as a seed jar, compressed downward so that its upper register is nearly flat, extremely difficult to achieve by coiling.[8]

While other potters did work in the "Sikyátki revival" style, Nampeyo's inventive approach and sheer skill made her a unique figure—and displayed an individualism that sat uneasily with the collective tradition she was taken to represent. Among white collectors, southwestern Native potters were valued for the supposedly pristine state of their craft. In the words of the contemporaneous Smithsonian curator

Otis Mason, "there is no reason to believe that their present methods and tools and products are different at all from what they were a thousand years ago."[9] This expectation was brought to Nampeyo and her work, even as her singularity was recognized. In 1905, representatives of the Fred Harvey Company invited her to demonstrate her skills at a luxury resort at the edge of the Grand Canyon; each pot was labeled with a sticker: "Made by Nampeyo, Hopi." They also brought her to Chicago in 1910—the same year Jarvie presented his silver punch bowl to the city's Cliff Dwellers Club—to make pottery at a railway exhibition. At these events, she became a living metaphor and a living contradiction: the embodiment of indigenous craft displaced into wholly alien surroundings.[10]

It was a part many Native people found themselves playing. The dynamic had been in place at least since the 1880s, when the nation's capital witnessed demonstrations on the loom by We'Wha, a Zuni *lhamana* (two-spirit person, born with male sex characteristics but living as a woman). Born in 1849, We'Wha was a skilled potter as well as a weaver. On her visit to Washington, D.C., she was received in grand style

John K. Hillers, *We'wha, Zuni Two-Spirit*, c. 1879–94. The J. Paul Getty Museum, Los Angeles.

as a "Zuni princess," and met with President Grover Cleveland. She made a series of blankets on the National Mall, then donated them to the Smithsonian. A surviving photograph shows her holding a handwoven basket of her own manufacture, as if offering it to the viewer; a curtain behind her reinforces the sense that she is playing a role, a *tableau vivant* with only one performer.

In later years, the famed potters Maria and Julian Martinez, of the Tewa-speaking pueblo at San Ildefonso, were much in demand as demonstrators. They first performed at the Louisiana Purchase Exhibition at the St. Louis World's Fair in 1904, and spent a whole year at the Panama-California Exposition in San Diego in 1915, bringing sacks of sand and clay to use. In 1934 the ceramic manufacturer Haeger Potteries brought them to the Chicago Century of Progress International Exposition, making an explicit juxtaposition between their "primitive" craft and modern industrial techniques. Like Nampeyo, the Martinezes drew inspiration from shards found in archaeological digs. They had initially made polychrome wares, not very different

Maria and Julian Martinez, bowl, c. 1919–20. Image copyright © The Metropolitan Museum of Art. Image source: Art Resource, NY.

from those of other Pueblo potters, with Maria forming the pots and Julian decorating them. The iconic blackware so strongly associated with them today began as research experiments meant to determine how certain historic pots were achieved. The answer lay in a "smothered" reduction firing that smoked the surface, turning the red clay black, a process they discovered in 1910. The effect was further refined through the addition of volcanic ash to the clay body and through selective scraping and polishing.[11]

The Martinezes adjusted their work to suit consumer taste after discovering at the expositions that their more sparely decorated pots sold best. They were as adept as entrepreneurs as they were as potters. By the late 1920s, they were conscripting family members into making work in their signature style—literally, as Maria and Julian's names were always put on the bottom of the pot, no matter who made it.[12] Even without assistance, they were incredibly efficient. During their stint in Chicago, they averaged twenty pots a day and sold every one of them.

In some ways, the Martinez family was as modern as any other American family. When the Manhattan Project to build the atom bomb began at Los Alamos, near San Ildefonso, both Julian and their son, Popovi Da, worked there as machinists. Nonetheless, an invincible aura of traditionalism has continued to surround them. Julian's death in 1943, combined with Maria's longevity—she lived until 1980, when she was ninety-three—has further tended to artificially isolate her as a figure of genius. She was the first Native artisan to be the subject of a full-length biography, published by the anthropologist Alice Lee Marriott in 1948. It praised her as an incarnation of "wholeness, continuity and essence"; one reviewer welcomed the book as "refreshing and healing for us to read, especially now when we see our own society so sadly shattered by the results of our own cleverness."[13] Toward the end of her life, a brightly painted highway marker was erected near the potter's house, paying homage to MARIA MARTINEZ, PERHAPS THE BEST-KNOWN OF PUEBLO INDIAN POTTERS. This prominence (and the financial rewards it eventually brought) was controversial in the pueblos, where many other potters worked. They had to wonder why they were not similarly acclaimed. The potter Susan Peterson, who wrote another book on Maria Martinez in the 1970s, recorded the experience of going with her to a museum storeroom filled with pueblo pots. Neither woman could reliably identify which of the unsigned pieces had been made by Maria and Julian, which by their family members, and which by other potters.[14]

Conflicts over individualism—the inevitable result when particular makers are treated as standard-bearers for entire traditions—also played out among the nearby

Navajo, or Diné, nation. Unlike the Pueblo peoples, who had retained most of their lands during the period of western settlement, the Navajo were subjected to extensive raiding and assault, eventually culminating in the Long Walk of 1864. This relocation, and subsequent forced internment, claimed many lives. Some of the remaining Navajo settled near army forts; their associated trading posts had access to Mexican coinage, which had a relatively high silver content. This confluence of factors led directly to the birth of a new craft. Over the course of the late nineteenth century, the

Slender Maker of Silver, c. 1885. National Anthropological Archives, Smithsonian Institution, NAA INV 02279200.

Navajo developed a whole vocabulary for jewelry and other metalwork articulated with cold chisel and stamp work. This was quite different from the lapidary techniques (cutting and polishing stone and shell) that previous generations had practiced. The Navajo even developed entirely new formats, such as the concho belt: flat disks hammered from coin metal ingots and strung on a leather thong. The necessary tools for silversmithing were either handmade from recycled metal or acquired through trade; in turn, local markets also provided a ready outlet for selling wares.

A potent portrait, taken in about 1885, has come to emblematize this formative moment in Native craft. It shows an artisan known as Slender Maker of Silver. Meeting the camera with a dead-level gaze, he proudly displays a gleaming concho belt. He wears other examples of his work around his neck, and his tools are placed on a saddlebag to one side. As the curator Henrietta Lidchi has observed, this striking photo may have been in the mind of the prominent conservationist Charles Frederick Harder in 1906, when he wrote an article for Stickley's *Craftsman* about Native artisans. Describing the Navajo, with approving condescension, as "famous manufacturers and 'good Indians'" who believed that "peaceful living is preferred to money making," Harder wrote that "It is not the jewelry which attracts one's attention, but the strong face of the worker—a type long to be remembered."[15]

In comments like this, the Native artisan was simultaneously singled out for strength of character and rendered as a type. This is true of Slender Maker of Silver's portrait, too. No less than Nampeyo or the Martinezes performing at a world's fair, his seemingly authentic presence is at odds with the artificial surroundings. Though at first he appears to be seated outdoors, perhaps offering his wares to passing tourists, in fact the photograph was taken in a studio at a military fort. The background is likely a painted cloth. Presumably, few of his prospective consumers realized that his exquisitely wrought silverwork was not representative of a deep Navajo tradition, but rather, a creative response to colonial incursion.

⁓

Authenticity takes work. It requires time and effort to construct it and constant tending to keep it in place. People go to all this effort because authenticity also has potency, which can be directed to many and varied ends. The Cliff Dwellers and the Pueblo artisans both laid claim to traditional Native culture, each in their own way. At the same time, a parallel situation was unfolding more than sixteen hundred miles east of the Pueblos, near the intersection of Hamlin Road and U.S. Highway 17 in South Carolina. On this spot today stands another historic marker, not unlike

the one near Maria Martinez's home in San Ildefonso. This one reads, SWEETGRASS BASKETS. It explains that in this general vicinity, a craft has been HANDED DOWN IN CERTAIN FAMILIES SINCE THE 1700s, making it ONE OF THE OLDEST WEST AFRICAN ART FORMS IN AMERICA. The marker also relates a more specific, and more recent, history. In 1930, a woman named Lottie Moultrie Swinton set up a chair right at the edge of the highway and began to sell her baskets to passersby. It was simple but smart marketing. A bridge had just opened connecting this rural area, known as Mount Pleasant, to nearby Charleston. Just as the train brought tourists to Nampeyo, cars brought prospective buyers to Lottie Swinton. Others in the community followed suit and set up more permanent stands to display their baskets. Eventually, the road would be known as the "Gullah Highway."[16]

The Gullah people, who inhabit the coasts and sea islands of South Carolina and Georgia, are celebrated for their unusually complete cultural inheritance. Historically, they have been rice farmers—little else will grow in this marshy low country—and have been relatively isolated, partly because of prevalent malaria and yellow fever, which dissuaded whites from settling on their lands. After the Civil War, the Gullah had an uncommonly high level of property ownership, and they also managed to retain their plots from one generation to the next, right to the present day. The result is a distinctive regional culture, with its own foodways and Creole language—both of which, like the basic techniques of grass basketmaking, have roots in West Africa.[17]

Yet Gullah sweetgrass baskets of the type Swinton would have been selling are very modern creations. Essentially, they are made using the same technique that came to the region from Africa in the eighteenth and nineteenth centuries: a coiled foundation continuously sewn in as the basket is constructed. In earlier times, the forms generated had been utilitarian agricultural items, such as rice fanners, broad and flat in shape, employed in winnowing chaff from grain. The principal materials were bulrush stalks and sometimes split oak, sewn with split palm leaf or raffia—so durable that the same combinations could be used for roofing and walling.

At some point—perhaps as early as the 1890s—Gullah makers in Mount Pleasant began to use finer materials in their baskets: slender sweetgrass and palmetto strips, sometimes with a decorative overlay of dark and light pine needles. While these were certainly still functional to a degree, they were locally known as "show baskets" and served a primarily ornamental purpose. It was these that tourists pulled up in their Model Ts to purchase. By the time Swinton set up her stand, the basket cottage

industry had already been commercialized by a white Charleston entrepreneur named Clarence Legerton, South Carolina's answer to the southwestern trader Thomas Keam. In 1916, Legerton set up his Sea Grass Basket Company, soon after rebranding it to the more modish-sounding Seagrassco. He reportedly paid artisans twelve dollars for enough baskets to cover a bedsheet, then sold their work at a 90 percent markup. Against this backdrop, Swinton's move to the roadside looks even cannier: She was cutting out the white middleman.

Meanwhile, another African American craft in the area was facing difficulties. The same automobiles that constituted such a good business opportunity for basket makers were disrupting the blacksmithing trade. The disappearance of horse-drawn vehicles and wooden wagons meant a sudden drop in business: no horseshoes to make, no saddle and bridle fittings to repair, no rims for wooden wheels to fit. Across the country, artisans made a difficult transition, turning their forges into auto body shops—a transition memorably captured in Buster Keaton's 1922 short film *The Blacksmith*. (At one point, Keaton inadvertently smears engine oil all over a horse's pristine flank, a sign of the changing times.) The best-documented example of this shift in the Charleston area is a shop that had been established prior to the Civil War by Guy Simmons, an enslaved artisan. After emancipation, his son Peter Simmons inherited the shop, and eventually moved it to downtown Charleston. In 1925, Peter took on a thirteen-year-old apprentice named Philip Simmons (no relation).

Just as Philip began learning the trade, it all but disappeared. He responded creatively, shifting from the carriage trade to more skill-intensive architectural metal-work: decorative gates, railings, and window grills. He became a self-taught specialist in the techniques and styles of the historic city. "You got to study this thing," he told a later interviewer. "Put a lot of time in studyin' it. Just like you get books on Charleston—study the wrought iron—I walk around here and see what the other man got." At a time when American decorative art history was in its infancy, resto-ration artisans like Simmons were the most expert authorities on their subjects. Over the course of his career he worked on hundreds of metalwork elements on buildings all over town—in many cases, replacing or repairing the handwork of enslaved arti-sans of past generations. By the 1950s, he was the one and only blacksmith registered in the city directory.[18]

While some southern craftspeople, like Swinton and Simmons, found ways to continue in their trades, many other African Americans concluded that they would be better off elsewhere. Amid the post-Reconstruction reassertion of white supremacy,

lynchings and other forms of violence were commonplace, disenfranchisement and segregation nearly universal, and economic opportunities thin on the ground. Beginning in the 1890s, the South was also struck by a cotton blight caused by a pest called the boll weevil, which devastated plantation agriculture. The result of all these pressures, the Great Migration, was a demographic transformation of awe-inspiring scale: About 1.5 million African Americans left the states of the former Confederacy for points north and west. Many did find greater prosperity, but also profound new challenges. Migrants were leaving an agricultural economy and arriving in rapidly expanding metropolises. Former sharecroppers (much like rural Irish immigrants who had settled in the same cities during the Famine years of the 1840s) lacked marketable skills. Those Black migrants who did have artisan trades faced open prejudice on the part of employers and labor unions and often remained trapped in low-income laboring and service jobs.

Even so, many African American migrants prevailed through force of will and craft. Casiville (Charlie) Bullard, born in 1873, had worked the cotton fields of Tennessee as a child, but was then taken on by his brother-in-law in Memphis and taught the masonry trade. Though educated only to the third grade, he was reportedly a mathematical prodigy, able to read a set of blueprints and calculate the amount of bricks, mortar, sand, and other materials that the building would require. When a rash of lynchings in Memphis triggered a northward exodus, Bullard joined the flow, arriving in St. Paul, Minnesota, in 1902. Initially he could find work only as a porter, but eventually he managed to land a job as a skilled bricklayer. He joined a local union and established himself as an independent contractor, eventually mastering the crafts of carpentry and stonecutting. Bullard was legendary for his facility; one man who watched him work later remembered his skill with a hammer: "He'd measure where he wanted the brick to fit and—bing—just knock the corner right off. That alone, shows his skill."[19] St. Paul is filled with buildings that he helped to construct, from the State Capitol to his own house, which he confidently built in an otherwise white neighborhood. Bullard was exceptional in many ways; he joined the Great Migration relatively early and was able to parlay his skills and business acumen to achieve a level of prosperity that eluded many. But stories like his show why so many Black people went north: Despite an intimidating range of obstacles, there was at least an opportunity to succeed.

They also help to explain why educators remained devoted to vocational training for young African Americans. In 1904, a racist segregation law was passed in Kentucky, making it illegal for whites and Blacks to study together. Berea College, founded as

an integrated school in the years before the Civil War, was forced to capitulate. African American students were relocated to the newly founded Lincoln Institute, which adopted the Tuskegee model in the face of heated criticism. The editor of the *Kentucky Standard*, echoing the arguments of W. E. B. Du Bois, warned that its Black students would be fated to be "hewers of wood and drawers of water" for wealthy whites. In reality, the picture was more mixed. While only one fifth of Lincoln students managed to continue on to college—and as late as the 1940s, not a single Kentucky university offered professional or graduate courses to Black students— the institute did have its success stories.

One of the first boys to enroll there was Whitney Moore Young. He arrived in the Booker T. Washington mode, carrying all his worldly belongings in a sack. After graduating from Lincoln, he joined the Great Migration, finding work as a railway engineer in Detroit; he also served in the Great War, fighting in France for thirteen months. Up until then, his life story was like that of many African Americans of his era. When his tour of duty was over, though, Young did something surprising: He returned to the South, and to Lincoln, as the school's engineering instructor. The environment was hostile, to say the least. "An occasional cross was burned within sight of Lincoln Institute," one historian of the school writes, "and Young sometimes slept with a pistol under his pillow." But he stayed, and eventually was promoted to be the school's first African American president, transforming the institution into a showcase for that now-traditional value, "the dignity of honest manual toil." And his legacy was impressive indeed. During World War II, Lincoln became an important training site for radio technicians in the U.S. Signal Corps. Young's son, Whitney Jr., who also attended the school, would go on to be one of America's prominent civil rights leaders. He helped to organize the March on Washington of 1963, formally known as the March on Washington for Jobs and Freedom, which culminated with an address by Martin Luther King Jr. rolling like thunder across the National Mall. His words were freighted with the unrealized hopes of every man, woman, and child of the Great Migration: "I *still* have a dream . . ."

～

As African Americans struggled to define their place in the newly industrialized economy, some white southerners, in a curious reversal, began to look at Hampton and Tuskegee as a model to emulate for themselves. Among them was a group of intellectuals known as the Southern Agrarians. This affiliation of historians and literary figures came to believe that a modernizing "New South" had turned its back

Whitney Young at Lincoln Institute, 1940s. Caufield & Shook Collection, CS 125285, Archives and Special Collections, University of Louisville.

on the region's true values. In an influential anthology entitled *I'll Take My Stand*, published in 1930, twelve authors connected to the movement expressed their fears that the South would become just an "undistinguished replica of the usual industrial community." They called for a recommitment to agricultural traditions, celebrating the "mighty variety" of farm life, and proclaimed their preference for "religion to science, handcrafts to industry, and leisure to nervous prostration."[20]

One essay in *I'll Take My Stand*, by the Arkansas poet John Gould Fletcher, applied Southern Agrarian thinking to the question of education. He took a condescending but ultimately positive view of Black vocational schools as "adapted to the capacity of that race," producing "far healthier and happier specimens of it than all the institutions of 'higher learning' that we can ever give them." He also advocated similar craft-based education for southern whites. Otherwise, he thought, they would be subjected in high school to the same standardized and soulless experience

that they would in a mass-production factory. "Conventional schooling," he wrote, "can produce more of a fool than the meanest farm laborer, who knows, with precision, from the lore handed down by his fathers, when it is likely to rain, when to sow and reap, and what to give his cattle when they are ailing."[21]

To be sure, there were despicable aspects in the Agrarians' thinking. The so-called historian Frank Lawrence Owsley, in particular, was a virulent racist who believed that slavery had been beneficial to Africans, civilizing people who "could still remember the taste of human flesh."[22] He thought that Reconstruction had been a monstrous imposition on states' rights and was not alone among the Agrarians in supporting ongoing segregation. Yet *I'll Take My Stand* also contains rhetoric echoing that of the Arts and Crafts reformers: "The first principle of good labor is that it must be effective, but the second principle is that it must be enjoyed. Labor is one of the largest items in the human career; it is a modest demand to ask that it may partake of happiness."[23]

This conscription of craft to white identity politics—which was by no means exclusive to the Southern Agrarians or, for that matter, to southerners—needed a pure strain, a historical wellspring for its claims to authenticity. This undisturbed source was found in the Southern Highlands, a thickly wooded, picturesque, and occasionally impassable stretch of the Appalachian mountain range. Politically speaking, the region was neutral ground. It had strong cultural connections to the South, but much of it had remained loyal to the Union during the Civil War—a "secession from the secession" that had, among other things, led to the formation of the state of West Virginia.

At the turn of the century, large-scale coal mining was just getting under way in the Highlands, transforming its economy. But reformers largely ignored this nascent industrial development. Instead, they treated the region as if it were an outdoor museum filled with perfectly preserved specimens. One travel writer from the North, memorably describing it as the "housetop of eastern America," claimed that the "mountain folk still live in the eighteenth century . . . enmeshed in a labyrinth that has deflected and repelled the march of our nation for three hundred years."[24] This supposed isolation inspired a contradictory reaction among craft reformers; they were at once impelled to glorify craft and rescue those trapped within it. Though the idea would have astonished people at the time, in retrospect, it's easy to see parallels with what was happening among the Puebloans and the Gullah people. In each case, the desire to find authenticity led, paradoxically, to innovation.

Missionaries and social workers began working to relieve poverty in the Highlands in the late nineteenth century. Among them was a diminutive Yale-educated minister's daughter named Frances Goodrich. A few years after she first arrived in North Carolina in 1890, a generous local gifted her an antique coverlet in a mesmerizing "eye-dazzler" pattern. Its dark threads had been dyed brown with oak bark, and the fabric woven in an overshot technique, in which supplementary wefts float over a plain weave. Goodrich had already intended to involve local women in producing craft as a means of increasing their income. Though the coverlet that inspired her was not a specifically southern type—similar textiles were woven up and down the East Coast—she believed that it was, and embraced it as a model, recruiting women to re-create it. Goodrich's rationale was threefold: first, to provide a direct means of income; second, to preserve purportedly local traditions; and third, to build the character of her individual suppliers. As she put it, "a slack-twisted person cannot make a success as a weaver of coverlets."[25]

But there was a problem. Involving local women in textiles was fine in theory, but in practice, few of them had the relevant skills. Households had abandoned their looms decades earlier, as soon as inexpensive store-bought cloth had become available. This meant that Goodrich was not so much preserving a tradition as starting one, and this of course required considerable creativity. She first located an old loom, "stored away in a barn loft," and then tracked down a few old women who knew how to use it, traversing the mountains on her pony, Cherokee. Within a couple of years, she had established a company called Allanstand Industries. It was organized as an outworking system, strangely similar to those of the early Industrial Revolution. She provided standardized patterns to the weavers and then retailed their work—initially from a roadside market and, eventually, at a store in Asheville and through mail order. Goodrich created a success while marketing her products as genuine folk art, gradually supplementing the coverlets with quilts, brooms, baskets, chairs, and dolls.[26]

A parallel effort was under way at Berea College in Kentucky. In the early 1890s, well before its legally enforced expulsion of Black students, the school had already started refashioning itself in rustic regional garb. The school's newly arrived president, William Goodell Frost, was an evangelical minister from upstate New York. By the standards of the South at the time, he was no racist; his childhood home had been a stop on the Underground Railroad, and he arrived in Berea fully intending to carry on the college's legacy of integrated education. He changed his mind once faced with the reality of Jim Crow and the naked hostility of the state legislature.

His early experiences in the mountains convinced him that whites, too, were in need of "uplift"—and this became his rationale for a racial reorientation of the school. In fact, Frost had a caricatured view of the local Appalachians he intended to help, describing them as "religious, truthful, hospitable, and much addicted to killing one another." He also saw them, crucially, as anachronisms, "leading a life of survivals [sic], spinning cloth in a manner of centuries ago, and preserving many fine Shakespearean phrases and pronunciations; they may be called our contemporary ancestors." In keeping with this stereotype, much of the college's quarterly magazine was written in an invented mountain dialect.[27]

Frost also started a craft program at Berea called Fireside Industries. Its stated purpose was to "preserve so far as possible the simple life of the mountains, and to build upon what is best in their present customs and traditions."[28] In fact, as at Allanstand, its products were a mixture of identifiably Appalachian forms, such as ladder-back chairs, with more generic Americana. On one occasion, thinking he could outsource coverlet manufacture much as Goodrich was doing, Frost asked a local weaver if she could furnish six within a month. "President Frost," she replied, "we will have to raise more sheep, shear them, pick and wash the wool, card it and spin it, then collect the bark and sich to color it. Then we will have to have the loom all set up, fix the warp and beam it, then get a draft and thread the warp for the pattern we want, then tie up the loom, and then we will be ready for the weaving . . . It would take we'uns nigh one year or more to afore we could have that many kivers [covers] wove." Frost loved this story; he called this his "first lesson in weaving."[29]

Many were inspired by Allanstand and Berea, among them Olive Dame Campbell, who in 1925 established the John C. Campbell Folk School, named for her late husband. The couple had first become involved in the handicraft revival as researchers for the Russell Sage Foundation, a northern charity created by Margaret Olivia Slocum Sage, the widow of a wealthy financier and railroad magnate. The foundation worked across the country aiming to relieve poverty, and its program in the Highlands recalled northern philanthropists' efforts on behalf of African Americans in the Reconstruction era. Russell Sage operatives fanned out through the mountains, gathering information and dispensing aid. The Campbells approached this work indefatigably, attempting to penetrate the mythology of the region and determine its people's true living circumstances.

After John Campbell's death in 1919, Olive Campbell compiled their research into an information-packed report, which she generously published under his name.

It is an unusually clear-eyed document, describing the region as "a land of romance, and a land about which, perhaps, more things are known that are not true than of any part of our country." She included statistics on illiteracy, death rates, and homicide (which, she found, was closely correlated to coal mining activity). She included an extended, non-romanticized discussion of the region's notorious clan feuds. She discussed the region's compelling music, sung ballads and dance tunes played on the fiddle, banjo, and dulcimer. And she included numerous photos and descriptions of craft activity, including the recent revival of quilting, basketmaking, and spinning—which women could do between other household and farming tasks. While obviously entranced by the quaint atmosphere of these literally "fireside industries," Campbell concluded that the constantly interrupted rhythms of the work made the "output small and uncertain." The handicraft revival as it currently stood, in her view, was not "one which promises an independent living to a large number of women."[30]

The John C. Campbell Folk School was her attempt to remedy this economic situation. It was another hybrid, drawing from Allanstand, from Berea, and from model folk schools (folkehøjskoler) that Campbell had visited on a recent trip to Denmark. A few years later, she initiated a cooperative called Brasstown Carvers. She had noticed mountain boys and men whittling as a pastime, and thought that with sufficient organization, she might be able to monetize it. And she was right: One married couple affiliated with Brasstown, Bonnie and Hayden Hensley, derived their primary income from their wood carvings throughout the Depression. They earned enough to buy a new home, which they called "the house that carving built."[31]

One of Campbell's close allies was a woman named Lucy Calista Morgan, born in 1889 in the mountains of North Carolina—uniquely among the leading Highlands craft reformers, she actually hailed from the region. "Miss Lucy," as she was always called, had first become involved with crafts through a local Episcopal industrial school and had learned to weave in the Berea workshops. In 1929, just a few years after the opening of the Campbell Folk School, Morgan founded the Penland School of Handicrafts (now the Penland School of Craft). Its summer program would eventually become the most influential of all American craft summer programs. Initially she pursued the same strategy that Goodrich and Campbell had in their work, taking on local women and teaching them weaving and other crafts with Appalachian roots, such as natural dyeing. Penland also taught techniques with no particular regional association, like molded pewter.

Miss Lucy had wider horizons, however. In her memoir, she said that she had been inspired to begin the school during a visit from Edward Worst, an authority on textile technology who had originally learned his trade at the Lowell mills. "One my most joyful memories," Lucy wrote, was "seeing Mr. Edward F. Worst of Chicago—North Shore Drive, Art Institute, Marshall Field, Al Capone, stockyards, political conventions, booming business, roaring traffic—happily engrossed in the exchange of ideas with Aunt Cumi Woody, who dressed in a basque and full skirt, parted her hair in the middle, and combed it evenly into a bun at the back of her neck. It always seemed mighty American and so right to me."[32] This image of worlds colliding and minds meeting, with craft as a bond, was intrinsic to Morgan's vision for Penland. Rather than adopting the tried-and-true approach of working only with locals, she engaged in national (and eventually international) outreach. Through the 1930s, students came in increasing numbers. Worst's weaving instructions were the main draw, though classes in basketry, pottery, leatherwork, and wood carving were also offered. Morgan was thrilled to see more "city folk and country folk" learning from one another, on an egalitarian basis. And she took the mountains to the city, too, exhibiting Penland products at the 1934 Century of Progress International Exposition in Chicago. She even brought with her a small log cabin, transported from North Carolina and reassembled on site. A visitor to the Expo could have bought a Penland weaving and a Martinez blackware pot on the same day.

The unexpected significance of Chicago to the early years of Penland is appropriate, given that the mountain craft reformers were performing a rural version of Jane Addams's work at Hull-House. Like Addams, they drew on Arts and Crafts movement ideas to explain and ennoble their efforts. This was particularly true of Allen H. Eaton, a curator from Oregon who emerged as the Highlands craft revival's principal spokesman. While women such as Frances Goodrich, Olive Dame Campbell, and Miss Lucy Morgan did the teaching and the grassroots organizing, Eaton formulated an intellectual framework. (Folk craft, like seemingly any subject, could be "mansplained.") In 1926, at Campbell's invitation, he came down to North Carolina to deliver a lecture entitled "Mountain Handicrafts: What They Mean to Our Home Life and to the Life of Our Country." He invoked William Morris's principle of joy in labor and challenged the "tight-compartment idea of art still held by many people," which prioritized painting, sculpture, and architecture over other disciplines. Art, he argued, meant doing things in the richest, most fitting way possible,

regardless of what resulted: "not so much the thing that is done as the manner of doing it."[33]

Over the next few years, the mountain craft reformers worked to link local organizations and makers in a single, overarching cooperative. In 1930, these efforts culminated in the formation of the Southern Handicrafts Guild (now the Southern Highland Craft Guild), which still exists today, pursuing its founding mission of promoting local handwork. The great document of its early years was Eaton's *Handicrafts of the Southern Highlands*, published by the Russell Sage Foundation in 1937, and illustrated with luminous images by the photographer Doris Ulmann. It is an impressive and affecting account, which attends not just to the narrow details of process, but also to the vivid personalities of contemporary Highlands makers such as W. J. Martin, who "likes to whittle out animals both domestic and wild. His first whittling was a wild turkey. He is here shown with a 'chance of pigs' made from apple wood."[34]

"Granny Greer" at her spinning wheel, photographed by Doris Ulmann, c. 1932–33. Courtesy of Berea College.

Convinced that the Highlands way of life, so well preserved by isolation for so long, was threatened with disappearance, Eaton reserved his greatest praise for the practices that seemed to have the deepest roots. With seeming inevitability, his survey begins with that emblem of rural authenticity, the log cabin—he always claimed to have been born in one out in Oregon; and Berea, the Campbell Folk School, and Penland had all erected log cabins in connection to their craft programs. He then proceeds to discuss spinning, weaving, pottery, woodwork, basketry, and other processes. Throughout, Eaton protests any modern disruption of tradition. Coverlets: "There is no textile more inappropriate for quantity or mass display than this one." Natural dyeing: "There is probably no craft in which greater interest exists at the present time . . . nor one about which there are more erroneous ideas."[35]

The continuity between Eaton's thinking and that of the earlier Arts and Crafts movement is clear from very first lines of his book: "The time will come when every kind of work will be judged by two measurements: one by the product itself, as is now done, the other by the effect of the work on the producer. When that time comes the handicrafts will be given a much more important place in our plan of life than they now have, for unquestionably they possess values which are not generally recognized."[36] The way he expanded on this principle, however, was quite different from the thinking of William Morris and Gustav Stickley. Eaton saw that craft alone would not bring prosperity to the Highlands, and he was under no illusions as to the deprivation there (though he and Ulmann, not wishing to repel potential philanthropists, did downplay social ills such as alcoholism and domestic violence). He may even have realized—though this is not explicit in his writing—that the continuance of "old ways," picturesque yet inefficient, were to some extent responsible for the region's poverty.

Certainly, Eaton did not pretend, as turn-of-the-century reformers often did, that the Highlands craft revival could be an engine of economic development. Instead, he emphasized what he called "therapeutic value," the profound feeling of satisfaction that the stewardship of tradition offered to the maker. In short, Eaton thought that craft was its own best reward. It required no further justification. On the basis of this essential conviction, he abstracted a broader ethical importance: "The worker in handicrafts will ask himself if there are not ways by which the sense of beauty could be extended from the somewhat narrow fields of art to the broader field of human relations. And he comes to see that to ask the question is in part to

answer it." It's an appealing notion, if a vague one: Personal fulfillment, anchored in traditional crafts, will inevitably make a better society.

~

Even as he looked to the past, Eaton helped introduce something novel to the conversation about American craft: the idea that it was under threat and needed urgent protection. Even a few decades earlier, this would have seemed preposterous. Mass manufacture had long been eroding artisans' economic prospects; and the Arts and Crafts movement had certainly diagnosed decreasing exposure to handiwork as a social crisis. But craft itself was not seen as an endangered species. This is exactly what Eaton believed—of the Highlands, at least. If something were not done, he claimed, whole traditions of making would disappear, swallowed up in the mists of time. Previously, this argument had been applied only to Native Americans, in portrayals of them as the vestiges of a noble but doomed culture. In the 1920s, though, a similar—and similarly stereotypical—view began to be applied to craft in general. It was a shift in consciousness with major effects.

The most extraordinary, and extravagant, early champion of this view was Henry Chapman Mercer, a Pennsylvania scholar and collector who devoted his life to the preservation and re-creation of historic crafts. Mercer, born in 1856, was taken by his wealthy parents on a grand tour through Europe when still a teenager. A trip down the Rhine Valley, lined with picture-postcard castles, captured his imagination, as did a visit to the Philadelphia Centennial Exposition when he was twenty years old. Upon graduation from Harvard, he returned to his hometown of Doylestown, helped found a historical society there, and was appointed to a professorship at the University of Pennsylvania. He began pursuing his lifelong avocations of archaeology, academic research, and, especially, acquisition. His preferred method of learning about something was to buy it—everything old he could get his hands on: Native American artifacts, rare books and prints, every type of useful artifact imaginable. Often, he acquired objects in "penny lots" at country sales, in which a mass of useless stuff was sold for virtually nothing. Of particular interest to him were decorated ceramic tiles and antique stove plates, molded in cast iron, with imagery and ornament in relief.

In 1897, Mercer staged the first exhibition of his rapidly growing material archive, filling the local courthouse with 761 antique hand tools. Though they were of various ages, he associated them with America's very beginnings, suggestively titling the

display *The Tools of the Nation Maker*. At one time, he wrote, these humble items had been the means by which the country itself was fashioned. But as the twentieth century approached, even a typical farmer might not be able to identify them: The old hand tools "grow curious in his own eyes, while to the man of cities they are things unknown." Mercer insisted that it was worth studying these "castaways" nonetheless, for the lessons they might still impart about America, "leading us by way of an untrodden path, deeper into the lives of the people."[37] The catalogue he prepared included extensive historical annotations and precise descriptions of the use of each tool, from a scythe ("You reap holding in right hand bevel down, grasping grain with the left") to a sausage stuffer ("You fill it with sausage meat, pull the entrail over the nozzle and press the wooden piston against your breast . . . Discontinued 1830 to '40").[38] Reading this compendium, a thought irresistibly presents itself: In the case of an apocalypse, this would be a mighty helpful book to own.

The exhibition in the courthouse was just the beginning. Between 1908 and 1912, he set about realizing his schoolboy fantasy and constructing his own castle. After considering various options ("Look Away Hill," "Fontrose," "Appledore"), he settled on the name Fonthill, inspired by an underground spring on the property. From a distance, the building looks like a fairy-tale palace; up close, like a military bunker. It is built principally of reinforced concrete, not a recent invention, but highly unconventional for a residential building of its time.

The glory of Fonthill is its inset tile work, including some historical Delftware and majolica, sometimes accompanied by ceramic "labels" set right into the walls. The vast majority of the tiles, however, are the product of Mercer's own Moravian Pottery and Tile Works, which had its first successful kiln firing in 1899. This ambitious craft undertaking ran alongside his collecting, and aimed at similarly didactic and preservationist goals. As he put it in 1925, "If tiles could tell no story, inspire or teach nobody and only serve to produce aesthetic thrills, I would have stopped making them a long time ago."[39] He mostly used red clay, press-molding into it patterns adapted from antique stove plates, Aztec stone carvings, and medieval cathedrals, or into Mercer's. Color was introduced by putting glaze into the recessed areas, where it would not wear with use, even on a floor. Particularly ingenious were the large-scale ceramic pictures he made, realized by projecting a design onto a grid of tiles using a kerosene-lit "magic lantern," and tracing the lines out on the surface.[40]

Moravian tiles were immediately successful and were commissioned for architectural projects ranging from the Pennsylvania State Capitol in Harrisburg to the

palatial home of collector Isabella Stewart Gardner in Boston. But it is at Fonthill that they can be seen in their fullest glory. Touring the maze-like interior of the building is like clambering through Mercer's brain; the space bursts with imagery on every surface. This includes the curved ceilings, which were made by constructing a mound of wood and sand, laying tiles facedown atop it, and then pouring wet concrete over the whole structure. When the concrete had set and the armature was cleared away, a richly decorated room was revealed. A crew of ten men refined this technique as they went along and were clearly as proud of their achievement as Mercer himself was. One ceiling rosette is surrounded by the signature of Moravian's head modeler and tile setter: JACOB FRANK POSUIT ("Jacob Frank placed me.")

Nearby is another bit of Latin, each word spelled out in the risers of a staircase: FELIX QUI POTUIT RERUM COGNOSCERE CAUSAS ("Happy is the one who knows the causes of things"). It was a fitting motto for Mercer. Even as he and his builders were working on Fonthill, they began excavating the site for a museum—a better word might be *ark*—that would expand on *The Tools of the Nation Maker* exhibit. Comprising seven stories of massive poured concrete, with a soaring central atrium capped by a ceiling crowded with baskets and boats, it opened in 1916 as the Bucks County Historical Society. Today it is known as the Mercer Museum. Even more than Fonthill, the building is the spatial equivalent of an illustrated book, organized not by chronology or geography but by individual trade. Every craft has its own dedicated gallery space—basketry, carpentry, clockmaking, coopering, printing, shoemaking, stonecutting, wheelwrighting, and on and on—each filled with tools and products and patient explanations. Mercer's beloved stove plates have their own attic display space—by this time, he had published a book about them, called *The Bible in Iron*—as do Native American artifacts. By the time of Mercer's death in 1930, the collection included more than twenty-five thousand objects, a comprehensive archive of American know-how contained in an impregnable concrete fortress.[41]

The subsequent century has proved Mercer to be prescient. Few visitors to his museum today could identify a froe maul, howel, croze, scorper, or bung auger. (All are cooper's tools.) Fewer still know how to use them. Thanks to Mercer's relentless campaign of preservation, anyone can find out. In directing his gaze so firmly backward, however, he helped to construct a new understanding of craft itself as a relic. Even his newly manufactured tiles were purposefully antiquarian, made using the techniques of a German medieval pottery rather than those of a modern ceramic factory like the ones at nearby Newark, New Jersey. Mercer had unbounded fondness

and respect for craftsmanship. He saw it as the most important anchor of American culture. Like any working anchor, though, it was sunk into the depths of culture, almost out of sight.

~

One of the more impressive displays at the Mercer Museum is a New Bedford harpooning boat, shown alongside implements for cutting blubber and even an enormous try pot straight out of Melville's *Moby-Dick*. As for so many industries across America, the Civil War had marked a turning point for whaling. Confederate raiders destroyed more than fifty of the vessels that made regular sailings from New Bedford, and the whaling business began shifting over to the West Coast, to avoid the main theater of military operations. Even worse, the nearby whale population was being decimated. Ships had to sail ever farther to find the animals, which meant a diminishing return on investment. Then kerosene and petroleum, first discovered in Pennsylvania in 1859, began to displace whale oil for lighting and industrial applications. New Bedford shifted its economy to textiles and coal. By the early twentieth century, the golden age of whaling was gone.

But not forgotten. It was idealized in books and magazines, the more industrial aspects of the port's past downplayed while its crafts were celebrated. That history was totally whitewashed: no Queequegs, all Ishmaels. Its primary architect was Clifford Warren Ashley. Born in New Bedford in 1881, he had whale oil in his blood. His grandfather had been a dockside carpenter; two of his uncles, ship captains. Ashley first established himself as a writer, recounting his own experience on a whaling voyage: "Of all pursuits, it has preserved to the greatest degree its original picturesqueness."[42] He was also a painter, specializing in depictions of the hunt and attendant trades such as coopering and sail making. As the historian Nicole Jeri Williams has written, these latter images subscribed to the Arts and Crafts ideal of purposeful, ennobling work and also expressed nostalgia for New Bedford's preindustrial waterfront, when it was still oriented exclusively to the sea. In 1916, the same year that Mercer inaugurated his museum in Doylestown, the local historical society in New Bedford opened a whaling museum. Ashley was heavily involved in the planning; he displayed his pictures in the building, then conceived a suite of replica craft workshops that brought the same subjects to life. They opened in 1923, among the first period rooms in any American museum. The dioramas provided a sanitized version of New Bedford, cleansed of any hint of past "vice and vulgarity," as Williams

puts it, and a remedy to the port's grimy industrial present: "the new filth of the factories, their soot-belching plants, and squalid immigrant workers."[43]

Though his concerns were local, Ashley was in perfect lockstep with national trends. In the early 1920s, as he was crafting his romanticized version of New Bedford, the past was in vogue throughout the country. This Colonial Revival was, to a remarkable degree, forged in America's museums, still a relatively new presence in the civic order. Even more remarkably, it was orchestrated and bankrolled by the nation's wealthiest families, shapers and beneficiaries of the modern factory system. The Metropolitan Museum of Art's leading early patron had been J. Pierpont Morgan, America's richest financier; its American Wing, which opened to great fanfare in 1924, was built on a foundational gift of six hundred objects from Margaret Olivia Slocum Sage—the same woman who had put her late husband's railroad fortune toward the cause of relieving poverty in the Southern Highlands. Henry Francis du Pont, who built one of America's finest collections of early decorative art and, between 1928 and 1931, an enormous mansion to house it (today's Winterthur Museum, in Delaware), derived his wealth from his family's gunpowder and chemicals business.

Henry Ford also was an avid collector of Americana. (He visited Henry Chapman Mercer at Fonthill and sometimes competed with him for purchases, to Mercer's annoyance.) In 1933, Ford opened to the public a museum to show his collection and an associated historic site called Greenfield Village, located in Dearborn, Michigan, with the goal of re-creating Colonial times. It was just a few miles from his enormous River Rouge automotive plant. The juxtaposition was perplexing. An editor at the *New York Times*, after touring the village in Ford's company, mused, "It was a strange sensation to pass old wagons while walking with one who had rendered them obsolete. The Dearborn collection of spinning wheels, Dutch ovens, covered bridges and other relics of an early American past is the work of a man whose life mission has been to take us away from that past as quickly as might be."[44] Ford explained this seeming contradiction by appealing to a narrative of progress. From his perspective, early craftsmanship was important not in and of itself, but as a moral lesson about the American drive to improve. A pamphlet circulated by Greenfield Village in its early days, entitled *Looking Forward Through the Past*, suggested that visitors should measure the technical achievements of the present day in relation to past handicraft and see the two as part of a single evolution: "Look at the blacksmith shop of seventy-five years ago. The smithy with its bellows, forge, and anvil is one of the lineal ancestors of the great automobile plants of today."[45]

Ford's chief counterpart in the campaign to rewrite the American past was John D. Rockefeller Jr., heir to his father's Standard Oil fortune. He was among the most active philanthropists in America at the time and, like Ford, animated by seemingly contradictory impulses toward old and new. On the one hand, he was the lead investor in the stylishly progressive art deco complex in Manhattan that still bears his name, Rockefeller Center. Yet he spent considerable time and money in restoring the architecture of Williamsburg, Virginia, transforming it into an idealized theater set. Thanks to the economic lassitude that this part of Virginia had experienced after the Civil War, the town's eighteenth-century architecture had survived relatively intact. Once modern accretions were edited away and some historic properties rebuilt, and its shops and streets populated with costumed interpreters, the town became one of America's top tourist attractions.[46]

Like Ashley's New Bedford, though at a far grander scale, Rockefeller's Colonial Williamsburg presented a very partial view of the past, "planned, orderly, tidy, with

A costumed interpreter at Colonial Williamsburg, Virginia, 1937. F. S. Lincoln, Condé Nast Collection/Getty Images.

no dirt, no smell, no visible signs of exploitation," in the words of one historian.[47] Its public facilities were racially segregated, like the rest of the South at the time, and African Americans were not employed except in narrowly circumscribed roles, such as liveried carriage drivers. (The museum's first programs about slavery would not be in place until 1979.) Ironically, the restoration work on the site actually did follow historic precedent, as Black artisans were brought in to do much of the manual work. One brick mason, named Babe Sowers, recruited from a farm near Winston-Salem, was legendary for his speed and prowess, molding four thousand bricks per day, about twice the usual rate.

But once the park opened, visitors did not meet local artisans like Sowers. Instead, they encountered men like Max Rieg, a German silversmith who had trained at the Bauhaus and continued to produce modernist designs in his spare time, but was game enough to don period attire and demonstrate historic skills to interested schoolchildren.[48] His successor in the silversmithing shop was William De Matteo, an Italian immigrant who had acquired his skills working for the Massachusetts metalware manufacturer Reed and Barton. De Matteo's account of the working atmosphere at Williamsburg reads like a film director's script: "The shop's dark wood-work, as if smoke-begrimed from the smelting forge, the ring of the master silver-smith's hammer against sonorous metal . . . all these sights and sounds truly represent and recreate another age."[49] As the involvement of men like these suggests, the tendency at Williamsburg was to rely on people with modern know-how, and encourage them to act a historical part. This was not wholly unlike the situation in the Highlands, where the industrially trained Edward Worst was considered the authority on weaving. But the narrative was very different from that at Penland. Rather than trying to preserve historic craft as a living tradition, Rockefeller was interested only in its outward appearance. For his patriotic purposes, all that was needed was a compelling evocation of America's supposedly simpler past.

Williamsburg's popularity, along with a general craze for antiques, made for an irresistible business opportunity. The first to grasp it was a company called Tomlinson, located in the town of High Point, North Carolina, which had recently established itself as a center for mass-produced furniture. In 1936, Tomlinson unveiled a new set of "Williamsburg Galleries" at the Chicago Merchandise Mart, without permission from the museum. The pieces were made entirely with modern techniques and equipment—joints were made with dowels and glue rather than hand-cut dovetails, for example. The unlicensed use of their employer's name outraged the staff at

Colonial Williamsburg and spurred them into action. As they lacked the resources to make a commercially viable line themselves, they contracted the Kittinger Company of Buffalo, New York, to create what might oxymoronically be called "authentic reproductions," based on original pieces that were shipped to the factory to be copied.

Advertisements for the Kittinger reproductions, launched in January 1937, described them in quasi-religious terms: "silent sermons of the lasting power that lies in genuine beauty and sincerity."[50] They were also rich in detail. "If a table top is reinforced with twelve hand-cut locks," one ad ran, "the twelve are seen in the reproduction. The exact curve in the line of the legs of a chair is reproduced. Wrought iron nails fasten the piece together. Hardware is identical in design and even thickness. In other words, the craft idea is revived in the 20th Century as nearly as it existed in the 18th." If all this sounds too good to be true, that's because it was. The furniture historian Charles Alan Watkins has studied surviving examples from the Kittinger line and found that they were made using band saws and duplicating lathes. Open up a joint and you will find, yes, a machine-grooved dowel. In one instance, Kittinger even obtained brass hardware from a company that had furnished Colonial Williamsburg with its replacements; he then advertised that they matched the originals exactly. The museum's licensing team seems to have lacked the artisanal expertise to notice any of this chicanery. They were more concerned about cutting costs: "There is great interest in our furniture but definite resistance to what the buying public refers to as 'awfully high' prices . . . You will hear it from the rich on down to the school teachers."[51]

The reality was that the buying public had little concern for accuracy. People furnished their homes in the Williamsburg taste because they admired "the opulent culture of those plantation gentry who had caught the ease and comfort of graceful living," as the architect Alfred Bossom put it.[52] Their instincts were aspirational, not archaeological. Just like the Arts and Crafts movement, whose ideals were hard to put into practice but made for great marketing copy, the Colonial Revival was more a style trend than a revolution in manufacturing practices. This flummoxed some of its protagonists. At the opening of the American Wing at the Metropolitan Museum in 1924, the museum's president, Robert de Forest, mused that Colonial decorative art "has been crowding the antiquity shops and invading the auction rooms. It has become a commercial product. Perhaps we have helped to make a market for it to our own undoing."[53] By 1930, though, the Met had formed its own "industrial contact"

team to coordinate reproductions, and de Forest had changed his tune. "Thanks to machinery," he said, "hundreds of thousands are now beginning to appreciate the best in the 'early American' styles where otherwise only hundreds could have."[54]

A starchy New England minister named Wallace Nutting was way ahead of him. Among the first to capitalize on the Colonial Revival, Nutting had built a large collection of Americana in the 1910s, well before the style's rising popularity drove prices up. He then leveraged his antiques to various profitable ends. Nutting published illustrated books such as *Furniture of the Pilgrim Century* and *A Furniture Treasury*, which became influential guides for other collectors (though they were riddled with fakes and inaccuracies). He produced staged photographs, using his furniture as props, often showing a young woman involved in some virtuous fireside activity. Hand-tinted in pastel shades, these images portrayed Colonial life through a sickly sweet veil of sentimentality. They bore more than a passing resemblance to film stills, and sold in the millions.

Nutting manufactured replicas in three separate furniture factories, all located in Massachusetts, using pieces published in his books as models. He also forged a strong association with Berea's Fireside Industries, first as a financial benefactor and then as a sort of creative consultant, helping to build the furniture program there. (When Nutting died in 1946, his company was willed to Berea College.) In his craft dealings, he claimed to be a stickler for authenticity, and handed down Ten Commandments to his workers, among them "If the work can be done better by hand, do it that way," and "Follow the sample strictly, take no liberties." But once again, the rhetoric was at variance with the reality. The curator Thomas Denenberg, who conducted an extensive study of Nutting's life and work, has discovered that he, too, used standard machine production techniques. He was also more than willing to adapt historic forms to modern uses, like office furniture, despite his proclamations that such hybrids were "humbug" and "mongrel."[55]

That last word, with its implication of an impure racial stock, is a reminder of the close connection between the Colonial Revival movement and conservative, even xenophobic attitudes. The fictional past devised by Ashley, Ford, Rockefeller, and Nutting was a counterpart to other techniques of "Americanization" that gained ground in these years, aimed at immigrants entering the country (and working on assembly lines) in unprecedented numbers. These were the years that the metaphor of the "melting pot" came into general circulation, popularized by a 1908 play of that title; in one scene, its main character declares, "Germans and Frenchmen, Irishmen

and Englishmen, Jews and Russians—into the Crucible with you all!"[56] Advocates for cultural assimilation picked up this artisanal metaphor and ran with it. "Let us acknowledge the excellence of the metal flowing white hot to us from other lands," Frank Cody, the superintendent of Detroit schools, said in 1921, "and seek by intelligent effort to direct it into the American mold."[57] Nor was this idle talk. In cities like Detroit, the educational system was transformed into a tool of acculturation, with night classes in English and civics offered to adult learners. Immigrants were met with a homogenous American ideal wherever they looked: in the factory, the museum, and the school alike.

Ironically, though, the Colonial Revival could not have done without immigrants, particularly Jewish families from eastern Europe. Boston's leading collector of Americana was Maxim Karolik, an Orthodox Jew from Romania and an accomplished opera singer. He married into wealth and, together with his wife, built a period-style home which he furnished with antiques. The couple later gifted the collection to the city's Museum of Fine Arts, where it forms the core of the American collections to this day.[58] The commercial antiques trade in its formative years was dominated by Israel Sack, who was originally from Lithuania. On arriving in Boston in 1903, he opened a furniture repair shop and then gradually began dealing in decorative art. By the time he moved to New York in the early 1930s, he had constructed a canon of American furniture that collectors and museums dutifully followed—memorably sorted by his son Albert into the categories of "good, better, best."[59]

Boston was also the adopted home of Isaac Kaplan, a furniture maker who arrived a year after Sack did, in 1904, and hailed from a part of Russia just across the border from Lithuania. Kaplan's career as a Colonial Revivalist began when a client asked him to copy an old chair, presumably to fill out an incomplete set. This gave him the idea of selling duplicates, which he did very successfully through the local department store Jordan Marsh and other retailers. He hired a diverse workforce, made up of other eastern European Jews, Italians, Portuguese immigrants, and African Americans. It was a smart business decision—in all these demographics, there were artisans who were both skilled and underemployed—but one that Kaplan certainly did not advertise, instead describing his workshop simply as a "repository of good tradition." When not copying an antique piece directly, he drew from Wallace Nutting's *Furniture Treasury* and, as in Nutting's own reproduction shops, used dowel construction and other expedient techniques to get the job done. There is no doubting his workforce's skills, though; in 1937, they produced a series of furniture

at one-sixty-fourth scale, carving them with dental tools. Two years later, these miniature masterpieces were a hit at the New York World's Fair.[60]

It's possible that Kaplan launched into the miniatures business because of the success of another, much more ambitious project: the fully decorated, entirely hand-crafted, one-inch-to-one-foot scale interiors created by Narcissa Niblack Thorne. These miniature rooms, today one of the prime attractions at the Art Institute of Chicago, are the ultimate expression of the period's historicist theatricality. Narcissa Niblack was born to wealth in Indiana, in 1882. She married into more of it, wedding James Ward Thorne, son of a co-founder of Montgomery Ward and Co., in 1901. Growing up—like the young Henry Chapman Mercer before her—she was brought along on tours to Europe and fell in love with the castles and mansions she visited. At some point in the 1920s, she became interested in the challenge of making minia-tures. Responding to the current vogue for period rooms in museums, she began researching and executing a series of shadowbox rooms, initially based on European styles and eventually progressing into the American Colonial period and nineteenth century. For the interior paneling and other architectural elements, Thorne conflated elements from multiple real buildings and added some passages of pure invention. She sourced the furnishings in various ways, buying some from professional minia-turists and occasionally finding antique material that would suit, such as silver and ceramics made for dollhouses and portrait miniatures that could play the part of full-size paintings.

With these exceptions, everything was made in Thorne's Chicago studio. She did a great deal of the work herself (particularly needlework for bed hangings, carpets, and other textiles) and also hired architects to make detailed plans and artisans to work to her specifications. Among these craftsmen was Eugene Kupjack, who got his job after he read about the rooms in the paper and mailed Thorne a tiny caned chair and a "glass" goblet (actually Lucite) that he had made. The level of detail Thorne's team achieved is astonishing, more akin to the realm of precision instruments than home furnishings. Her Massachusetts drawing room miniature, emulating an interior of 1768, includes a tall case clock that actually tells time and a secretary desk with more than thirty minuscule drawers; one even has a secret compartment. Another has a tiny clipper ship inside an inch-long glass bottle sitting on the mantel-piece. Thorne repurposed pennies to make copper trays and had faux porcelain carved in ivory.[61] Taken as a totality, the rooms offer not just a view of elite taste over

the centuries, but a dense repository of skill, all in the service of edification and astonishment.

~

The Thorne Miniature Rooms present a strange paradox: enclosed and airless in their perfection, yet seductive as vehicles for the imagination. It's a combination that recurs again and again in early twentieth-century craft, an era when making was very often tied to make-believe. From the Cliff Dwellers' parties to the turrets of Fonthill to the lanes of Colonial Williamsburg, craft was claimed as a secure anchor for American identity even as it was employed to theatrical effect. This was an escapist formula. It helped Americans sidestep difficult histories of racial and class conflict and pretend that the nation was one big happy family. Yet there was at least one group of craft-intensive activists who refused to play along.

Since Susan B. Anthony and her sister protestors had stormed the Philadelphia Centennial, the women's movement had made significant strides. By 1900, four newly constituted western states (Wyoming, Colorado, Utah, and Idaho) had approved voting rights for women, perhaps a reflection of the nontraditional gender roles that prevailed on the frontier. This method of enfranchisement was painfully slow, however, and in the 1910s, a new generation of suffragists joined the cause, determined to win a constitutional amendment. The most influential of these women was Alice Paul, born to a wealthy Quaker family in New Jersey in 1885. She could trace her family lineage back to both John Winthrop, an early leader of the Massachusetts Bay Colony, and William Penn, the founder of Philadelphia. In her early years, Paul pursued the expected course for a progressive young woman, attending Swarthmore and, on graduating in 1905, joining a New York City settlement house as a caseworker. She was frustrated with the limited impact of this strategy, however; unlike Jane Addams, she doubted that genuine change for women could be achieved at neighborhood scale. Her moment of radicalization arrived while she pursued further study in England. She came into contact with the suffrage movement there and had her first experiences of protest—not to mention of imprisonment, a hunger strike, and the traumatic experience of force-feeding.

Paul's experiences in Great Britain convinced her that a more confrontational approach was required; it also exposed her to tactics that would prove extremely effective back in America. Paramount among these was the adroit use of the media.

Paul founded a gazette called *The Suffragist*, which reported on the progress of the movement. She helped organize pageants and carefully choreographed processions, ensuring that they were photographed and picked up in the newspapers.[62] Craft was intrinsic to these spectacles. Participants dressed as allegorical figures like Hope and Liberty, or performed in tableaus with themes like "The Age of Homespun"— Colonial Revival playacting turned to the purpose of Progressive Era politics.[63] The suffragists also carried handmade banners, sometimes simple flags in the movement's colors of purple, white, and green, but also more complex designs reminiscent of labor union emblems. Paul masterminded a press relations campaign that included photographs of herself and other women sewing these tools of the protestor's trade.

One of these images showed a woman sewing stars to a banner; it was captioned, "The Betsy Ross of the Suffragist Movement."[64] This was a particularly ingenious bit of branding, as Ross had recently become a contested figure in the culture war over American women. On the one hand, she could be deployed as a paragon of feminine virtue—a female revolutionary who knew her place and sat home sewing while the men went off to fight.[65] On the other hand, some conservatives imagined her to be a troublesome figure. One guidebook recommended omitting Ross from civic pageants, on the grounds that she had abandoned "the domestic virtues in the feverish reach for sensational publicity." Instead, tableaus should feature more feminine characters who "uphold the sweetness, charm, and sanctity of the home."[66] Paul's tactics conveyed precisely the opposite message: For the first time, she harnessed the power of American mass media to mobilize craft as a political instrument. As suffrage crested into an unstoppable tide—first in Washington (1910), then California (1911), then Arizona, Kansas, and Oregon (1912), and onward to the East Coast—Paul created a "Ratification Banner" in the movement tricolor. A star was added each time a state approved votes for women. When the Nineteenth Amendment finally passed in 1920, guaranteeing women the franchise nationwide, Paul sewed on the final star herself.

The suffrage movement had its prejudices, too. In particular, it was inhospitable to Black women's participation. As African American voting rights in the South were eradicated through a combination of violence and Jim Crow laws, white suffragists worried that welding themselves to another civil rights movement would impede their own progress. Black women were typically excluded from suffragist pageants. On one occasion, the pioneering African American campaigner Ida B. Wells had to

National Woman's Party activists watch Alice Paul sew a star onto a flag, representing a state's ratification of the Nineteenth Amendment, c. 1919–20. Records of the National Woman's Party, Manuscript Division, Library of Congress, Washington, D.C.

refuse point-blank a request to march at the rear of a women's rights parade, as if she were boarding the back of a bus. This racial divide was typical of women's organizations at the time. The Daughters of the American Revolution is one example. It had strong connections to the suffrage movement—Susan B. Anthony and Alice Paul were both members—and followed the Hull-House model by opening an immigrants' craft shop in Chicago, in the hope of "making a bond between new Americans and the old, old stock."[67] Yet the DAR did not allow Black women to join its ranks. In keeping with the general tendency of the Colonial Revival, it painted a picture of the nation's founding in just one color.

Racism also shadows the early years of the Girl Scouts of America, another women's organization that was formed in this era. It was founded by Juliette Gordon Low in 1912, two years after the Boy Scouts, and like its male counterpart, it initially had a policy of racial segregation. Though neither explicitly restricted membership

to white children—an independently run scout troop for African American boys was set up in North Carolina almost immediately, in 1911, and a social worker named Josephine Holloway created one for girls in Nashville, in 1924—the leadership of both organizations stubbornly resisted Black participation until well after World War II. The scouting movement also had at its very center a problematic appropriation of Native American culture, which has survived right down to the present day. This aspect of the movement had its roots in an organization called the Woodcraft Indians (later renamed the Woodcraft Rangers), founded in 1902 by Ernest Thompson Seton. His thinking was right in line with Theodore Roosevelt's worship of the "strenuous life," ideally lived out of doors. Seton's innovation was to adopt Native American society (as he imagined it) as a template for preparedness.

In a book entitled *The Birch Bark Roll of the Woodcraft Indians*, a compendium of material that Seton had previously published in the *Ladies' Home Journal*, he encouraged his readers (white boys and young men) to set up "tribes" and take to the woods to hunt, fish, and otherwise fend for themselves. These little bands would have their own hierarchy, with a chief at its head. They would adopt bylaws, written out in a "birch bark roll," and their camps would have a decorated totem pole and handmade tipis. Each participant would wear "as much Indian dress as he likes," and would, after his exploits in the woods, receive his own "Indian name." Seton suggested tough-sounding monikers like "Redjacket," "Big Otter," "Speardeep," and "Deerblinder," but also noted that they could be used to keep members in line. A lazy boy, for instance, might be called "Young-man-afraid-of-a-shovel."[68]

For all the absurdity of Seton's prescriptions, his influence on the scouting movement was profound. He inspired its merit badge system, its penchant for apocryphal Native wisdom—when you get turned around in the forest, for example, "you are not lost, it is the teepee which is lost"—and its basic emphasis on survival skills.[69] It is dismaying to realize that this playacting was happening even as actual Native children were experiencing enforced assimilation through the Indian school campaign. It also reflects the culturally conservative side of the scouting movement, which had as its declared aim the shaping of upright citizens who were (as the famous Scout Law puts it) "trustworthy, loyal, helpful, friendly, courteous, kind, obedient, cheerful, thrifty, brave, clean and reverent." Yet, despite its unapologetic racism, its authoritarian tendencies, and its quasi-militaristic imposition of discipline, the scouting movement could be a liberating force for the young people who participated in it.

This was especially true for Girl Scouts. Though they were instructed to learn "homemaking" skills that were not expected of boys, they also were constantly reminded of the importance of self-sufficiency and were encouraged to acquire as much competency as they could—messages that girls rarely heard in those years. Measured in terms of sheer participation, the organization may have been the most influential vehicle for women's empowerment through craft that America had yet seen.

This ethos came right from the top. Juliette Gordon Low, known familiarly as "Daisy," was born in Savannah in 1860, the daughter of a Confederate Army captain. Ironically, her first teenage attempt at craft-based benevolent work, a joint effort with several cousins called Helpful Hands, went poorly. As Gordon Low later

A girl scout troop poses with hand-sewn semaphore flags, c. 1920. National Photo Company Collection, Prints & Photographs Division, Library of Congress, LC-DIG-npcc-02710.

recalled, the club banded together to make clothing for local Italian immigrant children, but the garments fell apart almost immediately—"so we got the name of Helpless Hands."[70] Undaunted, she continued her artistic pursuits, among them painting, sculpture, and wood carving. She seemed set to have the life of an unremarkable southern gentlewoman; but then her marriage to an Englishman fell apart, ending in a separation. When her estranged husband died, she fought a successful legal battle to control his estate. Casting about for direction, Gordon Low came into the orbit of Robert Baden-Powell, a former military officer who had been influenced by Seton's work in creating the British scouting movement. She adopted Baden-Powell's methods, forming a youth group for women in Scotland and teaching them useful skills such as knot tying and wool spinning. Even at this early stage, her goal was to enable her young charges to avoid low-paid factory work and achieve a measure of economic autonomy.[71]

Gordon Low returned to Georgia in 1912 and founded her own scouting group, initially calling it the American Girl Guides, one of several competing organizations, each of which sought to claim Baden-Powell's mantle. But it was Gordon Low, whose promotional skills rivaled Alice Paul's, who prevailed. Within three years she had established a headquarters, initially in Washington, D.C., and hosted a national convention. During the First World War, Girl Scouts sewed and knitted garments for the troops. Some volunteered for the Red Cross. By 1920, there were more than eighty thousand members nationwide. The craft skills that a Girl Scout might learn were not, in themselves, much different from those taught to girls in the Victorian era. There were no merit badges offered in carpentry, leatherworking, or machinery, as there were for boys; only needlework, with an emblem of scissors on the patch. Yet the context in which Girl Scouts learned to sew was quite different. It was part of an extensive repertoire of self-reliance, including camping skills such as knot tying and tent building and athletics, including archery and rifle marksmanship, Morse code, and cycling—the last just then coming into vogue for women as a means of independence. Gordon Low also subtly manipulated gender codes of the time, informing young Scouts that "the influence of women over men is vastly greater than that of men over one another," and encouraging them not to worry about being admired, which is nothing but a "form of bondage." Instead, she exhorted them to "be strong," for "your most constant companion throughout life will be yourself."[72]

The year 1929 was a big one for the Girl Scouts. Lou Henry Hoover, who had succeeded Gordon Low as the organization's president, entered the White House as First Lady. The organization had passed the two-hundred-thousand-member mark, and launched a plan to increase that figure to five hundred thousand within five years by establishing regional offices nationwide. (It was in the context of this outreach campaign that the organization had its first cookie sale, in 1932.) In late September, the Girl Scouts lent their name to an astonishing loan exhibition of more than nine hundred pieces of antique Americana, displayed at the American Art Association, forerunner to the auction house Parke-Bernet. It ran for just two weeks, but for that short time, it was the single best gathering of early American craft ever realized. Gathered from many wealthy private collectors, including the Rockefellers and Du Ponts, the show was organized by Louis Guerineau Myers, whose wife, Florence, was on the Girl Scouts' national board. Myers was also treasurer of the Rockefeller Foundation. To this day, the exhibition is legendary among decorative art specialists for the quality and range of its displays; it lived up to Florence Myers's stipulation that "if the thing is done at all it must be done with a Girl Scout standard, which was the very best that could be done."[73]

It was also a last hurrah. On October 24, 1929, just fifteen days after the loan exhibition closed, the U.S. stock market plummeted 11 percent. Panicked bankers rushed to the money pumps and managed to temporarily shore up prices. The next day, it seemed that things had stabilized. But early the following week—now remembered as Black Monday and Black Tuesday—the bottom fell out again. The market lost about a quarter of its value, and this time it didn't recover. In hindsight, we know that the crash was the key triggering event for the Great Depression. The illusions that had held the nation spellbound were shattered.

To be sure, the Colonial Revival continued—in many suburban living rooms, it has never ended—as did enactments of Native, African American, and Appalachian authenticity. Through the strange workings of time, those pantomimes would themselves come to seem more and more authentic. People would forget how inventive their origins had truly been. All the same, October 1929 marked the end of an era. The curtain came down on an age of revivals, an age of make-believe. But in one of those odd confluences that history provides now and again, it took only two more weeks for the curtain to rise again. For on November 7, in a rented town house on Fifth Avenue in Manhattan, a new museum opened to the public. Its inaugural

Chapter 6

Making War

I N 1936, CURATORS AT THE Museum of Modern Art declared that they had made "the most dramatic discovery . . . in American art for the past several years": a self-taught wood carver and "humble day laborer of New Mexico" named Patrociño Barela.[1] The context for this proclamation was an exhibition called *New Horizons in American Art*. It was a survey of work done under the auspices of the Federal Art Project, part of the government effort to haul America's economy out of its sinkhole. This program employed thousands of artists to make murals for schools, post offices, and hospitals, as well as large-scale sculpture, graphics, and other work in the public interest. The exhibition was not enormous in scale—nor was MoMA itself, still in temporary quarters. It did, however, capture the breadth of the Federal Art Project's output.

Against a diverse and occasionally dismal backdrop—among the images on view were depictions of a homeless mission and an unemployment office—Barela's works blazed forth as if illuminated from within. The exhibition included no fewer than eight of his carvings, each fashioned from a single block of juniper pine. Most were on religious themes, recalling southwestern *santos* (Spanish for "saints"), a sculptural format handed down from colonial times. Eschewing the bright color and narrative detail typical of this tradition, however, Barela left his compositions bare—simply massed rounds and hollows retaining the outer contours of the logs from which they were excavated and clothed in nothing but potent spirituality. One exceptional work included in the MoMA exhibition, which he entitled *Hope, or the Four Stages*

Irving Rusinow, *Patrociño Barela*, 1941. Record Group 83: Records of the Bureau of Agricultural Economics, 1876–1959, National Archives.

of Man, is an allegory of optimism. Its roughly shaped heads ascend a trunk like ripe fruits on a tree.

Barela was received as a revelation. He was featured in *Time* magazine. Critics compared his work to that of European modernists such as Brancusi, Modigliani, and Picasso, to early medieval stonework, to African ceremonial masks, to ancient American steles. Russell Vernon Hunter, who headed the Federal Art Project in New Mexico and had nominated Barela for the *New Horizons* exhibition, said that his works "are closely related to the simple patterns of his daily life, but there is in them always a search for the universal."[2] Who was this Everyman, and what did his work really mean?

Barela was born in about 1900, the son of a shepherd who also worked as a *curandero*, or traditional healer, for Native communities—among them, the Tewa of the Taos Pueblo. The family was impoverished, and Barela left home at twelve. Over

the next two decades he worked as an itinerant laborer, in all sorts of places (beet fields, mines, and logging camps), and roamed throughout the western states, as far north as Wyoming. He is thought to have remained illiterate. The year 1931 found him back in Taos working as a teamster, having begun his carving. After Barela was hired on to the Federal Art Project, he did make sculpture full time for a few years. But his government pay was so little—less than he earned as a laborer—that he left the program and headed up to Colorado to harvest potatoes. He kept making sculpture, despite failing eyesight in his later years, until his death in 1964 in an accidental fire in his own studio. His life had been hard, but fiercely independent. Another of his works, probably made in 1937, just after he'd become famous, shows a figure with eyes half closed, arm upraised. Barela explained its meaning as follows: "This is what he holds, which is his by natural right, received from above." He called it *Man Who Stands on His Own.*[3]

As to what Barela's work signified to others, the story is complicated. Latino and Latina artists of the Southwest had not received anything like the attention that Native Americans did in the 1910s and '20s, but they did have some champions. Foremost among them were the charismatic arts patron Mabel Dodge Luhan and the suffragist and author Mary Hunter Austin. Luhan was known for her sparkling salons, her avant-garde connections, and her decision to marry a Tewa man from the Pueblo—prompting headlines like WHY BOHEMIA'S QUEEN MARRIED AN INDIAN CHIEF.[4] She was a collector of *santos* and Spanish Colonial antiques, among many other things, and is known to have encouraged Patrociño Barela in his carving. With her husband she built an adobe residence—named "Los Gallos" for the rooster-shaped ceramic totems mounted on its roof.[5] The home became a pilgrimage site for writers and artists, among them D. H. Lawrence, Willa Cather, Thornton Wilder, Ansel Adams, and Georgia O'Keeffe. Her very first guest there, though, was Mary Austin.

A prolific activist and writer based in New York City, Austin was no stranger to the Southwest, having done extensive fieldwork among the Native peoples of the Mojave Desert. Her plays, novels, and essays were often built around female figures. One early book told the story of the Basket Woman, a Native American artisan with quasi-magical powers: "As tribesmen stroked the perfect curves of the bowls or traced out the patterns, they were heard to sigh, thinking how fine life would be if it were so rich and bright as she made it seem, instead of the dull occasion they had found it."[6] Austin first visited Mabel Dodge Luhan in Taos in 1919 and moved permanently to New Mexico a few years later. Luhan was well aware that her friend's

interest in the Native American and Latino/Latina communities was primarily ideo-logical, not artistic, but advised her, "That it began as politics does not prevent its being channeled into aesthetics. Please get busy and write."[7]

Austin did. She lobbied the government for support of indigenous crafts, worked to protect an endangered historic adobe church called the Santuario de Chimayó, and set up a Spanish Colonial Arts Society, which organized an annual market for local artists and craftspeople. In 1923 she published a book called *Everyman's Genius*, in which she assigned herself the difficult task of explaining how creativity actually worked. What Austin came up with was a fascinating and fashionable mixture of psychology, mysticism, and educational theory based on the premise that every walk of life should be placed on an equal footing. She praised "the blacksmith, the forest ranger, the sheep herder, the village dressmaker who could take your things as they came from the mail-order catalogue, and with a twist and a tuck or two, make them over into something she had never seen except in pictures."

Genius conceived in these broad terms, Austin believed, was not vanishingly rare, as most people assumed, but "one of the most widely distributed human traits, no age and no tribe being without its notable examples." Its only precondition was craft mastery. The "self-originating capacity" necessary for true creativity, she wrote, could come only through "complete submergence of the acquired skill in the subcon-scious." Austin also subscribed to racial theories prevalent in her day and believed that personal creativity stemmed from a "deep-life," which was ethnically specific. Individual geniuses drew from this wellspring and channeled it to their own purposes, making it their own.[8]

Patrociño Barela was the perfect exemplar of this kind of thinking. He fit into a set of expectations about Latinos as "machineless men" still in contact with ancient energies.[9] This belief in a universal art, inflected by racial difference yet expressing the innate human capability for genius, was widespread in the 1920s. Similar ideas can be found in the primitivism of Picasso and other French artists; among British critics who spoke of "significant form," as evident in pottery as in sculpture or painting; and in the Japanese *mingei* ("folk craft") movement, which embraced peasant crafts for their unselfconscious beauty.[10]

This same belief in a universal aesthetics lay at the heart of the Museum of Modern Art. Visitors to the institution today might be surprised to learn that in the 1930s, alongside recent currents in abstraction, cubism, and surrealism, MoMA regularly showed American folk art, presenting it as proof of humanity's inherent

creative powers. Abby Aldrich Rockefeller, a leading patron of the museum, was one of several collectors who defined this new category. It included paintings and sculpture by self-taught artists like Barela and earlier decorative arts that seemed "naive" rather than cosmopolitan. Folk art was, and remains, a somewhat arbitrary classification, one that lumps together many disparate types of object. But in the 1920s and '30s, it was an important context for the appreciation of previously disregarded things.

MoMA's presentation of this material began in 1932 with an ambitious exhibition called *American Folk Art: The Art of the Common Man in America*, and continued throughout the decade. The museum also explored other topics with an implied universalism, such as prehistoric rock paintings, the art of ancient Mesoamerica, African sculpture, and even children's art borrowed from New York elementary schools. At the other end of the spectrum, its 1938 exhibition *Machine Art*—filled with ball bearings, springs, pistons, and propellers—proposed the novel idea that engineering could be appreciated as a branch of abstraction. This was American modernism in its first incarnation: far more encompassing than one might expect and open to the possibility that just about anything or anyone, including the vigorous carvings of a "humble day laborer from New Mexico," could be a work of genius.

These ideas introduced a new paradigm for the appreciation of craft. It might no longer be the mainstay of the American economy, as it had been prior to the Civil War. And its potential for social critique might be shadowed by the problem of elitism, the quandary that had beset the Arts and Crafts movement. But if craft could be understood as the artistic expression of the people, then surely that was enough to earn it an honored place in American institutions of art and learning.

The most influential proponent of this new view of craft was a man named Holger Cahill. Born in 1887 in Iceland, nearly at the Arctic Circle—his birth name was Sveinn Kristjan Bjarnarson—he was still a toddler when his parents immigrated to Canada in search of a better life. They didn't find it. After the family moved over the border to North Dakota, his father, a man of artistic temperament ill-suited to agricultural labor, abandoned them. Cahill was sent off to another Icelandic family, who were apparently brutal to him; he ran away at fifteen. His next years were those of a hobo. He worked trains and ships, attending night school when he could. He discovered the writings of Leo Tolstoy, whose sympathetic accounts of

Russian peasant culture perhaps stayed with him. Finally, in 1913, he pitched up in New York City. There he assumed his new name, as much an invention as everything else about him. Supporting himself as a short-order cook, Cahill enrolled in a journalism course and then found work as a newspaper editor. He immersed himself in the art scene of Greenwich Village, befriending painters associated with the so-called Ashcan School. By 1921, he was established as one of the city's rising critics. He saw himself as one of "the spade and shovel laborers, the axmen and levelers who prepare the ground where the artists are to come in and build." [11]

Cahill's next move was an extremely fortunate one. He took a job at the Newark Museum. It could not have been a better place to develop his populist outlook. He reported to John Cotton Dana, who was at that time the most innovative museum director in America. Dana had first arrived in Newark to run the city's library, and he founded the museum in 1909 as a way of extending its pedagogical reach. He cared little for canonical masterpieces and not at all for conventional ways of doing things. In an essay memorably entitled, "The Gloom of the Museum, with Suggestions for Removing It," he mocked the grandiosity of the typical art museum, built to look like a classical temple "in the splendid isolation of a distant park." The goal of a modern museum, Dana said, should not be to safeguard masterpieces and flatter the taste of the rich. Rather, it should engage the local community, "promote skill, exalt handwork." [12] Accordingly, he set about creating a program that would be relevant to Newark's factory laborers, showing them exemplary work in their own trades. Eager to connect with the city's ceramic industry, Dana put three toilets on display in his galleries in 1915. As the historian Ezra Shales has pointed out, this was two years before Marcel Duchamp's infamous *Fountain*, a urinal reclassified as an artwork, was refused exhibition by the Society of Independent Artists in New York City. [13]

Cahill never really gravitated to Dana's interest in industrial artisans—on the whole, he considered mass-manufactured products as a "fearful clutter of unlovely things." [14] He did, however, fully accept Dana's conviction that "the genius and skill which have gone into the adornment and perfecting of familiar household objects [should] receive the same recognition as do now the genius and skill of the painter in oils." [15] Craft's basis in everyday life, from this perspective, was not a reason to disregard it but, on the contrary, the strongest argument in its favor. This precept motivated Cahill to undertake a pioneering study of folk art—an interest he pursued with the curator Dorothy Canning Miller, whom he had met at the Newark Museum.

(The two eventually became romantically linked; they would marry in 1938.) Following Dana's death in 1929, Cahill and Miller mounted two exhibitions at the Newark Museum, *American Primitives* and *American Folk Culture*, which helped to define the parameters of the new category. Cahill also served as Abby Aldrich Rockefeller's personal folk art curator.

Thanks to this latter connection, he was tapped as interim head of the Museum of Modern Art in 1932, while its pioneering director, Alfred H. Barr Jr., was on a leave of absence. Cahill immediately set about implementing his personal vision of modernism. He was there for less than a year, but in that short space of time, he mounted an exhibition on Mesoamerican culture—later described by Barr as "the first large showing of 'primitive' art *as art* in America"—and another folk art show, drawn entirely from the Rockefeller collection.[16] Working alongside him was Miller, whom Barr retained as MoMA's first curator. She would go on to an illustrious career there in her own right, taking a central role not just inside the museum but among the city's avant-garde.

In 1935, now a widely recognized figure, Cahill was invited to assume the leadership of the Federal Art Project. The vision that he and John Cotton Dana had pursued in Newark was now a nationally funded experiment affecting thousands of artists. It was this connection that led to MoMA's *New Horizons in American Art* the following year, the exhibition that vaulted Patrocinio Barela to fame. The power couple set to work, Miller curating the exhibition, Cahill contributing to the catalogue. His essay would doubtless have found Mary Austin nodding in agreement: "It is not the solitary genius but a sound general movement which maintains art as a vital, functional part of any cultural scheme. Art is not a matter of rare, occasional masterpieces." Simultaneously, as head of the Federal Art Project, he not only supported community works such as murals and public sculpture, but also instigated a new Index of American Design. This was a touchingly impractical attempt to create a record of the nation's decorative and folk art, one delicately rendered watercolor at a time. Aiming to fully document "the arts of the common man," the project was framed explicitly as a search for American origins, for American art as free as possible from foreign influence. The first objects selected were Shaker made, "which we could call our own without reservations," as one administrator put it.[17]

The index, compiled between 1935 and 1942, ultimately included more than eighteen thousand watercolor renderings, executed by a paid staff of about four

Hazel Hyde, *Billethead from Ship "Favorite,"* 1938. Index of American Design, National Gallery of Art.

hundred people—mostly commercial illustrators, who were relieved to have the work. Cahill described this huge undertaking as a "search for a usable past . . . a wellspring to which workers in all the arts might turn for a renewed sense of native traditions in design." [18] That phrase, "a usable past," was borrowed from Van Wyck Brooks's essay of 1918. But Cahill was no revivalist, like the reformers of the Southern Highlands, or even his own patrons, the Rockefellers. He was interested in form, not theater. Each object in the index was shown floating in a void of space, much in the way that artworks were held up for admiration in MoMA's white-walled galleries. This was exactly the opposite of a fully appointed period room or a historic museum with costumed interpreters. Cahill did not want to re-create the past. He simply thought that a vital American art could grow only if it were connected to authentic roots; otherwise, it would be as artificial as anything made in a factory. Some years later, in a novel called *The Shadow of My Hand,* he put the point like this: "Someone had to be an old-days man, otherwise

people would forget, and wouldn't really know what they come out of. Like kittens born in a bake oven growing up to think they were biscuits."[19]

~

Places don't get much more artificial than Treasure Island, the location for the 1939 Golden Gate International Exposition. Just three years before its opening, the site was open water, an area of the San Francisco Bay too shallow for shipping traffic. With the support of the federal Works Progress Administration, the city committed to extending a shoal into a man-made island—the world's largest at the time of its completion. The Army Corps of Engineers first built a seawall of boulders, then filled it with about twenty-five million cubic yards of rock and sand. (The construction overlapped by a few months with the completion of the Golden Gate Bridge.) San Francisco in those days was proud but anxious. Having spent decades recovering from the devastating 1906 earthquake, it found itself suddenly surpassed in growth by Los Angeles, compounding its long-standing rivalries with Chicago, New York, and other points east. In 1934, the city's economic heart, its dockyard, was convulsed by one of the biggest strikes of the Depression era, which ended in a violent clash between longshoreman and the police. It was against this tense backdrop that city officials and local businessmen began planning the Exposition. The grand event would be a reassertion of San Francisco's importance, and add a permanent asset to the city; down the road, the intention was to turn Treasure Island into an international airport.[20]

Civic strategy faded into the background, though, when the Exposition opened. A vivid departure from previous world's fairs (and the one running concurrently in New York City), this event was devoted primarily not to industry and technology, but to leisure and fantasy. "Instead of a factory manual," one official guide proclaimed, it was "a saga of the West—a pageant of the Pacific." At night, the fair was lit with $1.5 million worth of artificial illumination, including glow-in-the-dark paints under newly invented ultraviolet "black lights." By day, it was an architectural extravaganza in which Asian and Mesoamerican motifs were freely combined. One member of the planning team explained their working assumption: that what visitors wanted was "the breath of romance and the perfume of far and romantic places; that what they would like to do about the machine age, if anything, was forget it for a while."

There was a section called Vacationland, about good, clean fun in the outdoors, and another called the Gayway, with more louche adult entertainment. A tall neo-Gothic spire called the Tower of the Sun was topped with a phoenix, symbolizing the city's rise from the rubble of 1906. There was a Japanese Pavilion, complete with a castle, samurai residence, and rock garden. An eighty-foot allegorical statue of *Pacifica*, conceived by the artist Ralph Stackpole in a style best described as Buddhist-Mayan, loomed over the fair's main court.[21]

Tucked into all this extravagance, and doing its part to support the fair's vision (a populist version of the universalism that MoMA was so assiduously exploring), was craft, in the form of two groundbreaking exhibitions. The first was the Indian Court, a presentation of museum-quality artifacts made by Native peoples across North America. Instead of the ersatz "Indian Village" typical of earlier fairs, this was a self-consciously modern exhibition. Two totem poles, carved on site by the Haida artist John Wallace, marked the entrance to the court.[22] Inside, the visitor encountered one atmospheric presentation after another. The gallery of Inuit art was snowy white. That representing the Northwest Coast was dark and shadowy, with carved masks illuminated from below to suggest a campfire. A fifty-foot-high gallery of totem poles was painted in horizontal bands of gray, gradually lighter from top to bottom, suggesting a bank of Pacific fog. In another space, Navajo blankets were presented against a backdrop of blinding white, with a high partition in turquoise blue and slanting platforms painted orange to evoke sandstone cliffs. A gust of wind was pumped through the gallery devoted to Plains cultures, gently ruffling the feather headdresses. Over the course of the Exposition, sixty Native artisans demonstrated their work on-site, among them basket makers, silversmiths, stone carvers, and weavers.[23]

All this stagecraft was devised by the curator René d'Harnoncourt, an Austrian who had come to the United States by way of Mexico City. By no means wealthy but preternaturally poised, he had parlayed his job at a leading antiques store into a career-making opportunity: to create a major exhibition about Mexican art for the Metropolitan Museum in New York. It opened in 1932, positioning him to join the Indian Arts and Crafts Board three years later. This newly constituted government body took on a promotional role akin to that played in earlier decades by private philanthropists (the so-called Friends of the Indian), but with a significant difference in approach. In 1934, the Indian Reorganization Act (nicknamed the "Indian

New Deal") had passed. No longer was it U.S. policy to force assimilation on Native people. This new law had its own impositions—for example, tribes were required to mirror American political instruments, such as written constitutions, rather than traditional tribal structures. But at least in theory, the government respected their political and cultural autonomy. Instead of encouraging the development of a broad tourist market reliant on low-cost souvenirs, the Indian Arts and Crafts Board established an authentication scheme, aiming to protect legitimate expressions of skill.

D'Harnoncourt's exhibition at the Golden Gate Exposition was a spectacular delivery system for this new philosophy. As the *New York Times* reported, he "insisted on elevating the exhibit from a musty museum technique popularly associated with a 'vanishing' race." Even the contrasting thematic styling of the galleries, based on cultural groupings—instead of lumping Native people all together indiscriminately, as had previously been the norm at expositions—mirrored the government's new policy of recognizing tribal sovereignty. Perhaps the most progressive aspect of the Indian Court, though, was its portrayal of Native craft as fully compatible with modern life. The *Times* paraphrased d'Harnoncourt's view like this: "Far from vanishing, the Indians are enjoying a resurgence of numbers and of skill, which dictates that their contribution to the industrial arts and contemporary life should be conceded its proper place."[24] There were model rooms that showed Native-made products integrated into the typical suburban home. Some displays, like that of Navajo silverwork, resembled the windows of a department store. A sales area, which d'Harnoncourt described as the "last and possibly the most important part of the exhibit," gave visitors the opportunity to act immediately on these implicit recommendations.[25]

The Indian Court's blurring of exhibition and retail was also seen in the other main presentation of craft at the Golden Gate Exposition, located in the fair's Palace of Fine and Decorative Arts. The big draw there was a loan show of famous paintings, including Botticelli's *Birth of Venus* and a Raphael Madonna; there was also a juried exhibition sponsored by Cahill's Federal Art Project called *Frontiers of American Art*, featuring the work of Patrociño Barela, among others. It was in the decorative arts section, however, that craft had its real showcase: another series of model rooms, "designed in the living spirit of our times," as the Exposition's official guidebook put it.[26] Contributions by European luminaries such as Alvar Aalto and

Marcel Breuer sat alongside those by American designers like Gilbert Rohde and Kem Weber. Handmade furniture and textiles were heavily represented, and one section of the pavilion featured live demonstrations of bookbinding, ceramics, and weaving.

The mastermind of this presentation of design was Dorothy Liebes. Born in California in 1897, she had become interested in textiles through her involvement in the settlement house movement, including a summer weaving session at Hull-House in Chicago. She spent some years as an art teacher, but in 1930 she established an atelier under her own name in San Francisco. This incurred the displeasure of her new husband, Leon, the proprietor of a luxury department store, who did not want a wife who worked outside the home. She chose weaving over the marriage, and divorced him. Over the next few years, Liebes established a successful business oriented mainly toward one-off commissions for wealthy clients. She also began

Dorothy Liebes on the set of a television show, 1940s. Dorothy Liebes papers, 1850–1973, bulk, 1922–1970, Archives of American Art.

Jeffrey Gibson, *American History (JB)*, 2015. This work by a prominent contemporary artist of Native American heritage places handcrafted emphasis on the words of James Baldwin: "American history is longer, larger, more beautiful and more terrible than anything anyone has ever said about it." Courtesy of the artist and Sikkema Jenkins Gallery.

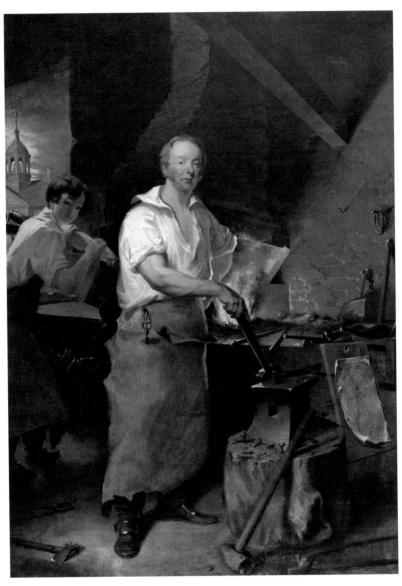

John Neagle, *Pat Lyon at the Forge*, 1829. A self-conscious statement of artisanal pride, this is a rare full-length portrait of an early American craftsman in his workshop.

Courtesy of the Pennsylvania Academy of the Fine Arts, Philadelphia. Gift of the Lyon Family.

Elizabeth Van Horne Clarkson's honeycomb quilt, c. 1830, was likely made as a wedding present for the maker's son. The craftwork of women, even when it was of the highest standard, often circulated as gifts or otherwise in the economic margins. Metropolitan Museum of Art.

A dressmaker who was born into slavery, Elizabeth Keckley lived an extraordinary life. She attained her freedom thanks to her skills and ultimately became a perceptive confidant of the Lincolns during the Civil War. Courtesy of Moorland-Spingarn Research Center, Howard University Archives, Washington, D.C.

Elizabeth Keckley's ball gown for Mary Todd Lincoln, 1861.
Division of Political and Military History, National Museum of American History, Smithsonian Institution.

Adelaide Alsop Robineau, American, Syracuse, New York (1865–1929). *Scarab Vase (The Apotheosis of the Toiler)*, 1910. This exquisite work in porcelain represents the apex of achievement for the Arts and Crafts Movement—and its emphasis on beauty over pragmatism. Collection of Everson Museum of Art, Museum Purchase, PC 30.4.78.a-c.

Sideboard by the Craftsman Workshops. Designed 1902, executed 1908. Stickley's monumental oak furniture was pitched right at the midpoint between medievalism and modernity. Crab Tree Farm, courtesy Dallas Museum of Art, photo by Brad Flowers.

Wallace Nutting, *Slanting Sun Rays*, 1916. Nutting's sentimental portrayals of the American past lacked accuracy, but reached a wide audience during the Colonial Revival. Photo by Allen Phillips, Wadsworth Atheneum Museum of Art, Hartford, CT.

Cape Cod Living Room, 1750–1850. One of the many miniature period rooms created by the Chicago patrician Narcissa Niblack Thorne, who restaged the American past as a series of magical shadowboxes. The Art Institute of Chicago.

Mary Ann Schildknecht with her embroidery hoop, as pictured in Alexandra Jacopetti Hart's 1974 book, *Native Funk & Flash*, an indelible document of the American counterculture. Photo by Jerry Wainwright.

Two team members at the studio of Chris Schanck in Detroit, Michigan, where a Bangladeshi immigrant community rubs shoulders with art school graduates and industrial artisans. Courtesy of the artist and Friedman Benda Gallery.

In her performance work *Unraveling*, Sonya Clark stands side by side with museum visitors, unpicking a Confederate flag—a highly charged act, suggesting that the past is only what we make it. Courtesy of the artist.

working as a consultant to industrial mills, advising them on style trends, color palette, weave structure, and material selection.[27]

By 1939, Liebes was a well-known name in textile design, particularly for her use of metallic threads, which helped project an image of luxurious modernism, and her incorporation of reeds, bamboo, and rattans, sourced from San Francisco's Chinatown. She delighted in her image as a flexible experimentalist able to break through industry's self-imposed rules. "The only reason I am not a frustrated woman," she liked to say, "is that weavers do not frustrate easily."[28] Thanks to her client list and architect collaborators, she was also extremely well connected. All this made her an ideal candidate to lead the Decorative Art Pavilion, but she also brought something even more important to the project: a mission. Liebes set out to demonstrate that craft could play a new role in the industrial age. "The machine does it better," she would write. "I am not a Colonial goodwife, or a Mexican señora, but an American woman of 1944."[29] Yet craft also helped to humanize mechanical production, introducing variation and expertise to what would otherwise be soulless repetition.

Perhaps indulging in a degree of after-the-fact rationalization, Liebes presented her own extravagantly expensive custom work as a form of research, which could be translated into cheaper products made on a power loom. Consistent with this outlook, she drafted the artist Maurice Sterne (the husband of Mabel Dodge Luhan, as it happens) to write a statement in support of the craft workshops she had organized at the Golden Gate Exposition. "Absolute reproduction is contrary to life, to experience, to nature," he said. "Living things are not cast from a mold. They must evolve through the life process, and this process is equally true in art, whether fine or applied."[30] In practical terms, this view positioned the artisan as a prototyper for industry. In philosophical terms, it presented craft as a great humanizing force for the machine age.[31]

The Golden Gate International Exposition was so popular—more than ten million people visited in 1939—that it was held over to the following year, attracting another five million before it finally closed. The event's impact reverberated far and wide, including to New York City and the Museum of Modern Art itself. In 1941, MoMA invited d'Harnoncourt to collaborate with Frederic H. Douglas, an anthropologist and curator at the Denver Art Museum, on an exhibition called *Indian Art of the United States*. It was to some extent a reprise of the Indian Court, with one of Wallace's totem poles planted like a standard in front of the museum's sleek facade on Fifty-Third Street. The emphasis on Native craft's commercial viability was also

transplanted from San Francisco. Model rooms were once again featured, and a Swiss fashion designer named Fred Picard was hired to create sportswear incorporating Native-made components. Among the improbable results were an opera cape with Osage beadwork and an après-ski suit with Navajo silverwork buttons and Seminole patchwork.[32]

The catalogue boasted a foreword by no less than Eleanor Roosevelt, who voiced the government's new position on Native affairs: "At this time, when America is reviewing its cultural resources, this book and the exhibit on which it is based open up to us age-old sources of ideas and forms that have never been fully appreciated." For their part, d'Harnoncourt and Douglas voiced an appropriately outraged condemnation of past attitudes. "For centuries the white man has taken advantage of the practical contributions made by the American Indian to civilization," they wrote. "An almost childish fascination with our own mechanical advancement has made us scorn the cultural achievements of all people who seem unable or unwilling to follow our rapid strides in the direction of what we believe to be the only worthwhile form of progress." Yet, somehow, Native tradition remained strong in America, despite the fact that "every available means was employed to destroy it thoroughly and forever." Native craft, they argued, still had "a basic soundness and vigor," and "fit perfectly into the contemporary scene." The curators also noted that there were more artisans in this population, proportionally speaking, than in any other ethnic group, countering the widespread narrative of cultural decline.[33]

As in San Francisco, Native artisans were invited to present in live demonstrations at MoMA during the run of the show. One was the silversmith Dooley Shorty, who would soon achieve fame as the leader of the Navajo "code talkers" during the Second World War. Fred Kabotie, a Hopi sand painter who demonstrated his sacred art form in the museum galleries, later recalled his experience at the exhibition opening—all noise and flashbulbs—and the experience of meeting Mrs. Roosevelt. "She seemed like a wonderful person," he said. "I wished we could have gotten together for a quiet visit."[34]

As he had in San Francisco, d'Harnoncourt deployed craft to deliver a powerful rebuke to the idea that Native cultures were stuck, unchanging, in the amber of the past. To be sure, neither exhibition was free of stereotype. The Indian Court exhibition was accompanied by a didactic section of lightboxes showing the morphology of Native people's skulls and facial features and comments on their "intellectual capabilities." Though it was marshaled as evidence of their equality, this material

was still within a long-standing framework of racist pseudoscience.[35] Nor were tribal voices foregrounded. For all the good intentions, these projects still involved white people speaking on behalf of indigenous people. And though they did emphasize present-day activities, there were still boundaries to that acknowledgment. You would never know from the MoMA presentation that the most modern architecture in New York City, just blocks away, was being made by Mohawk ironworkers from Canada—the famous "Skywalkers" who had helped construct the Empire State Building, among other skyscrapers and bridges. By the 1930s, a community of these skilled riveters and fitters had settled in the Gowanus neighborhood of Brooklyn. They would contribute to the city's skyline for decades, earning a reputation for fearlessness that was tinged with romanticism. As late as 2002, the ironworker Kyle Karonhiaktatie Beauvais remarked, "A lot of people think Mohawks aren't afraid of heights; that's not true. We have as much fear as the next guy. The difference is that we deal with it better."[36]

Despite the limitations of the exhibitions at the Golden Gate Exposition and at MoMA, they were watersheds. A long review of *Indian Art of the United States* by the anthropologist Oliver La Farge, published in in the *New York Times*, reinforced the sense that a change had come. The MoMA exhibition, he wrote, "brings the Indian to the surface of our reluctant consciousness in a new and compelling way," demonstrating a cultural achievement as impressive, in its way, as the skyscrapers in the blocks surrounding the museum. La Farge concluded his review with the striking line "We are not going to give America back to the Indians, but perhaps we shall have sense enough to give the Indians back to America."[37]

The MoMA exhibition was also important in that it inaugurated a long-standing relationship between the museum and d'Harnoncourt. He joined the curatorial team full time in 1944, initially as the head of a new (though short-lived) Department of Manual Industry. "This interest is not a form of sentimental antiquarianism," the museum explained, "but is based on the recognition that manual methods can be an important means of enriching and supplementing mechanical mass-production."[38] Five years later he was made director of the museum, and stayed in the post until 1967. Dorothy Liebes did not achieve quite that degree of centrality at MoMA, but she, too, would be an important presence there in years to come, particularly following her permanent relocation to New York in 1948.

By then, the institution had an extremely active design program. It had begun a decade earlier with the aforementioned *Machine Art* show, with its celebration of

technical aesthetics. There had also been exhibitions of artist-designed rugs; of work from the Bauhaus design school in Germany; and a consumer-friendly series that began with *Useful Household Objects Under $5.00* (upped to $10 and eventually to $100 in subsequent installments). In 1941, MoMA staged its most ambitious project in this area yet: a juried exhibition called *Organic Design in Home Furnishings*. A sort of pendant to the earlier *Machine Art*, it was intended to show the softer, more humane side of modern design. "The forms of our furniture should be determined by our way of life," the curator Eliot Noyes wrote. "Instead, for the most part, we have had to adapt ourselves uncomfortably and unreasonably to what has happened to be manufactured."[39]

With *Organic Design*, MoMA set out to demonstrate that the forces of mass production could be mastered and the harsh depersonalization of the machine age transformed into a livable future. All this activity indicated a new role for the museum as an arbiter of modern taste, with craftspeople like Liebes as avatars of a new secular order: the cult of Good Design. That project picked up speed in the late 1940s and early 1950s, but for now it would have to wait. For, on December 7, a month after *Organic Design* ended its run, Japanese planes rained death from the skies over Hawaii. What America would make now was war.

~

You know her as Rosie the Riveter, but her real name was Naomi Parker. She was twenty-one years old in 1942 when a photographer captured her at an aircraft plant in Alameda, California. Standing at her workstation operating a grinding wheel, Parker is in overalls, her hair protected by a bandana. The picture was not remarkable in itself, just one of countless similar press images taken in America's wartime factories. But it happened to be printed in a Pittsburgh newspaper, where it caught the eye of an illustrator named J. Howard Miller. The following year, his poster of a similarly attired woman was put up on the walls of the local Westinghouse plant. Miller showed his worker literally rolling up her sleeve, a company identification badge on her collar. Above her head floats a blue speech bubble: WE CAN DO IT!

Hardly anyone saw this now-iconic image during the Second World War: It was shown in only one factory for only a few weeks.[40] But it was rediscovered in the 1980s and appropriated as a feminist emblem; the poster's slogan was sufficiently open in its phrasing that it could be understood to refer to lots of things besides making tank guns and jet engines. In fact, neither Miller's archetypal worker nor

Naomi Parker (Fraley) in a Navy machine shop, 1942. Bettmann/Getty Images.

Naomi Parker in the Alameda photograph is riveting anything. The character of Rosie, with whom they later became associated, actually began life in song, a bit of propagandistic doggerel that would likely have been forgotten had the most beloved artist of the era, Norman Rockwell, not immortalized the character on one of his

covers for the *Saturday Evening Post*. Published in May 1943, it shows a distinctly working-class woman, ham sandwich in hand, feet firmly planted on a copy of Adolf Hitler's *Mein Kampf*. Her pneumatic riveting gun lies across her lap, along with her lunchbox, and a halo floats above her head.[41]

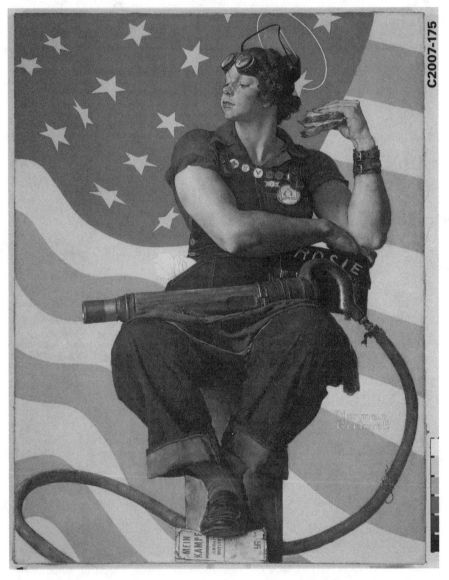

Norman Rockwell, *Rosie the Riveter*, 1943. Crystal Bridges Museum of American Art, Bentonville, Arkansas, 2007.178. Photography by Dwight Primiano.

It was Rockwell's picture, rather than Miller's poster, that permanently fixed Rosie the Riveter in American mythology. With the Stars and Stripes flying behind her, she is a modernized Betsy Ross, physically powerful, her craftswomanship devoted to the cause. But of course, much of women's wartime experience as skilled workers is left out of this image. At the beginning of the war, the great majority of Americans agreed with Dorothy Liebes's husband: If a man had a job, his wife should be willing to stay home. Pressure had been mounting on this gender divide for years, particularly during the Depression, when families were desperate for income, no matter how they got it. Fully half of all female war workers had some form of previous employment. Even so, there was still tremendous prejudice against women in the workplace, especially in skilled trades. As late as 1943, fewer than one third of married men said they were comfortable with their wives going off to work.[42]

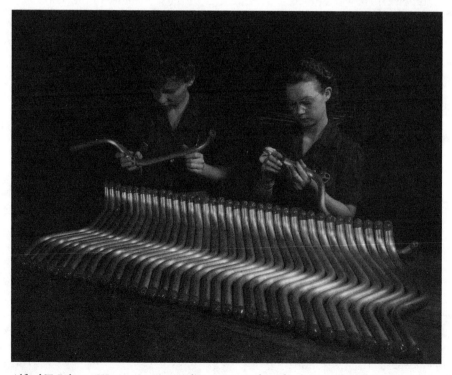

Alfred T. Palmer, *Women Capping and Inspecting Tubing for the "Vengeance" Dive Bomber Made at Vultee's Nashville Division*, 1943. Farm Security Administration/Office of War Information Color Photographs collection, Prints & Photographs Division, Library of Congress, LC-DIG-fsac-1a35372.

They went anyway. As the draft took effect and women started to replace men in the labor force, both government propaganda and popular culture (not always easy to distinguish from one another) aimed to ease the transition. One advertisement for the Women's Army Corps offered this encouraging advice: "Many war time jobs are very similar to running a sewing machine or vacuum cleaner, assembling a meat grinder, sewing by hand, and other household tasks." Another, for an electric company, featured a woman who was a "regular grease monkey," but was nonetheless glad to say, "The plant's as bright and cheery as my own kitchen!" A dismaying emphasis was laid on how to be attractive in work clothes—for, as one fashion guide put it, "there is neither virtue nor patriotism in dowdiness, in or out of uniform."[43]

If there was one dominant message here, it was that women should accept their wartime employment as a strictly temporary condition—and so it proved. Despite the fact that (according to one poll taken at the time) 75 percent of women wanted to remain in work at the close of the war, only a small minority was able to fulfill this ambition. There was a permanent increase in the gender equity of the workforce, but it was only modest in scale. Partly this was thanks to the baby boom—at a time when pregnancy often led immediately to job loss—but mostly, it was the result of unrelenting pressure from unions, management, and the media for women to reassume their domestic duties. As the war neared its end, working mothers were presented with guilt-inducing images about bereft children making their own little sacrifice for their country. America was not ready to face the fact, which the war years had amply demonstrated, that a woman could perform any job just as well as a man could. The aircraft manufacturer Boeing, to take just one example, had its peak year of efficiency and production in 1944, when it also had its maximum number of newly trained female employees.[44] Lola Weixel, who had worked as a wartime welder in Brooklyn, said that "men had been sold a bill of goods, that the skills were so hard to learn. In fact, they could be quickly learned." After the war, though, she was never again able to earn a living at the craft. When she was interviewed in 1980, she said that she still carried the dream "to make a beautiful ornamental gate. Was that so much to want?"[45]

For some women, World War II was indeed the gateway to permanent employment as industrial artisans. One who beat the odds was Fanny "Tina" Hill, who, like Naomi Parker, had just turned twenty-one when the war began. Until then she had supported herself as a live-in maid and seamstress, among the few options open to a young Black woman. She liked the sewing well enough—it meant that she "didn't

have time for a lot of evil thought"—but when the war came, she was eager to take a factory job. Though originally from Texas, she had moved to Los Angeles before the war, and there, in 1943, she signed on as a riveter at North American Aviation. Hill received four weeks' training; "after a couple of whiles you worked on the real thing." But once she moved to the main factory floor, she concluded that riveting was not the job for her ("too much a'shooting and a'bucking and a'jumping and a'bumping," as she put it). So, she transferred to a precision bench job, cutting and shaping parts. Eventually she was relocated to the plastics department and put in charge of installing gun sights. When the war ended, and her husband returned from overseas service, Hill became pregnant and lost her position at the plant. For a while she was obliged to work as a maid, and then in a low-paid job as an operative in a textile factory. But then the aviation factory offered her a place again: "Was I a happy soul!" She worked there for a total of about forty years. For her, war work had been the ticket to a middle-class life. "It was Hitler," she dryly observed, "that got black women out of the white folks' kitchen."[46]

~

One reason that Tina Hill was taken on at North American Aviation in 1943 was union pressure—and this is itself a remarkable fact. Ever since the days of Samuel Gompers, the American labor movement had been not just pervasively sexist, but explicitly racist, too. Black workers were relegated to unskilled jobs in nearly every industry. The national census taken in 1933, for example, showed that about 85 percent of Black steel workers were low-waged operatives or laborers, compared to only 44 percent of whites.[47] The booming aircraft industry, with its high-paid and high-skilled jobs, was a fortress of white supremacy. In 1941, it has been claimed, there were only four Black workers in the sector in all of Southern California.[48] That same year, a researcher in New York City conducted a survey of African American high school students. "Staggering under the impact of poverty and deprivation," she wrote, "these young people are planning to launch a frantic attack upon the labor market for economic security." A few expected to go into a skilled trade—boys hoped to be mechanics; girls, dressmakers—but only one out of twenty, as they had poor prospects of such employment.[49]

One might have thought that the New Deal would improve this situation. After all, Black voters supported Roosevelt by large majorities, switching away from their traditional allegiance to the Republican Party, which had persisted since the Civil

War. But his administration did relatively little to promote African American interests, refusing even to support an anti-lynching bill. There were some exceptions: In 1940, for example, the Works Progress Administration sponsored an American Negro Exposition in Chicago. Though only pocket-size in comparison to the grand events in San Francisco and New York, it was billed as the "first Negro World's Fair." The displays highlighted the contributions of Black workers to the government's construction of schools, hospitals, housing, and infrastructure. Chrysler mounted a display about its integrated workforce, and there was a booth about African American fraternal organizations, such as the Masons. In general, the fair encouraged its visitors to acquire mechanical skills, for "the most highly mechanized industrial operation could not carry on a single day without a corps of competent craftsmen." That message was reinforced through inclusion of a working machine shop, run by the National Youth Association, and a display of African American hobby craft.[50]

The largest of all New Deal projects, the regional development project overseen by the Tennessee Valley Authority, was typical in hiring comparatively few African American workers, and those mainly in laboring jobs. Its widespread effects of electrification and transport, however, benefited Blacks and whites alike. The opportunities that it did offer inspired an unusual craft project, overseen by a woman named Ruth Clement Bond. Born in 1904 to a minister's family in Louisville, she had managed to study English to master's level—rare for a Black woman at the time—and by the early 1930s was department head at Kentucky State College. When her husband was appointed as the TVA's highest-ranking African American official, however, the couple moved down to Alabama so that he could direct construction projects there. Bond launched into a parallel effort focused on home improvement. Dismayed that former sharecroppers "were buying things they didn't need, yet weren't fixing up their houses," she helped local women make curtains from dyed feed sacks and rugs woven from corn husks.[51]

Many of Bond's new acquaintances were quilters, so she also made patterns for them to execute, cutting out templates in brown paper. To some extent, her designs resemble standard posters promoting New Deal values of progress and modernization. But they also have a stylistic affinity with art of the Harlem Renaissance and are thematically focused on African American uplift. Because one of the key goals of the TVA was to build a hydroelectric dam, she created a quilt (now lost) depicting a full-length figure with his hands upstretched, clasping a lightning bolt—"instead of

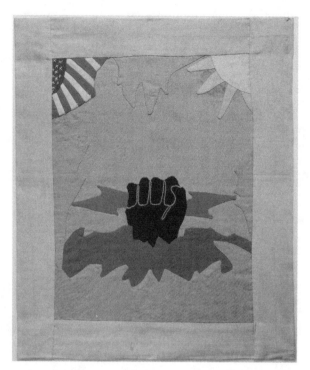

Ruth Clement Bond, *Black Power (Tennessee Valley Authority Appliqué Quilt)*, 1934. Photo by Maggie Nimkin, 2005. Museum of Arts and Design, New York. Gift of Mrs. Rosa Philips Thomas, 1994.

the banjo he would normally hold," as she put it—and another (which does survive) showing a Black fist grasping red lightning, with an American flag and a shining sun above. When students assigned to the TVA from Fisk and Tennessee State saw the quilts, they suggested a title: *Black Power*. Bond herself came to believe that this potent phrase had originated with her quilts; whether or not that is true, she bequeathed to America one of its most resonant crafted icons.[52]

The real boost to African American workers came only with the war. One government estimate predicted that three quarters of military factory jobs would be either skilled or semiskilled, and with the draft on, every able-bodied American, no matter his or her color, was needed in the factories. Even before Pearl Harbor, Franklin D. Roosevelt was facing up to this reality. In June 1941, under pressure from Black labor leaders, he signed Executive Order No. 8802, banning racial discrimination in war-related industries. It was the first time in U.S. history that the government attempted to enforce equal employment for Black workers. Unions howled in protest. Their

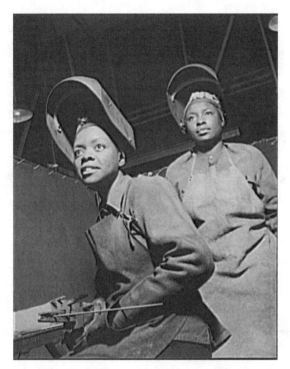

Gordon Parks, *Women Welders at the Landers, Frary, and Clark Plant, New Britain,*
Connecticut, 1943. Farm Security Administration/Office of War Information Color Photographs collection,
Prints & Photographs Division, Library of Congress, LC-USW3-034282-C.

greatest fear was that if African Americans became dues-paying members, it would
be impossible to remove them when the war ended. In many cases they established
Black "auxiliaries" that were subservient to the existing white unions. Some factories
created internally segregated facilities. At Sun Shipbuilding and Drydock, located
eight miles outside Philadelphia on the Delaware River, white workers refused
outright to train newly arrived African Americans. Only a round of government-
enforced firings settled the issue. Just two years later, in 1943, the Sun docks launched
the *Marine Eagle*, the first steel-hulled ship made entirely by Black craftsmen.[53]

 Similarly dramatic changes were occurring nationwide. In the year after Pearl
Harbor, the proportion of nonwhite workers in defense plants more than doubled.[54]
Blacks did join labor unions, and as their makeup shifted, these integrated unions
started fighting on behalf of their new constituents. Meanwhile, the dynamics of the
Great Migration years returned, as African Americans once again made their way to

the West Coast, as Tina Hill did, and to the North, following the opportunities that war work afforded. This geographical movement was accompanied by a political one, known as the Double V campaign: Victory overseas, victory at home. Black Americans wholeheartedly supported the war against the Axis powers, but they also noted parallels between Nazi racial attitudes and those of white supremacists. This was, after all, a time when the armed forces were segregated. The Red Cross turned away Black blood donors for fear that their bodily fluids would be transfused into white soldiers. The civil rights advocate Roy Wilkins said that African Americans wanted a "new world which not only shall contain no Hitler, but no Hitlerism . . . That means a fight for a world in which lynching, brutality, terror, humiliation and degradation through segregation and discrimination shall have no place—either here or there." An editorial in the *Baltimore Afro-American* newspaper put it somewhat more bluntly: "We cannot march against enemy planes and tanks and challenge warships armed only with a whiskbroom and a wide grin."[55]

At war's end, African American war workers faced the same disappointment that white women did. The great majority of highly skilled jobs were reclaimed by returning white GIs. Blacks were laid off in huge numbers, and now the unions refused to protect them, using a traditional excuse: "Last hired, first fired." At Sun Shipbuilding, fully four fifths of the Black workforce lost their jobs. Almost all of them were forced to leave the trade for good.[56] On D-day itself, white workers were on strike at a Cincinnati aircraft plant because seven Black machine operators had been transferred there.[57] Just as for women, though, the expectations of a generation were completely transformed. African Americans not only had served bravely in combat—most famously, the Tuskegee Airmen, a group of pilots trained at Booker T. Washington's old vocational college—but also had done much to build the Allies' arsenal. They fought and worked, as one Black boilermaker put it, for "the unification of all peoples, to a common ground of workmanship."[58] Like the war itself, this peace would be hard to win.

～

African Americans' move into the upper echelons of factory work was, for the most part, temporary; their migration to new parts of the country, however, was permanent. Things were made somewhat easier for them on the West Coast because a substantial housing inventory had suddenly become unoccupied.[59] This was not because the former inhabitants were off fighting at the front, but for a more terrible

reason: These had been the homes of Japanese Americans who were now in prison camps run by the U.S. government. Businesses, too, were suddenly unoccupied, their owners forced to sell out at a fraction of fair market value. Maya Angelou vividly recalled her own experience in the Bay Area: "As the Japanese disappeared, sound-lessly and without protest, the Negros entered with their loud jukeboxes, their just-released animosities, and the relief of escape from Southern bonds. The Japanese area became San Francisco's Harlem in a matter of months."[60] The internment, today considered one of the most reprehensible chapters in the nation's history, affected nearly 120,000 Japanese Americans living in California, Oregon, and Washington State, the majority of them U.S. citizens. Some were from families that had been in the country for decades. Many were just children.

In trying to grapple with this horrible episode, descendants and historians alike have often focused on the art and crafts produced in the camps. This is not surprising, for what the internees accomplished was nothing less than astounding. They had been deposited in deserts or swampland with few resources, frequently in unbear-able heat or cold, in crowded, poorly constructed wooden barracks covered with tar paper. In these forbidding surroundings, they managed to create beauty—not just an object here or there, but complete aesthetic transformation. The story is one of tragic dimensions, to be sure. But it also attests movingly to the human will to create.

The first retrospective look at craft made in the relocation camps was entitled *Beauty Behind Barbed Wire*, published in 1952 on the tenth anniversary of President Roosevelt's internment order and written by none other than Allen H. Eaton, the great documenter of the Southern Highlands. During the war years, he had continued his exploration of rural handicraft, including an extended study of New England.[61] Right at the close of the war, just before the internment camps were disbanded, he visited five of them and dispatched photographers to the others still in operation. There were certainly parallels between this subject and his research into Appalachia: relative isolation, scarcity of means, and a distinctive cultural inheritance. Also, as with *Handicrafts in the Southern Highlands*, he intended his book as a form of advocacy. In a decision that now seems surprising, he invited Eleanor Roosevelt to contribute a foreword to the book. She had opposed internment from the start, and visited one relocation camp in 1943; disappointingly, however, she repeated the oft-made but totally false claim that the internment had been necessary to protect Japanese Americans from other citizens. Eaton himself was unsparing in his criticism of the

government's actions, and said that he hoped the book would promote "better understanding, appreciation and love."[62]

Eaton's book does indeed provide a valuable window into the life of the camps and the struggle and ingenuity that went into remaking them. Supplies of everything were short, so tools had to be made from worn-down saw blades and automobile springs. Patterned rugs were woven from the unraveled strands of onion sacks. People hunted for driftwood and stones that suggested animal forms, then tactically carved and polished them to enhance the resemblance. Flowers, so symbolically important in Japanese culture, were initially absent where the camps had been situated, so artificial ones were made instead, using bits of paper, cloth clippings, and shells on armatures of wire salvaged from the ragged edges of window screens.[63]

The sculptor Isamu Noguchi was legally exempt from the internment—he lived in New York, and only West Coast residents were subject to the order—but he willingly entered the Poston War Relocation Center in the Arizona desert. According to an official's account, his express intention was to "contribute toward a rebirth of handicraft and the arts," which second-generation Japanese Americans had "largely lost in the process of Americanization." Somewhat naively, Noguchi hoped to set up a fully functioning craft guild at Poston and to transform the camp into a model architectural environment. He was horrified by the conditions he discovered there and the complete lack of support he received from the authorities. "Here, time has stopped," he wrote to the artist Man Ray, "and nothing is of any consequence, nothing of any value, neither our time or our skill."[64] Though he entered as a volunteer, he became enmeshed in the bureaucratic machinery of the internment program and was trapped in the camp for seven months. His experience is a sobering reminder of just how adverse the situation was. "We plan a city," he wrote, "and look for nails."[65]

And yet many internees did manage to develop their skills in the camps, if only as a way to pass the interminable days. At one camp, a wood carver named Yutaka Suzuki trained twenty others; in another, a professional embroiderer named Mr. Nagahama taught classes to as many as 650 students, distributing thread he had unpicked from silk fabrics. These students were amateurs, but there were also isolated cases of far more ambitious craftsmanship, of the kind that Noguchi dreamed of. George Nakashima, born in 1905 in Spokane, arrived at the camps as a highly trained designer with international experience, including a period working in Japan under the architect Antonin Raymond, a disciple of Frank Lloyd Wright. As a consequence, he had some exposure

to Japanese joinery techniques, but it was not until he was interned and sent to the Minidoka Relocation Center, in Idaho, that he had the time and opportunity to study with a master. This was Gentaro Kenneth Hikogawa, a carpenter about Nakashima's age who had been traditionally trained in Japan before immigrating to Tacoma, Washington. When these two highly skilled men were thrown together in the camp, they immediately set about collaborating, first in a general improvement of the barracks. To maximize the use of the tiny living spaces, Nakashima designed folding tables and seating that doubled as coal storage. Hikogawa created more refined furniture out of packing crates and greasewood, a desert scrub plant.

Nakashima was released early in 1943, thanks to strings pulled on his behalf by Raymond. He went on to become one of America's leading furniture makers, and he always credited his brief apprenticeship for opening his eyes to the possibilities of traditional woodworking. "The time," as he put it, "was not entirely lost."[66] Hikogawa was not freed until 1945, at which point he returned to Tacoma. He

Gentaro Kenneth Hikogawa, 1942. Courtesy of National Archives, photo no. 26-G-3422.

never worked as a professional carpenter again, but he did build a successful garden center with a specialty in bonsai. By the standards of "issei" (first-generation immigrants) who had been subjected to internment, he did well. Most struggled to acclimate to their old lives and recover from their financial ruin. A Japanese concept often invoked to describe their response is *gaman*, comparable to the British idea of having a "stiff upper lip." The camp experience, once over, was rarely spoken of. It was not until the 1980s that activists forced the government to make reparations. A climactic moment came in one Senate hearing when the crafts made by internees were cited by Sen. Sam Hayakawa as proof that the camps had been "trouble-free and relatively happy." He was immediately shouted down by the audience in attendance.[67] They knew better: Craft is most vital when you live in a whole world of trouble.

~

Craft was one of the universal experiences of the war. While military production was obviously mass production, every factory needed highly skilled machine builders, pattern makers, and repair technicians. Regular recruits to the army were tested for mechanical aptitude. Those who scored highly were sent to special training facilities—one school in Inglewood, California, produced 13,500 crew chiefs—and then dispatched to motor pools across Europe, to naval vessels in the Pacific, and to bases at home. The Manhattan Project involved not just advanced physics but competent bricklaying, metalwork, and carpentry. The atomic bombs dropped on Hiroshima and Nagasaki were themselves handmade.[68]

The U.S. military distributed to soldiers and sailors more than four hundred thousand Handicraft Kits, which included materials for leatherwork, metal and plastic forming, clay modeling, and wood carving. They were particularly valued by men who were stationed in isolation, such as antiaircraft gunners or the crew of transport ships. One officer said of the program that "the soldier who lacks a hobby is the man who tends to break down on D-Day."[69] This activity was mirrored on the home front. As factories were converted to military purposes and rationing set in, magazines encouraged their readers to "wave a magic wand (plus a little elbow grease)" to modernize their old furniture rather than buying new.[70]

Prisoners of war on both sides of the conflict also practiced crafts such as whittling and sewing, both to make basic necessities and to stay sane. And handwork was considered an ideal occupation for the wounded and those with "battle fatigue"

(that is, posttraumatic stress disorder). Dorothy Liebes sat on the board of an Arts and Skills Corps for the Red Cross, advising on programs for their patients; it was surprisingly ambitious, with provision for ceramics, woodwork, basket weaving, and even macramé.[71] The Museum of Modern Art mounted a show on the role of arts and crafts as occupational therapy. One display showed how clay modeling could help burn victims regain dexterity in their hands. Another featured a little carved dog made by a patient who had previously attempted suicide by slashing his wrists; the museum praised his use of a knife for "constructive instead of destructive purposes."[72]

Finally, and most important for the future course of events, craft was seen as an ideal next step after demobilization, particularly if soldiers had enlisted when young. They were still young when the war was over, of course, and without professional qualifications. But many had acquired manual skills during the course of the war, and some observers thought that craft would be just the thing to ease them back into civilian life and perhaps provide them with a livelihood.

One woman not only believed this, but also was prepared to do something about it. Her name was Aileen Osborn Webb, and during the years of the war, she built up an institutional framework that would come to define American craft in future decades. Webb's strategy was unlike any the country had ever seen simply because of its ambition. She aimed to create a unified movement, at national scale, binding together disparate preexisting advocacy groups under a single umbrella organization, backed by her own financial resources. Remarkably, she achieved everything she set out to do, supporting the lives of countless makers in the process.

She was born in 1892 in the Hudson River Valley town of Garrison, the daughter of one of New York City's most prominent lawyers. After an education suited to her high status (an elite private school and then a period of study in Paris), she married into a family even wealthier than her own. The wedding ceremony at her parents' estate, disrupted by a driving hailstorm, was attended by the governor of New York, the mayor of New York City, and the financier J. P. Morgan.[73] As a young wife, she became active in Democratic Party politics (a family tradition) and involved herself in various charities such as the Junior League. She was a typical patrician of her era and retained that personal bearing all her life: tall, courtly, and coiffured. Yet her pathway would eventually lead her into the heart of the American counterculture.

That long road began right at home, in Garrison. With the onset of the Depression in 1929, Webb set up a government-supported organization called Putnam County

Marc Slivka, *Aileen Osborn Webb*, 1976. Courtesy of American Craft Council Library & Archives.

Products. Her initial intention was simply to provide much-needed income to the nearby rural population. "We expected," she later said, "to be asked to sell string beans and eggs. But, on the contrary, there poured in objects people had made themselves. This was especially true of the women who brought their home crafts of needle and stove."[74] Her eyes opened to the possibilities of craft, she started to learn pottery (though never became very good at it), and pivoted her organization so that it more closely resembled the Southern Highland Craft Guild. She explored the weaving, basketry, and woodwork of the area, and opened a restaurant and shop along the highway leading north through the Hudson River Valley.

Webb's genius for leadership and coordination really began to be evident in 1938, when, at her family's property in Shelburne, Vermont, she convened a national gathering of craft organizations. The largest, apart from the Southern Highlanders, was the League of New Hampshire Craftsmen, led by an architect named David Campbell; there were also representatives from Maine, Vermont, Florida, and New Jersey. They all agreed to affiliate within a single organization, called the American Craftsmen's Cooperative Council, and to create an urban retail outlet where handmade goods would command respectable prices. In 1940, Webb achieved this, opening a store called America House, in Manhattan. The following year, she started a newsletter. Its first issue, rather charmingly, asked readers to suggest a title for the publication: "Shall it be just plain Bulletin or Magazine or something fancy and 'highfalutin'?"[75]

The name that was chosen, *Craft Horizons*, echoed Holger Cahill and Dorothy Miller's *New Horizons in American Art*. A text by Cahill himself, simply entitled "Unity," was printed in the inaugural edition. It was a manifesto arguing for the oneness of fine art, craft, and design. Once again, Cahill used a folk carver—not Patrociño Barela, but a nineteenth-century self-taught artist named John Bellamy— and the Pueblo communities of the Southwest as exemplary of the integration of craft and culture. He urged his audience to notice how pervasive handwork was in their own everyday lives. And he made a case for the ongoing relevance of craft in the industrial age: "There will always be room for skilled hands . . . Everything made by the machine has first to be made by the hand."[76]

This was precisely the argument that Dorothy Liebes had been making out on the West Coast, and Webb would quickly embrace it as her own core premise, too. She used the hybrid term *designer-craftsman* to describe this idea, implying that making by hand was most important as a preliminary stage of mass production. She

forged an alliance with Liebes, first asking her to advise about merchandise at America House and then bringing her on to the council's board. (The weaver was one of a "galaxy of Dorothys" she brought on as consultants, the others being the prominent interior decorator Dorothy Draper and Dorothy Shaver, a department store executive.) Liebes's involvement and Webb's social connections aligned the council closely to developments at MoMA, setting up close collaboration in the postwar years.

Webb also turned her attention to education, particularly to the needs of veterans. She founded a School for American Craftsmen, originally located at Dartmouth University. (It would quickly be relocated to Alfred and then Rochester, both in upstate New York.) The very first student was a wounded Seabee—that's from "CB," for "construction battalion"—and though he did not last long on the course, his presence there foreshadowed things to come. In 1944, the U.S. government passed the Servicemen's Readjustment Act, popularly called the G.I. Bill. It put in place mortgage assistance and business loans for veterans and also provided financial support for any who wanted to go to college or vocational school. Millions of men—fully half of those who served in the war—took advantage. Some of the brightest luminaries of the postwar craft scene were beneficiaries, among them the enamelist Earl Pardon, the Native jeweler Charles Loloma, the furniture maker Arthur Espenet Carpenter, and the ceramic sculptors Peter Voulkos and William Daley.

Before the war, Webb had followed the lead of women like Olive Campbell and Lucy Morgan, directing her efforts primarily to rural makers. Now her attention was devoted to the colleges and universities. In recognition of this fact, she even renamed her umbrella organization: In 1943, it became the American Craftsmen's Educational Council. This strategy made a great deal of sense. The G.I. Bill was an unprecedented windfall for the education sector, taking up fully 15 percent of the entire federal budget by 1948. This allocation of resources had tremendously positive effects—indeed, historians see it as the single most important factor in the postwar rise of the American middle class. The majority of those supported by the program attended vocational schools (5.6 million, as compared with 2.2 million who attended higher educational institutions). They studied to be builders, electricians, auto mechanics, even repairmen for newfangled television sets. These fields represented genuine upward social mobility, finally delivering the "American Dream" to immigrants and working-class families. "We had to face the world," said Sam Marchesi, an eighth-grade dropout who had been seriously wounded in the invasion

of Manila, had trained as an apprentice carpenter, and had gone on to be a successful custom home builder. "We had to make a living. Thank God the government had the doors open for us."[77]

The G.I. Bill's infusion of funding into higher education had, as one of its unintended consequences, a sudden explosion of craft courses. Many of the veterans arriving on the nation's campuses were the first in their family to earn a bachelor's degree, and they were motivated to pursue practical subjects. Colleges and universities, under pressure to accommodate the influx, began offering ceramics, metalwork, and textiles. The result was a rapid, large-scale expansion of craft's footprint in the academy. This would be a crucial factor in the postwar years, as successful makers no longer needed to earn a living from their work—they simply taught others, who (if they were successful) might also go on to teach. Effectively, colleges and universities became a life support system for independent craftspeople. This began quite pragmatically, but long term, it would have the opposite effect. Individual makers, shielded from immediate economic need, had the freedom to direct their energies along more artistic pathways.

Another important aspect of the G.I. Bill was that it overwhelmingly favored white men. Women made up only 2 percent of the armed forces during World War II, and even within that small population, they were less likely than their male compatriots to pursue a government-funded degree.[78] African Americans should have benefited more equitably, as they had served in the war in large numbers. But the G.I. Bill was conceived along racist lines from the start. As Ira Katznelson explains in his crisply titled book *When Affirmative Action Was White*, congressmen from the Jim Crow South feared that expanding Black property ownership and higher education would spell the end of segregation. So, they designed an implementation structure with strong local control, knowing full well that state administrators would withhold job training and mortgage loans from African Americans. The employment service run under the G.I. Bill placed almost all its Black applicants into low-paid, unskilled jobs. Colleges and universities themselves remained segregated, and there were far too few African American schools to take on all the veterans who wanted to attend.[79] The net result was that after World War II, the demographics of American craft—at least, in its new degree-granting version—narrowed to an unprecedented degree.

～

In August 1945, two weeks to the day after the Japanese announced their surrender, the Museum of Modern Art put up a display on modern textiles. It was a small affair, only twenty-five panels' worth of fabric samples, some handwoven or hand-printed, some made by machine. Despite its modest scale, the exhibition included an impressive roster of participants. Dorothy Liebes was among them, of course. So, too, was Anni Albers, the great weaver from the Bauhaus, who was then living and working at Black Mountain College, the famed avant-garde educational experiment in North Carolina; and Marli Ehrman, another Bauhaus graduate, then running the textile program at its American successor program in Chicago, the School of Design. During the war, Marianne Strengell, originally from Finland, had become department head for textiles at Cranbrook Academy of Art, just outside Detroit, an outpost of Scandinavian modernism in the Midwest.

There a few striking things about this list. First, with the exception of Liebes, all the exhibitors in MoMA's textiles show were educators, not full-time consultants. Second, nearly all were immigrants. Some, like Albers and Ehrman, had fled the Nazis. Others, like Strengell, had come to America because it was so welcoming of her skills. This influx of talent from European countries that still retained their artisanal base would be critical to the postwar growth of craft courses. Third, they were female. There were a couple of men in the show, but they were outnumbered and outclassed. Even in its early experimental phase, MoMA primarily showed male artists—and of course, it was hardly alone in that respect. But craft disciplines such as textiles, as well as metalwork and ceramics, were far more open to female participation than painting, sculpture, architecture, or most other creative fields. While the G.I. Bill did disproportionately bring men into craft courses as students, the instructors themselves were often women.[80]

Over the next few years, MoMA carried on with its craft program: *Modern Handmade Jewelry* in 1946, *Printed Textiles for the Home* in 1947, and a one-woman show for Anni Albers in 1949. Finally, in 1950, came *Good Design*. This was the first in an annual series of juried exhibitions conceived by curator Edgar J. Kaufmann Jr. as a deliberate intervention into American manufacturing. By the time the series ended in 1955, the *Good Design* initiative had produced an international touring spinoff, copycat programs at other museums, and a bold graphic tag that could be used by retailers to designate products that had been featured—a kind of modernist seal of approval. The German-born curator Greta Daniel joined MoMA's staff and created additional design exhibitions, among them *Textiles U.S.A.* in 1956. Much

larger than the fabric show held at war's end, its emphasis was on industrial produc-
tion and the miracle of technology: "Corn cobs, coal, air, and petroleum, processed
into fiber, now adorn our homes and our persons." But Daniel once again made
space for craft weavers, so long as they designed for mass production.[81]

Other crafts, too, were part of the *Good Design* series. Potters Marguerite
Wildenhain and Lucie Rie were featured, as were the Chicago glass artists Michael
and Frances Higgins, the wood turner Bob Stocksdale, and Ronald Hayes Pearson,
who taught metalwork at Webb's School for American Craftsmen. The exhibition
juries included craftspeople such as the ceramist F. Carlton Ball; in 1952, George
Nakashima was invited to speak. Overall, handmade objects were in the minority in
the *Good Design* shows, but they sat alongside mass-produced goods in perfect
comfort. The politics of production—which had been central for the Arts and
Crafts movement and the early modernists who followed—were set aside in favor of
aesthetics and consumer taste. The official criteria for selection were "eye-appeal,
function, construction and price, with emphasis on the first."

MoMA's doors were wide open to craft, then, and Aileen Osborn Webb strode
right through. She cultivated friendships among the museum's staff, paramount
among them René d'Harnoncourt himself, who joined her council's board of
trustees. Greta Daniel contributed to the pages of *Craft Horizons*. Webb's shop,
America House, was in constant dialogue with the *Good Design* program. And in
1953, she orchestrated an exhibition at the Brooklyn Museum that proclaimed the
new paradigm: *Designer Craftsmen U.S.A.* It was an enormous show with more than
two hundred participants, identified through a nationwide search with ten regional
hubs. The project marked the culmination of an idea that Dorothy Liebes had been
among the first to advance: that through design, the long-standing opposition
between the artisanal and the industrial could be resolved. According to an essay
in the exhibition catalogue, written by the *Craft Horizons* editorial board member
Dorothy Giles, "a society in which direction is inspired by artists and by designer-
craftsmen is a healthier, richer and more productive society than one which leaves it
to industry and business to point the way and set the pace."[82] And there was certainly
a legitimacy to the "designer-craftsman" ideal. It made all the sense in the world to
prepare test swatches on a handloom before committing to the time and cost of
setting up the pattern on a big power loom. The same logic held for ceramics, metal-
work, and furniture, all of which required initial models to guide eventual mass
production. These seemed like genuine opportunities for craft makers.

But there was one problem: American industry was not interested. Some companies did find it helpful for promotional reasons to have a living, breathing person attached to their products. But this role was typically played by freelance industrial designers like Raymond Loewy or in-house styling gurus like Harley Earl at General Motors, not by craft makers. Even textiles, which had inspired the whole idea that craft could be a consultancy gig, were far less promising than Liebes and Webb had hoped. Certainly there were some success stories, like Jack Lenor Larsen, who studied at Cranbrook with Marianne Strengell and then went on to a stellar career as a fabric designer. Larsen inherited Liebes's mantle as Webb's staunchest ally, exemplifying and promoting the "designer-craftsman" ideal both at home and abroad. Yet the experience of his classmate Ed Rossbach was far more typical. Rossbach later looked back on his student years at Cranbrook in total bemusement. He made one small sample after another, delving deeply into the language of weave structure. Upon graduating, he had a terrific portfolio, but no corporate clients. Companies did need to invest in a certain amount of product development, but they had the capability to do this in-house, and had no motivation to work with artistically inclined free spirits. Rossbach took up a teaching job out in California, where he eventually started pursuing much more expressive work in basketry and collage, never again concerning himself with design for industry. "That whole phase of things," he recalled. "You wonder what in the world all that was."[83]

Well aware of these problems, craftspeople and their supporters looked abroad for successful models, particularly to Scandinavia, where artisanal manufacturing remained strong. Danish furniture, Swedish glass, and Finnish ceramics were indeed designed by in-house makers, typically in a softened modernist idiom, and then executed largely by hand. This formula was wildly effective, and throughout the 1950s, Nordic products flowed across the American market in a gentle wave. Entranced, American craftspeople flocked to Scandinavia to study, and many of the new university programs hired Scandinavians as faculty. At Webb's School for American Craftsmen, for example, furniture was taught by the Danish master Tage Frid and metalwork by the Danish-trained John Prip. American craftspeople also sought advice from men like Arthur Hald, a representative of the Swedish Society for Arts and Crafts, who openly criticized the "newness-neurosis" of America. There was another way, if consumers could be persuaded to invest in "the very best in craftsmanship and design as opposed to the vulgar and cheap."[84] This argument did have a broad appeal, as the taste for Scandinavian design itself demonstrated. But the economy of scale in the United

Chapter 7

Declarations of Independence

Y OU'D HATE TO HAVE LIVED next to the Hoff family. Not that they would have been bad neighbors. Far worse: They were perfect. According to a 1950 issue of *Better Homes and Gardens*, dad Amos, mom Fern, and children Wilbur, Lucille, Carol, and Edward were prodigies of self-improvement. In the previous two years, the family had done about 80 percent of the construction work on their new home, modern in style, in the suburbs outside Phoenix, Arizona. They saved about five thousand dollars, doubtless welcome, as the family subsisted on Amos's salary as a university professor. "What they can't afford to buy," the magazine noted, "they prefer to make anyway; and hobby knowledge usually is turned to a direct, practical value."

The Hoff home was built from concrete block with a facing of stone quarried on-site. The fireplace had a hand-hammered copper chimney hood, with a half-ton stone base dynamited out of a nearby hillside. A big sliding-glass door, perfect for the indoor/outdoor lifestyle then becoming all the rage, had a metal frame welded by Amos and Wilbur, who had learned the craft in night school. The doors led out to a masonry fishpond. Fern, Lucille, and Carol had learned about color by doing ceramics and fabric painting; they decided to paint the bathroom "peach and dubonnet, capturing the desert sunrise." Even young Edward, only twelve, was an avid wood carver. He made a yo-yo so large it could be operated only from the roof, and another the size of a thimble. For nighttime entertainment, they built a telescope with a hand-ground mirror and a war surplus lens. An encyclopedia was kept

in the dining room "to bolster dinner conversation." "We achieved family happiness by deliberately and studiously planning for it," Fern said, "then applying the plan consciously almost every hour of the day and night."[1]

Better Homes and Gardens featured the Hoffs because they were exceptional. Yet, in their over-achieving way, they exemplified the values of postwar American suburbia. In the space of just a few years, the country had gone from all-out war to all-consuming leisure. Rationing was a distant memory. For the white middle class, prosperity seemed to be there for the taking—or the making. The huge demand for housing prompted developers (most famously William Levitt, whose first epony-mous suburb was built on Long Island between 1947 and 1951) to experiment with prefabrication and mass-production techniques that had never before been applied to construction at such a vast scale. The standardized units of Levittown, cookie-cutter ranches and Cape Cods, fairly cried out for personalization. And the young people who had gone through the war were ready. While they might not have had much money, they likely had hand skills, picked up either in the military or on the home front.

The result was the "Do-It-Yourself" movement, a craft craze that swept America in the postwar years. If a pipe leaked, a suburban family did not call the plumber. They consulted a manual, grabbed a wrench, and got to work. If they wanted a swing set, they built one from boards and pipe. New linoleum floors were laid by hand. "Millions have taken to heart Thoreau's example," said one government official, "withdrawing to their basement and garage workshops to find there a temporary Walden."[2] To be sure, very few parents developed the aptitude of Amos and Fern Hoff, or encouraged their children to be quite so proficient. But there was a general expectation that households would be self-reliant. Men in particular were meant to be "handy" around the house. Unlike previous generations, who had tended to see working with one's hands as a marker of low social status, this one took it as a point of masculine pride. In this stereotypical gender configuration, women were seen as managerial figures whose main role was to pick out plans and patterns. Advertisements showed them steadying ladders and reading out instructions as their husbands did the hard work.[3] *Popular Mechanics*, which had been in publica-tion for decades but now soared in popularity, promoted its own plans for self-built homes. One article imagined a G.I. during the war: "Someday he would build a home for himself and The Girl." The magazine enjoined an actual veteran, a twenty-three-year-old in Aurora, Illinois, to construct a dwelling using their

instructions; the main thing he wanted in the house was a basement where he could have a woodshop.[4]

As the enthusiastic involvement of *Popular Mechanics* suggests, the Do-It-Yourself movement was shaped by commercial interests from the beginning.[5] It strongly resembled the "self-made man" ideal that peaked about a century earlier, which drew a similar equation between craft-based initiative and upright citizenship. The difference was in the range and complexity of the productive forces at play. A hundred years of industrial capitalism had furnished far more powerful tools than mere magazines. In 1946, the sale of portable power tools was worth six million dollars, and by 1953, that number had multiplied fifteenfold. (Not coincidentally, home-improvement-related injuries also skyrocketed, to over half a million incidents annually.) Some equipment was designed expressly for the home handyman, like Magna Engineering's all-in-one Shopsmith, a bench outfitted with a saw, lathe, router, and drill.[6]

Shopsmith: The New Handyman for Every Home Farm and Service Shop, 1952. Courtesy of the author.

Plenty of other business interests were also pushing Americans to do it them-selves. In 1953 alone, according to one estimate, amateur home builders purchased 500 million square feet of plywood, 100 million gallons of paint, 150 million rolls of wallpaper, and "enough asphalt roof tiles to cover the entire state of Oregon."[7] Almost all of these materials were standardized—it's in this period, for example, that the modern 2-by-4 was codified. (It's actually 1½ by 3½ after drying and planing.) This highly consistent lumber was ideal for use in quickly built suburban subdivi-sions, where platform framing and light "stick construction" (plywood or drywall over studs) were the norm.[8]

Before the war, home building had been a domain of professional craftspeople. But prefabricated elements and quickly built, standardized housing—effectively, the techniques of the Fordist assembly line applied to architecture—now eroded this highly skilled workforce. To be sure, professional tradesmen did play a key role in building the suburbs. A good example is the construction of water towers, which replaced the individual wells that had previously serviced most homes in rural America. The new towers, emblems of civic pride wherever they were erected, were hand-built by itinerant crews of boilermakers welding metal several stories from the ground.[9] Yet the real mainstay of the construction industry was the single-family home, and here the effects of prefabrication were dramatic. Unions in the building trades tried to police their territory, objecting to everything from spray-painted walls to factory-built windows and kitchen cabinets. They earned little more than mockery. Their defensive policies, according to a writer from the National Labor Relations Board, had "ludicrous results from the viewpoint of industrial efficiency," and were swiftly overcome.[10]

By contrast, organized labor tended to be encouraging of amateur home builders, perhaps feeling that they would not have sought professional help in any case and that their involvement in craft would build sympathy with blue-collar workers. In 1957, the great anthropologist Margaret Mead, already famous for her studies of Oceanic cultures, directed her attention to another aspect of this intersection between professionalism and Do-It-Yourself. Her view was provocative: Mead theorized that the balance between work and leisure, in which the two were "tied together in a tight sequence," had broken down in America. As people identified less and less with their jobs, and spent fewer hours at them, they treated their home more and more as a work site. Though this transposition of labor into the domestic scene was popularly understood as recreation, in fact it was a new form of obligation. "Do-it-yourself with

five children," Mead wrote, "besides being delightful, is strenuous, time-consuming, backbreaking, nerve-straining, and confining." She called for a change in priorities. Amateur home builders should not replicate the wage worker's "dogged willing-ness to work long hours for very limited reward," but instead should treat their pursuits as a genuine form of play, taking pleasure "in high level proficiency" for its own sake.[11]

These conclusions were consistent with an emerging consensus among social scientists. Americans' new prosperity was not making them happy, because it was accompanied by overconsumption and crushing conformism. One scholar, writing in response to Mead's article, put it like this: "For centuries we have striven to remove the deadening yoke of servile toil from off the backs of most men. And now that most of us in America can look up at the stars, we have managed to find a million varieties of yo-yos with which to fritter our 'free' time away."[12] An even more damning critique of amateurism appears in the writing of Theodor Adorno, one of the most prominent and respected of Marxist philosophers. He had arrived in America in the late 1930s, in flight from the Nazis, and was both fascinated and appalled by what he found here: a manipulative array of mass media and commodities that he called "the culture industry."

Adorno was proud to say that he had no hobbies, in the sense of "preoccupations with which I had become mindlessly infatuated, merely in order to kill the time." He argued that any pursuit, particularly a creative one, must be taken with utmost seri-ousness. This was a matter of simple intellectual integrity, but also a necessity if one wanted to ward off the malign effects of consumerism. His view, even more pessi-mistic than Mead's, could be summarized in just four words: "Organized freedom is compulsory." Amateur craft was not just a way for companies to sell stuff: the tools and materials filling up the nation's garages. It was far more insidious than that. Adorno watched people pouring their time and energy into what he considered hollow demonstrations of prosperity, and saw nothing but servile deference to capi-talist interests. The "hobby ideology," he thought, was nothing more than a thinly disguised "continuation of the forms of profit-oriented social life."[13]

Adorno was out on the radical fringe, politically speaking; few Americans would even have heard of him, much less read his theoretical writings. Yet a compatible analysis offered by the sociologist David Riesman gained a surprising amount of popular traction in the 1950s. His book *The Lonely Crowd*, which sold 1.4 million copies, diagnosed America as suffering from a new ailment, one brought on by

"abundance psychology."[14] Riesman made an important point: All societies are to some degree conformist; otherwise, they could not function. He wanted to explain what was wrong with the particular *type* of conformity emerging in postwar America. Material constraints had been conquered by technology. Food and shelter were increasingly cheap and readily available. So, instead of devoting their energy to transforming their environment, people now worried mainly about other people. In a striking metaphor, Riesman wrote that if previous social constellations enabled a person to keep his or her bearings based on an intrinsic sense of self, the contemporary "other-directed" person was like a radar, constantly scanning social space to determine relative position.

Riesman could perhaps have presented this as a good thing, a rise in mutual awareness among citizens with inevitably competing interests. But he didn't. For him, other-directedness was a recipe for decline. The contemporary American is "said to be shallower, freer with his money, friendlier, more uncertain of himself and his values, more demanding of approval than the European." The new personality type was rotten at its psychological core: consumed by anxiety, plagued by constant worry about peer acceptance. One of the key indicators of an other-directed society, according to Riesman, is that instead of actually making things, workers are increasingly relegated to service jobs and bureaucracy. As he concisely put it, "if one is successful in one's craft, one is forced to leave it." The competent mechanic is promoted to a role in management, sales, or marketing.

Insofar as he saw this as a new dynamic in society, Riesman was particularly interested in its effect on America's youth, set adrift with only "mass-media tutors for instruction." He drew an explicit contrast with nineteenth-century biographies of self-made men, which counseled their young readers never to waste time, to improve themselves with every waking moment. Superficially, this might seem like a precedent for postwar DIY culture, but there was a key difference. Now self-improvement was "used, often quite desperately, for training in group adjustment." It prepared its juvenile audience for a life in which true productivity is replaced by mere simulation. (Riesman gives the nice example of a "car or house whose upkeep must be carefully maintained for resale purposes.") Here his analysis overlapped with Adorno's. Modern capitalism was turning its citizens into dupes fearful of stepping out of line, dutifully training themselves to fit in. The home improvers of the 1950s, and the kids who were raised in that environment, might

have seemed firmly fixed on their own upward mobility. In fact, they were looking over their shoulders.

~

The concerns expressed by intellectuals like Riesman penetrated deeply into the American consciousness. Alienated and anxious characters took center stage in Arthur Miller's play *Death of a Salesman* (1949); in the short stories of John Cheever; in novels like J. D. Salinger's *The Catcher in the Rye* (1951), John Updike's *Rabbit, Run* (1960), and Sylvia Plath's *The Bell Jar* (1963); and in films like *Rebel Without a Cause* (1955), starring James Dean. Even *Popular Mechanics* picked up the main argument of *The Lonely Crowd*, commenting in 1952 that "it appears that man has just about mastered technology. It remains for him to solve his economic, political and moral problems."[15] There was one subject, however, that seemed to arouse more disquiet, sometimes shading into outright panic, than any other. This was the American teenager.

The word itself was new, coined in the 1920s, and became common parlance only during the war. Even newer was the emergence of a mass consumer culture aimed at this demographic—and, to some extent, produced by it. Teenagers became increasingly numerous as the 1950s wore on, thanks to the baby boom, making an ever-larger market. They also were increasingly confident in testing social norms. As a demographic based on age, rather than class, ethnicity, or gender, they formed a unique bloc, with at least the potential to cross previously distinct social barriers. In general, though, adults found them to be brazen yet aimless, and ever on the verge of boredom. They seemed to devote their time to trivialities (strange haircuts, alarming music). They even spoke in a new style, disruptive and dismissive at the same time, suggesting that—as a linguist wrote of Holden Caulfield, the protagonist of *The Catcher in the Rye*—"there is more that could be said about the issue at hand, but he is not going to bother going into it."[16]

Teachers noted a seismic change in their classrooms. Students did not accept what they were taught. They instinctively challenged authority. One educator hypothesized, "We no longer represent a stable society . . . There is a much greater chance that what a student learns today may be obsolete tomorrow. Students sense this vagueness and they question and resist."[17] One team of sociologists conducted a study of three thousand high school students and decided that they had found proof

of Riesman's thesis: The students were sunk into "unthinking conformity" and plagued by "a syndrome characterized by atrophy of the will, hypertrophy of the ego and dystrophy of the intellectual musculature." Even the teenagers themselves seemed to agree that they were paralyzed by "other-direction." When asked to list their biggest problem, their top answer was "want people to like me more."[18]

If there was one context in which teenagers really expressed their own point of view, it was where intellectuals most worried about them: in their leisure pursuits. The stereotype of the teenager obsessively consuming prepackaged mass culture (Pat Boone movies and Elvis Presley records) has a lot of truth to it, of course. But teenagers also invented themselves, often using craft for the purpose. Their version of Do-It-Yourself, though just as responsive to commercial interests as that of their parents, could be far more creative and even more skilled. This hallmark of postwar youth culture had already been anticipated in the 1930s, mainly by girls, both white and African American, who were interested in swing music. These young women established a pattern of intense identification with certain star performers and demonstrated remarkable imagination in refashioning themselves. Some wore hand-made skirts decorated with notes from their favorite chart-toppers, or made hats out of favorite vinyl records.[19]

By the 1950s, the outsourcing system that had been commonplace in the garment industry had almost entirely vanished. Home dressmaking, marginalized in economic terms because of the cheapness of factory-produced garments, was pursued primarily for pleasure rather than income. The craft became so wholly the province of teenage girls that Singer, the sewing machine manufacturer that had pioneered mass marketing a hundred years earlier, focused its advertising primarily on this audience, through publications like *Seventeen* (launched in 1944 and often credited with molding the mainstream image of the teenage girl). Singer's promotions presented sewing as a means of attainment, recalling the "domestic accomplishments" of earlier periods in America, but now in modern guise. Even the most intellectual pursuits were packaged in terms of personal appearance and male approval. One ad, run in *Seventeen* in 1950, relates the tale of a girl on the debate team. Facing a big competition, she prepares by making a "sensational dress." She wins, of course, and even gets a date "with a wonderful-looking boy on the opposing team."[20]

Gender propaganda like this may well have influenced readers, but it's important to remember that it reflects the preconceptions of media executives, not necessarily teenagers themselves. In practice, their fashion consciousness was a more compli-cated matter, equal parts trend following and individual expression. Fashion was

H. Armstrong Roberts, *Two Teenage Girls Fitting a Dress*, 1953. ClassicStock, Archive Photos/ Getty Images.

certainly influenced by professional couturiers, most famously the "New Look" originated by Christian Dior in Paris. Yet there were also vivid departures from this top-down style industry. The most famous is the zoot suit, which first found popularity among African Americans and Mexican Americans during the war. Distinguished

by its abundant draped fabric, the style featured low-hanging coats with heavily padded shoulders and long "fingertip" sleeves. Young women who participated in the style wore short skirts, while men sported voluminous trousers, tight at the hips and ankles, with sharp "reet pleats" down the fronts. Zoot suits could be had from tailors at significant expense—the *New York Times* claimed that the very first suit in the style, nicknamed the "killer diller," was a custom commission ordered by a busboy in Georgia. (The term "killer diller," like "reet pleat" and "zoot suit" itself, was an example of rhyming slang common among Black teenagers at midcentury.) But they were also made at home, typically by adapting an overlarge used garment.[21] The style was so bold that it became the pretext for an infamous race riot in Los Angeles in 1943, when white servicemen attacked young Mexican Americans, stripped them, and symbolically burned their clothes. The incident reflected existing tensions between whites and Latino war workers, yet it also shows how provocative the style was, as a demonstration of conspicuous consumption by people expected to be poor and deferential.[22]

Seemingly at the far end of the cultural spectrum from the zoot suit was the poodle skirt, an emblem of respectable, white, middle-class girlhood. Yet it, too, was a means of individual expression, and was often homemade. In fact, the design originated as an expedient. In 1947, a singer named Juli Lynne Charlot, invited to a Christmas party, quickly made a skirt and decorated it with holiday motifs. "I cut it out of felt, because I didn't know how to sew," she recalled. "And that was the only material I knew wide enough to cut a complete circle skirt without seams."[23] Charlot eventually built a successful business out of the idea, often adding dogs as decoration—hence the name poodle skirt—and other manufacturers copied it. The design became wildly popular, particularly for dancing, as it emphasized the twisting and twirling steps then in vogue. The real secret of the skirt's popularity, though, was that it could be so easily made and customized, with imagery of the wearer's own choosing.

The poodle skirt was just the first of several fashion trends that teenage girls embraced in the postwar era, among them the pencil skirt, which Dior introduced in 1954, displacing his previous A-line style, and the amorphous "sack dress," which had a brief surge of popularity in 1958. Each time, teenagers responded to media promotion of the new style through a combination of purchase and personalization. Magazines carried features on the newest fashions alongside advertisements from paper pattern companies, like McCall's and Simplicity, aimed explicitly at teenagers. Patterns enabled teenagers and young adults to keep up with the fashions, while also

affording a wide spectrum of choice through the selection of fabric, trimmings, and (for the more skilled) creative adaptation. One ad that ran in *Ebony* featured a young African American woman in a handmade ball gown: "I haven't sewn since high school, but it was easy and it was fun . . . The first time I've had exactly the cut and the fit and the fabric and the color I wanted all at once."[24]

Used clothing, now rebranded as "vintage" (another new coinage of the era), was another hybrid of the manufactured and the custom. Buying secondhand garments and then retailoring them was far easier than making clothing from scratch. It could also project disregard for prevailing trends, a conception of teenage coolness that theorists such as Riesman might have had a hard time explaining. (Ironically, it was the very pace of change in mainstream fashion, including the introduction of new synthetic fabrics, that made prewar clothes seem so distinctive.)[25] And in a direct parallel to the taste for vintage dress, boys hand-customized automobiles, usually makes from the 1920s and '30s, making them into "hot rods" (*rod* being short for *roadster*). This was almost entirely a male hobby, reflecting the strict gender divisions of the time. Just as they had in the nineteenth century, girls typically studied home economics in school, while boys went to shop class. On the rare occasions when this convention was broken, rhetorical gymnastics were required. If boys were taught to sew and cook, the class was described as "Bachelor Living," with it taken for granted that these skills would no longer be required of them after marriage. When girls did learn woodworking, they were taught to make hope chests, emphasizing their future role as wives.[26] Dressmaking and hot-rodding were firmly located on opposite sides of a gender line, serving as potent emblems of femininity and masculinity.

The hot rod craze began during the war. With auto manufacturers converted to military production, new cars were in short supply. Young men started to lay their hands on old junkers, repair them, and rebuild them; the 1932 Ford, or "Deuce," which featured a reinforced all-steel body, was a favored option. Amateur builders in Los Angeles were especially ambitious, putting powerful V8 engines into their cars and redesigning the bodies to make them lower and faster. They competed in speed trials, held on dry lakes outside town, and in drag races on public streets. An aesthetic for the cars soon emerged, low and sleek, with a sloping "fastback" to the rear. The roof of the classic hot rod was lowered, or "chopped," a major metalworking project in which sections of the pillars and window frames were cut down and re-welded. The whole body was "channeled," lowered with respect to its frame.

Hot-rodder Lee Roan, on leave from the Navy, works on his car in Pasadena, California, 1952. University of Southern California, Corbis Historical/Getty Images.

Like other popular crafts among young men such as making surfboards, boats, and guitars, hot-rodding was a complicated mixture: a self-consciously individual-istic pursuit shaped by mass media. *Popular Mechanics* promoted the trend, and there were also specialist magazines, like *Hot Rod*, founded in 1948, and *Car Craft*, first published under the title *Honk!*, in 1953. These magazines, operated by entre-preneur Robert Petersen, sought to assuage public fears that hot-rodding was a dangerous, possibly even suicidal activity. Early issues actually ran editorials by the California Highway Patrol, and insisted, probably correctly, that "very few hot rod enthusiasts want to risk their specialized equipment for use as battering rams."[27] The most intensively crafted hot rods were reserved exclusively for racing; they were towed to meets, and might run for only thirty or forty minutes all year, albeit at top speed.[28] Petersen saw that stressing mechanical aptitude, rather than raw power or superficial style, would appeal to readers and their parents alike. This message was reinforced by a growing parts industry. Teen hot-rodders might not be spending

their money on "Detroit iron," as they derisively called new cars, but they did buy specialist gear such as turbochargers, which were obtained from dedicated "speed shops." As the hobby grew, so, too, did these suppliers. By 1961, they were selling $36 million worth of parts per year—a parallel to the mass marketing of materials for adult home improvement.[29]

Technical and economic considerations aside, hot rods were quite simply amazing to look at, and they attracted attention more than any other teen pursuit. An indelible record of the phenomenon is Tom Wolfe's 1963 essay for *Esquire* magazine, "There Goes (Varoom! Varoom!) That Kandy Kolored (Thphh-hhhh!) Tangerine-Flake Streamline Baby (Rahghhhh!) Around the Bend (Brumm-mmmmmmmmmmmmmmmm . . .)," an account of his encounter with custom cars at a teen fair in Burbank, California. As its title suggests, this was an unusual and inno-vative piece of writing, one that mixed standard reportage and subjective commen-tary. It's sometimes seen as the first published example of the "New Journalism" that would develop in the later 1960s. One could argue that Wolfe was taking his cue from the hot-rodders themselves, who were infusing standard automobiles with unprecedented verve and creativity. In particular, he fell under the spell of a car builder named George Barris.

By the time Wolfe met him, Barris was thirty-seven years old, but as teenagers in the 1940s, he and his brother Sam had helped define the techniques and look of the California hot rod scene. Wolfe describes George as "a solid little guy" who "looks just like Picasso," a comparison he then extends through an appreciation of his cars as rolling artworks. Barris's garage in Hollywood "looks like any other body shop at first, but pretty soon you realize you're in a gallery," Wolfe writes. "This place is full of cars such as you have never seen before. Half of them will never touch the road." This was not an "unencumbered art form," admittedly. "It carries a lot of mental baggage with it, plain old mechanical craftsmanship, the connotations of speed and power and mystique that the teen-age netherworld brings to cars." Even so, the best way to think of Barris was as a sculptor: "He's not building cars, he's creating forms."[30]

Wolfe also describes the interesting interchange between custom car makers and the big auto companies. He points out that Detroit borrowed many ideas from hot-rodders and integrated them into its mass-produced vehicles, among them tailfins, twin headlights, and the general principle of a low-slung body. (The so-called muscle cars of the 1960s, like the Pontiac GTO, marked the culmination of this appropriation

of grassroots style.) Meanwhile, the denizens of the custom car scene held themselves proudly independent. They would not dream of going to work in Detroit as stylists; that would "be like René Magritte or somebody going on the payroll of Continental Can." Yet Barris and other leading builders also welcomed the attention from the big auto companies, participating in spectacles such as General Motors's Parade of Progress and Ford's Custom Car Caravan, which was rolling through Burbank when Wolfe visited. As he saw clearly, the hot rod was a bundle of apparent contradictions: technical and aesthetic, individualistic yet saturated by all sorts of commercialism. The teenagers who built hot rods constituted what would eventually come to be called a subculture. They employed a language as bespoke as the cars themselves: Bumpers were "nerfing bars," pistons were "buckets," the camshaft was called the "stick."[31] They competed among themselves for forms of prestige that were all but incomprehensible to outsiders.

Though Wolfe seemed unaware of it, an even more developed form of this dynamic was unfolding nearby, among young Latinos in East Los Angeles: the distinctive "lowrider." This custom style is similar to that for other hot rods and was developed concurrently, in the 1940s and '50s, though as its name implies, a lowrider is dropped down closer to the ground, so that its running boards almost scrape the pavement. In its early years, it differed from the hot rod also in its make; rather than historic Fords, big new Chevrolets were preferred. Somewhat like the zoot suits worn by Latino men in the 1940s, the lowrider is purposefully, voluptuously impractical. Exteriors are sheathed in immaculate custom paint jobs. Interiors might be lined with thick carpet and outfitted with bucket seats and smaller-than-usual steering wheels, allowing the driver to sit even lower. Smaller-than-usual tires might be fitted to the car, too, with chromed rims to complete the look. These cars are not for racing, but the contrary: moving as slowly as possible down a boulevard, for purposes of admiration. One owner, quoted in a 1975 study, explained the aesthetic like this: "You want a car that's built long and low and sexy, so that like if you was to take a picture of you and your broad standing beside it, you'd see one long line."[32]

Lowriders of the 1950s and '60s were not typically customized by their owners, as most hot rods were, but built in specialist body shops. Even so, they were, as one historian comments, "masterly crafted signs of difference" within the usual traffic flow of the city.[33] The cars were an implacable refusal of authority—not least the authorities who rammed the country's busiest highway interchange through the ethnically diverse Boyle Heights neighborhood of East L.A. in the early 1960s.[34] The

lowrider manifested a lordly indifference to such assaults, bringing the tacitly rebellious energy of hot-rodding out into the open. This custom car culture was certainly "other-directed," to recall Riesman's terminology—even more purely so than other postwar amateur pursuits, for it was devoted solely to ostentatious display. But the message it sent was anything but conformist. Homogenous cultural theories have a hard time keeping up with the diversity of craft—even when it goes only five miles per hour.

～

George Barris, the protagonist of Wolfe's "Kandy Kolored Tangerine-Flake Streamline Baby," probably never met Peter Voulkos. It's a shame, for they had a great deal in common. Born just a year apart—Barris in 1925 and Voulkos in 1924—both were from Greek American families. For a time, both were in Los Angeles, their workshops only about six miles distant. Both were prodigiously gifted makers, right at the top of their fields. And both took a medium generally considered to be functional and transformed it into something that could be understood as fine art. Yet there was a huge distance between Barris's world and Voulkos's, and that says a lot about the changing state of craft in postwar America.

During the war, Voulkos worked in a shipyard in Portland, Oregon, and then served as a tail gunner in the Pacific Theater. After demobilizing, he attended college in his native state of Montana with funding from the G.I. Bill, and it was there that he discovered pottery. Under the supervision of an instructor named Frances Senska, he quickly became a skilled thrower on the wheel, and then went on to get a master's degree at the California College of Arts and Crafts, in Oakland. For a few years he made utilitarian wares, winning awards at regional fairs and juried exhibitions. In 1954, he moved to Los Angeles to take up a teaching position, and two years after that he launched himself into an extraordinary series of experiments with clay.

Though he still worked in a potter's vocabulary—his pieces were constructed mainly from thrown cylinders, for example—he used these techniques in a totally unconventional, rough-and-tumble way. He stuck fragments of cut slabs here and there. He made spouts, sometimes five or six, and attached them in odd places. He used slips and glazes as if he were an action painter, breaking up the surface with gestural marks. Voulkos's new approach attracted attention, both negative and positive. Some traditionally minded potters thought what he was doing was incomprehensible,

Oppi Untracht, *Peter Voulkos Working in His Studio*, 1956. Voulkos & Co. Catalogue Project.

but students gathered around him—and began developing their own equally idio-syncratic styles. And a few craft advocates realized that he was what they had been waiting for: a figure to rally behind, someone who could push their field into an entirely new domain.

Voulkos was hardly the only trailblazing craft luminary to emerge in the 1950s. There was Lenore Tawney, a weaver whose work combined ethereal abstraction and intense spirituality; Margaret De Patta, a jeweler who applied Bauhaus-style constructivism to her discipline; and Wendell Castle, who invented new ways of building furniture that allowed him to create innovative biomorphic forms. A little later, once the technical hurdles of blowing hot glass in a small workshop environ-ment were solved, this medium, too, found its champions, such as the technician-sculptor Harvey Littleton. This brief list could be extended ad infinitum with the names of other makers who sought to expand the conceptual, creative, and formal possibilities of their mediums.[35] Together they formed what eventually came to be called the studio craft movement—the word *studio* here referring to a one-person

atelier, like that of an artist. The movement flourished rapidly after the war, sheltering under the organizational infrastructure created by Aileen Osborn Webb. By the end of the 1950s, she had founded not just a national council, a shop, and a magazine, but also a series of annual conferences and even a small museum, situated in a converted town house right next door to the Museum of Modern Art in Manhattan. Initially called the Museum of Contemporary Crafts—today, the Museum of Arts and Design—it opened in 1956.

Though mainly composed of white middle-class people seeking unconventional pathways, the studio craft movement was not a monolith. Jade Snow Wong, for example, was raised in Chinatown, San Francisco, by immigrant parents who operated an overalls factory. She said that it was only when she discovered ceramics at Mills College and began selling her pots out of a storefront—"a woman in the window, her legs astride a potter's wheel, her hair in braids, her hands perpetually messy with sticky California clay"—that she felt contentment.[36] Her autobiography, *Fifth Chinese Daughter*, was so successful that, in 1953, she was sponsored by the U.S. State Department to travel through Asia to help counteract concerns about anti-Chinese prejudice in America.

The fittingly named Art Smith was an African American jeweler based in Greenwich Village, in New York City; he had moved to the neighborhood from nearby Little Italy in 1948 to escape racial hostility. Smith adapted the organic design style that MoMA had featured in 1941, bringing to it notes taken from modernist sculpture and African art. Among his clients was the Black choreographer Talley Beatty, who found Smith's oversize, asymmetrical forms to be the perfect visual counterpart for modern dance. "The body is a component in design," Smith wrote, "just as air and space are. Like line, form, and color, the body is a material to work with."[37] The wearer's skin became a backdrop for floating, abstract metal, communicating the idea that Black is beautiful.

Another jeweler to attain prominence in the period was Charles Loloma, from a Hopi reservation on Third Mesa. He'd trained as an artist early and had a job as an assistant painting murals at the Golden Gate International Exposition's Indian Court in San Francisco and the subsequent show at the Museum of Modern Art. After serving in the war, he attended the School for American Craftsmen. Drawing on his experiences there, he cofounded the Institute of American Indian Arts in Santa Fe, using it as a platform to promote individual innovation among Native makers. His own mature style as a jeweler was abstract, with stones projecting asymmetrically

Jeweler Art Smith in his showroom, 1960s. Estate of Art Smith.

from bracelets, rings, and buckles. He drew from Pueblo precedent in adopting techniques such as casting silver in tufa stone and in his choice of materials, notably turquoise. But he also expanded this palette considerably, using precious stones and figured woods. Like Maria Martinez before him, Loloma positioned himself as a representative of Native culture who was also in dialogue with modernism. "Indians are coming to be a fad," he once said, "but [only] on a level at which even the government tries to keep us, as though the Indian should not grow up. But we have. And the work is flowering—even surpassing some [other] contemporary work which has reached a point where it is no longer a growing thing."[38]

Jade Snow Wong, Art Smith, and Charles Loloma were certainly not alone as ethnic minorities in the studio craft movement, but they were exceptional nonetheless. One of the movement's greatest weaknesses was its lack of diversity. This was true not just demographically. Amateur and industrial artisans (people such as George Barris, the custom car builder, and Tina Hill, the aviation factory worker) were totally off the movement's radar. Following the somewhat arbitrary logic of

university curriculum, five mediums (ceramics, glass, fiber, metal, and textiles) were given pride of place. Yet this tight focus was also a strength, for it fostered a sense of community. When Webb hosted her first national conference in 1957, at Asilomar, in Pacific Grove, California, 450 people came from across the country. Some had never before met another independent maker in their own discipline; many felt a tremendous sense of discovery and possibility. Regional organizations in support of the national council were formed, as were regular exhibition series such as *California Design*, held in Pasadena, and *Fiber Clay Metal*, in St. Paul, Minnesota. Through these connections, craftspeople came to befriend and support one another. They traded examples of their work, shared technical insights, and discussed their shared goals. They felt strongly that America needed them. Craft was an alternative to bland suburban conformity, to impersonal mass production, to a world where all the objects looked the same. At Asilomar, the Bauhaus-trained potter Marguerite Wildenhain declared that the movement's shared cause should be nothing less than to "fight the lack of ethical standards in our times . . . devoted to an ideal based on human dignity and independence."[39]

Jeweler Charles Loloma, 1962. Arizona Chamber of Commerce.

Craft Horizons magazine, brilliantly edited from 1959 onward by the art critic and poet Rose Slivka, served both as connective tissue for this new network and a journal of ideas. It helped makers locate tools, materials, and other resources, and included a calendar of events where craftspeople could meet and see one another's work. Slivka demonstrated her intellectual force in essays like "The New Ceramic Presence," published in 1961, which served as a kind of manifesto for the avant-garde work being done by Voulkos and his compatriots on the West Coast. She framed her argument in extremely broad terms, presenting new currents in ceramics as a delayed corrective to the Industrial Revolution. The machine, Slivka wrote, was the most potent force in American life, and there was no questioning "its power, its speed, its strength, its force, its energy, its productivity, its violence." This appeared to leave craft without a productive role to play in society, but the new ceramists had proved otherwise. Feeling "even the slightest concession to function too limiting," they had made a great leap into pure, unconstrained expression. Rugged, spontaneous, improvisational, their work in clay was a perfect vehicle for the great tradition of American

individualism, which had lost its way. Ceramics could now stand alongside painting and sculpture, contributing in its own way to the ongoing existential mission of art, the "quest for a deeper feeling of presence."[40]

This was ambitious stuff, and very different from what Webb had in mind when she founded the American Craftsmen's Cooperative Council. Slivka turned away from the designer-craftsman model, seemingly concluding that it was unworkable—or, at any rate, too limited in its potential. Instead, craft would have to reinvent itself as an art form. This argument did meet with some resistance. The letter-to-the-editor column of *Craft Horizons* was briefly filled with invective and threats of canceled subscriptions. But it soon carried the day. If America was becoming one big lonely crowd, the craft movement could be the opposite: an alliance of the self-actualized. This conviction imbued making with a high-minded sense of mission that had been lacking since the days of the Arts and Crafts movement. And it was also strategic: Most of the influential figures in the movement were affiliated with colleges and universities, and this new way of looking at craft helped them position themselves in relation to other art courses. Faculty members were insulated from economic need by their teaching salaries, so the fact that there were very few galleries or collectors interested in their work was not an insuperable problem. They were confident that this interest would grow over time.

Things certainly seemed to be trending in the right direction. In 1969, Paul Smith, the pioneering and inventive director of the Museum of Contemporary Crafts, partnered with the New York City gallery operator Lee Nordness to curate *Objects: USA*, a huge exhibition about the studio craft movement that incorporated more than three hundred objects by more than one hundred makers. A major catalogue was produced, which immediately became a standard reference work. The exhibition traveled over a period of several years to no fewer than twenty venues in America and ten in Europe; it was seen by hundreds of thousands. An associated television program, broadcast on network television, reached an even wider audience. By any standard, *Objects: USA* was a tremendous success—except for the one goal it had really set out to achieve. Though the exhibition was greeted by voluminous press, the only New York art critic of any stature to review it, Barbara Rose, panned it. Writing in *New York Magazine*, she pronounced the exhibition to be "a disaster for the crafts," explaining, "The individual, divorced from a community of artisans, taking from fine art the license of self-expression, amusement, and occasional formal interest, is not capable of participating in a genuine craft tradition. *Objects: USA*, consequently,

is a collection of absurdist fantasies produced by individual egos striving for self-expression, as unwilling to assume any role of social responsibility as the fine artist."[41]

Rose's review indicated two big problems for the project of craft-as-art. The first was that the establishment art world was not interested—even less interested than American industry had been in the prospect of collaborating with designer-craftsmen. For Rose's reaction was by no means isolated. The *Objects: USA* co-curator Lee Nordness conceded, "I am having one hell of a time selling anything but paintings and bronzes in New York because the critics will not endorse the craft media work."[42] And other exhibitions that tried to establish craft mediums as equal players in fine arts also failed to persuade. In 1968, the Museum of Modern Art, in a return to its earlier involvement with textiles, mounted an exhibition called *Wall Hangings*. It included many of the leading figures in the fiber art movement, among them the great Lenore Tawney. Yet when *Craft Horizons* asked the sculptor Louise Bourgeois to express her view, she more or less shrugged. The works seemed to her like "*curiosa* or *objets d'art* rather than falling into the category of fine arts," she said. "A painting or a sculpture makes great demand on the onlooker at the same time that it is independent of him. These weavings, delightful as they are, seem more engaging and less demanding."[43]

There were a few reasons for this unfriendly posture, chief among them the tenacity of the idea that Slivka had tried to overturn, that craft was by nature utilitarian or decorative. This presumption of irrelevance was almost worse than active antipathy, because it threatened to make the new crafts invisible to their intended audience. This problem was compounded by longstanding associations between craft and women, and to a lesser extent, between craft and people of color. The art world of the 1960s was largely a world of white men, almost all of whom were casually sexist (some virulently so). Admitting craft materials into the sanctioned domain of sculpture would have meant addressing who counted as an artist at all, and that was not a step that the arbiters of the day were prepared to take.

Yet this was not the point that Barbara Rose had made in her review. Her argument, rather, was that the art-leaning posture of *Objects: USA* meant giving up on the very thing that made craft worthwhile: its thorough integration into everyday life. And here she had a point. In the unflattering glare of hindsight, it is clear that the early studio craft movement, perhaps dazzled by the prospect of art world acceptance, had a lot of blind spots. Webb and her allies were brilliant networkers, but like their predecessors in the Arts and Crafts movement, they made no attempt to

forge alliances with labor unions, which, though weakened in comparison to their position in the 1930s, were still the largest and most powerful craft organizations in the country. The studio craft movement's posture afforded no obvious means of connecting to them. Its initial focus on design consultancy aligned it, if anything, with management, while its ambitious swerve into fine art pointed to a more elitist context, largely apolitical, and remote from working-class concerns.

If studio craftspeople were disconnected from organized labor, they were positively dismissive of amateurs. One participant at the 1957 Asilomar conference, the potter F. Carlton Ball, presented the challenge for the assembled professionals as an active struggle against dilettantism: "If we are only concerned with the problems in our own studios, then the hobbyist, the manufacturers of craft kits, the purveyors of cute novelties will take over with a quite possible degeneration in American culture."[44] Craft makers were already self-conscious about their status in the art world, so the last thing the movement wanted was to be associated with do-it-yourselfers. This limitation, too, cut them off from a natural constituency. So, for all its creative achievements, which were indeed many, the studio craft movement stayed both small and isolated. The circulation of *Craft Horizons* peaked in the 1970s at about forty thousand, less than 10 percent that of *Hot Rod* magazine.

Yet if the studio movement was a niche phenomenon, it still occupies a special place in American craft history. In no other context had the creative possibilities of making things by hand in a mechanized world been so fully explored. And Aileen Osborn Webb, for one, was always looking to expand her horizons. In 1964, she achieved her greatest organizational feat yet: the first conference of a new World Crafts Council, held at Columbia University, in New York City. Webb had said, at Asilomar, "If the world wasn't so large, if there were not so many people in it, if there were not so many different cultures and languages, and if we could all talk to each other, face to face, I believe that many of the problems which now trouble the world would quickly disappear."[45] Now she acted on that instinct. Hundreds of representatives from Asia, Africa, Latin America, and Europe gathered alongside prominent figures from the United States such as the novelist Ralph Ellison and René d'Harnoncourt, Webb's old ally at MoMA.

Together the delegates pondered the future of craft, not just in the United States, but everywhere. Viewpoints were predictably diverse, but one thing came through particularly strongly: the need for a broader perspective. Pupul Jayakar, a reformer from India (who played a role there somewhat akin to Webb's in America), noted

that in her country, there were three million handlooms in operation, supporting the livelihoods of seven million people. This population of makers had stood at the heart of Mahatma Gandhi's *swadeshi* movement, which promoted the artisan manufacture of homespun textiles and garments, a rejection of the colonial imports that had devastated the country's historic craft economy. Gandhi knew well that spinning wheels and handlooms were inefficient in comparison to British factories. He nonetheless argued that a slow and sustainable approach would be better in the long term; and in the short term, it would disrupt the financial calculus of empire and help bring about independence for India.

Jayakar was among the inheritors of this cause, and she tried to balance Gandhi's idealism with her own, more pragmatic view. She saw clearly that artisans remained vulnerable to economic and technological disruption. So it was urgent to modernize their outlook, "to create a milieu where the craftsman can contact in a precise and yet creative context new functions and needs."[46] The sheer scale and complexity of this problem, the ethical burden of considering so many people's welfare, must have been sobering to the Americans in attendance. They were few in number. They lived in the world's most affluent economy. And if they were honest, they would have had to admit that industry had done much to create that prosperity. What lessons did they have to offer the numberless craftspeople of the world?

~

To the extent that the studio craft movement could answer this question at all, it could do so only on an individual basis. For it was, after all, a gathering of individualists. But elsewhere in America, even as Webb, Slivka, and their colleagues were elevating the discourse around craft, others were taking a more collective approach. Taking inspiration from Gandhi and his Indian Independence Movement, particularly his strategy of nonviolent protest, these activists realized that while one means of responding to conformity is individualism, another is solidarity.

In the popular imagination, this story begins with a seamstress on a bus. It was December 1955, in Montgomery, Alabama. Rosa Parks had been at work all day in a local department store, where she was an assistant tailor doing alterations. In that job, she recalled, "you had to be smiling and polite no matter how rudely you were treated."[47] Parks had plenty of experience with being treated badly, like any Black person in the segregated South. (She also had Cherokee-Creek ancestry.) And she had decided to make a stand, precisely by not standing. On her bus ride home that

evening, she was told to yield her seat to a white passenger, despite the fact that she was sitting in the "colored" section of the vehicle. "When that white driver stepped back toward us, when he waved his hand and order us up and out of our seats," she later said, "I felt a determination cover my body like a quilt on a winter night."[48] She refused, and was arrested. The local Black leadership, with backing from the NAACP, used the case as a rallying cause. They called for a boycott of the city's bus lines, and the greatest battle in America's long civil rights struggle was joined.

Parks's famous act of protest was no snap decision. Earlier that year, she had attended a strategy session on racial desegregation at the Highlander Folk School, in Grundy County, Tennessee. The school had been founded in 1932, right at the peak of the Appalachian craft revival, but Highlander had pursued a different path from the John C. Campbell Folk School or the Penland School of Craft. Its founder, a white Tennessean named Myles Horton, had been to Denmark and was inspired by the Scandinavian *folkehojskøler* he saw there, just like Olive Campbell. And the school did offer instruction in pottery, dressmaking, wood carving, and other crafts. But Horton was extremely politically progressive: an ardent integrationist and supporter of the labor movement. To run the workshops at Highlander, he hired Septima Poinsette Clark, an African American teacher from South Carolina who had been a fieldworker for the NAACP. Under her guidance, Blacks and whites attended and learned together. While a "workshop" at Highlander might involve making things at a bench, it could also be a union planning session. In its early days, the school was frequently used as an organizational base for coal mining strikes.

In 1953, Highlander began hosting similar assemblies for the nascent civil rights movement. Talks and group discussions about tactics (boycotts and sit-ins) were accompanied by folk songs and spirituals. It was at Highlander that an old hymn was recast into the powerful anthem "We Shall Overcome." Literacy and citizenship classes for African Americans were offered both on-site and in sponsored programs elsewhere in the South. For Parks, the school was an invaluable entryway to a network of allies. She is reputed to have said, "The only reason I don't hate every white man alive is Highlander and Myles Horton."[49] The story makes a fascinating counterpart to Webb's concurrent gatherings, like the one at Asilomar; both Highlander and the American Craftsmen's Council had emerged from the regional craft reforms of the 1930s, but they pursued wholly different forms of radicalism.

Martin Luther King Jr. himself visited Highlander, in 1957, in recognition of the role it had played in the formation of the civil rights movement. With Parks sitting

in the audience, he declared, "It is ultimately more honorable to walk in dignity than ride in humiliation." He noted the importance of the recent Supreme Court decision *Brown v. Board of Education*, which mandated the integration of schools and, by extension, other public institutions. He decried the recent resurgence of the Ku Klux Klan and predicted a long struggle ahead. But he also imparted a message of solidarity: "Organized labor has proved to be one of the most powerful forces in removing the blight of segregation and discrimination from our nation," King said. "Labor leaders wisely realize that the forces that are anti-Negro are usually antilabor, and vice versa. And so organized labor is one of the Negro's strongest allies in the struggle for freedom."[50]

These words indicated a new alliance on the political left, and one that would have tremendous consequence. To understand what was at stake, it is necessary to look back a bit, to the 1930s. Roosevelt's New Deal administration had been very pro-union, seeing organized labor as a key plank of recovery from the Depression. The year 1935 saw passage of the Wagner Act, which strengthened the right to engage in collective bargaining. This resulted in an immediate increase in union membership and also emboldened more politically radical working-class activists. A new federation called the Congress of Industrial Organizations (CIO) was formed to compete with the long-established American Federation of Labor (AFL), Samuel Gompers's organization. Compared to the AFL, which was still organized into skill-intensive craft unions, the CIO was more politically progressive, more confrontational, and also more inclusive. It welcomed women, African Americans, and other ethnic minorities into its ranks. Tactically speaking, it abandoned the idea that workers' skills were their best form of leverage; instead, it concentrated on cohesion across multiple trades within a given industry. Given the supportive political climate, this proved to be a great success, with strikes at auto and steel plants leading to favorable terms.

The war years would prove to be good ones for organized labor, too, because of the high demand for workers. Unions did not want to go on strike when the nation was at war, but they didn't need to, either—they were in a powerful negotiating position. With the end of the conflict, however, this settlement came crashing down. Industry downshifted swiftly, even as labor supply dramatically increased, as soldiers returned home. Wages fell sharply. Alarmed workers walked off the job in huge numbers: almost five million in 1946 alone. In response to this strike wave, an equally alarmed U.S. Congress passed the 1947 Taft-Hartley Act, overriding a veto

by President Harry Truman, who declared that the measure was "bad for labor, bad for management, bad for the country." The act made many of the key organizing tactics of unions illegal. Among these was the closed shop—that is, the requirement that all employees of a company be card-carrying union members. There was also a ban on sympathy strikes, in which workers at one company could apply pressure to protect those at another. Further setbacks for labor came with the "Red Scare" led by the demagogic senator Joseph McCarthy; unions fearful of political consequence blacklisted many of their own working-class activists as subversive Communists. With considerably more justification, corporate management could also point to extensive ties between organized labor and organized crime.[51]

Labor's most important failure in the late 1940s, however, was its inability to push into the South, a strategy the CIO leadership called Operation Dixie. It was a disaster from the beginning. The organizers hoped to apply strategies they had used in northern cities, but they greatly underestimated the barriers that racial divisions would present. (One operative recalled encountering a steelworking crew that was about evenly divided between members of the NAACP and members of the Ku Klux Klan.)[52] The new limitations imposed by the Taft-Hartley Act also handicapped their efforts, just as Southern Democrats had intended. In 1949, with union membership in the South no larger than it had been in 1945, the CIO abandoned the drive. This had significant long-term consequences, as the non-union South became a magnet for so-called runaway shops, companies seeking lower-wage zones and pliant workers. Southern states were delighted to have the business, of course. But this relocation of factories foreshadowed further movement in the 1970s, when companies would depart the United States entirely. This process of "offshoring" would drain the lifeblood from the American manufacturing sector.[53]

Despite lack of success in the South, the postwar years were not a bad time for organized labor nationwide. The profits of a booming economy were widely shared, with generous pension schemes and other benefits offered to employees. Union membership peaked in 1954, representing about one third of all American workers. The following year, the AFL and CIO, rival federations for two decades, united into one umbrella organization. The merger was motivated by the further decline of the AFL's specialist craft unions, which made the CIO's strategy of industry-wide organizing the only viable option. This development was correlated with a steady increase in African American membership. "The Negro union member is an important political

force in virtually all of the industrial unions," one labor researcher noted, but "he is politically insignificant in most craft unions."[54] The pattern in which higher-skilled jobs went disproportionately to white men had not itself changed. It was the erosion of higher-skilled jobs themselves that opened the labor movement to diversity.

Back in 1935, when the Wagner Act was signed into law, only 1 percent of union members nationwide had been African American. By the end of the 1970s, that number stood at 20 percent, with one in four Black workers unionized. It was not an easy or rapid process. As late as 1968, the writer James Baldwin said, "the labor movement in this country has always been based precisely on the division of black and white labor . . . There's never been any coalition between black and white."[55] After the AFL-CIO merger, the racist policies of the AFL were slow to roll back. But roll back they did, because labor leaders, elected by their constituencies, were dependent on African American support. As one Black organizer put it, "Well, you need our vote. What are we going to get out of it?"[56] This was the context for King's remarks at the Highlander School in 1957, for it was at this moment that the labor movement and the civil rights movement at last began to join forces. When King was imprisoned in Birmingham, Alabama, in 1963—the occasion on which he wrote his famous "Letter from a Birmingham Jail," calling for nonviolent resistance, and confidently predicting that "one day the South will recognize its real heroes"—it was Walter Reuther, the head of the United Automobile Workers, who paid his bail.

A prime example of civil rights action by organized labor is the International Ladies' Garment Workers' Union, or ILGWU, founded at the turn of the century as an amalgamation of existing trade associations. Its leadership was dominated by white male leaders in its early years—who were primarily concerned with representing the interests of skilled cutters, who had always been the aristocracy of the garment industry. But it was also one of the first unions to have a substantial female membership, many of whom were immigrants. By 1960, the organization was nearly a half-million strong, and very ethnically inclusive. It again broke ground in supporting Spanish-speaking local chapters, which helped to integrate Puerto Rican workers who had been closed out of higher-skilled, higher-paying trades such as construction.[57]

The ILGWU is probably best known today for its catchphrase "Look for the Union Label." Americans of a certain age will remember TV commercials featuring

Labor Day float for the International Ladies' Garment Workers' Union, 1959. ILGWU photograph collection, Kheel Center, Cornell.

a song by that title, with worker choruses of whites, Blacks, and Latinos, men and women, all singing together, as diverse as the nation itself:

> We work hard, but who's complaining?
> Thanks to the ILG we're paying our way!
> So always look for the union label,
> It says we're able to make it in the USA!

These lyrics weren't written until 1975, but the "Look for the Union Label" campaign had started in 1959, in an attempt to transform workers' rights into a patriotic cause. At the same time, the ILGWU was funneling money to the civil rights movement, beginning with the Montgomery Bus Boycott, and continuing through the era of the Freedom Riders, who fanned out through the South in the early 1960s.

Among these activists was an Episcopal priest named Francis X. Walter. Unlike many white civil rights workers, he had been raised in the South; he was originally from Mobile, Alabama. In December 1965, he and a colleague were canvassing for Black voters in a small town called Possum Bend, Alabama. Walter spotted three beautiful quilts hanging on a clothesline outside a cabin. He wanted to find out who had made them, but nobody was home. (He later learned that their maker, Ora McDaniels, had simply fled when she saw two white men approaching her home, which gives a good sense of the racial dynamic in the region at the time.) Seeing them, though, gave him an idea. He started buying up locally made quilts with the intention of selling them up north, to raise funds for the community. The project quickly turned into a cooperative, led by Father Walter, in partnership with Estelle Witherspoon, the wife of a retired sharecropper.

By the following March, sixty craftswomen were involved, calling themselves the Freedom Quilting Bee. Witherspoon coordinated the production and collection of

Jessie Telfair, *Freedom Quilt*, 1983. American Folk Art Museum/Art Resource, NY.

the quilts out of her home in Rehobeth, but some of the most adept makers were from another Alabama community, called Gee's Bend. They would attain nationwide fame in later decades, when their quilts made of work clothes and other reclaimed fabrics were rediscovered by collectors and museum curators. At first, the results of the bee's handiwork were sold at small auctions in New York City for about twenty dollars each. The sales were advertised by flyer: "It takes better than a week to make a quilt—when its creator is not working in the cottonfields."[58] Father Walter said that his motivation was entirely economic, that he would have been just as happy to start up a shirt or doll factory. And the Freedom Quilting Bee did make money for its members. The selling prices of the quilts slowly inched upward, as department stores such as Bloomingdale's and Saks Fifth Avenue began retailing them. One woman who worked as a domestic servant for a white family earned nearly as much from her after-hours craft as she did from her day job. Some quilters managed to buy televisions and washing machines with their additional income. Even so, it was difficult for them to earn as much as one dollar per hour, below the national minimum wage.[59] There was not much demand for their improvisatory quilts, either, so the bee secured a contract with the department store Sears, Roebuck, to execute corduroy pillowcases. "I started using patterns, but I shouldn't have did it," the Gee's Bend quilter Nettie Young later said. "It broke the ideas I had in my head. I should have stayed with my own ideas."[60]

The story of the Freedom Quilting Bee shows, in miniature, both the tremendous positive impact that the civil rights movement had on southern communities and its limitations. The momentous events of the 1960s brought new public attention to Black workers of many kinds, from factory seamstresses to self-taught quilters. And the Civil Rights Act of 1964 finally made it illegal to discriminate in the workplace on the basis of race or gender. But these successes did not bring anything like instant equality to African Americans, or to women, either. Both groups continued to receive lower wages, despite the new law, and to be blocked from leadership positions in unions and companies alike. The Civil Rights Act also helped trigger a realignment in America's balance of power. Following desegregation white working-class voters, particularly in the South, began to question their allegiance to the Democratic Party. In 1968, they helped put Richard Nixon in the White House, and in 1972 they helped keep him there. Over succeeding years, his Republican Party would become an implacable and effective enemy of organized labor and a staunch ally of business interests.

This shift in the political tides, in combination with widespread deindustrialization, hurt unions badly. Sad but true: As the labor movement became diverse, it also became weaker.[61] And with the decline of the craft union in favor of industry-wide organizing, what strength labor did retain was no longer based on individual workers' skills. Workers were protected and promoted on the basis of seniority, not expertise.[62] In 1968, one labor researcher noted, "Without the craft union, most craft occupations would cease being crafts; that is, the skill of the craft would be diluted and standards of entry weakened. The converse is also true. If an occupation is diminished in its craft qualities by a lowering of standards, the union based on the craft is diminished in power as a craft union."[63] That is exactly what was happening in the 1960s and '70s. Skill, once the American worker's best defense against exploitation, had never been less potent as a political force. It would remain to future generations—indeed, it still remains to our own—to knit independence and diversity into a single, strong fabric.

If there was one event that emblematized the new fault line in American craft politics, it was the so-called Hard Hat Riot of May 8, 1970. It was already six long years into the Vietnam War, and only four days since the Ohio National Guard inexplicably opened fire on student activists at Kent State University, killing four (including two bystanders) and wounding nine. In the wake of that tragedy, tensions were high across the country, not least in Manhattan. Protestors had been in the streets for days. Construction workers at the World Trade Center, among other building sites, were incensed by what they saw as unpatriotic behavior. Most followed labor leadership in supporting the war. That Friday, union organizers and at least one private contractor encouraged their workers to go "break some heads." And that is what they did, just before noon, descending on a group of activists in front of Federal Hall. They used their helmets as clubs, along with lead pipes and heavy wire clippers. No one died in the attack, but more than seventy people were injured, some severely.

Among the protestors there was some suspicion that Nixon, up to his usual trickery, had somehow incited the violence. Eyewitnesses claimed to have seen men in business suits directing the mob (which, if true, was the perfect encapsulation of the emerging right-wing coalition between the white working class and corporate interests). Those who smelled a rat felt even more convinced when, later that month, the labor leader Peter Brennan visited the White House and gave the president a symbolic hard hat reading, COMMANDER IN CHIEF. (Nixon later made Brennan

Stuart Lutz, Hard Hat Demonstrations, May 8, 1970. Gado, Archive Photos/Getty Images.

his secretary of labor.) Whatever the truth of these allegations, the basic facts were the same. In the twentieth century, the hard hat had replaced the leather apron as the emblem of America's skilled working class. Now it had been used as a weapon against unarmed civilians.[64]

The people protesting the war that day were not necessarily hippies, although those with long hair were particularly singled out for assault. The Hard Hat Riot was, however, a clear symptom of the new culture war in America. The conservative construction tradesmen were on one side of that conflict. On the other side was the counterculture, and the antipathy was absolutely mutual. It is difficult to date precisely the arrival of this new force in American life. The sociologist Theodore Roszak's 1969 book *The Making of a Counter Culture* gets credit for coining the term. Two decades on from Riesman's analysis in *The Lonely Crowd*, Roszak saw a generation that was "profoundly, even fanatically, alienated." Pervasive conformism had produced its reactive opposite, a set of behaviors that Roszak described as flexible, experimental, even bizarre, all expressing a horror of a hydra-headed monster, the "technocracy." The counterculture positioned itself against the apparent progress and prosperity that industrialism and military power had brought to America.

Given what was happening in Vietnam, it is not surprising that so many of America's young people distrusted the government and the military-industrial complex. But they understood the problem in far broader terms than that. Counterculturalists saw conventional, or "square," ways of living as impersonal, emotionally stifled, drunk on consumption to the point of stupor, and a menace to the world's ecology (another new term to most people, popularized by Rachel Carson's 1962 book, *Silent Spring*).[65] Teenagers of the 1950s had happily reflected the values propagated by mass media in their hobbies, their handmade dresses and hot rods. The counterculture rejected those values utterly. Like so many Americans before them, they wanted freedom. But they wanted it on more radical terms than the country had ever seen.

From the countercultural perspective, labor unions were just one among many faces of the establishment. Hippies may have played old strike anthems on their guitars—indeed, a popular songbook, called *Songs of Work and Protest*, published in 1973, was full of them.[66] But they felt a yawning chasm between themselves and professional standards of craftsmanship. Art Boericke, co-author of a book about creative hand-built houses—the "woodbutcher's art"—had worked for twenty years alongside union carpenters, electricians, and plumbers. He didn't regret his time in that brotherhood, he said, but he had come to loathe "the shoddy, unimaginative work that we do in order to earn a living in the trades." By contrast, Boericke was both entranced and liberated by the creativity of young people. They were salvaging material, ignoring building codes. He had nothing but praise for them, and just one piece of advice: If an inspector comes calling, say your place is a potting shed or a mining claim. And if that doesn't work, "then you can enter the courthouse declaiming 'life, liberty and the pursuit of happiness'!"[67]

Hippie house builders were generally self-taught and had a high tolerance for ad hoc solutions. Yet in comparison to their parents, who might have undertaken DIY projects to improve a suburban ranch home, they could be quite ambitious, creating dwellings entirely from scratch on a budget close to zero. The most famous were those in communes like Drop City, founded in 1965 in Colorado, and its spinoff Libre, founded three years later. The iconic structures of these independent communities were geodesic domes, a typology developed by the futurist architect R. Buckminster Fuller. In theory, these were meant to be quick and easy to build, but the reality was rather different. Peter Douthit, a resident of both Drop City and Libre—he went by the name Peter Rabbit—wrote a vivid account of materials

sourcing: begging for two-by-fours from a local sawmill, cutting pentagons and hexagons out of scrap plywood, making windows from auto glass, "[tearing] apart railroad bridges, barns and deserted houses by moonlight."[68] It soon became clear that domes were not actually that expedient to construct, particularly when one worked with eclectic building materials that had been intended for rectilinear framed structures. As one early guidebook conceded, "You must exercise great care and take your time, as a dome won't tolerate funk."[69] Far better to build idiosyncratically and improvisationally, thinking of the house as a creative, evolutionary process.[70]

Home building was, of necessity, the paradigmatic craft of the counterculture. But this generation was interested in many other practices as well. Just like the first American towns, communes had their own woodworkers, blacksmiths, and potters. Robert M. Pirsig's surprise bestseller, *Zen and the Art of Motorcycle Maintenance* (1974), was a pop-philosophical tribute to mechanical skill, a theme picked up in John Jerome's engaging memoir *Truck* (1977), in which the author loses himself in "quiet hours of scraping carbon by cozy droplight" and reflects on the pleasures of "organic hot-rodding."[71] And there were even more creative things happening. Peter Schumann's Bread and Puppet Theater, founded in 1963, deployed cloth and celastic (a moldable, plastic-impregnated fabric) over armatures to make impressive large-scale puppets, masks, and other performance props. The group's plays and pageants, sometimes colorful, sometimes haunting, were among the most memorable protests against the Vietnam War; they were also staged in support of civil rights causes. Sourdough bread was always offered to the audience, and performances were free, though donations were gladly taken. After a few years of operation in New York City, Bread and Puppet headed to the countryside, setting itself up in rural Vermont. It remains there today, presenting "a great variety of puppet shows, some good, some not so good, but all for the good and against the bad."[72]

By the mid-1970s, about 750,000 people were living in communes across America.[73] Some were in urban squats, but the primary direction of travel was back to the land. As was frequently noted at the time, it was as if a whole generation were emulating "Henry Thoreau, doing his thing at Walden Pond" (or, more fancifully, "Walt Whitman, tripping out on grass.")[74] The failure rate was high, due to lack of experience not just in building shelters, but also in other basic necessities, like farming. Even those communes that were initially successful, like Drop City, sometimes collapsed under the weight of new arrivals who were less dedicated to the hard work of self-sufficiency. Yet many countercultural settlements did survive. One that

still exists today, the Twin Oaks Community, in central Virginia, was explicitly inspired by the behaviorist B. F. Skinner's 1948 novel *Walden Two*, a thought experiment generalizing Thoreau's ideals to a whole society. Communes also emulated nineteenth-century precedent in developing cottage industries, much as the Shakers and the Oneida Perfectionists had done. East Wind Community, an offshoot of Twin Oaks located in the Missouri Ozarks, created six thousand handmade rope hammocks in its first year, and later branched out into nut butters and "Utopia" rope sandals.

Counterculturalists were particularly attracted to places like the Ozarks and Appalachia, because of their beautiful countrysides and their traditions of craft and self-sufficiency. (An Ozark Foothills Handicraft Guild, founded in 1962 and based on the Southern Highland Craft Guild, had belatedly joined the movement of regional craft development.) The high regard these so-called hipbillies had for the locals was not necessarily reciprocated; one regional journalist said in 1976: "The trouble is, while the hippy-type refugees from the cities seek mutual admiration alongside Ozarks farmers, they are more often ridiculed because of their life-style, which permits the use of food stamps, unmarried men and women living together, and the use of dope."[75]

Yet this conjunction also produced one of the era's most enduring documents, *The Foxfire Book*. Billed as a guide to "hog dressing, log cabin building, mountain crafts and foods, planting by the signs, snake lore . . . and other affairs of plain living," it was the outgrowth of a quarterly magazine put out by a high school in Rabun Gap, in the Appalachian region of Georgia. All this was the brainchild of a teacher named Eliot Wigginton, who had arrived at the school in 1966 and initially struggled to reach his students. He solved the problem by encouraging them to study their own regional traditions, which they took to with great enthusiasm. Together they recorded stories of local people and provided clear descriptions of traditional crafts and foodways, much as Allen Eaton had done in the 1930s. *The Foxfire Book* also echoed Eaton in claiming that these crafts were on the verge of disappearance. What was new was the book's suggestion that, like Thoreau, self-sufficient mountain people could be inspirations for a new countercultural lifestyle. The students involved with the project learned "that they can act responsibly and effectively rather than being always *acted upon*."[76]

Wigginton's story ended in shame and tragedy, as it later emerged that he had sexually molested some of the children involved in his project. Long before that

terrible revelation, though, *The Foxfire Book* had become a runaway bestseller and produced eleven sequels, along with other associated publications. An admirer named Pamela Wood, operating out of a high school in Kennebunk, Maine, published a New England version called *The Salt Book*. In place of log cabins and coverlets, it substituted stone walls, snowshoes, and other "Yankee doings." Wood, a gifted writer, was particularly concerned with stressing the compatibility of traditional lifeways with ecological imperatives. "We can harness nature," she wrote, "but she pulls us to our knees and may drag us to our death if we don't break the traces."[77]

~

Hippie makers usually worked part time and were self-taught, and few of them put the effort into developing fine workmanship. They soon earned a reputation for handmade schlock, earnest but of poor quality. This made for a sharp distinction from the studio craft movement, which remained a cadre of professionals. Even so, there were some interesting connections between the two. The director of the Museum of Contemporary Crafts, Paul Smith, became interested in yoga and transcendental meditation, which led him to conceive shows like *Contemplation Environments* (1970), the exhibition equivalent of a Be-In. Up in New Hampshire, *Studio Potter* magazine (founded in 1972) offered a view of ceramics from a communard, back-to-the-land perspective. Its first issue included a proposed curriculum for potters with lessons "on being a person" and another on "clay and meditation." The editor Gerry Williams, a man of the political left, offered "a few words of advice from Chairman Mao: Dig tunnels deep, and store grain."[78] And potters across the country did dig in, eking out a living with homely, functional wares that were the perfect accompaniment to a hippie home.

Perhaps the strongest aesthetic affinity between the studio craft movement and the counterculture was in the realm of fiber sculpture, which enjoyed a brief surge of popularity in the early 1970s. Some of this work was merely shaggy and formless, but the more talented artists in the field created mesmerizingly intricate works, well worthy of contemplation. Lenore Tawney, the doyenne of the fiber art scene—she was sixty years old during the Summer of Love—had long been a spiritual seeker. She got herself to a psychedelic happening in New York, visited a New Mexico commune called Lama, then spent most of the 1970s following an Indian guru. When she did pause from her meditation practice long enough to make handwoven tapestries, they were serene yet intense, equal parts mandala and modern abstraction.

Like many craftspeople whose lives crossed paths with the counterculture, she understood the making of her art, the sheer time and concentration it required, as a deep well of meaning: "You reach an ecstatic state when you work all day, you know?"[79]

One craft that fiber artists helped to develop and publicize was macramé, the creation of a structure through knotting sequences. This was an appealing technique for sculptors, as it allowed them to build out a form in all directions, freed from the rectilinear plane of a loom-woven textile. It could also be practiced at an amateur level, and became one of the crafts most associated with countercultural kitsch—a rare example of the studio craft movement instigating a popular fashion. Macramé was put to impressive purpose by the Bay Area artist Alexandra Jacopetti, who used the technique to make a great knotted ark from twelve thousand feet of sailmaker's rope, for children and adults to play in. Created in 1974, the project was located in Bolinas, California, the epicenter of a self-organized guild that taught textile and furniture skills through an apprenticeship system.

Jacopetti also published a book, called *Native Funk & Flash*, showing that denim work clothes and other garments could be elevated to high flights of expression through the use of embroidery and patchwork. (The most accomplished of the makers profiled, Mary Ann Schildknecht, had learned to embroider in Milan while serving a two-year sentence on a hashish-smuggling charge.) But this was not a how-to book. Jacopetti gave her readers no instructions or patterns, because she believed that "the patterns are all within, languishing and longing, like dreams, for expression."[80] Here she was articulating a conviction that traveled widely in the counterculture, marking its most decisive departure from previous craft ideals: Making was not primarily an economic activity, or even an aesthetic one. It was spiritual in nature, a means of getting in touch with oneself—or, as the saying went, tuning in.

This was a view expressed by the poet M. C. Richards, for example. She was not a highly skilled potter, but she nonetheless saw transformative power in "the union of natural intelligences" involved in the craft: "the intelligence of the clay, my intelligence, the intelligence of the tools, the intelligence of the fire."[81] Similarly, in the widely read book *Be Here Now*, the prominent proponent of psychedelic drugs Richard Alpert (also known as Ram Dass) gave this counsel: "There is a task to do— you *are* the task . . . If I am a potter I make pots. But who is making the pots? I am not under the illusion that I am making the pots. Pots are. The potter is. I am a hollow bamboo."[82] Such ideas, based loosely on Zen Buddhism and Hindu spiritualism, suggested that the most realized form of individualism would be the

transcendence of individuality itself, a dissolution of the self into the greater oneness of the cosmos.

In *Native Funk and Flash*, Jacopetti comments that "many of us have hungered for a cultural identity strong enough to produce our own version of the native costumes of Afghanistan or Guatemala, or for a community life rich enough for us to need our own totems comparable to African and Native American masks and ritual objects." As the historian Julia Bryan-Wilson has pointed out, a question arises here: Who exactly is this "us"?[83] The counterculture, like the studio craft movement, was largely a white middle-class phenomenon, but it borrowed freely from other ethnic traditions, not only in its spiritual practices but also its iconography. Native Americans, in particular, occupied a central position in the hippie imagination, as they were seen as paragons of harmony with nature. The Human Be-In held at Golden Gate Park in January 1967, which inaugurated San Francisco's so-called Summer of Love, was billed as a "Pow-Wow" and a "gathering of the tribes." There was intense interest among counterculturalists in peyote, a natural hallucinogen historically used in ritual practices by Native people in Mexico and the Great Plains. One publication, the *Oracle,* even claimed that hippies were themselves reincarnated Indians, the original longhairs.

Unsurprisingly, Native Americans were not thrilled about all this. Buffy Sainte-Marie, a folk singer from the Cree Nation, commented, "The white people never seem to realize that they cannot suck the soul out of a race. The ones with the sweetest intentions are the worst soul suckers." At the same time that Native people were initiating their own civil rights campaign, the Red Power Movement, which included prominent occupations of Alcatraz Island and the town of Wounded Knee, South Dakota, the counterculture was perpetuating stereotypes that had been in circulation for decades. But there was another side to the relationship between Red Power and "flower power." The long trajectory that had begun with invasion and genocide, that continued through the reservation system, and that then underwent a long period of patronizing romanticism had finally arrived at a point where whites realized they could learn from Native people, looking up to them, not down.[84]

An exemplar of this more positive attitude, and of the counterculture more generally, is the futurist Stewart Brand. He was born in 1938, in Rockford, Illinois, a machine tool manufacturing town on the Wisconsin border. After college and a period of military service, he began to explore the full mind-expanding apparatus of the counterculture: psychedelic drugs, communes, experimental art, the writings of

Buckminster Fuller. His portal into Native culture was peyote, stereotypically enough, but then he began visiting reservations to take photographs. He came to believe that "Americans dwelling in the wilderness of changing eras are re-learning to be natives from the most native Americans, The Indians, studying with the new clarity the ancient harmony of a shared land-heritage."[85] He founded an organization— his first of many—called America Needs Indians, and presented slide shows of reservation life to attract support for Native people.

In 1966, Brand partnered with the novelist Ken Kesey and his "Merry Pranksters" to stage one of the first big events of the counterculture, the Trips Festival, held in Longshoremen's Hall in San Francisco. (As it happened, the location perfectly captured the shift in left-wing tactics. In 1934, it had been a headquarters for the city's dock strikes; in 1966, the Grateful Dead and Janis Joplin headlined.) Tom Wolfe was also on hand, a few years on from his breakout article about hot rods, and still writing in the reflected glory of youth culture. He described Brand as "a thin blond guy with a blazing disk on his forehead," with no shirt, "just an Indian bead necktie on bare skin and a white butcher's coat with medals from the King of Sweden on it." Brand's truck had a Red Power movement bumper sticker that read, CUSTER DIED FOR YOUR SINS.[86]

Meanwhile, Brand was accumulating supplies, books, and technologies that might be useful in the new communes sprouting up across the country. He sold these goods from the "Whole Earth Truck Store," which actually was a truck, at first, but eventually had a permanent shopfront in Menlo Park, California. Then, in 1968, he and a team of contributing editors published the first issue of the *Whole Earth Catalog*, with its simple but powerful slogan, "Access to Tools." Physically, it resembled a large-format magazine, but its contents were more akin to the Sears, Roebuck catalogues that had brought mass-produced goods to rural farms at the turn of the century. Brand wanted to do the same for the new American frontier—a frontier of the mind. The *Catalog* included listings for books by Buckminster Fuller and others, spiritual guides, and primers to key technical concepts like cyber-netics. (Brand saw feedback systems as key to understanding both technology and ecology.) It also included resources for handcraft: various forms of shelter construction, of course, but also bookmaking, leatherwork, beadwork, and even glassblowing. Editorial comments provided encouragement and the occasional warning to its amateur readership: "It remains obvious that a good deal of patience is required to cast a bronze by the lost wax method."[87]

The *Whole Earth Catalog* was a harbinger of things to come. It uniquely fused two spheres of thinking, both newly born: the fiercely hand-built world of the Bay Area's communes and the high-tech experimentation that would soon become associated with nearby Silicon Valley. The tools it tried to put into people's hands ranged from hammers to calculators to LSD.[88] Brand was also ahead of his time in seeing the earth itself as an operating system, and every person on it as a software engineer. These concepts have become familiar in the age of the internet, but then, they were far out in the extreme.[89] Brand was a utopian, to be sure, but one who thought in networks rather than centers—centralization, after all, being a hallmark of the technocracy. ("Workers of the world, disperse," as the cover of one *Catalog* special issue had it.)[90] From the point of view of the traditional left, including many of the activists protesting against the Vietnam War, this stance seemed avoidant, even apolitical. It's impossible to mount the barricades when you've gone back to the land. Brand was not deaf to this argument. In *The Last Whole Earth Catalog*, published in 1972, he joked that "recent cybernetic thoughts can cheer you up and give you better concepts to worry with."[91] But he also glimpsed the first signs of a migration of the political arena itself, out of the streets and factories and into the realm of pure information. What's more, he realized that craft would still have an essential role to play in this emergent new reality. What would that role be, exactly? It would take fifty years, at least, to find out.

In the meantime, for better and for worse, the word *craft* was now inextricably tied to the counterculture in the public imagination. This did not involve seeing it as the necessary counterpart to future technologies. Instead, shorn of its association with skilled labor, it was subjected to an unprecedented degree of simplification and caricature. Making things by hand did retain an air of optimistic idealism, an association with the back-to-the-land lifestyle, perhaps even a vaguely progressive politics. But even to mention "craft" now prompted thoughts of macramé plant hangers, tie-dyed T-shirts, and brown pottery. In the hands of the hippies, artisanal values had been reimagined once again. As the 1980s approached, and a new money culture bared its claws, those values had never been more vulnerable.

Chapter 8

Cut and Paste

I T'S BEAUTIFUL, THE EMBROIDERY PROBLEM. I love it." The year was 1977, and Georgina Garcia was at home in New York City. She could usually be found there, sitting at her Singer sewing machine. But today was different: She was giving an interview to a feminist activist who wanted to know all about her life, and Garcia was happy to oblige. She was originally from a rural province in the middle of Cuba, she said, and had taught herself needlework there. Actually, she'd had little choice in the matter. If you were a young woman from the poorer classes, it was almost the only steady work to be had. But she discovered that she had an aptitude for the craft. In addition to the jobs she took on for pay, she sewed and embellished her own dresses and sheets, making herself a trousseau before marriage.

After moving to America, Garcia took on a position as a sample maker for a fashion firm. Her role was to execute embroidered patterns so they could be evaluated for design and color. If approved, a single one of her samples might be the basis for an order of more than forty thousand garments, all made by machine. Garcia was paid by the hour, and worked very long days—typically, six thirty A.M. to ten thirty P.M.—because she was putting her daughter Mayra through college. "You have to keep counting the stitches continually or else you're lost," she said. "You have to have a *lot* of patience." By the end of each day, she was "dead, dead, dead, tired, tired." The eyestrain, too, was terrible. "Every day that passes I'm left with less sight," she admitted. And yet, Garcia still loved embroidery. She considered it an art, "because not everybody can do it," and insisted that she did it not for money alone, but also

for the pleasure of a job well done. "When it doesn't come out good," she said, "I take it out and embroider it again."[1]

Garcia was one of fourteen specialist embroiderers employed by her company, all of them outworkers, and one of many thousands of women still employed in the American garment industry, doing the same kind of precision craftwork that women had done since the eighteenth century. Yet firsthand accounts of lives like hers are fairly rare, for a simple reason. Few people have bothered to ask. Garcia's experience was documented only because members of the women's movement insisted that it should be. Her interview appeared in *Heresies*, a journal published by a feminist collective in New York City, in a landmark issue focusing on women's traditional arts. It collected, for the first time in one place, a huge range of crafts done by female makers: Peruvian weaving, Nepalese jewelry, Native American quill-work, the ceramics of Adelaide Alsop Robineau, weaving from the Bauhaus. Several contributors interviewed their own grandmothers—or, in the case of the artist Hannah Wilke, her father's brother's wife's mother—to get their views about knitting and crochet. Another artist, Howardena Pindell, traced her family's craft lineage back to the making of Gullah baskets, which, she noted, were now sold in the Old Slave Mart in Charleston, South Carolina. With supreme understatement, she offered this opinion: "I feel there is amnesia concerning the day-to-day fine points of the more unpleasant aspects of American history."[2]

The *Heresies* account of craft was a diverse patchwork, a cut-and-paste collage—or, as contributors Melissa Meyer and Miriam Schapiro put it, a "femmage."[3] What made the project exceptional, though, apart from its unprecedented focus on women, was its acknowledgment that craft could be both a passion and a compulsion at the same time, a matter of pride and suffering in equal measure. The conversation with Georgina Garcia made that quite clear, and it was a theme picked up throughout the publication. "At times weaving is not a pleasant task," observed the writer Madeleine Burnside, "but a wasteland of drudgery."[4] The critic Lucy Lippard wrote of the motivations involved in women's amateur crafts, which reflect limited opportunity just as much as genuine creative expression: "All over the world, women privileged and/or desperate and/or daring enough to consider creation outside traditional limits are finding an outlet for these drives in an art that is not considered 'art.'"[5]

Heresies emanated from a community of artists and writers, and it was primarily in these disciplines that the feminist embrace of craft was most strongly felt. The late

1970s saw the realization of Judy Chicago's celebrated and controversial installation work *The Dinner Party*, which gave monumental form to women's history. Its main feature is a great triangular table laid with thirty-nine place settings, each one devoted to a significant female figure from the past—from the Primordial Goddess through to Georgia O'Keeffe. Each has her own custom-designed ceramic plate and embroidered table runner, with the plates becoming progressively more sculptural as time marches on, symbolizing the slow but inevitable emergence of women's rights. Chicago's project literalized the feminist struggle all too explicitly for many in the movement—the plates feature vaginal imagery, which some women found offensive and reductive. She was also criticized for drafting a team of assistants to help her with china painting and embroidery, while retaining sole authorship over the work. As she pointed out, male artists did this all the time and were never disparaged for it; even in the context of this triumphant feminist statement, she seemed to be held to a different standard.[6]

Chicago and the members of the *Heresies* collective were among many artists who turned their backs on modernist abstraction and conceptual art, opening their work to previously forbidden territory: ornament, sentimentality, and craft. The most prominent group, based in New York and California, came to be known as the Pattern and Decoration movement. Not all of the artists involved were women, but all were sympathetic to feminist politics, and they saw the embrace of decorative traditions

Joyce Kozloff, *tent-roof-floor-carpet/Zemmour*, 1975. Courtesy of the artist.

as a symbolic liberation.[7] They also viewed the rhythms and forms of craft as inherently anti-hierarchical, "a process that goes on and on," as the artist Joyce Kozloff put it, in which much joy could be found. "Much contemporary women's art has to do with rage and pain (as if we identify ourselves as women through our suffering)," Kozloff wrote. "But the decorative arts that women have traditionally done over the ages have expressed a sense of wholeness and continuity."[8]

Pattern and Decoration artists were interested in all kinds of craft (tilework, calligraphy, fabric printing, and more) from all over the world. But if there was one technique that really came to the fore at this time, it was quilting. The interest that had arisen during the civil rights campaign broadened into a wider embrace. In 1971, a hastily arranged exhibition at the Whitney Museum of American Art in New York City, *Abstract Design in American Quilts*, was a surprise blockbuster. Antique examples from the Amish communities in Pennsylvania, Indiana, and elsewhere were snapped up by dealers, sometimes right off clotheslines. Doug Tompkins, whose clothing brand Esprit went on to commercial success in the 1980s, was an enthusiastic collector of quilts, inspired by their bold blocks of color.[9]

The embrace of quilting extended beyond feminism, but it was women in the movement who made the most of it. The artist Faith Ringgold drew inspiration from her own family history, back to the era of slavery—which included stories of her grandmother boiling and bleaching flour sacks and then using the fabric as quilt lining—and created complex narrative works in the medium.[10] In *Who's Afraid of Aunt Jemima?*, completed in 1983, Ringgold used the quilt as a storytelling medium, replacing crude stereotype with humanity and complexity. Her Jemima joins the Great Migration to Harlem, where she prevails over racism to build a successful business; when she is killed in a car accident, she is laid to rest with an African-style funeral. The work exemplifies the feminist understanding of quilting as "an art form rooted in both meaningful work and in cultural oppression, [of] limitations overcome and of sorrow and anger at limitations imposed." As Ringgold has put it, "in order to do any of this, you have to get rid of all the limitations—at least in your head."[11]

The Pattern and Decoration movement and related developments in the art world were clearly indebted to the counterculture of the late 1960s, which had also looked to other cultures for aesthetic inspiration. But the feminists were in many ways less naive than the hippies. In part, this was due to the experiences that women had had in the civil rights and antiwar movements, which could be just as sexist as

the establishment they sought to overturn. Both campaigns had depended mightily on women's participation. The activist Ruby Nell Sales has memorably characterized the civil rights movement as "a rebellion of maids," yet women were not entrusted with leadership positions, instead being expected to serve in supporting roles.[12] In the communes of the counterculture, too, women were often typecast as caregivers, and burdened with the majority of child rearing, cooking, and cleaning. And in organizations like Students for a Democratic Society (SDS), the leading campus-based antiwar movement, female activists were assigned office duties and the foot-work of organizing. One participant recalled: "Here were all these sanctimonious young men going around pontificating about how the world was a bad place and we really ought to change the way people related to black folks and brown folks. But they treated women in totally abysmal ways."[13] The most well-known feminist slogan, "The personal is political," originated as a counterargument to leftist men who failed to see that everyday relationships were themselves shot through with power dynamics.

One of the most perceptive and hilarious early writings from the feminist move-ment, Pat Mainardi's essay "The Politics of Housework," touched right on this nerve. It is an account of her futile attempts to get her male partner, who is supposedly a progressive, to realize that women's liberation might actually involve him doing some chores. She mercilessly records his flimsy and increasingly desperate excuses: "I don't mind sharing the work, but you'll have to show me how to do it ... We have different standards, and why should I have to work to your standards? ... Unfortunately I'm no good at things like washing dishes or cooking. What I do best is a little light carpentry ... We used to be so happy! (Said whenever it was his turn to do something.)" What he really meant when he said all these things, Mainardi came to realize, was "I am only interested in how I am oppressed, not how I oppress others."[14]

As Mainardi's deft juxtaposition of dishwashing and carpentry implies, there was another kind of politics underlying such kitchen debates: the politics of skill. Women's work in America had always been lower-waged, less professionalized than men's. By the 1970s, unions had finally begun to back the interests of their female constituencies, but only in the context of a general shift toward unskilled workers, which had resulted in a weaker position for organized labor as a whole. This is one reason the feminists opened up a new front in the battle for gender equality: the home. They were determined to fight for women laboring *outside* the

official workplace, not just skilled artisans like Georgina Garcia, but women doing unpaid and unrecognized labor everywhere. The first issue of *Heresies* included a call for state-funded compensation of housework, acknowledging it as the informal foundation for the whole economy. "This is the sexual division of labor: workers make cars, and women make the workers who make the cars. And to make a worker is a much more time- and energy-consuming job than to make a car."[15]

As these debates progressed, the broader economic picture was becoming steadily less favorable. The country was introduced to an ugly new word, *stagflation*, in which persistently low employment was accompanied by rising prices, two things that should not go together. Economists still debate why this happened, often pointing to the 1973 oil crisis as a triggering event. For workers, what mattered was that jobs were harder to come by, and less well compensated, than at any time since the Great Depression. Across the country, particularly in the Northeast and Midwest, manufacturing plants either moved away to cheaper wage zones or shuttered entirely. Ironically, these developments may actually have helped to nudge the workforce slightly toward gender parity. The majority of the nation's female employees were not in the manufacturing sector, but in offices, restaurants, and other service jobs, which were less subject to immediate contraction.[16] But the era's macroeconomic trends did not mean that female unskilled workers got more respect and compensation, as feminists wanted, just that skilled men were permanently dislodged from their jobs. For the factory operatives of earlier periods in American history, the Industrial Revolution had been a terrible experience. Deindustrialization may have been even worse.

～

Studs Terkel's book *Working*, published in 1974, is a panorama of American production. It is filled with edited interviews, not too different from the one that *Heresies* conducted with Georgina Garcia. Terkel recorded his conversations on reel-to-reel tapes, like an itinerant anthropologist. He talked to the skilled and unskilled, women and men, Black and white, rich and poor, people in all sorts of trades. His project was so wide-ranging that it is difficult to pick out any general pattern, apart from one: The American work ethic seemed to be in freefall. A foundational, nearly mythic quotient in the national character, almost taken for granted since the days of Alexis de Tocqueville, was under threat. "Inchoately, sullenly, it appears in slovenly work,

in the put-down of craftsmanship," Terkel wrote. "The careless worker who turns out more that is bad is better regarded than the careful craftsman who turns out less that is good." The interviews in the book, particularly those involving industrial workers, seemed to bear out this diagnosis. A spot welder in a Ford plant says of the assembly line, "It don't stop. It just goes and goes and goes. I bet there's men who have lived and died out there, never seen the end of that line. And they never will, because it's endless. It's like a serpent. It's just all body, no tail." Another worker simply tells his sons, "If you ever wind up in the steel mill like me, I'm gonna hit you right over the head." [17]

In retrospect, we can see this decline in morale as the early warning of an existential crisis for American manufacturing. In the latter half of the 1970s, the stiff spine of the economy went into a deep slump. The steel, machine tool, and automotive sectors came to be described as "sunset industries," without any implication that a new dawn would come. As plant closures rippled across the economy, accusatory fingers pointed every which way. The easiest people to blame were foreigners, particularly firms in Japan and Germany, who had invested in automation at a greater rate than American companies. Decreasing domestic demand was a factor, too, as was the high cost of energy. Another problem was the long-standing opposition between labor and management, which had rendered both sides inflexible, unable to cooperate. "One of the problems in the mills is that no union man would trust any of the companies," said one labor representative. "To the average union man, they're always crying wolf. And the wolf finally came." [18]

These factors notwithstanding, there is no doubt that the damage to American manufacturing was primarily self-inflicted. When factories in the North and Midwest were profitable, they had been used as cash cows to fund expansion into the nonunionized South, and then abroad. Now those "runaway shops" were long gone, employing people in other countries. The real culprit, maddeningly enough, was an abstraction: the velocity of capital, the fact that money was much more mobile than the brick-and-mortar facilities that had generated it. [19] In 1978, Buckminster Fuller, the prolix sage of the counterculture, summed it all up in a single sentence: "All the great American corporations of yesterday have now moved out of America and their prime operations have become transnational and conglomerate and are essentially concerned with the game of selling their corporation's very complete, technical, managerial and vast credit handling and money making." [20]

Reactions to deindustrialization were diverse and, to some extent, predictable. Unions blamed management, and vice versa. Conservatives blamed government—among them was Ronald Reagan, whose victory in the 1979 election portended further deregulation and antilabor measures. Some faulted the decline in the craft ethic that Terkel had identified, seeing it as a cause rather than a symptom of the crisis, though this is not very persuasive. (American steelworkers, for example, still led the world in productivity per person, despite the inferior technology at their disposal.)[21] Some wrote songs. The image of American industry as a fallen giant, once heroic and now humbled, inspired Bruce Springsteen's "Factory" (1978), James Taylor's "Millworker" (1979), and Billy Joel's "Allentown" (1982). The effect of deindustrialization could also be measured in statistics. In the area around Pittsburgh, nearly 65,000 of 90,000 steelworkers were on indefinite layoff in the summer of 1983. That year, U.S. Steel recorded a record $1.16 billion loss (though David Roderick, the chairman and CEO, received a salary increase of about $50,000).[22] Detroit lost nearly 20 percent of its population in the 1970s.[23] And as a share of overall employment, manufacturing began a long drop from its peak in 1965, when it stood at 28 percent, to only 8.5 percent today.

Beyond the numbers was the psychological toll. It is a short step from being unemployed to feeling unemployable. The physical transformation of America's industrial centers into a "Rust Belt" was a tangible reminder of a failed social contract; one steelworker was quoted as saying that "the great mills fell like broken promises."[24] A cult of so-called ruin porn eventually developed around gutted industrial structures, fixated on the poignancy and sublimity of their shattered remains—an aestheticization of communities in distress that was much to the irritation of the communities themselves.[25] Some old manufactories were transformed into museums. These were devoted either to contemporary art, emblems of the shift from physical making to symbolic capital, or to local history, often told from the worker's perspective (in which case, one might argue, it was a case of too little, too late).[26]

All this had dramatic effects on American ideas about craft. The industrial artisan had always been a somewhat offstage figure, represented in stereotypes and clichés, if at all. And this is understandable. Because individual contributions disappear into standard product lines, the people themselves remain anonymous.[27] But even so, manufacturing had been an important anchor for individual workers' identities. Now that sense of autonomy was hollowed out, as surely as the industrial districts themselves. If craft was going to reassert itself in the culture, it would need to be on

Fisher Body Plant 21, Detroit, Michigan, 2009. Timothy Fadek, Corbis Historical/Getty Images.

a different basis: not as the proud possession of a single person, whether in a factory or a studio, but as a social glue that could help put America's pieces back together again. A great pendulum that had begun all the way back in the eighteenth century, when craft first became strongly associated with individualism instead of community, was now swinging back the other way, having bounced violently off the unyielding face of economic reality.

~

The era that America had now entered, stumbling rather than striding, has been assigned quite a few names. There is *postindustrial,* coined by the sociologist Daniel Bell, a term that emphasizes the shift from an economy based on manufacturing to one based on services. *Postmodern,* popularized by the architect and historian Charles Jencks, stresses the precedence of communication and image over structure and form. *Information revolution* and *knowledge economy* reflect a shift in value from tangible to intellectual property. The German sociologist Ulrich Beck postulated the rise of a *risk society,* in which power is projected slightly into the future and used to allocate potential hazards elsewhere. There are others, too: *post-Fordism, liquid*

modernity, society of the spectacle, late capitalism. (However described, it's been a golden age for theories.) Each of these concepts has its own complexities, and its own explanatory power. But what they all share is the idea that physical stuff no longer matters—or, anyway, it matters a lot less than it once did. Whatever drives history forward, it will be immaterial in nature. Value will be created as if from thin air.

And that air was getting thinner and thinner. By 1983, the tide of recession began to ebb, beaten back by Reaganomics (in essence, huge tax cuts funded by deficit spending). Manufacturing never did rebound, but other parts of the economy took up the slack, notably finance and the ever-expanding service sector. Tom Wolfe had his finger on the pulse as usual with his *Bonfire of the Vanities*, published serially in *Rolling Stone* magazine, and then as a novel in 1987. He portrayed a New York City riven by racial conflict and obsessed with money: "By age forty you were either making a million a year or you were timid and incompetent. *Make it now!* That motto burned in every heart, like myocarditis."[28] Wolfe's book, along with the film *Wall Street* (1987) and the pop culture status of antihero investors (among them, the disgraced junk bond trader Michael Milken and a farcical blowhard named Donald Trump), helped to make Manhattan corporate executives, perched in nosebleed-altitude office suites, into emblematic figures of the era. Few Americans knew anyone like that, much less had the experience of being one. But like so much else about the 1980s in America, this was a matter of symbolic capital.

None of this sounds very promising for craft. The counterculture had sputtered out, and industry was on its knees. But there was a surprising amount of handwork happening behind the decade's culture of appearances, glitz, and self-conscious artificiality. The flashy print graphics of the 1980s were all done by hand, cut-and-paste. Films like *Star Wars* (1977) were filled with painstakingly prepared models of spaceships and elaborate prosthetics. (Even that film's iconic opening title sequence, with a scroll of yellow text receding into space, was made using an ingenious hand-built contrivance: The designer Dan Perri printed the letters on a clear sheet of acetate, which he then mounted on rollers at an angle and shot straight on with a film camera.) Hip-hop music, which introduced sampling to mainstream America, also involved considerable skill. Turntablists deftly manipulated two or more record players simultaneously, cutting the track together on the fly. The trendsetting Harlem fashion designer Dapper Dan printed Gucci, Fendi, and Louis Vuitton logos on leather, then tailored the material into tracksuits and jackets. It may never even have occurred to the audiences of these various pop culture phenomena that they were experiencing something

Roxanne Shanté wearing an outfit by Dapper Dan, 1989. Michael Ochs Archive/Getty Images.

handmade. Craft had not quite gone away—it never totally goes away—but was hiding in plain sight.

Meanwhile, perhaps contrary to expectation, the studio craft movement actually became a solid moneymaking proposition in the 1980s. Ever since Webb started America House in 1940, studio craft had been something one bought in a store, and pretty cheaply, too. Despite the pretensions of the movement to fine art status, only a handful of dealers attempted to sell it in a gallery context—among them Lee Nordness, the co-curator of *Objects: USA*, and the pioneering Helen Drutt, who established her first space in Philadelphia in 1973. It was not until the 1980s that a larger cohort of dealers emerged and started to play a key role in shaping the field. The decade saw a bumper crop of new galleries, often specializing in a single discipline. Drutt showed several craft media, but was a particularly effective advocate for avant-garde jewelry, much of it brought over from Europe. In ceramics the dominant figure was Garth Clark, an articulate South African who also served as the field's self-appointed historian. In both his scholarship and his selling program, he constructed

a rigorous account of ceramics' artistic development—the studio craft field's first authoritative canon.[29] Toward the end of the 1980s, the wealthy financier Peter Joseph made a decisive intervention into the studio furniture field. In a beautifully (and expensively) appointed space in New York, he elevated a few talents to exalted status, often acquiring the work on display himself.[30] Eventually there were enough galleries that studio craft got its very own art fair, SOFA (Sculpture Objects Functional Art), which began operating out of a Chicago hotel in 1993 and then moved to the larger space of the city's Navy Pier.

From its earliest years, the main attraction at the SOFA fair was blown glass. It was the craft medium that enjoyed the greatest commercial success, the one that was best suited to the spectacle culture of the 1980s and that had the highest price points. The challenge and expense of hot glass are considerable, partly due to the costs of constructing and continuously operating a furnace. After 1964, though, when a first gathering for studio glass artists was held in Toledo, Ohio, knowledge and capacity expanded quickly. The remnants of a once-extensive American industry—companies such as Libbey in Toledo, Blenko in West Virginia, and Corning in upstate New York— were one important source of support. Expertise was also imported by artisans from Italy and Czechoslovakia, who generously overlooked long-standing traditions of trade secrecy. By the 1980s, glass had matured into a field with strong international connections and internal camaraderie. For those without their own studios, accessible "hot shops" (like UrbanGlass, in Brooklyn) made it possible to create work in a supportive group context. Glassblowing at such sites is uniquely performative, requiring multiple hands working in unison, with the added drama of heat, risk, and speed. This theatrical quality helped to attract a healthy collector base, who in turn patronized a network of specialist galleries, the earliest and most significant being Habatat (founded in 1971 in Detroit) and Heller (founded in 1974 in New York).

The turning tide in glass's fortunes is best seen in the story of the Pilchuck Glass School, founded in 1971 and located outside Seattle. It began more or less as a commune; over the first rainy summer, the first resident artists there lived and worked in rough conditions. They did manage to make a working furnace and batches of thick-walled, blobby vases that, for most of them, marked the extent of their technical expertise. They also created some wild experiments using the then-new art medium of video, and made installations and "happenings" out in the woods. The leader of the group was an ambitious young man with a mop of curly hair named Dale Chihuly. Concerned that the group was focusing too much on lifestyle to the

exclusion of art making, he soon redirected the hippie energy of the place in a more establishment direction. It was, participant Ruth Reichl remembers, "a struggle between this vision for Pilchuck as a major glassblowing center and Pilchuck as a place to try living in the forest."[31]

A turning point came in 1977, with a new focus on fund-raising and architectural development. Tents and self-built cabins were replaced by proper buildings, blobs by exquisitely made technical tours de force. By 1980, Chihuly was sidelined as a maker due to injuries, but this seemed to make him only more productive, as he began orchestrating teams of artisans to realize his vision. His work became increasingly ornate, recalling the Venetian baroque or art nouveau or, for that matter, cinematic special effects. He would go on to make gigantic open-air projects in Venice and elsewhere, and to populate botanical gardens with his variously spiky and seductive sculptures, like so many oversize tropical flowers. Museums love to put his extravagant, show-stopping chandeliers in their entry halls. Gardens and lobbies are appropriately indeterminate spots for Chihuly's works, as their status is somewhat unclear. Is this decoration? Sculpture? Something else? As Bruce Metcalf and Janet Koplos write in *Makers*, their comprehensive history of the studio craft movement, "as Chihuly began to stage-manage his traveling exhibitions and gargantuan public projects, it became impossible to gauge his work as any kind of craft or art; it became instead an accessible popular entertainment."[32]

It is a matter of debate whether all this was actually a good thing for studio craft. Chihuly's unique prominence, and that of studio glass in general, did dramatically raise the profile of the movement. This arguably helped to clear the way for other fields, like wood turning and metalwork, which gained their own medium-specific organizations, publications, and dedicated collector groups. Museums were acquiring things. Books were being published. Most important, it was now possible for at least some independent makers to earn a decent living without depending on a teaching salary. In all these respects, Webb's initial goals were being achieved. Happily, she lived until 1979, just long enough to see the wave of success begin to crest. Yet something in studio craft may have drowned as the money flooded in. Any market has winners and losers, and a competitiveness entered the field that had not previously existed. Earlier moments of pure experimentation and community building began to be regarded with a certain nostalgia.

And there was one persistent frustration: For all the achievements of the movement, it remained an enclosed and somewhat marginalized phenomenon. In

particular, the fine art world proper remained all but impervious to entry from the studio craft ranks. The barrier was not so much because of ancient prejudice against the lowly crafts—by the 1980s, pretty much anything was fair game as art—but rather, because the movement had become defined by its own medium-based concerns. It was telling its stories to a captive audience, a circumscribed constituency. This sidelining caused ongoing resentment, partly because of money. The market for contemporary art was ballooning, with works selling for prices that were magnitudes higher than the most expensive studio glass. But what studio craftspeople really wanted, above all, was respect. And even in times of plenty, that is always in short supply.

~

Nagging status issues aside, the studio craft movement was doing just fine in the 1980s, and looked to gain strength in the ensuing decade. But the real money to be had in craft was absolutely elsewhere: in the hands of people like Michael J. Dupey, David Green, and Martha Kostyra. Those names may not ring a bell, but these probably do: Michael's, Hobby Lobby, and Martha Stewart, three companies that today are collectively worth billions of dollars. All had their takeoff moment in the 1980s. They proved that craft could still be an economic engine for America—though not in the way one might have expected.

Dupey and Green were the entrepreneurial competitors who brought the world the "arts and crafts superstore." In some respects, their backgrounds were similar: Dupey was from Dallas, and Green grew up about two hundred miles to the northwest, in Altus, Oklahoma. Both opened their first stores in the early 1970s. But while Dupey's father was wealthy, the owner of a home store chain (named for Ben Franklin, as it happens), Green was a poor pastor's son. In his ghostwritten autobiography, which strongly echoes nineteenth-century self-made man narratives, Green describes himself as "the kid washing dishes in the cafeteria in order to afford a lunch pass." Once he secured a work placement in a local department store, he never looked back: "I began to see that in retail, the sky was the limit. You could always open more stores, or expand the stores you had. There was no end. I found this tremendously inspiring." Even selling blankets to migrant workers at a dollar apiece was a thrill. Feeling that amateur craft was an opportunity in the marketplace, he went into business for himself and opened the first Hobby Lobby. Among his first items were picture frames assembled by residents at a local cerebral palsy center, and beads, which he remembered hippies plucking out of bins, one by one, and

stringing into necklaces right there in the store. Deeply religious, Green claimed that his first rule of business was to conduct himself according to God's laws, citing the Book of Ecclesiastes: "Whatever your hand finds to do, do it with all your might."[33]

As Green was living out his own personal Horatio Alger myth, Dupey was establishing the Michael's chain in Dallas, first converting one of his father's stores into a specialist craft emporium and then gradually expanding to eleven locations across Texas. The model was borrowed from other "big-box" mass retailers like Walmart, which had been spreading across America along with suburban sprawl. Green quickly adopted the same strategy, stocking a bewildering variety of items: glue guns, acid-free scrapbook paper, pinking shears, rubber stamps, and U.S. flags, "small, medium, and large."[34] Both entrepreneurs were supremely attentive to trends, with rapidly overturning product lines. In terms of their architecture (which was banal), the quality of the jobs they offered (which were poor), and the nature of their products (which were mass-produced in sweatshops), Green and Dupey's superstores exemplified everything that craft is supposed to remedy. But customers didn't see it that way. Michael's and Hobby Lobby targeted middle-class suburban women as their key customer demographic. The pitch was simple: You can improve your home, enjoy yourself, learn skills, and feel the pride that comes from making things by hand. All you have to do is buy our stuff.

Dupey's and Green's trajectories eventually diverged. In 1983, Michael's was bought out by a diversified corporation, which placed it on the Nasdaq stock exchange for $2.50 a share—America's first publicly traded craft business. Dupey started another brand, MJ Designs. It was eventually forced into bankruptcy, but his old firm thrived; Michael's now has more than 1,250 locations across the country. Green avoided such complexities by keeping his company family owned. In 2012, he landed in the newspapers when he contested the recently passed Affordable Care Act on the grounds that its provision of funding for abortion services conflicted with his religious beliefs. Just as his arts and crafts superstore was the practical antithesis of the arts and crafts movement, this conservative stance positioned him against the progressive politics that one might associate with craft—but of course this is a matter of perspective. After all, many more Americans know about Hobby Lobby than know about sculptural ceramics.

If Green did consider himself to have an ideological opponent, it was not the artistic avant-garde, or counterculturalists, or craft reformers, or feminists. It was Martha Stewart. In his autobiography, he singles her out as a "home-decorating

guru" who created "adverse publicity" for his business.[35] And certainly, she is not an enemy anyone would want to have. Stewart (her married name) has probably attracted more journalistic commentary than anyone else in recent American craft history, much of it half joking, but half deadly serious, too. She started building her brand in 1982, with a bestseller simply titled *Entertaining*. It was the first step on the way to becoming an unprecedented cultural phenomenon. In an extraordinary burst of multiplatform organization, surpassing even that of Aileen Osborn Webb, Stewart produced more books, a magazine, a TV show, goods for home stores, a line of house paints, and in 1997, a newfangled thing called a website.

All the while, she maintained a mesmerizingly meticulous lifestyle, which in turn was documented across her media empire. A 1995 *New York Magazine* profile by the journalist Barbara Lippert, in an issue with the memorable cover headline SHE'S MARTHA STEWART AND YOU'RE NOT, drew attention to Stewart's "particular genius for taking quotidian activities that have been tedious for centuries and transforming them into opportunities for excellence . . . Her standards are so exacting that *almost anything she says* is hilarious." Witness her monthly calendar: "clean the canoe, plant nasturtiums, begin excavation for new road."[36] The authors of a parody book, entitled *Is Martha Stuart Living?*, admitted that it was difficult to be as funny as the real thing. An American studies conference in 1999 devoted a panel to her, prompting jokes about the emergent field of "Martha Stewart Studies."

It all came crashing down for a while, after Stewart was indicted on charges of insider trading in 2003. The blizzard of schadenfreude was blinding in its intensity, with a strong current of sexism: At last, the "uber-perfectionist who turns chilly and imperious once the kitchen door closes" had gotten her comeuppance. According to one feminist media scholar, the coverage was about two hundred times the volume of that devoted to Kenneth Lay, the disgraced CEO of Enron, and about three times as much as Donald Trump, then promoting his new TV show *The Apprentice*.[37] But after a brief prison sentence, she returned to work, and remains head of her company today.

So, what has Martha Stewart meant? Certainly, she has proved that the craft ethic and the profit motive can coexist. She embodies both principles so fully: a stockbroker turned caterer turned corporate mogul, still a dab hand with a glue gun. As Hobby Lobby's David Green recognized, Stewart has also encouraged an aspirational attitude to craft that makes amateurism of the prepackaged kit variety look wholly inadequate. This is not quite the same as professionalism, because Stewart applies

the same approach to every project. She is a multitasker, not a specialist, and her message is not so much about skill as about satisfaction: the simple importance of doing something properly, by and for oneself.

Yet—and here is where it gets really interesting—the average Stewart consumer does not actually follow her lead. As Lippert wrote in *New York Magazine*, the brilliance of her brand "is not in how-to; it's actually in how well it crosses over to the exhausted non-do market."[38] The pop culture critic Karal Ann Marling agreed, describing the contents of a Martha Stewart Christmas guidebook as "elaborate how-to instructions and sumptuous photos of finished projects—gingerbread houses, topiaries, cookies shaped with homemade cutters, pastel trees, gilded wrapping paper fashioned from grocery bags—that you and I will never quite manage to duplicate."[39]

Back in the nineteenth century, domestic guides like Catharine Beecher had generated an equally lofty mountain of expectation, too steep for all but the most motivated to climb.[40] In the 1950s, magazines about hot rods and homemade fashion doubtless collected in piles in the garages and junk rooms of America, their helpful tips perhaps read but untried. The difference between Stewart and these precursors is that she consciously manipulates this dynamic, positioning craft achievement as an ever-receding horizon. Her primary audience was the first generation of women who had entered the workforce en masse, leaving a hole in the domestic fabric that she expressly set out to fill.[41] In one 1995 television interview, she was confronted with the charge that she was "selling perfectionism," an unrealistic set of standards. To this she replied, "Dreaming, to me, is an awfully good thing . . . Fantasy, dreams, aspirations. Those are the things that I think life is really made of."[42] That was a characteristically elegant way of putting it, but she was hinting at something rather complex: In the postmodern era, craft has greater viability as an idea than as an actuality. Even as it becomes less common as a daily activity, it still circulates, and the public brings to it associations of domesticity, pride, and longing.

~

Martha Stewart's version of "living," then, is best seen as a well-polished funhouse mirror held up to a country that had quite literally lost touch with its artisan past. But not all Americans liked the idea of that. In fact, some wanted to do more than touch the past. They wanted to crawl inside it and stay for a while. Stewart's affection for the traditional touch was one reflection of this trend, as were other popular

television shows like *Little House on the Prairie* (which ran from 1974 to 1983) and *This Old House* (which first aired in 1979). A far more intense version of historical escapism, though, was amateur reenactment, which experienced an extraordinary surge of popularity in the 1980s. This was quite a different thing from the revivalism of earlier decades. Certainly, great men and women such as Paul Revere and Betsy Ross were still venerated. (In one survey of high school students, the two Revolutionary-era artisans ranked as the top-recognized figures from all of American history, apart from presidents.)[43] But alongside the standard hagiography came a new focus on the everyday experience of the past, with a premium on archaeological accuracy.

It was during the celebrations of the American Bicentennial that reenactments began to gain ground. In 1973, on the two-hundredth anniversary of the Boston Tea Party, a party boarded a brig in the city's harbor and dumped some crates into the water, with a crowd of twenty thousand cheering them on. Then, when the banner year of 1976 came, towns across America held re-created militia musters and faux battles. There were stagings of Washington's crossing of the Delaware and Revere's ride. There was a brisk trade in souvenir artifacts, including full-size re-creations of the Liberty Bell, made by the London foundry that had cast the original. On the funny pages of America's newspapers, Charlie Brown's little sister, Sally, sold "exact replicas of snowballs that the troops threw at each other during lunch break at Valley Forge."[44]

Bicentennial fever came and went for most Americans. But for a few, it inspired a lifelong interest in history. It is thought that by 1986 there were some fifty thousand serious reenactors in the country. The most popular form by far was the re-creation of Civil War battles. This activity had a long history in America, going back at least to 1878, when a New Jersey regiment of Civil War veterans staged a mock battle. After the Bicentennial, though, reenactment took on a new seriousness, particularly among those who described themselves as "hardcore." These enthusiasts distinguished themselves by virtue of their thorough preparation and Method acting–like immersion. They sometimes chose a specific soldier to portray, perhaps a family ancestor, and often made their own gear, cultivating a range of making skills to do so. Hobbyists also bought items from professional suppliers called sutlers (an antiquated term for military purveyors), whose high degree of expertise and small scale of production actually did resemble that of nineteenth-century craft workshops.

A reenactor needs a lot of kit—not just a uniform or other appropriate clothing, but also underwear, boots, a hat, a blanket roll, a cartridge box, a canteen, and of course a gun. Few reenactors, even the most hardcore, were able to make their own firearms.

(Ironically, these were not sourced in America, but were bought mainly from specialist artisan producers in Italy.) They did, however, sew their own attire, roll their own cartridge ammunition (powder only, no projectiles), and prepare their own hard-tack, the desiccated flour biscuits that formed the unappetizing main course of a Civil War dinner. When at a reenactment event, they slept rough on the ground, spooning one another for warmth at night, and otherwise acted out the period experience in every detail. For all this emphasis on authenticity, however, reenactors could be seen as engaging in a form of postmodern behavior in their total immersion into an obvious fiction. "The actor tries to fool the audience into thinking he is the person he is portraying," said one popular guide to the hobby; "the re-enactor tries to fool himself."[45] Tony Horwitz, author of a book about reenactors entitled *Confederates in the Attic*, described one woman who had decided to portray a war widow. She had sewn herself a seven-layered outfit, complete with corset and hoop skirt. "It may sound silly," she said, "but I really do mourn the Union dead."[46]

Squanto (played by Frank Hicks) and Chief Flying Eagle (portrayed by Earl Mills) with Governor Carver (played by Dr. Robert M. Bartlett) reenact the signing of the Treaty of 1620 at Plimoth Plantation, 1971. Boston Globe/Getty Images.

Civil War reenactment peaked in the mid-1990s, encouraged by Ken Burns's multipart documentary about the conflict (1990) and by the movies *Glory* (1989) and *Gettysburg* (1993), both of which were filmed with reenactors as extras. An event held to mark the 135th anniversary of the Battle of Gettysburg, in 1998, was the largest reenactment ever held, with perhaps twenty thousand participants. Horwitz, who conducted his research just at this moment, developed a theory: All this pageantry was actually politics by other means. He detected a "hardening, ideological edge to Confederate remembrance," a holding fast to southern white identity, with the resentments of the Reconstruction era still in place, and maybe the racism, too. This explained the time and expense that reenactors committed to the hobby. (For, as one dealer in rebel merchandise put it, "quality Confederama don't come cheap.") Their mania for authenticity was a displacement for frustrations that otherwise had no outlet, a way of building legitimacy around beliefs that the rest of America had repudiated. To this day, one of the leading purveyors of Confederate "Stars and Bars" battle flags to the reenactment market lists its address as "Cartersville, (occupied) Georgia."[47]

That said, Civil War reenactment has declined in popularity since the 1990s, in part thanks to the renewed critical examination of this fractious past. As the reenactor Thomas Downes, a retired machinist from Cleveland, explained in 2018, "Up until the last five or ten years, the social causes of the war did not come into what we do. We were paying tribute to the fighting man. It wasn't 'I'm racist and I want to glorify slavery.' Nobody really thought a lot about the social reasons of why the South went to war." He thought that had changed, but he was still out there on the battlefield. And given all that he and his fellow reenactors had put into their pursuit, maybe that was not that surprising. As one of his comrades-in-arms put it with a smile, "Without these uniforms, we're just a bunch of middle-aged schlubs."[48]

～

Another term used for reenactment is *living history*. It's an apt term, perfectly capturing the way that it brings the past, with all its problems and possibilities, into the present. All this was in play on November 26, 1970, when twenty-five Native Americans went aboard the *Mayflower II*, a replica of the ship that had brought white settlers to New England 350 years earlier. They were certainly not there as reenactors. This was a protest, one of the first to occur within the Red Power movement. As most Americans were celebrating Thanksgiving, this group declared a National

Day of Mourning. Their leader, Wamsutta (Frank) James, read out a speech nearby, watched over by a statue of the seventeenth-century Wampanoag sachem Massasoit. Wamsutta had originally prepared the text for a civic dinner commemorating the anniversary, but when the event hosts reviewed it, they were horrified, and rescinded their invitation. What he had intended to say, in part, was this: "History wants us to believe that the Indian was a savage, illiterate, uncivilized animal. A history that was written by an organized, disciplined people, to expose us as an unorganized and undisciplined entity. Let us remember, the Indian is and was just as human as the white man. The Indian feels pain, gets hurt, and becomes defensive, has dreams, bears tragedy and failure, suffers from loneliness, needs to cry as well as laugh."

Every year since, Native activists have observed a National Day of Mourning on the fourth Thursday of November. The annual ceremony is a reminder that the story of Thanksgiving that was long propagated—of easy friendship between settlers and the Wampanoag—is a self-serving myth, and that the violence of the past still demands far greater recognition. Native people already had long experience in revisiting their own traditions. Now they began more actively to contest the way they were represented. One flashpoint in this controversy was right nearby: the living history museum Plimoth Plantation, where visitors are invited to "step back in time" and experience the settlement that the Mayflower voyagers and their immediate successors built. This experiment in historical re-creation was founded in 1947, toward the end of the Colonial Revival, just in time to present the brave "Pilgrims" (as the settlers were invariably called then) as role models for postwar suburban America.

At first, Plimoth Plantation was no more concerned with authenticity than Colonial Williamsburg had been. Wax figures and performers, including white people dressed in "redface," conjured a theme park atmosphere. Decorous oyster shell walkways crisscrossed the site. The re-created buildings varied in size depending on how much money had been donated by the descendants of the particular colonist portrayed.[49] But in 1969, there was a revolution in interpretation. An anthropologist on staff, James Deetz, pushed the museum to embrace a much more informed version of the past. The shell paths and wax mannequins were taken away. Settler homesteads were gradually rebuilt based on archaeological evidence. Above all, it was clear that a dialogue with the Wampanoag was long overdue.[50]

The direct result of this conversation, originally called the Algonquian Summer Camp (today, the Wampanoag Homesite), opened at Plimoth Plantation in 1973. It

was a small settlement, including wigwam-style shelters and a cornfield. In the 1990s, the site was reinterpreted as the settlement of a historical figure named Hobbamock, who had served as an adviser to Massasoit and an intermediary and translator for the European settlers. Today, it features three impressive structures, including a *nush wetu*, or longhouse. Even the crops grown there are seventeenth-century varietals. Although the nearby white colony at Plimoth Plantation is staffed by interpreters portraying settlers in first person (complete with approximations of seventeenth-century accents and speech patterns), Native interpreters speak in third person. To some extent this is a pragmatic decision; interpreters gently point out to visitors that if they were role-playing, they would need to speak in a totally different language.[51] But it also allows them to describe historical Patuxet (the Wampanoag term for this area) in explicit relation to present-day life. The result is a nuanced discussion about heritage and loss.

A similar approach guides the craftwork conducted at the site, which includes a wide range of techniques: pit-fired pottery, twining and matting, leatherwork, wampum shell beadwork, and the making of *mishoons*, dugout canoes fashioned through a combination of burning and carving. Interpreters are careful to explain what is and is not traditional about revived craft processes; authenticity is a guiding concern, but there are inevitably compromises. For example, clay may or may not be hand-dug from the ground. Wampum beads may be pierced with a bow drill or mechanically. Trees for boatmaking are felled with a saw, rather than brought down with a skillfully controlled fire. While certainly a means of educating the public, on-site making has played an equally important role for the Wampanoag themselves. "It's recovering our culture and maintaining our identity," says Darius Coombes, a lead interpreter at the museum, who has worked there since the 1990s. "I would say to any Indigenous person: 'Hold on to what you can and revive what you can revive. You'll be more in tune with yourself and what you are as a person.'"[52]

Plimoth Plantation is no utopia cut off from the rest of America. Like other historic sites, Colonial Williamsburg among them, the museum has seen its attendance figures fall steadily from their peak in the mid-1980s. In recent years, it has also struggled with management-employee relations; about half the staff has formed a union, affiliated with the United Auto Workers, to protest low pay and poor working conditions.[53] One sort of realism—verisimilitude with regard to traditional practice—is necessarily balanced with another sort of realism, the facts of modern

American life. Craft reenactment remains a means of closing the distance to a vital past, but it is certainly not easy.

As similar efforts to revive historic crafts have unfolded among Native nations elsewhere in the country, establishing standards of authenticity has been a constant challenge. A fascinating chapter in this story is that of the Indian Arts and Crafts Act of 1990, cosponsored by Congressman Ben Nighthorse Campbell, the legislature's first Native representative, and a silversmith in his own right. The law strengthened legislation that had been passed back in the 1930s, now formally recognizing enterprises "dealing in genuine Indian-made handicraft products," and empowering the Indian Arts and Crafts Board to bring legal action against counterfeiters. The principal targets were mass-manufacturers in China and the Philippines, who were flooding the American market with cheap knockoff pottery, kachina dolls, beadwork, and other products, making it difficult for Native craftspeople to compete.

The Indian Arts and Crafts Act passed easily with bipartisan support, with one representative characterizing it as an "essentially noncontroversial piece of legislation."[54] But problems resulted immediately. Who, exactly, is a "genuine Indian"? Many people who considered themselves to be Native American had not been officially recognized as such by a tribe. This might have been because they were unable to document their genetic heritage—the paper trails lead back to problematic nineteenth-century census data—or because their tribe happened to be in conflict with the U.S. government about its own status. Other Native people simply rejected, on principle, the government's right to regulate their ethnicity. (After all, that does not happen for any other American demographic.) Practically speaking, too, the law placed a burden on each sovereign tribe to certify artists and artisans, which it may not have had the infrastructure to perform.

Just two days after President George H. W. Bush signed the bill into law, a museum in Oklahoma temporarily closed its doors, as it had no way of verifying the legal status of many of the artifacts in its collection and was unsure if it might be subject to litigation. Artisans were disinvited from showing their work in exhibitions, commercial galleries, and fairs unless they could prove their heritage based on "blood quantum." The artist Hulleah Tsinhnahjinnie, who is of Seminole, Creek, and Navajo heritage, was one of many to raise her voice in protest, commenting that this business of verifying racial purity reminded her of "the numbers tattooed on the arms of the Jewish people."[55] Ironically, Ben Nighthorse Campbell would himself

have been ineligible to sell his silver jewelry in his younger days under the provisions of the act, as he was not certified as a member of the Northern Cheyenne nation until shortly before he turned to politics.[56]

In this case, the clash between globalized manufacture and local authenticity had created a morass. If Native craftspeople were to receive protection, some definition of Native identity was indeed necessary. In Alaska, a similar program called the Silver Hand has been in effect since 1972, certifying Inupiaq ivory carving, Haida basketry, and other regional crafts. This truth-in-advertising campaign was again based on narrow definitions of ancestry, with all the problems of potential exclusion that entails. Even so, according to the anthropologist Emily Moore, most of the state's Native artisans remained in favor of the scheme. This is perhaps understandable given that (as of 2001) as many as 75 percent of retail items marketed as "Alaska Native made" were actually imports from the Far East and elsewhere.[57]

Globalism had deposited this problem on America's doorstep, and Native people did not face it alone. Where did things come from? Who really made them? What were their lives like? How can one live ethically in such a state of ignorance? These questions did not admit of easy answers. But more and more people were at least beginning to ask.

~

"Could there be a more telling indicator about our brave new 'post-industrial' world than the vampire-like rebirth of the sweatshop?"[58] So wrote one activist in the turbulent wake of one of the more horrific news stories in recent memory. In 1995, police in El Monte, near Los Angeles, had discovered dozens of Thai garment workers imprisoned behind locked doors and barbed wire. They had been brought to America by human traffickers and told that they needed to work off the cost of their transport. But their debt only mounted over time, as they were required to pay exorbitant prices for basic necessities inside the compound. Meanwhile, they were required to operate their sewing machines seventeen hours a day. It was appalling that such things could still happen in America: the terror of early nineteenth-century slavery brought back to life in the suburbs.

The El Monte case was just one of several high-profile exposés about sweatshops to make headlines in the 1990s, unusual only because the case had happened on American soil. In 1996, an article by Sydney Schanberg in *Life* magazine revealed that Nike and other athletic brands were selling soccer balls that had been made by

Pakistani children for six cents an hour. Even this meager wage was counted against a fraudulent debt, as at El Monte, keeping the underage workers in perpetual servitude. They also endured disciplinary beatings and unsanitary living conditions. "I could have gone almost anywhere in the third world for this story," Schanberg wrote, "to China or Brazil or Thailand or Central America."[59] Sweatshops were a global epidemic, and American companies were their best customers.

In response to these revelations, a protest movement swept the nation's university campuses. It began with a sit-in at Duke, in North Carolina, when a group of students called on the university to break off contracts with any producer of school apparel that depended on sweatshop labor; at the time, Duke was selling twenty-five million dollars' worth of branded merchandise annually, thanks to the popularity of its basketball team. The protest worked. A year later, the university administration signed on to a new ethics policy. By then, an organization called United Students Against Sweatshops had chapters across the country, making similar demands at their own schools and pushing for corporate transparency about manufacturing. At Yale, a group of students held a "knit-in" to raise awareness.[60]

Companies heard the protests, and they responded—with counterarguments. They claimed, unconvincingly, that their supply chains were so complex that it was impossible to conduct decent oversight. A more persuasive defense came from mainstream economists, including Paul Krugman, who wrote that "bad jobs for bad wages are better than no jobs at all." While not insensible to the experiences of poverty-stricken populations—he gave the example of a garbage dump in the Philippines where families picked through toxic waste to find salable scrap metal—he nonetheless pointed out that these workers were taking on such jobs willingly, in preference to traditional subsistence farming. Krugman also made a broader case that sweatshops and other exploitative labor practices were a necessary step on the way to economic development. America itself had undergone precisely that experience, and it was even truer in the late twentieth century, given the transformation of the whole world into one competitive marketplace. In this context, the best thing an impoverished nation had going for it was low labor costs. Preventing such nations from exploiting that advantage would block the only opportunities for growth they had. This predicament, according to Krugman, "is not an edifying spectacle; but no matter how base the motives of those involved, the result has been to move hundreds of millions of people from abject poverty to something still awful but nonetheless significantly better."[61]

The contest of wills between human rights activists and neoliberals like Krugman has raged ever since. NGOs such as Oxfam have partnered with a growing international union movement in an attempt to implement factory inspection programs, gender quality in pay, and other objectives.[62] Yet terrible working conditions persist worldwide to this day. The struggle to impose ethical standards on global manufacturing has strong echoes of the Arts and Crafts movement and the early days of the World Crafts Council, but it has had to contend with a whole other order of scale. It is not just in the garment industry that sweatshops are prevalent; they occur in any sector that cannot be affordably automated, including computer and electronics manufacturing. Those high-tech goods are assembled by hand, and have been ever since the explosion of home computing in the 1980s and '90s, when silicon chips and circuit boards were first manufactured in large quantities.[63] "To understand the electronics industry is simple," the business analyst Louis Hyman has commented. "Every time someone says 'robot,' simply picture a woman of color."[64]

As the turn of the millennium approached, against this contested backdrop, American craft once again began to shape-shift. Two new overlapping tendencies emerged: craftivism and the maker movement. Both were grounded in the ideal of individual responsibility that had always been a hallmark of the nation's craft culture. Yet each also introduced a strong ethos of collective action, as a response to post-industrialism and technological change. They are perhaps best seen as two sides of the same coin. They sought in craft the potential to change the way Americans look at the world. Again.

The textile artist and activist Betsy Greer coined the term *craftivism* in 2003. As an idea, it has a long prehistory, with inspirations including abolitionist sewing circles, suffragist protests, and the 1970s feminist movement. One major instance of the phenomenon, *avant la lettre*, had its inception in 1985, in San Francisco. The political organizer Cleve Jones was attending a candlelight service in memory of Harvey Milk, the state's first openly gay elected official, who had been assassinated seven years earlier by a former colleague. There had been too much death in the city since. The AIDS epidemic was ravaging the gay community there and across the country. As government authorities remained silent about the catastrophe, activists like Jones had taken it upon themselves to raise visibility. That evening, he and a friend invited attendees of the vigil to make signs dedicated to people they had lost to the disease

and put them up on a wall. Standing back from what they had made, Jones said to himself, "That looks like a quilt."

This was the birth of the AIDS Memorial Quilt (formally, the NAMES Project), which Jones conceived and then led through its early years. He developed a simple and powerful idea. Those who had lost a loved one would create a textile panel, three feet by six, in that person's honor. These panels would then be stitched together into larger blocks, twelve feet square, which could be presented either singly or in a larger grid. Already by 1987, there were enough panels made—nearly two thousand—to cover a sizable patch of the National Mall. This was the first of several visits the quilt would make to the capital, each time bigger, commemorating more of the deceased. Today, there are about fifty thousand panels, over one million square feet in area.

The art historian Julia Bryan-Wilson, in her definitive study of the AIDS Quilt, observes that each panel is the size of a grave and that when the whole thing is laid out, it brings to mind a vast cemetery.[65] She also notes that, technically speaking, it is not a quilt at all, as it lacks batting (the padding between the top and the backing, which provides warmth). Many of the panels are made without any kind of stitch work, names and accompanying pictures instead executed with spray paint or Magic Marker. Others are sewn, but only in a rudimentary way, perhaps after a quick trip to an arts and crafts superstore.

Poignant as it is, the AIDS Quilt was controversial from the beginning. At one of its presentations in Washington, a homophobic protestor stood nearby with a sign reading BURN THE FAG BLANKET. Feminists, more justifiably, could not help but notice that a craft traditionally associated with women was being usurped by a movement made up primarily of gay men. African Americans, a demographic hard hit by the disease, were underrepresented in the panels, prompting questions about the project's community outreach strategy. But the most searching criticism came from the gay activist community itself. Many people associated with ACT UP, the main organization demanding action on the AIDS crisis, found the quilt far too pliant. Was this really an adequate way to represent a tragedy that has caused so much raw pain? Given how difficult it was to get the government to pay attention to the crisis, wouldn't a more confrontational gesture have been more appropriate? As Bryan-Wilson writes, the handcraftedness of the AIDS Quilt did make it accessible to a broad audience, helping it attract widespread attention, but at the same time tied it "to the realm of the regressive, the romanticized, the ineffectual."[66]

AIDS Memorial Quilt at the National Mall, 1987. Jeffrey Markowitz, Sygma/Getty Images.

Similar questions would be asked of craftivism when that movement began in the first years of the twenty-first century. Greer published a manifesto saying that "craftivism is about raising consciousness, creating a better world stitch by stitch."[67] Another early participant, Cat Mazza, said that craftivism happens "the second you decide to make something instead of buying it."[68] As this already begins to suggest, the term has been used to cover quite a broad spectrum of practices. Probably the most recognized is yarn bombing, originated in 2005 by the group Knitta, in Dallas, in which an object in public space (a door handle, a parking meter, a tree trunk) is given a colorful, hand-knitted sheath. The use of the term *bombing* here, borrowed from graffiti culture, is (like a lot of things about craftivism) meant to be ironic. The gesture is obviously nonviolent and is intended to introduce warmth, individuality, and hominess into the public realm. Indeed, it has been deployed to explicitly anti-militaristic ends, as was the case with a project by the Danish artist Marianne Jørgenson in 2006, in which she asked members of her online community to knit little squares of pink yarn and send them her way. She stitched them all together

into an afghan and threw it over an army tank on display in Copenhagen; a pom-pom dangled from its cannon.

Jørgenson's collaborative creation was taken away by the authorities almost immediately, but pictures of it went viral on the internet, making it an instant icon of craftivism. This points to one of the contradictions of the phenomenon: Insistently handmade, it is also thoroughly dependent on digital tools.[69] Most craftivist actions are consumed online rather than in person, these days through social media and sites like Ravelry (founded in 2007), the leading website for knitting patterns and projects. Rather than seeing this as a conflict, some craftivists have celebrated the common historical roots of weaving and computing or, more abstractly, have pointed to a deep connection between text and textiles.[70]

In 2003, Cat Mazza undertook a craftivist protest against sweatshop labor, using her website microRevolt to organize hobbyist knitters from more than twenty-five countries in the fabrication of a giant "swoosh," Nike's corporate logo. The smooth curves of the original were replaced with an awkward blockiness, suggesting a low-quality digital image. Mazza considered this to be a petition in crafted form, with each square as a stand-in for a signature. (She originally intended to send the whole thing to Nike's headquarters, but ultimately decided to keep it.) The project obliquely recalls the Declaration of Independence—all that beautiful calligraphy at the bottom of the document—and more immediately, the AIDS Quilt, which has a similar collaborative, grid-based structure. In 2007, Mazza was invited to show the banner in an exhibition entitled *Radical Lace and Subversive Knitting* at the Museum of Arts and Design, Webb's old craft museum in New York City, now rebranded in a bid for greater relevance. She was bemused when the curator pulled her contribution at the last minute, on the grounds that it looked "too 'funky' among the other work." Though disappointed, Mazza was also interested that the museum had "assumed that the banner aspired to some high-art quality, which was never the intention."[71]

The incident is indeed revealing, an indication that the long-standing rift between amateur and professional craft had not yet closed. Craftivism purposefully disrupted this divide, picking up where the women's movement of the 1970s left off. It has often been seen as part of broader third-wave feminist currents, with connections to less overtly political but still gender-empowering uses of craft. A prominent figure in this context has been Debbie Stoller, co-founder of the magazine *Bust*, which launched in 1993. Stoller is a sort of subcultural Martha Stewart, whose brand

is "girly feminism." She plays ironically on gender stereotypes rather than refusing them as inherently retrograde. This includes knitting and other forms of needlework: "We found ourselves thinking, as feminists, that instead of shutting the door on these skills, perhaps we should be celebrating them." In 1997, the magazine started a new column entitled She's Crafty, featuring DIY projects with a dash of confrontational humor (tips on making a box for sex toys, or a punning cross-stitch sampler reading, BABIES SUCK). The column also gave advice on starting an income-generating craft business, encouraging the reader to "create life on your own terms."[72]

By the early years of the new millennium, multiple platforms were springing up around the country to help the new generation of "crafters" realize this goal of self-actualization. Some were oriented to community building, such as the Church of Craft, founded in 2000 in New York City—a secular organization, despite its name, devoted to bringing "the blinding love of craft to all who seek it."[73] Others were more commercial, like the Renegade Craft Fair, founded in Chicago in 2003, or the online seller Etsy, which launched in 2005. These organizations positioned themselves to provide empowerment through entrepreneurship. Predictably, though, with success came controversy. In 2015, a seller named Grace Dobush closed her Etsy account and published a widely circulated description of what she perceived to be the company's hypocrisies. Mass-produced items with a cheap and cheerful hand-made look had flooded the site, and Etsy did nothing to prevent it. A website called Regretsy was formed to call out the ersatz producers, but to no avail. To compete, Dobush claimed, makers were lowering their prices to unsustainable levels, eroding the possibility of real income generation. The only people making money were sweatshop factory owners and Etsy's own shareholders—in 2013, the site processed $1.35 billion in sales, earning some $47 million in transaction fees. The sheer scale of this supposedly grassroots marketplace was having a deadening, homogenizing effect on the DIY scene. Even the Renegade Craft Fair, supposedly a redoubt of the independent creative soul, was getting to look like Etsy's homepage. "It's so incredibly boring," Dobush wrote. "How many pieces of geometric jewelry with a pop of color can the earth bear?"[74]

Even before the emergency of Etsy, Stoller was expanding her own brand under the catchphrase Stitch 'n Bitch, a name she borrowed from a knitting circle she'd helped to found in Brooklyn. She published a series of upbeat pattern books, updating this traditional form to serve the DIY "crafter" subculture. The first of these, published back in 2003, had included many innocuous projects (woolly mittens, a cat bed) but

Callie Janoff, co-founder of the Church of Craft. Courtesy of Callie Janoff.

also some with a bit more snarl to them, like a sweater with a motif of oversize skulls. One pattern, entitled the "Official Kittyville Hat" (contributed by a Philadelphia knitter named Kitty Schmidt), happens to bear a remarkable resemblance to the later apotheosis of craftivism, the pink Pussyhat that became an emblem of protest against the Trump administration in early 2017. Created by the Los Angeles–based activists Krista Suh and Jayna Zweiman and released into the wilds of the internet for anyone to make for themselves, the Pussyhat was an ingenious riposte to the Trump campaign's red MAKE AMERICA GREAT AGAIN baseball cap. The two hats captured the moment perfectly: for the left wing, handmade ironic identity politics; for the right, mass-produced jingoism.

Prior to the Pussyhat, one might have argued that craftivism was ill-conceived from the start. If the AIDS Quilt was too submissive for many activists, tank cozies and protest blankets are even less likely to trouble the powers that be. Yet, at the Women's March of January 2017, the sight of hundreds of thousands of the hats was an impressive statement of solidarity—all the more so because they were *not*

identical, having been handmade in homes across America. Craftivism does flirt knowingly with triviality. But it has also been animated by a key strength. Making something by hand requires personal investment of a kind that mass production and digital communication simply do not. This remains true even in an era of pervasive social mediation. Craft has an irreducible connection to human time, effort, and skill. For that reason alone, it will always retain political potential. It will never be fully displaced.

~

Or will it? In the first years of the new millennium, technologists began to wonder. As Americans were plunging headfirst into the shallows of their screens, another frontier was already edging into sight: the prospect of digitally powered home manufacturing. Futurists believed that this was something the average person would be able to do, and soon. With just a basic kit of tools—most important, a 3D printer— every household would become a factory. The implications were staggering. The economy would be reshaped in a way that Karl Marx and William Morris could not have predicted. Consumers would now own the means of production.

In fact, they would no longer be consumers at all. Instead of buying things, people would make them, then recycle them into new things as needed. Mass customization would be the order of the day, everyone realizing their own distinctively individuated products, leading to a much more varied environment. Society would enjoy the benefits of bespoke craft without the expense. History itself would come full circle, as the family would again become the unit of production just as it had been in the eighteenth century. Virtual guilds would form, pooling knowledge and designs.[75] And the most exciting part was that the tools were already out there, being used as rapid-prototyping machines in industrial contexts. Once these means of production reached a mass market, as seemed inevitable, a brave new world would dawn.

These were the utopian principles behind the maker movement, which developed simultaneously with craftivism and was in many respects its natural counterpart. There was a strong gender divide between the two: If craftivism drew on feminist precedent, then the maker movement inherited the "toys for boys" legacy of *Popular Mechanics* and hot-rodding and the ideas promoted by Stewart Brand in the *Whole Earth Catalog*. But craftivism and the maker movement also shared a great deal. Both were democratizing impulses that positioned individual making as a liberating force

and a way to displace mass consumption. And both embraced the analog and the digital alike, seeing the two not just as compatible, but mutually empowering.

The first prominent spokesman for the maker movement was an MIT professor named Neil Gershenfeld, a gifted writer and speaker who could make esoteric technical matters seem downright approachable. His working premise was that data and matter were becoming interchangeable. In 2001, he created a research group called the Center for Bits and Atoms, whose centerpiece was a course called How to Make (Almost) Anything. This class became the basis for the first Fab Labs (*fab* being short for *fabrication*, though Gershenfeld obviously didn't mind the implication of fabulousness). In 2003, he established an international pilot program of Fab Labs, choosing locations that might benefit from access to manufacturing capabilities: a low-income neighborhood in Boston; communities in rural India, Costa Rica, and Ghana; and a Sami settlement in Norway. Each facility was outfitted with a laser

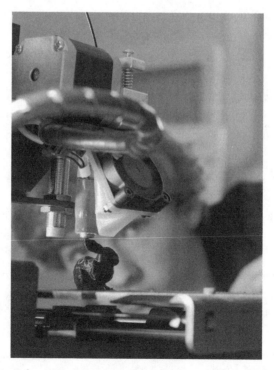

A Fab Lab in Cely-en-Biere, France, 2014. Andia, Universal Images Group/Getty Images.

cutter, a milling machine, and a 3D printer, as well as other tools and associated software, at a cost of about twenty thousand dollars each. It was an ingenious way of rolling out the model, reversing the usual flow of globalism by situating cutting-edge technology in undercapitalized locations.

This was consistent with another of Gershenfeld's working hypotheses, that it was the geographical periphery that would most benefit from digital manufacturing. What might only be a novelty in America could transform lives elsewhere. Perhaps this was even a solution to the problem of globalized labor, a variable that would resolve the terrible ethical dilemmas pondered by the likes of Paul Krugman. With a Fab Lab, people could control their own economic destiny. Gershenfeld was delighted when a group of textile workers in India asked to scan and print the printing blocks they used for *chikan*, a local embroidery technique—just the kind of unpredictable application that an outsider might never have considered. He did recognize that at the time it was impossible to make Fab Labs economical, but he felt confident that costs would decline, computing power would increase, and people worldwide would begin to see the benefits.[76]

What has actually happened is somewhat less exciting, though still pretty remarkable. The maker movement did not jump the rails of income inequality; nor was it a disruption of business-as-usual consumerism. MIT-sponsored Fab Labs and other maker spaces did proliferate. Universities embraced the model, as did some city libraries, hoping this might help offset an anticipated decline in conventional book circulation. The up-by-your-own-bootstraps mentality of the maker movement has remained intact, with much enthusiasm for "hacking" this and that. Maker Faires, sponsored by *Make* magazine beginning in 2006—the spelling is a deferential nod to ye olde artisanry—hybrids of hobby gatherings and trade fairs, are intermittent hives of activity. The U.S. government got fleetingly interested under President Obama. His administration hosted a Maker Faire on the White House grounds in 2014 and declared a National Week of Making in 2016.

But for the most part, the take-up of digital fabrication was in existing production sites, for which it was not a form of radical empowerment, but an extension of the existing tool kit. Subtractive techniques, including computer-controlled cutting machines and 3D printing, have become nearly universal as prototyping tools, used in architecture, medicine, and design. (Wendell Castle, the leading studio furniture maker of the 1960s, got himself a robotic carving arm when he was in his eighties

and did extraordinary things with it.) The forces that embraced digital manufacturing were primarily commercial. As digital tooling improved, becoming both more user-friendly and more powerful in its capabilities, companies such as TechShop and Autodesk sought to capitalize by opening hubs for public use on a fee-paying basis. Other companies such as Othr and Shapeways have experimented with various business models for selling 3D-printed products, operating on the assumption that manufacturing would still be done by manufacturers, not citizens.

And there the matter rests, at least so far. Gershenfeld conceded in 2012 that the rush to 3D printing had been a "curious sort of revolution, proclaimed more by its observers than its practitioners."[77] Criticisms have also been leveled at the maker movement by feminists, notably Debbie Chachra, who characterized it as just another bastion of white male privilege: "Making is not a rebel movement, scrappy individuals going up against the system. While the shift might be from the corporate to the individual (supported, mind, by a different set of companies selling a different set of things), it mostly re-inscribes familiar values, in slightly different form."[78] There is also the all-important question of sustainability. While the idea that digital manufacturing would reduce waste and transportation costs was heavily promoted, so far it has just put more stuff into an over-full world.

If neither craftivism nor the maker movement fully attained its advocates' ambitions, perhaps the ambitions were simply too high. Both attempted an end-run around long-standing problems with craft: for the one, cultural stereotypes associated with amateurism; for the other, economic inefficiency. Those intractable issues were never likely to be solved in the space of a generation. But the very attempt to subvert them, to rewrite the rules, was of value, as was the realization that handwork could play an important role beyond that of sheer contrarianism. Without craftivism's overt politicization of making, or the technological expansiveness of the maker movement, the situation for American craft today would be far less auspicious. What it promises the nation is nothing less than redemption—though doubtless that promise will be hard to keep.

Chapter 9

Can Craft Save America?

I T WAS JULY 2018, AND AMERICA'S first-ever master's degree program in craft studies was having its inaugural session. Run by guest instructor Lisa Jarrett, the discussion was part brainstorm, part soul search. She simply asked the group to start posing questions, whatever came to mind, and to keep going until they had reached one hundred. Jarrett would write each question down as it was offered.[1]

By the time they were done, the class had pondered fundamentals: *What is craft? What is history?* They talked about scope: *Is there bad craft? Where do hobbies fit in?* They raised political issues: *Does every problem have an American solution? What gives us the right to talk about things we haven't experienced?* They wondered about their own roles: *What does it mean to be an ally? What makes us think anyone can be an authority?* All good questions. But when I arrived a few days later to teach on the course, and saw the list hanging on the wall, written out by hand on a long taped-together scroll, one in particular, number fifty-four, rang out like a bell: *Can craft save America?*

This seemed to me a remarkable thing to ask, partly because it took for granted that America needed saving—from what, or whom, I wondered?—but also because the question had been asked so many times before, though not quite so explicitly. Over the course of American history, craft has often been seen as a means of salvation. During the revolution, artisan identity was bound up with the cause against tyranny. In the nineteenth century, even as the myth of the self-made man emerged

as a national ideology, craft was taken up as a shield for the oppressed, a tool of educational uplift for African Americans, and of social reform more generally. The Arts and Crafts movement treated craft as a protective mantle, a bulwark against industrialism, while Progressives understood it in more proactive terms, as a means of assimilating immigrants. In the 1920s and '30s, revivalists imagined craft as a pathway back to an earlier, more authentic America. After World War II, it was invoked yet again, this time as an alternative to dispiriting conformity. That instinct initially motivated attempts to partner with industry, then flourished into an artistic avant-garde. Countercultural communes sprouted up across America, each one an expression of the idea that things could be wholly otherwise. With equal purpose, civil rights activists, Native American leaders, and feminists laid claim to craft traditions, intertwining the rhythms of making with the long march toward freedom and equality.

By the 1980s, craft's radical edge seemed to have dulled, as if blunted from overuse. Its most conspicuous role was as a commercial proposition. But then, as the millennium turned, craftivism and the maker movement began to invest craft once again with a sense of possibility. What will it become next, and who will decide? Clearly, there won't be just one answer to this question. Craft's role in America has always been multiple, with profound differences in perspective between communities of makers. Yet, at a time of unusually fierce political conflict, it does seem possible that craft might once again do its part to "save America." The same qualities that have often made it divisive—its connection to livelihood, pride, and everyday experience—may help us to cross ideological boundaries that otherwise seem impregnable. Craft may regain its place at the nation's center rather than out on the warring flanks. It may even liberate itself from the racism, xenophobia, and sexism that have formed such a tragic part of its story in America.

All this may sound like unwarranted optimism and certainly, American craft has had its share of disappointed utopians. Yet there are some good reasons to think that a unifying moment may at last be arriving. There is increasing awareness that craft is a shared undertaking, a single story in which Americans of many backgrounds play a part. I've written this book with that principle in view. I have tried to emphasize the pervasiveness of craft, how many lives it has touched, how important it has been to America's idea of itself. But there is always a second reason to write history: to use it to think through current concerns. As Frederick Douglass put it, "We have

to do with the past only as we can make it useful to the present and to the future."[2] So, let's take one more walk through America's craft experience, this time with an eye toward the present day.

~

We can begin with the striking parallels that exist between the current craft economy and the one that prevailed in the Colonial era. In the seventeenth and eighteenth centuries, craft was not a social cause, freighted with oppositional status. It was a way of getting things done, and those who could do the doing were accorded respect commensurate with their abilities. Across the great diversity of Native peoples, craft existed within a sophisticated repertoire of self-sufficiency. Among the colonizing population, the artisan class was a main pillar of society, and none disputed that. With the onset of mass production, however, this stable structure began to crack. By the post–Civil War years it was tottering, and in the twentieth century it fell apart almost completely. Craft never disappeared; it still had an important presence in amateur hobbies, in safeguarded ethnic traditions (Native, African American, and otherwise), in fine art practice, in bespoke luxury trades, and in many other contexts. Relative to its preindustrial condition, though, it was decisively marginalized, so much so that its cultural potency often resided in claims to outsider status.

Now things are coming full circle. Native groups are successfully raising awareness about the damaging effects of stereotype and appropriation, while practicing craft in the context of economic and cultural sovereignty. More broadly, there is a quiet revolution in the way craftspeople are working, which has resulted in a proliferation of small shops across America. As with the rural artisans of the Colonial era, these enterprises rely on specialist skills while retaining high flexibility. Consumables such as cheese, bread, whiskey, and beer; engineered products like bicycles and lighting; home goods like clothing, textiles, and tableware: Entrepreneurial makers in all these arenas and many more are finding success.[3] Regions with especially strong craft traditions, like Appalachia and the Southwest, depend on these legacies for their economic growth. Some makers cleave to tradition, while others create more experimental work—everyone can learn from one another. I live in New York City, and among my closest friends are a weaver, a costume designer for the theater, several furniture designers and ceramists, a graphic designer/cocktail guru, and a maker of hyper-detailed props for store window displays. All of them are self-employed. None

would say it is easy, but they are all extremely good at what they do, and there is solid demand for their work.

How have these craftspeople, and others like them, managed to carve out space for themselves? For many of them, the answer is technology. The central insight of the maker movement, that analog craft pairs effectively with digital tools, has proved to be absolutely correct—but not necessarily in the ways its proponents first envisioned. The really transformative effects have not been in the arena of micromanufacturing, a 3D printer in every home. Rather, the impact has come from distribution networks, which fling information, equipment, and products around at incredible speed. Aspiring makers now learn skills by watching videos online. The "access to tools" promised by the *Whole Earth Catalog* has, fifty years on, become a universal reality, almost taken for granted. No matter how esoteric the equipment one might need, it can be delivered to the doorstep within a few days. Social media has vastly accelerated maker-to-maker networking, performing the same service for an increasingly diverse community that conferences and magazines did in the postwar decades. As Sarah Marriage, a founder of the Baltimore feminist woodworking center A Workshop of Our Own, observes, "Now a woman who is the only woman on her job site can meet other women who are also the only women on their job sites."

Even more important, the cost of direct marketing has plummeted. Some makers are able to maintain full-time businesses while selling exclusively through digital platforms—no advertising expense, no intermediary venue taking a cut. On the customer's side, bespoke products can be purchased at a distance, broadening the potential client base. It becomes possible to order a custom dining set from a furniture maker hundreds of miles away. If you want a pair of handmade shoes, it's still best to have your feet measured by hand, but some cobblers are willing to work on the basis of a scanned outline of each foot, a few measurements, and a video taken with a smartphone. Admittedly, these services are expensive for buyers, and for makers, careful management of scale is essential for survival. The mass-production factory and the craft studio have problems that mirror each other. The former achieves efficiency at the cost of quality; the latter, the reverse. But in the middle ground, it is possible to achieve a finely tuned balance.

I often wear jeans manufactured by a company called Raleigh Denim Workshop, founded in 2007 by Victor Lytvinenko and Sarah Yarborough. Raleigh, North Carolina, was historically a center for garment production, but most of the local factories closed in the wave of deindustrialization that swept the southern textile industry in the late

twentieth century. The region still has a great many skilled artisans seeking work, and specialist sewing machines and other equipment lying idle. Lytvinenko and Yarborough exploited these local resources in the creation of their own company, which now produces denim for sale through their outlet and retailers nationwide. Everything about Raleigh Denim is oriented to finding a "sweet spot" in terms of scale. It has only one workspace, but it is big enough to accommodate thirty or so employees. Staff are paid on salary rather than on a piecework basis, to encourage them to maintain high quality. The firm purchases raw materials (most important, fabrics from nearby mills) in amounts large enough to be affordable but small enough that the company can be involved in specifying and checking the quality of each order.[4]

Enterprises like this can be found in cities nationwide. Another example, in Manhattan, is a company called Let There Be Neon, which has been active for forty years as a producer of signage for shops, bars, hotels, nightclubs, and anyone else who comes calling. Because of the nature of this work—most orders are for only one sign—it has always made sense to structure the shop in an artisanal manner.

Raleigh Denim workshop, Raleigh, North Carolina. Courtesy of Victor Lytvinenko and Raleigh Denim Workshop + Curatory.

The business has certainly changed over the years—design and communication with clients is now done mainly digitally, for example—but glass bending is still done in the same way it has been for generations. The owner of the company, Jeff Friedman, says that they face an unusual challenge in that most people do not even realize that neon signs are handmade products. Clients sometimes "don't understand why I can't go downstairs and pull their custom logo in a custom color in the exact size that they want off of a shelf in a day or two. And I think that's a direct result of our instantaneous society."

As any of these craft entrepreneurs will tell you, the economic realities of craft are still very much in place. Raleigh Denim won't be competing with Levi's anytime soon. Many of America's new artisan businesses—the craft breweries and tattoo parlors that seem to be everywhere nowadays—are boutique concerns, located in gentrified neighborhoods. It's easy to stick some gold lettering up on a storefront and hang some Edison lightbulbs from the ceiling; far more difficult to build a genuinely creative space. Equally, contemporary artisans are still extremely vulnerable to economic cycles. Digital sales platforms do not offer the sheltering protection that large employers do; artisans must work within the unpredictable environment of the so-called gig economy, enjoying a high level of autonomy but a high level of risk as well. In this sense, the new craft economy is fragile. But of course, that was true in the eighteenth century, too. America's early colonists didn't have our term *precariat*, but they would readily have grasped the principle.

~

Here we arrive at one of the cautionary lessons that American craft history has to offer. It is great to see artisans flourishing again, but it is dismaying to see the myth of the "self-made man"—formulated so effectively by Benjamin Franklin, then popularized throughout the nineteenth century—returning in force. Matthew Crawford's widely read book *Shop Class as Soulcraft* and, more recently, Eric Gorges's *A Craftsman's Legacy* are among the titles that have put this rhetoric back into circulation. Both Crawford and Gorges repair motorcycles, a classic emblem of American freedom, and both see themselves as "gearheads" who have escaped dehumanizing white-collar experience. In a garage, Crawford says, "one feels like a man, not like a cog in a machine," while Gorges writes that "the craftsman 'battles' for perfection. I use that word consciously because it *is* a battle; it's a messy and valiant struggle that each one of us is bound to lose . . . To win the war you have to accept loss in the

battle."⁵ Such macho swagger ignores the broader context that craftspeople actually need in order to thrive—for starters, the executives, marketers, and other paper pushers at Harley-Davidson and other companies without whom motorcycle repair shops would have nothing to repair. If we're not careful, we might find ourselves back under Longfellow's spreading chestnut tree, proclaiming the freedom of new-model village blacksmiths when we should instead be seeing craft as a great connector.

The sort of unfettered individualism that Crawford and Gorges espouse has always been an unacknowledged expression of privilege. Frederick Douglass certainly made effective use of the "self-made man" ideal, but he was also well aware that systemic injustice could not be solved by personal commitment alone. Unfortunately, though, collective action has never been a real strength of American craft. The labor union movement has been (and remains) the best way for the skilled to join in solidarity, but it has long been disconnected from other forms of craft, while suffering from its own problems of racism, nativism, and sexism. These were ultimately self-defeating instincts, excluding African Americans, immigrants, and women who would have been valuable participants.

It doesn't need to stay this way. Craft has the potential to bring together people from all backgrounds, with the workshop as common ground. This is exactly what is happening, here and there, in America. Tellingly, areas ravaged by postindustrial decline are the most fertile ground, as inexpensive real estate, well stocked with suitable workshop space, is being reoccupied by makers. The Kensington and Fishtown neighborhoods of Philadelphia (a century ago, the most productive textile districts in the country) are seeing a revival of making, with old factories transformed into multipurpose artisanal ateliers like the Globe Dye Works and MaKen Studios.⁶ Similarly, Detroit is transforming itself into one of America's most creative and exciting places. According to the Urban Manufacturing Alliance, which has studied small-batch production in a number of American cities, the manufacturing sector employs the second-highest number of people in Detroit (the first is health care) and, on average, is the best paid. Machine shops, audio equipment manufacturers, leather apparel makers, and artists' studios have all breathed life into the city's neighborhoods. Research also indicates that one of small businesses' biggest problems is finding qualified new employees. Even in Detroit, with its rich heritage of manufacturing, demand for skilled artisans actually outstrips supply.

The workshop of the Detroit designer Chris Schanck demonstrates the possibilities. After graduating from nearby Cranbrook Academy, he set up a studio in his own home, located in Banglatown, a Detroit neighborhood nicknamed for its large Bangladeshi immigrant population. In the rooms of his little house, he began making unusual furniture, built from salvaged scrap parts layered with foam, metallic foil, and resin—cheap materials elevated to spectacular effect. "I always left the door open," he remarks, "and people would wander in. Sometimes they stayed." Casual contributions from passersby eventually turned into full-on collaboration, with local Bangladeshi women, upholsterers, and welders with experience in the auto industry, and art students all taking part. The tasks are divided, as in a nineteenth-century workshop, but there is also high internal morale and contributions from everyone involved. Eventually Schanck became successful enough to buy a vacant tool-and-die facility and turn it into a functioning workshop. The furniture that he and his team make there is expensive, sold through galleries and direct commissions. His particular route to success would be hard to replicate. Still, he has proved that a business model first developed during the Arts and Crafts movement can still be effective in the twenty-first century: high-end craft not for its own sake, but as a means of support for a whole community.

Detroit, as it happens, is also a center for a far less admirable contemporary phenomenon: craftwashing. This term is adapted from the earlier neologism, *green-washing*, in which a company presents itself as ecologically minded without really committing to sustainability. In craftwashing, similarly, a company uses artisanal imagery in its advertising while continuing to use mass production or even sweat-shop techniques. The company Shinola, which sells watches, bicycles, and other products, has effectively built a brand as a scrappy, self-starting Motor City manu-facturer. In 2016, however, the Federal Trade Commission directed it to cease using the slogan "Where American is made" in its watch advertisements, and to include more honest language: "Built in Detroit using Swiss and imported parts."[7]

More mainstream companies also use the rhetoric of craft in slippery ways. A 2011 television commercial, run by Jeep for its new Grand Cherokee, consists mainly of archival film showing artisans at work. Over this montage, a male voice intones, "This has always been a nation of builders, craftsmen. Men and women for

whom straight stitches and clean welds were matters of personal pride. They made the skyscrapers and the cotton gins. Colt revolvers, Jeep four-by-fours—these things make us who we are. As a people, we do well when we make good things, and not so well when we don't." The ad culminates in glamour shots of the new Jeep, described in voiceover as "carved, stamped, hewn, and forged here in America." It is a fascinating compound of pro-craft sentiment, outright deception (not much "hewing" goes into a mini-SUV), and flag-waving nationalism, with clear precedents in the distortion field generated by entrepreneurs like Elbert Hubbard and Wallace Nutting in the early twentieth century. Craft has an inherent honesty about it; a well-made object serves as its own testimony, proof of its maker's skill. But that quality of authenticity is easily exploited. Starbucks advertises "handcrafted tea beverages," and McDonald's describes its Big Macs as "handcrafted for that one-of-a-kind taste."[8] In New York, I once saw a banner advertising "handmade condominiums."

The problem of craftwashing is unlikely to go away anytime soon; to the extent that artisans command respect, others will try to take advantage of that cachet, confirming the significance of craft culture in the very act of exploiting it. Recognizing this phenomenon is an important first step, and again, online tools can be a help. One of the oldest factories operated by the manufacturing company John Deere is in Ottumwa, Iowa, not far from the Amana colonies. Hay balers, wind rowers, and mowers are manufactured in the 1.2-million-square-foot facility. A promotional video about the Ottumwa Works proclaims that "through these doors pass the most passionate, highly skilled craftsmen, dedicated to building a legacy." A series of technicians face the camera, each declaring, "I build it, I use it." The pretense is that these John Deere workers are also farmers, a self-conscious echo of the rural yeoman economy of bygone days.

Yet a different story is told by comments left on Glassdoor, a website that gives employees a chance to report on their own workplace experiences. If Glassdoor is useful to prospective hires considering a job, it is an absolute gold mine for researchers, achieving something comparable to Studs Terkel's classic book *Working*. Like any unverified online source, it should be taken circumspectly; but you sure do wonder about the Ottumwa plant when a worker there writes, "John Deere only cares about its salaried employees and not about the people actually making the tractors . . . Also more and more injuries are happening because people are complacent and tired from being worked so hard." Another commentator offers some "Advice to Management: Treat your shop workers like they mean something and

quit being so greedy."[9] A recent spate of union activism at the Ottumwa plant echoes late nineteenth-century conflicts between labor and management, complete with support for an actual socialist for the Iowa governorship in 2018 (though she didn't win).[10] The point is not to single out John Deere for hypocrisy, but rather, to recognize that we have ever better tools for paying attention, to push for transparency and accountability wherever possible.

Speaking of attention, craft has also come into recent focus as a way of slowing down and connecting more to the world around us. (I've been part of that conversation, as this was the topic of my last book.)[11] The shift in economic value from products to services to experiences that began to pick up speed in the 1980s has been hugely accelerated by information technology. This might be considered a good thing—a way to maintain the economic growth that capitalism requires without burdening the earth with more and more physical things. It can also be seen as a crisis in which a device-saturated population is driving itself to perpetual distraction. In the fall of 2019, Microsoft announced the launch of *Minecraft Earth*, an augmented reality version of the world-building video game *Minecraft* (which is played by more than one hundred million people per month worldwide). The interface allows users to build objects that seem to inhabit real-world space. Now a player can make a virtual barrel, via the screen of a smartphone, and then watch it roll down the street and out of sight. How many more barrels were made last year by Minecrafters than by actual coopers, who have no magic buttons to push and must instead train for long years to learn their subtle art? Even as such interactive technology continues to advance, it is hard to picture it maturing into a viable social infrastructure. Indeed, the image of a citizenry out in some leafy park pointing their phones into thin air, fiddling with illusions only they can see, is the perfect metaphor for disconnection.

By centering craft in the frame, we get a very different picture. Whether as an occasional "digital detox" or, more ambitiously, as an antidote to the lack of human connection that enables our era's knee-jerk politics, making things by hand offers an alternative pathway. This puts a new spin on the project of craft reform. It also reflects the inheritance that has come down to us from the Arts and Crafts movement, the counterculture of the 1960s, and even the scouting movement of the early twentieth century. A core principle of all those campaigns—that the process is more important than the product—has once again been embraced as a means of renewal. The instinct might express itself simply in attending an evening pottery class, or

tuning in to a reality television show such as *Blown Away*, which features heated competition among skilled glassblowers.

For those more serious about "reconnecting with traditional living," there are the weeklong Buckeye Gatherings, held in Northern California since 2010. Attendees learn crafts such as basketry, blacksmithing, and wood carving, sometimes working with handmade stone tools, getting a taste of self-sufficient living without risk. "What we offer has not always been known as Primitive Technology, Ancestral Arts, Wilderness Survival, or Earth Living Skills," the organization notes. "At one time it was simply *life*." The first Buckeye Gathering was held at Ya-Ka-Ama (literally, "Our Land"), administered by the Kashaya Pomo nation, and many of the skills taught there are drawn from Native American cultures—another echo of the Scouts and the hippies, who both held indigenous people in high regard.

As sustainability has become an increasingly pressing concern, this respect accorded to traditional lifeways has acquired additional urgency. As a society, we badly need to change our relationship to the environment, and Native people are often taken as paragons of balance with nature. Localism is clearly part of the answer. We can make at least some of our products in the same way that people are starting to grow their food, cooperatively, within tight, geographically specific networks. As Tim Jackson writes in his study *Prosperity Without Growth*, we collectively need to develop "low-carbon economic activities that employ people in ways that contribute meaningfully to human flourishing." Craft workshops serving nearby customers are an important part of this picture, but they are by no means capable of averting climate change on their own. The problem is, again, one of scale; Jackson says that local enterprises may amount to "a kind of Cinderella economy that sits neglected at the margins of consumer society."[12]

If it is difficult for artisans to compete with mass production economically, it is even harder for them to compete ecologically. The carbon footprint of a dish made in a potter's studio in Vermont may well be much higher than that of a dish made in a large factory in China, because the factory is typically far more efficient with respect to material sourcing, energy consumption, and distribution. It's true that, because a well-made thing is more likely to be valued by its owner, it is also more apt to be kept than discarded—a point often made in defense of luxury trades. Unfortunately, in the grand scheme of things, this consideration is marginal. Industry is steadily destroying the planet, and only industrial economies of scale can deliver real solutions.

A speculative project by the designer Kelly Cobb called the 100-Mile Suit, completed in 2007, dramatized just how daunting this problem really is. Cobb tried to create a man's outfit from scratch using only materials and skills available in the Philadelphia area. The project ultimately involved the contributions of more than twenty makers, who spun wool and wove it into cloth, carved buttons from wood and bone, tanned leather for a belt and shoe uppers, and even knitted socks and underwear. The whole ensemble took about five hundred hours of work in total and was ultimately, by Cobb's estimate, about 92 percent local (the exceptions included thread cores and rubber shoe soles). "If we worked on it for a year and a half," she said, "I think we could have eliminated that 8 percent."[13]

As impressive as the 100-Mile Suit was, it was also a proof of its own impracticality. Even if every artisan who participated had made only minimum wage, the outfit's direct production costs would have approached four thousand dollars—hardly a viable business model. Yet there is another way of looking at Cobb's project. It could be seen as a calculation of the "real" value of a suit—what it would cost if our unsustainable global exchange networks no longer existed. What's interesting about this is not that it establishes a new way of clothing America—that we should all start carving our own buttons, or wearing hand-knitted undies. Rather, it draws attention to the complex displacement of knowledge and materials that everyday fast fashion involves. The depth of research that Cobb and her team undertook has a rhetorical power, derived from its fusion of pragmatism and idealism—the signature combination of modern craft.

Questions about fast fashion have become all the more acute in the wake of the Rana Plaza disaster in 2013, in which an eight-story garment factory in Bangladesh collapsed, killing 1,134 people and injuring about 2,500 more—a tragic echo of the Triangle Shirtwaist Factory Fire a century earlier.[14] The ethical conscience that drove Progressives back then, which also animated Aileen Osborn Webb's founding of the World Crafts Council in 1964, deserves a place in the calculus as we weigh the costs and benefits of the globalized economy. The same goes for the pressing issue of the climate crisis, which is ultimately a test of wisdom and will: whether governments and corporations, pressured by citizens, will decide to take action. In this context, craft's long-established fusion of practicality and symbolism is a tremendous asset. Climate activists often say that we should "trust the science," and they are right. But for many people, it may be easier to trust a craftsperson. Making something by hand involves a tightening of focus, a close attention paid to objects. It can

heighten awareness of the environment and the systems that produce it. This precept motivated Arts and Crafts reformers and the "designer-craftsman" proponents of the postwar years, and it is still valid today. If craft does have a role to play in the struggle against climate change, this is it: not as a way of literally remaking the world, but as a means of encouraging material concern and responsibility.

Just as this book was going to press, this inherent potential of craft acquired new urgency, as the COVID-19 crisis disrupted lives and the economy. In this over-whelmingly dark hour, craft was one of the few bright spots. The Center for Disease Control called for all Americans to wear face masks, while saying nothing about where those masks would come from; supplies for medical professionals were already running dangerously low. So people would have to make their own, however they could. It was the first time in living memory that the government had effec-tively said to its citizens: Get crafting.

As if on cue, helpful tips began proliferating online: the simplest of sewing patterns, which even a novice could master; recommendations on fabric selection (pillowcases and flannel pyjamas seem to work well); advice on proper fit (all the way over the nose and mouth and under the chin). Social media was filled with people wearing their own handmade masks, often in showy patterns, images that bespeak anxiety and pride in equal measure. This was just one way that a nation on lockdown began turning to craft, as if by ancient instinct. It was an important part of improvised homeschooling methods (the cartoonist Emily Flake, in the *New Yorker*, imagined the perfect parents: "And *that's* how we re-create the Bronx Zoo out of cardboard!"), and for those who suddenly had a lot of unstructured time, a way of measuring out the hours and fending off cabin fever. Knitting, crochet, quilting, jewelry-making: these and other activities helped America get through the crisis, quietly and behind closed doors.

These developments uncannily echoed the role that craft had played in previous national traumas: knitting for soldiers in the Civil War, building DIY bomb shelters in the wake of World War II. The slogan of the *Whole Earth Catalog*, "access to tools," also seemed newly relevant. Fab Labs that had previously been used primarily for educational purposes suddenly became emergency supply depots. In the Bay Area, a man named Danny Beesley threw himself into organizing the distributed manufacture of PPE (personal protective equipment) for frontline workers and health professionals. He helped orchestrate the making of (at the time of this writing) over 15,000 cloth face masks, 150,000 face shields, and 700 isolation gowns,

among numerous other items. The masks were made using laser cutters, working with unused T-shirts from a canceled marathon; the face shields from sheet plastic donated by Coca-Cola, in dispersed teams of four workers. In this case, decentralization was not an economic disadvantage but a matter of life and death, as social distancing was so vitally important. Beesley worked hand in glove with local medical staff, so that preapproved designs could be delivered in bulk, right to hospital doorsteps. He says that he drew one overwhelming lesson from the experience: America's lack of preparedness in the face of the pandemic was a symptom of an even larger malady: "this country's inability to produce what it consumes."

Stephanie Syjuco, a Bay Area–based artist who made hundreds of protective masks by hand in her studio during the coronavirus crisis, expressed a related concern, noting how much emergency mask-making was done on a volunteer basis, largely by women. Within this network, the image of Rosie the Riveter once again came into wide circulation, along with the encouraging slogan "We Can Do It!" But as Syjuco pointed out, Naomi Parker—the original model for Rosie—was at least paid for her vital war service. "I am absolutely not saying that everyone should stop making things free or accessible to others during a global pandemic," Syjuco said. "Far from it: We should be mustering as much as possible to create support systems and networks when our own government is failing us. But we should not be celebrating this work at the expense of critical engagement with the very political structure that put us in this position to begin with."

There are indeed lessons here that we should all hold on to. Pre-pandemic, all America's conversations with itself seemed to be about divisiveness and conflict. During the crisis, however, many expressed the hope that the shared, harrowing experience of the coronavirus might help the nation to rediscover a sense of unity. Maybe we would find a silver lining: a better balance between what we produce and what we consume; less reliance on environmentally unsustainable commodity chains; the capability to grow and make more of what we need in our own communities.

These objectives point to craft's ongoing significance in American life.

～

Americans are shielded from (some would say blinded to) the worst effects of climate change by virtue of our wealth and geography. Even so, the problem confronts us all. This fact—our collective responsibility to care for our environment—points to the very core of craft's significance: Throughout the nation's history, it has stood right at

the junction between individual and community. Individualism is one of the most powerful currents in American thought, an inheritance passed down from generations of courageous immigrants, frontier settlers, and inventive entrepreneurs. Craft has frequently been positioned as a quintessential expression of this spirit of independence. We see that dynamic at work in Paul Revere's silver shop, in the seamstress Elizabeth Keckley's journey to the White House, in the critic Rose Slivka's praise for the artist-craftsman. Yet, just as often, craft has been understood as the fabric of communal memory, a wellspring of tradition that each generation can draw from. At its most compelling, craft marks the intersection of these two principles. Think of the many extraordinary objects that sit at the crossroads between the individual and the group: the pots of Nampeyo, and Julian and Maria Martinez; the banners sewn by Alice Paul on behalf of American women; the religious wood carvings of Patrociño Barela; the cabinetry that Gentaro Kenneth Hikogawa managed to cobble together from scrap and scrub while interned in a relocation camp. Craftworks like these—and there are more of them in American history than could be counted—are proof of the feminist rallying cry "The personal is political." That equation is straightforward enough, but each maker must solve it in his or her own way.

The way that craft articulates the relationship between the individual and the community is always shifting, because conceptions of personal and group identity are themselves ever on the move. Today, no less than at the time of the American Revolution, the Civil War, or the civil rights movement, these are vigorously contested issues. In one worldview, rigid definitions hold sway: People are native or foreign, male or female, Black or white, straight or gay; we need to establish clear borderlines and police them vigorously; and if we lose those fixed anchors, we'll be adrift in storm-tossed cultural seas. A contrary view holds that identity is fluid and intersectional, composed of many flexible parts; that gender and ethnicity are not binaries, or even spectrums, but rather, wide-open territories to explore; and that borders are not essential protections, but barriers to mutual understanding. In this headlong confrontation of perspectives, it can feel like there is no common ground. Yet craft is equally congenial to both. Wherever you go in America, country or city, north or south, red state or blue, you will find makers, and communities of support around them. There is tremendous potential in this universality. Craft can be a way to bind together people who talk past one another. It is an invitation to mutual respect.

In 2015, to mark the 150th anniversary of the end of the Civil War, the artist Sonya Clark created a beautiful metaphor for what it means to stand together,

face-to-face with American history. The work, entitled *Unraveling*, could not be simpler, or more resonant. Clark hung a commercially made Confederate battle flag from a gallery wall and invited members of the public to help her unpick it, thread by thread. Since that first performance, she has restaged it several times. Unraveling a textile with one's fingers is hard work, and those who choose to participate are often surprised at how hard it is to unmake. So, Clark is offering a little lesson in the materiality of cloth, which explicitly symbolizes the difficulty of getting past racism in America. She is also echoing the experience of a quilting bee and, as with that communal experience of handwork, making an occasion for solidarity. For an African American woman like Clark to undertake this act, even in the comparative safety of an art museum, does feel like a risk. Yet the audacity of the work is not just physical. It is also emotional for all concerned. "What's curious to me is that someone will say I'm being courageous," Clark says, "And I tell them: you're standing right here next to me. *We* are being courageous."

Flags are indeed potent things. This was true when Betsy Ross manufactured them in her Philadelphia upholstery shop, and when Constance Cary Harrison and

Sonya Clark, *Flag of Truce*, 2019. Based on the textile used by Confederate forces to surrender the Civil War at Appomattox, Virginia, in 1865. Courtesy of the artist.

her relatives made the very first Confederate battle flag at the outset of the Civil War. It remains so in our internet age. Though made only of fabric, they are remarkably tenacious; we carry them around in our heads all the time, as emblems. Yet, as Clark points out, there is nothing inevitable about the Confederate battle flag's power. It is just one fragment taken from a complex history. In fact, there is another flag to which she has directed attention by remaking (rather than unmaking) it: the *Flag of Truce*, a field of white interrupted only by a few red stripes. The original (a small piece of cloth, probably made from a dishtowel) was present at Appomattox Court House in 1865 at the end of the Civil War. At some point after the peace treaty was signed, the flag was cut into pieces, which are today kept as relics in various museums. That hardly anyone remembers the Flag of Truce, while the battle flag remains so present in our thoughts, is itself an indication of a troubled history. "The flag that brought our nation together was dismantled and forgotten," Clark says, "while the flag that drove us apart is in all our imaginations."

Over the centuries, America's experience of craft has revealed a great deal about us. But if it offers one single lesson, it is this: We are all in it together. This history tells us to refuse the false choice between individualism and community, to see in craft a unique connection between these apparently opposing values. After all, the inheritance of skill is precisely what allows for new experimentation. It is the foundation of tradition that permits individual makers to flourish. Every craft object reflects its singular maker's ability and vision, and also a debt to other makers, one stretching back over many generations. Above all, it reflects the value of tolerance. One of the artisans interviewed by Studs Terkel for *Working* was a trade carpenter named Nick Lindsay. The craft had been in his family, he said, since 1755. He himself had started out at the age of thirteen. Even over the course of his own career, he had witnessed increasing pressure from factory-made components, which forced artisans like him to work ever faster. A tile should ideally be laid perfectly true in a ninety-degree angle, he explained, "Just altogether straight on, see? Do we ever do it? No." In fact, there is always a little give, perhaps a sixty-fourth of an inch off of square. "A craftsman's life," Lindsay said, "is nothin' but compromise."[15] Craft is not just about striving for perfection, but also about making a reasonable peace with what's possible. So, can craft save America? Maybe so, if we all get behind this idea: Our shared past is what the future will be made from, the best that we can.

ACKNOWLEDGMENTS

Craft is as old as the hills but craft studies is quite new. In the 1990s, few considered that such a field could (or should) exist. I was fortunate indeed to study with Edward S. (Ned) Cooke Jr., for whom it was not only a possibility but also already a daily practice. He saw that focusing intently on craft could bring together many different strands of human experience—politics and economics, art and design, technology and science—while attending to marginalized forms of creativity. When I set out to write this book, Ned was the first person I consulted. Those early conversations had a decisive impact on its structure and scope, and his influence is felt on every page.

The same is true of Tanya Harrod, whose book *The Crafts in Britain in the Twentieth Century* still serves as the gold standard for scholarship in the field. Tanya, Ned, and I founded the *Journal of Modern Craft* in 2008. (Since then, Elissa Auther, Stephen Knott, and Jenni Sorkin have joined the editorial team, along with many reviews editors.) You'll notice more than a few citations to the *Journal* in the endnotes to this book. The publication has been one of the ways I have navigated the growing field, and it's been particularly gratifying to see younger scholars publish in our pages.

One of these outstanding new talents is Forrest Pelsue, who also served as the research assistant for this book. Though primarily a specialist on French craft history, Forrest plunged into American-specific literature with remarkable skill and adroitness, locating innumerable primary and secondary sources, thus helping to build the book's infrastructure. I am greatly in her debt and certain that she has an outstanding career ahead of her.

My next thanks go to the team at Bloomsbury, who encouraged me to undertake an expansive approach: an American history book with craft at its heart. My editor, Ben Hyman, has been perceptive and supportive throughout, as have editorial assistant Morgan Jones, senior production editor Barbara Darko, senior publicist Rosie Mahorter, copyeditor Jenna Dolan, proofreader Tanya Heinrich, and indexer Kay Banning.

As I was writing this book, I was also working on a related exhibition for Crystal Bridges Museum of American Art. That project, entitled *Crafting America*, made for an ideal parallel thought process. I am deeply grateful to my brilliant co-curator, Jen Padgett, as well as Sandy Edwards, Bernie Herman, Anya Montiel, Seph Rodney, and Jenni Sorkin, all of whom helped me formulate some of the ideas I explore here.

I've dedicated this book to my twin brother, Peter Adamson, and boy, does he deserve it. Not only is he an excellent historian in his own right (in the field of philosophy), but he was also the first person to read the manuscript and made numerous suggestions for improvement.

Passages of the book have also benefited from suggestions and observations from colleagues Aaron Beale, Sarah Carter, Meghan Doherty, Alexandra Jacopetti Hart, Joyce Kozloff, Brian Lang, Ethan Lasser, John Lukavic, Mark McDonald, Jonathan Prown, and Jennifer Roberts. My thanks also to Amana Heritage Society and Abigail Foerstner for assistance with the passage about the Amana Colony, and to the many photo rights holders who allowed their images to be reproduced in these pages.

The Center for Craft in Asheville has provided lead support for this book through its Craft Research Fund, as indeed it has for many of my previous undertakings (including the *Journal of Modern Craft*). Simply put, without this organization and its generous, insightful sponsorship, the field of craft studies would be only a shadow of its current self. It's an honor to have this book associated with them.

Finally, and most importantly, I thank my partner, Nicola. As I worked at this book, whenever I finished a day of writing, there she was. And I was always happy.

NOTES

Introduction

1. James Baldwin, "A Talk to Teachers," *Saturday Review*, December 21, 1963, 42–44.

2. For discussion of these relationships, see my previous books *Thinking Through Craft* (Oxford: Berg Publishers, 2007) and *The Invention of Craft* (London: Bloomsbury, 2013).

Chapter 1: THE ARTISAN REPUBLIC

1. Ethan Lasser, "Selling Silver: The Business of Copley's Paul Revere," *American Art* 26, no. 3 (Fall 2012): 26–43.

2. Jane Kamensky, *A Revolution in Color: The World of John Singleton Copley* (New York: W. W. Norton, 2016).

3. Copley is quoted in Susan Rather, "Carpenter, Tailor, Shoemaker, Artist: Copley and Portrait Painting Around 1770," *Art Bulletin* 79, no. 2 (June 1997): 269.

4. Robert Martello, *Midnight Ride, Industrial Dawn: Paul Revere and the Growth of American Enterprise* (Baltimore: Johns Hopkins University Press, 2010), 92.

5. Gary J. Kornblith, "The Artisanal Response to Capitalist Transformation," *Journal of the Early Republic* 10, no. 3 (Autumn 1990): 320.

6. Tyler Ambrose, *City of Dreams: The 400-Year Epic History of Immigrant New York* (Boston: Mariner Books, 2016), 54.

7. David Jaffee, *A New Nation of Goods: The Material Culture of Early America* (Philadelphia: University of Pennsylvania Press, 2011), 21. See also Charles Hummel, *Hammer in Hand: The Dominy Craftsmen of East Hampton, New York* (Charlottesville: University Press of Virginia, 1976).

8. Noah Webster, *Sketches of American Policy* (Hartford, CT: printed by Hudson and Goodwin, 1785).

9. Christine Daniels, "Wanted: A Blacksmith Who Understands Plantation Work; Artisans in Maryland, 1700–1810," *William and Mary Quarterly* 50, no. 4 (October 1993): 743–67.

10. Paul B. Henslie, "Time, Work, and Social Context in New England," *New England Quarterly* 65, no. 4 (December 1992): 531–59.

11. Richard K. MacMaster, "Philadelphia Merchants, Backcountry Shopkeepers, and Town-Making Fever," *Pennsylvania History* 81, no. 3 (Summer 2014): 342–63.

12. Richard J. Orli, "The Identity of the 1608 Jamestown Craftsmen," *Polish American Studies* 65, no. 2 (Autumn 2008): 17–26.

13. The Wampanoag population in 1600 is thought to have been approximately twelve thousand. By the end of Metacom's (also called King Phillip's) War of 1675–76, they comprised less than 10 percent of that number, mostly due to ongoing epidemics. Today, between four thousand and five thousand Wampanoag live in Massachusetts and surrounding states.

14. My thanks to the Wampanoag artist Jonathan Perry for his insights on historic Native American crafts.

15. Pierre-François-Xavier de Charlevoix, *A Voyage to North-America*, vol. 1 (Dublin: John Exshaw and James Potts, 1766).

16. Katharine Vickers Kirakosian, "Curious Monuments of the Simplest Kind: Shell Midden Archaeology in Massachusetts," doctoral diss., 2014, University of Massachusetts, Amherst.

17. Quoted in Nancy Shoemaker, *A Strange Likeness: Becoming Red and White in Eighteenth-Century North America* (Oxford: Oxford University Press, 2004), 65.

18. Jeffrey Ostler, *Surviving Genocide: Native Nations and the United States from the American Revolution to Bleeding Kansas* (New Haven, CT: Yale University Press, 2019), 11.

19. John Lawson, *History of North Carolina* (London: W. Taylor and F. Baker, 1714), 205–6. See also Lynn Ceci, "The Value of Wampum Among the New York Iroquois," *Journal of Anthropological Research* 38, no. 1 (Spring 1982): 97–107. Lawson commented that wampum was for the Native Americans "the Mammon (as our Money is to us) that entices and persuades them to do any thing, and part with everything they possess, except their Children for Slaves" (206).

20. James Adair, *The History of the American Indians* (London: Edward and Charles Dilly, 1775), 170.

21. Vivien Green Fryd, "Rereading the Indian in Benjamin West's *Death of General Wolfe*," *American Art* 9, no. 1 (Spring 1995): 72–85.

22. John Galt, *The Life, Studies, and Works of Benjamin West* (1816; repr., London: T. Cadell and W. Davies, 1820), 18.

23. Benjamin Franklin, *Remarks Concerning the Savages of North America* (Passy, France: printed by the author, 1784).

24. Mark Twain, "The Late Benjamin Franklin," *Galaxy*, July 1870, 138–40.

25. On Franklin's career of dissembling, see Jill Lepore, *The Story of America: Essays on Origins* (Princeton, NJ: Princeton University Press, 2013), 44ff.

26. Simon Newman, "Benjamin Franklin and the Leather-Apron Men: The Politics of Class in Eighteenth-Century Philadelphia," *Journal of American Studies* 43, no. 2 (August 2009): 161–75.

27. Benjamin Franklin, *A Modest Enquiry into the Nature and Necessity of a Paper-Currency* (Philadelphia, 1729).

28. Gordon S. Wood, *The Americanization of Benjamin Franklin* (New York: Penguin, 2003); Ralph Frasca, "From Apprentice to Journeyman to Partner: Benjamin Franklin's Workers and the Growth of the Early American Printing Trade," *Pennsylvania Magazine of History and Biography* 14, no. 2 (April 1990): 229–48; Allan Kulikoff, "Silence Dogood and the Leather-Apron Men," *Pennsylvania History* 81, no. 3 (Summer 2014): 364–74.

29. James H. Hutson, "An Investigation of the Inarticulate: Philadelphia's White Oaks," *William and Mary Quarterly* 28, no. 1 (January 1971): 3–25.

30. James Hawkes, *A Retrospect of the Boston Tea-Party* (New York: S. S. Bliss, 1834), 38, 92.

31. *Rivington's Gazetteer*, April 25, 1774, quoted in Carl Lotus Becker, *The History of Political Parties in the Province of New York, 1760–1776* (Madison: University of Wisconsin, 1907), 110.

32. Sean Wilentz, *Chants Democratic* (1984; repr., Oxford: Oxford University Press, 1984; 2004 edition).

33. Charles Olton, "Philadelphia's Mechanics in the First Decade of Revolution 1765–1775," *Journal of American History* 59, no. 2 (September 1972): 311–26: 314. See also Charles Olton, *Artisans for Independence: Philadelphia Mechanics and the American Revolution* (Syracuse, NY: Syracuse University Press, 1975).

34. Edward S. Cooke Jr., *Inventing Boston: Design, Production, and Consumption* (New Haven, CT: Yale University Press, 2019), 61.

35. Christine Daniels, "From Father to Son," in Howard Rock, Paul Gilje, and Robert Asher, eds. *American Artisans: Crafting Social Identity, 1750–1850* (Baltimore: Johns Hopkins University Press, 1995).

36. Mary Ann Clawson, *Constructing Brotherhood: Class, Gender, and Fraternalism* (Princeton, NJ: Princeton University Press, 2014); Steven C. Bullock, "The Revolutionary Transformation of American Freemasonry, 1752–1792," *William and Mary Quarterly* 47, no. 3 (July 1990): 347–69.

37. Maurice Wallace, "'Are We Men?': Prince Hall, Martin Delany, and the Masculine Ideal in Black Freemasonry, 1775–1865," *American Literary History* 9, no. 3 (Autumn 1997): 396–424.

38. Theda Skocpol, Ariane Liazos, and Marshall Ganz, *What a Mighty Power We Can Be: African American Fraternal Groups and the Struggle for Racial Equality* (Princeton, NJ: Princeton University Press, 2006).

39. These quotations come from the "charges," or speeches, Hall delivered to his African Lodge in 1792 and 1794.

40. James Sidbury, "Slave Artisans in Richmond, Virginia, 1780–1810," in Rock, Gilje, and Asher, *American Artisans*, 55. Ford is quoted in Mary Ferrari, "Obliged to Earn Subsistence for Themselves: Women Artisans in Charleston, South Carolina, 1763–1808," *South Carolina Historical Magazine* 106, no. 4 (October 2005): 243.

41. Jared Hardesty, "'The Negro at the Gate': Enslaved Labor in Eighteenth-Century Boston," *New England Quarterly* 87, no. 1 (March 2014): 72–98.

42. This saying is adapted from Virginia Woolf's *A Room of One's Own* (1929): "I would venture to guess that Anon., who wrote so many poems without signing them, was often a woman." The phrase was used as the title for a widely read book on American women's folk art, Mirra Bank, *Anonymous Was a Woman* (New York: St. Martin's Press, 1979).

43. Dickman's sampler is the earliest dated example in the collection of the National Museum of American History, Smithsonian Institution, Washington, D.C.

44. Laurel Thatcher Ulrich, "Furniture as Social History: Gender, Property, and Memory in the Decorative Arts," *American Furniture* (Chipstone Foundation) (1995).

45. *Virginia Gazette*, February 27, 1772. Reprinted in Nancy Woloch, ed., *Early American Women: A Documentary History* (1997; repr., Boston: McGraw-Hill, 2013), 64. "Nuns Work" and "Dresden Point Work" refer to lace making.

46. Monique Bourque, "Women and Work in the Philadelphia Almshouse, 1790–1840," *Journal of the Early Republic* 32, no. 3 (Fall 2012): 383–413; Laurel Thatcher Ulrich, "Wheels, Looms, and the Gender Division of Labor in Eighteenth-Century New England," *New England Quarterly* 55, no. 1 (January 1998): 3–38.

47. Marla R. Miller, *The Needle's Eye: Women and Work in the Age of Revolution* (Amherst: University of Massachusetts Press, 2006).

48. This is reprinted in the *Boston News-Letter* but was originally published March 12, 1766. See Laurel Thatcher Ulrich, "Daughters of Liberty: Religious Women in Revolutionary New England," in Ronald Hoffman and Peter J. Albert, eds., *Women in the Age of the American Revolution* (Charlottesville: University of Virginia Press, 1989).

49. Marla R. Miller, *Betsy Ross and the Making of America* (New York: Henry Holt, 2010), 181.

50. The strongest evidence of a designer for the original Stars and Stripes points to the attorney and dry goods merchant Francis Hopkinson, who was involved with navy requisitioning (including flags) and had previously designed both currency and a seal. For these services he suggested that "a quarter cask of the public wine" might be appropriate compensation, but he was turned down on the grounds that, as the Treasury Board put it, Hopkinson "was not the only person consulted on those exhibitions of Fancy." Miller, *Betsy Ross and the Making of America*, 180.

51. Ronald Schultz, "Small Producer Thought in Early America, Part I: Philadelphia Artisans and Price Control," *Pennsylvania History* 54, no. 2 (April 1987): 115–47.

52. Barbara M. Tucker, "The Merchant, the Manufacturer, and the Factory Manager: The Case of Samuel Slater," *Business History Review* 55, no. 3 (Autumn 1981): 297–313.

53. Quoted in Bruce Laurie, *Artisans into Workers: Labor in Nineteenth-Century America* (New York: Noonday Press, 1989), 30.

54. Alan Dawley, *Class and Community: The Industrial Revolution in Lynn* (Cambridge, MA: Harvard University Press, 1976); Mary H. Blewett, "Work, Gender and the Artisan Tradition in New England Shoemaking, 1780–1860," *Journal of Social History* 17, no. 2 (Winter 1983): 221–48.

55. Tench Coxe, "Sketches on the Subject of American Manufacture" (1787), in Coxe, *A View of the United States of America* (Philadelphia: printed for W. Hall and Wrigley & Berriman, 1794).

56. Ruth Bogin, "Petitioning and the New Moral Economy of Post-Revolutionary America," *William and Mary Quarterly* 45, no. 3 (July 1988): 391–425.

57. Charles G. Steffen, "Changes in the Organization of Artisan Production in Baltimore, 1790 to 1820," *William and Mary Quarterly* 36, no. 1 (January 1979): 101–17.

58. Sharon V. Salinger, "Artisans, Journeymen, and the Transformation of Labor in Late Eighteenth-Century Philadelphia," *William and Mary Quarterly* 40, no. 1 (January 1983): 62–84.

59. Quoted in Paul B. Henslie, "Time, Work, and Social Context in New England," *New England Quarterly* 65, no. 4 (December 1992): 531–59.

60. Thomas Jefferson, *Notes on Virginia* (1781), Query XIX: Manufactures.

61. William Duane, "Politics for Mechanics, Part I," *Aurora*, January 29, 1807; Duane, "Politics for Mechanics, Part IV," *Aurora*, February 7, 1807; Andrew Shankman, "A New Thing on Earth: Alexander Hamilton, Pro-Manufacturing Republicans, and the Democratization of American Political Economy," *Journal of the Early Republic* 23, no. 3 (Autumn 2003): 340. See also Allan C. Clark, "William Duane," *Records of the Columbia Historical Society* 9 (1906): 14–62; Ronald Schultz, "Small Producer Thought in Early America," *Pennsylvania History* 54, no. 3 (July 1987).

Chapter 2: A Self-Made Nation

1. James W. C. Pennington, *A Textbook of the Origin and History of the Colored People* (Hartford, CT: L. Skinner, 1841). Pennington attended Yale Divinity School classes, but was not allowed to earn a degree. For a full biography, see Christopher L. Webber, *American to the Backbone* (New York: Pegasus Books, 2011).

2. James W. C. Pennington, *The Fugitive Blacksmith, or, Events in the History of James W. C. Pennington* (London: Charles Gilpin, 1849), iv, vii.

3. Pennington, *The Fugitive Blacksmith*, 7.

4. Pennington, *The Fugitive Blacksmith*, 20.

5. Pennington, *The Fugitive Blacksmith*, 8.

6. Pennington, *The Fugitive Blacksmith*, 79–80.

7. James W. C. Pennington, *A Two Years' Absence, or, A Farewell Sermon* (Hartford, CT: H. T. Wells, 1845), 4, 8.

8. William and Ellen Craft, *Running a Thousand Miles for Freedom* (London: William Tweedie, 1860).

9. Douglas R. Egerton, "Slaves to the Marketplace: Economic Liberty and Black Rebelliousness in the Atlantic," *Journal of the Early Republic* 26, no. 4 (Winter 2006): 633.

10. Douglas Egerton, *Gabriel's Rebellion: The Virginia Slave Conspiracies of 1800 and 1802* (Chapel Hill: University of North Carolina Press, 1993).

11. Ethan J. Kytle and Blain Roberts, *Denmark Vesey's Garden: Slavery and Memory in the Cradle of the Confederacy* (New York: New Press, 2018).

12. *Baltimore Afro-American*, April 26, 1930, 6.

13. John Hope Franklin, "James Boon, Free Negro Artisan," *Journal of Negro History* 30, no. 2 (April 1945): 150–80; Catherine Bishir, "James Boon," in *North Carolina Architects and Builders: A Biographical Dictionary* (Chapel Hill: University of North Carolina Press, 1990).

14. Tiya Miles, *The House on Diamond Hill: A Cherokee Plantation Story* (Chapel Hill: University of North Carolina Press, 2010).

15. Loren Schweninger, "John Carruthers Stanly and the Anomaly of Black Slaveholding," *North Carolina Historical Review* 67, no. 2 (April 1990): 159–92.

16. Stephen F. Miller, "Recollections of Newbern Fifty Years Ago," in *Our Living and Our Dead* (1874). See also Catherine Bishir, *Crafting Lives: African American Artisans in New Bern, North Carolina, 1770–1900* (Chapel Hill: University of North Carolina Press, 2013).

17. Sidbury, "Slave Artisans in Richmond, Virginia, 1780–1810," in Rock, Gilje, and Asher, *American Artisans*, 61.

18. Patricia Phillips Marshall and Jo Ramsay Leimenstoll, *Thomas Day: Master Craftsman and Free Man of Color* (Chapel Hill: University of North Carolina Press, 2002).

19. Jonathan Prown, "The Furniture of Thomas Day: A Reevaluation," *Winterthur Portfolio* 33, no. 4 (Winter 1998): 215–29.

20. Ann Senefeld, "Henry Boyd: Former Slave and Cincinnati Entrepreneur," *Digging Cincinnati History* (online resource), February 6, 2014; Juliet Walker, "Racism, Slavery, and Free Enterprise: Black Entrepreneurship in the United States before the Civil War," *Business History Review* 60, no. 3 (Autumn 1986): 343–82.

21. Catherine Bishir, "Black Builders in Antebellum North Carolina," *North Carolina Historical Review* 61, no. 4 (October 1984): 423–61.

22. John Hope Franklin, "The Free Negro in the Economic Life of Ante-Bellum North Carolina, part 1," *North Carolina Historical Review* 19, no. 3 (July 1942): 251.

23. Michele Gillespie, "Artisan Accommodation to the Slave South: The Case of William Talmage," *Georgia Historical Quarterly* 81, no. 2 (Summer 1997): 265–86; Michele Gillespie, *Free Labor in an Unfree World: White Artisans in Slaveholding Georgia, 1789–1860* (Athens: University of Georgia, 2004).

24. Alexis de Tocqueville, *Democracy in America*, vol. 1 (1835), part 4, chap. 18.

25. Quoted in Bess Beatty, "I Can't Get My Bored on Them Old Lomes: Female Textile Workers in the Antebellum South," in Susanna Delfino and Michele Gillespie, eds., *Neither Lady nor Slave: Working Women of the Old South* (Chapel Hill: University of North Carolina Press, 2002), 250.

26. Edward Jay Pershey, "Lowell and the Industrial City in Nineteenth-Century America," *OAH Magazine of History* 5, no. 2 (Fall 1990): 5–10.

27. Joshua B. Freeman, *Behemoth: A History of the Factory and the Making of the Modern World* (New York: W. W. Norton, 2018), 60.

28. Paul B. Henslie, "Time, Work, and Social Context in New England," *New England Quarterly* 65, no. 4 (December 1992): 557.

29. Ethelinda, "Prejudice Against Labour," in *Mind Amongst the Spindles: A Selection from the Lowell Offering* (London: Charles Knight, 1845), 73–83.

30. Quoted in William Scoresby, *American Factories and their Female Operatives* (Boston: William D. Ticknor, 1845), 21.

31. James Bessen, "Technology and Learning by Factory Workers: The Stretch-out at Lowell, 1842," *Journal of Economic History* 63, no. 1 (March 2003): 33–64.

32. Reprinted in Woloch, *Early American Women*, 64.

33. George Fitzhugh, *Cannibals All! Or, Slaves Without Masters* (1857), 32.

34. Tyler Anbinder, *City of Dreams: The 400-Year Epic History of Immigrant New York* (Boston: Mariner Books, 2016), 160.

35. Jane Gaskell, "Conceptions of Skill and the Work of Women: Some Historical and Political Issues," *Atlantis* 8, no. 2 (1983): 11–25.

36. Frederick Jackson Turner, "The Significance of the Frontier in American History," *Annual Report of the American Historical Association* (1893), 197–227.

37. Tocqueville, *Democracy in America*, vol. 1, part 4, chap. 18; Francis Grund, another European traveler, concurred: "There is, probably, no people on earth with whom business constitutes pleasure, and industry amusement, in an equal degree with the inhabitants of the United States of America. Active occupation is not only the principal source of their happiness, and the foundation of their national greatness, but they are absolutely wretched without it." Grund, *The Americans in their Moral, Social, and Political Positions* (Boston: Marsh, Capen and Lyon, 1837), 202.

38. One version of the painting is still at the Pennsylvania Academy of the Fine Arts, the other at the Museum of Fine Arts, Boston.

39. *The Narrative of Patrick Lyon, who suffered three months severe imprisonment in Philadelphia gaol; on merely a vague suspicion, of being concerned in the robbery of the Bank of Pennsylvania* (Philadelphia: Frances and Robert Bailey, 1799), 3. See also Laura Rigal, *The American Manufactory: Art, Labor, and the World of Things in the Early Republic* (Princeton, NJ: Princeton University Press, 1998), chap. 6.

40. *The Narrative of Patrick Lyon*, 8.

41. William Dunlap, *History of the Rise and Progress of the Arts of Design in the United States* (New York: George P. Scott and Co., 1834), 2:375.

42. Howard Rock, "All Her Sons Join as One Social Band," in Rock, Gilje, and Asher, *American Artisans*, 185, 169.

43. Between 1815 and 1860, the cost of inland shipping fell 95 percent.

44. Sean Wilentz, *Chants Democratic* (1984; repr., Oxford: Oxford University Press, 2004), 104.

45. Wilentz, *Chants Democratic*, 94.

46. Quoted in Peter Kenny and Michael K. Brown et al., *Duncan Phyfe: Master Cabinetmaker of New York* (New York: Metropolitan Museum of Art, 2010), 36.

47. Alexander Rose, *American Rifle: A Biography* (New York: Delacorte Press, 2008).

48. Robert Hounshell, *From the American System to Mass Production, 1800–1832: The Development of Manufacturing Technology in the United States* (Baltimore: Johns Hopkins University Press, 1984), chap. 1.

49. David Jaffee, *A New Nation of Goods: The Material Culture of Early America* (Philadelphia: University of Pennsylvania Press, 2011), 178.

50. De Tocqueville, *Democracy in America*, vol. 2, chap. 11. The making and repair of watches was a growth industry in nineteenth-century America, increasingly aided by the mass production of components. Alexis McCrossen, "The 'Very Delicate Construction' of Pocket Watches and Time Consciousness in the Nineteenth-Century United States," *Winterthur Portfolio* 44, no. 1 (Spring 2010): 1–30.

51. These details were recalled by an attendee, James Nimroll, in 1897; quoted in Ron Grossman, "How Andrew Jackson's Inauguration Day Went Off the Rails," *Chicago Tribune*, January 13, 2017.

52. Benjamin Caldwell, "Tennessee Silversmiths," *Tennessee Historical Quarterly* 74, no. 1 (Spring 2015): 2–21.

53. Thomas Hunt, *The Book of Wealth* (New York: Ezra Collier, 1836), 23. Some social critics did make precisely this objection, among them the Transcendentalist writer Orestes Brownson: "One fact is certain, no man born poor has ever, by his wages, as a simple operative, risen to the class of the wealthy. Rich he may have become, but it

has not been by his own manual labor." Brownson, "The Laboring Classes," *Boston Quarterly Review* (1840).

54. John Frost, *Self-Made Men of America* (New York: W. H. Graham, 1848), iii, 126.

55. James McClelland, "Losing Grip: Emerson, Leroux and the Work of Identity," *Journal of American Studies* 39, no. 2 (August 2005): 241.

56. Ava Baron, "Masculinity, the Embodied Male Worker, and the Historian's Gaze," *International Labor and Working-Class History* 69 (Spring 2006): 143–160: 147. See also Michael Kimmel, *Manhood in America: A Cultural History*, 2nd ed. (Oxford: Oxford University Press, 2006).

57. "Mr. Clay's Speech, in Defence of the American System, Against the British Colonial System," as printed in *Nile's Register*, March 3, 1832, 11.

58. As the historian Jill Lepore comments, "there is no older or more hackneyed gambit in American politics, no maneuver less maverick." Lepore, "Man of the People," in Lepore, *The Story of America: Essays on Origins* (Princeton, NJ: Princeton University Press, 2012), 152–57.

59. Warren E. Roberts and Ada L. K. Newton, "The Tools Used in Building Log Houses in Indiana," *Material Culture* 33, no. 1 (Spring 2001): 8–45; W. Stephen McBride, "A Village Blacksmith in the Antebellum South," *Southeastern Archaeology* 6, no. 2 (Winter 1987): 79–92.

60. Edwin T. Freedley, *Leading Pursuits and Leading Men* (1854; repr., Philadelphia: Edward Young, 1856), 61, 408.

61. E. H. Chapin, "The Printing Press in the Age of Steam and Electricity," 1855; quoted in Ronald J. Zboray, "Antebellum Reading and the Ironies of Technological Innovation," *American Quarterly* 40, no. 1 (March 1988): 68.

62. Charles Seymour, *Self-Made Men* (New York: Harper and Brothers, 1858), 429, 41.

63. Elihu Burritt, *Sparks from the Anvil* (London: Charles Gilpin, 1847), 58–59, 73–74.

64. Brades's stamp, WHS, reflected its original company name, William Hunt and Sons. Tradesmen said it actually stood for "Work Hard or Starve."

65. Elihu Burritt, *Walks in the Black Country and Its Green Border-Land* (London: Sampson Low, Son, and Marston, 1868).

66. Merle E. Curti, "Henry Wadsworth Longfellow and Elihu Burritt," *American Literature* 7, no. 3 (November 1935): 315–28.

67. Other candidates have also been mooted as inspirations for the village blacksmith, including a local man named Dexter Pratt, whose house still stands at 54 Brattle Street in Cambridge. During the Civil War, it was owned by the family of Mary Walker, who had escaped enslavement in North Carolina in 1848.

68. Henry David Longfellow, "The Village Blacksmith," first published in *The Knickerbocker* (November 1840); reprinted in Longfellow, *Ballads and Other Poems* (Cambridge, MA: John Owen, 1841). The horse chestnut tree referred to in the poem was felled in 1879, its wood used to make an armchair. It is now in the Longfellow House in Cambridge, Massachusetts, a National Historic Site.

69. Quoted in Jill Anderson, " 'Be Up and Doing': Henry Wadsworth Longfellow and Poetic Labor," *Journal of American Studies* 37, no. 1 (April 2003): 1.

70. Ralph Waldo Emerson, *Nature* (Boston: James Munroe, 1836).

71. Kathryn Schulz, "Pond Scum," *New Yorker*, October 19, 2015.

72. This was not an imaginary scenario. Many Native Americans in New England did eke out a living by making baskets and selling them as peddlers. A minister in Connecticut recalled a Pequot woman called Anne Wampy, a fine maker of splint baskets ranging in size from a half-pint up to six quarts in volume: "She carried upon her shoulders a bundle of baskets so large as to almost hide her from view." Wampy was later converted to Christianity by the Pequot preacher William Apess. John Avery, *History of the Town of Ledyard* (Norwich, CT: Noyes and Davis, 1901), 259.

73. Kevin MacDonnell, "Collecting Henry David Thoreau," *Antiquarian Booksellers' Association* (online resource).

74. Quoted in Joshua Kotin, *Utopias of One* (Princeton, NJ: Princeton University Press, 2018), 18.

75. Henry David Thoreau, journal entry, April 23, 1857. In Bradford Torrey, ed., *The Writings of Henry David Thoreau: Journal* (Cambridge, MA: Riverside Press, 1906), 9:335.

76. Margaret Fuller Ossoli, *Woman in the Nineteenth Century* (New York: Greeley and McElrath, 1845). In an amazingly foresighted passage, she also comments that the two genders were, in any case, not monolithic, as they were "perpetually passing into

one another. Fluid hardens to solid, solid rushes to fluid. There is no wholly masculine man, no purely feminine woman."

77. Gregory L. Kaster, "Labour's True Man: Organised Workingmen and the Language of Manliness in the USA, 1827–1877," *Gender and History* 13, no. 1 (April 2001): 24–64.

78. William Alcott, *The Young Wife, or, Duties of Woman in the Marriage Relation* (Boston: G. W. Light, 1837), 129–34.

79. The two sisters later collaborated on a jointly written book, *The American Woman's Home, or, Principles of Domestic Science* (New York: J. B. Ford, 1869), which placed particular emphasis on new domestic technology. Harriet Beecher Stowe made her own contribution to the self-made man genre: *Lives and Deeds of the Self-Made Men* (Hartford, CT: Worthington, Dustin and Co., 1872).

80. Catharine Beecher, *A Treatise on Domestic Economy* (Boston: Marsh, Capen, Lyon and Webb, 1841).

81. Ellen Lindsay, "Patchwork," *Godey's Lady's Book and Magazine* 55, no. 2 (February 1857): 166.

82. Nancy F. Cott, *The Bonds of Womanhood: "Woman's Sphere" in New England, 1780–1835* (New Haven, CT: Yale University Press, 1977).

83. Frances Trollope, *Domestic Manners of the Americans* (London: Gilbert and Rivington, 1832), 17.

84. Wright to Lafayette, February 11, 1822, quoted in Lloyd S. Kramer, *Lafayette in Two Worlds: Public Cultures and Personal Identities in an Age of Revolutions* (Chapel Hill: University of North Carolina Press, 1996), 158.

85. Frances Wright, *Views of Society and Manners in America* (New York: Bliss and White, 1821), 193, 285.

86. Gail Bederman, "Revisiting Nashoba: Slavery, Utopia, and Frances Wright in America, 1818–1826," *American Literary History* 17, no. 3 (Autumn 2005): 438–59.

87. Chris Jennings, *Paradise Now: The Story of American Utopianism* (New York: Random House, 2016), 128.

88. Teju Cole, "The White-Savior Industrial Complex," *Atlantic*, March 21, 2012.

89. Fanny Wright, *Fanny Wright Unmasked by Her Own Pen: Explanatory Notes, Respecting the Nature and Objects of the Institution of Nashoba* (New York, 1830); Frances Trollope, *Domestic Manners of the Americans* (London: Gilbert and Rivington, 1832).

90. George Henry Evans, *Working Men's Advocate*, May 8, 1830; quoted in Edward Pessen, "The Workingmen's Movement of the Jacksonian Era," *Mississippi Valley Historical Review* 43, no. 3 (December 1956): 428–43.

91. Frances Wright, address delivered at the opening of the Hall of Science, New York, April 26, 1829; in Frances Wright, *Course of Popular Lectures* (New York: The Free Enquirer, 1829), 204, 224.

92. Quoted in Wilentz, *Chants Democratic*, 132.

93. Frederick Douglass, *Narrative of the Life of Frederick Douglass, An American Slave, Written by Himself* (Boston: Anti-Slavery Society, 1845).

94. Frederick Douglass, "Learn Trades or Starve," *Frederick Douglass' Paper* 6, no. 11 (March 4, 1853).

Chapter 3: LEARN TRADES OR DIE

1. Herman Melville, *Moby-Dick* (1851), chap. 47.

2. Nancy Shoemaker, *Native American Whalemen and the World* (Chapel Hill: University of North Carolina Press, 2015).

3. For a study of soldiers from Dubuque, Iowa, see Russell L. Johnson, *Warriors into Workers: The Civil War and the Formation of the Urban-Industrial Society in a Northern City* (New York: Fordham University Press, 2003), 147, 247, 250.

4. Quoted in Jeanne Boydston, *Home and Work: Housework, Wages, and the Ideology of Labor in the Early Republic* (Oxford: Oxford University Press, 1990), 107.

5. "The Sewing Machine and Its Merits," *Godey's Lady's Book and Magazine* 60, no. 4 (April 1860): 369.

6. Ava Baron and Susan Klepp, " 'If I Didn't Have My Sewing Machine . . . ': Women and Sewing Machine Technology," in Joan Jensen and Sue Davidson, eds., *A Needle, A Bobbin, A Strike* (Philadelphia: Temple University Press, 1984).

7. Lisa Tendrich Frank, *The World of the Civil War: A Daily Life Encyclopedia*, vol. 1 (Santa Barbara: Greenwood, 2015), 143.

8. Willard Glazier, *Three Years in the Federal Calvary* (New York: R. H. Ferguson and Company, 1874), 116; quoted in Dean Nelson, "Right Nice Little Houses: Impermanent Camp Architecture of the American Civil War," *Perspectives in Vernacular Architecture* 1 (1982): 83.

9. Quoted in Tyler Ambrose, *City of Dreams: The 400-Year Epic History of Immigrant New York* (Boston: Mariner Books, 2016), 257.

10. Quoted in Marc Leepson, *Flag: An American Biography* (New York: St. Martin's, Griffin, 2006), 95.

11. Woden Teachout, *Capture the Flag: A Political History of American Patriotism* (New York: Basic Books, 2009), 86, 95.

12. *Diary of Caroline Cowles Richards, 1852–1872* (Rochester, NY: 1908), 65, 70.

13. Barbara Brackman, *Facts and Fabrications: Unraveling the History of Quilts and Slavery* (Lafayette, CA: C&T Publishing, 2006). The myth of the Underground Railroad quilt was propagated by Jacqueline Tobin and Raymond Dobard in *Hidden in Plain View: A Secret Story of Quilts and the Underground Railroad* (New York: Anchor Books, 2000). They claimed to have learned of the secret codes from a single informant, Ozella McDaniel Williams, a Charlestown quilt maker.

14. Quoted in James H. Brewer, *The Confederate Negro: Virginia's Craftsmen and Military Laborers, 1861–1865* (Durham, NC: Duke University Press, 1969), 23.

15. Vincent Colyer, *Report on the Services Rendered by the Freed People to the United States Army, in North Carolina* (New York: printed by the author, 1864), 6.

16. Quoted in Brewer, *The Confederate Negro*, 14.

17. Elizabeth Keckley, *Behind the Scenes, or, Thirty Years a Slave and Four Years in the White House* (New York: G. W. Carleton and Co., 1868). See also Janaka B. Lewis, "Elizabeth Keckley and Freedom's Labor," *African American Review* 49, no. 1 (Spring 2016): 5–17; and Xiomara Santamarina, *Belabored Professions: Narratives of African American Working Womanhood* (Chapel Hill: University of North Carolina Press, 2005), 148.

18. Jill Beute Koverman, "The Ceramic Works of David Drake," *American Ceramic Circle Journal* 13 (2005): 83–98. See also Jill Beute Koverman, *I Made This Jar: The*

Life and Works of the Enslaved African-American Potter, Dave (Columbia: McKissick Museum/University of South Carolina, 1998); and Aaron de Groft, "Eloquent Vessels/Poetics of Power: The Heroic Stoneware of Dave the Potter," *Winterthur Portfolio* 33, no. 4 (Winter 1998): 249–60.

19. Henry Louis Gates Jr., *Stony the Road: Reconstruction, White Supremacy, and the Rise of Jim Crow* (New York: Penguin, 2019).

20. Martin Ruef and Ben Fletcher, "Legacies of American Slavery: Status Attainment Among Southern Blacks after Emancipation," *Social Forces* 82, no. 2 (December 2003): 445–80.

21. James W. C. Pennington, *A Textbook of the Origin and History of the Colored People* (Hartford, CT: L. Skinner, 1841).

22. Sarah Anne Carter, *Object Lessons: How Nineteenth-Century Americans Learned to Make Sense of the Material World* (Oxford: Oxford University Press, 2018).

23. W. E. B. Du Bois, *The Souls of Black Folk* (Chicago: A. C. McClurg and Co., 1903).

24. Quoted in Sarah Robbins, "Gendering the Debate over African Americans' Education in the 1880s," *Legacy* 19, no. 1 (2002): 82.

25. Quoted in Robert Francis Engs, *Educating the Disenfranchised and Disinherited: Samuel Chapman Armstrong and the Hampton Institute, 1839–1893* (Knoxville: University of Tennessee Press, 1999), 76.

26. Quoted in Edith Armstrong Talbot, *Samuel Chapman Armstrong: A Biographical Study* (New York: Doubleday, Page and Co., 1904), 155.

27. Booker T. Washington, *Up from Slavery* (New York: Doubleday, Page and Co., 1906), 5, 18.

28. Quoted in Jacqueline Fear-Segal, "Nineteenth-Century Indian Education: Universalism versus Evolutionism," *Journal of American Studies* (August 1999): 323.

29. Manning Marable, "The Politics of Illusion in the New South," *Black Scholar* 8, no. 7 (May 1977): 13–24.

30. Ellen Weiss, "Tuskegee: Landscape in Black and White," *Winterthur Portfolio* 36, no. 1 (Spring 2001): 19–37.

31. Mark Bauerlein, "Booker T. Washington and W. E. B. Du Bois: The Origins of a Bitter Intellectual Battle," *Journal of Blacks in Higher Education* 46 (Winter 2004/5): 106–14.

32. W. E. B. Du Bois, "The Hampton Idea," 1906; in Du Bois, *The Education of Black People: Ten Critiques* (New York: Monthly Press, 1973), 25–26.

33. Du Bois, *The Souls of Black Folk*.

34. Stokely Carmichael and Charles V. Hamilton, *Black Power: The Politics of Liberation in America* (New York: Random House, 1967).

35. James D. Anderson, *The Education of Blacks in the South* (Chapel Hill: University of North Carolina Press, 1988), 73.

36. Christopher Alan Bracey, *Saviors or Sellouts: The Promise and Peril of Black Conservatism* (Boston: Beacon Press, 2008).

37. *The Negro Artisan* (Atlanta, GA: Atlanta University, 1904), 32.

38. Carter G. Woodson, *The Mis-Education of the Negro* (1933); Leslie Pinckney Hill, "Negro Ideals: Their Effect and Their Embarrassments," *Journal of Race Development* 6, no. 1 (July 1915): 91–103, 96.

39. Mark Twain and Charles Dudley Warner, *The Gilded Age: A Tale of Today* (Hartford, CT: American Publishing Company, 1873).

40. "Centennial Pictures, No. 2," *American Farmer* 5 (October 1876): 355.

41. Bruno Giberti, *Designing the Centennial: A History of the 1876 International Exhibition in Philadelphia* (Lexington: University Press of Kentucky, 2002).

42. Susan N. Carter, "Ceramic Art at the Exhibition," *Appletons' Journal* 1, no. 1 (July 1876): 74–77.

43. "The Sheet-Metal Pavilion at the Centennial," *Manufacturer and Builder*, July 1876, 169; Pamela Hemenway Simpson, *Cheap, Quick, & Easy: Imitative Architectural Materials, 1870–1930* (Knoxville: University of Tennessee Press, 1999), 30.

44. "The Centennial Exposition," *Manufacturer and Builder*, September 1876, 148–49.

45. William Dean Howells, "The Sennight of the Centennial," *Atlantic Monthly* 1, no. 38 (July 1876): 96.

46. The *Weekly Clarion* (Jackson, MS), May 3, 1876; Jack Noe, "'Everybody Is Centennializing': White Southerners and the 1876 Centennial," *American Nineteenth Century History* 17, no. 3 (September 2016): 327, 339.

47. Quoted in Jennifer Pitman, "China's Presence at the Centennial Exhibition, Philadelphia, 1876," *Studies in the Decorative Arts* 10, no. 1 (Fall/Winter 2002/3): 53. This writer, for the *American Architect and Building News*, was also expressing a view of Chinese artisans as uninventive, a prejudice that was becoming commonplace in America at the time: "There is a positive incapacity for striking into new paths. The Chinese do not learn. The forms, the patterns, the colors, and the glazes brought into use, are the exact counterpart of those which have served long-dead generations. The race has lost not only the faculty of inventiveness, but the conception of its utility or possible need."

48. William H. Rideing, "At the Exhibition: A Few Curiosities," *Appleton's Journal*, June 3, 1876, 723.

49. Abigail Carroll, "Of Kettles and Cranes: Colonial Revival Kitchens and the Performance of National Identity," *Winterthur Portfolio* 43, no. 4 (Winter 2009): 355.

50. Philip Foner, "The French Trade Union Delegation to the Philadelphia Centennial Exposition, 1876," *Science and Society* 40, no. 3 (Fall 1976): 257–87.

51. Mary Frances Cordato, "Toward a New Century: Women and the Philadelphia Centennial Exhibition, 1876," *Pennsylvania Magazine of History and Biography* 107, no. 1 (January 1983): 113–35.

52. "Women's Pavilion," *Pennsylvania School Journal* 25 (August 1876): 58.

53. "The Exposition," *New Century for Women* 1 (May 13, 1876): 1.

54. Elizabeth Cady Stanton, quoted in Judith Paine, "The Women's Pavilion of 1876," *Feminist Art Journal* 4, no. 4 (Winter 1975/76).

55. Robert Davis, "Emma Allison, A 'Lady Engineer,'" *New Inquiry*, July 20, 2017.

56. "The Centennial Exposition," *Manufacturer and Builder*, September 1876, 148.

57. Susanna W. Gold, "The Death of Cleopatra, The Birth of Freedom: Edmonia Lewis at the New World's Fair," *Biography* 35, no. 2 (Spring 2012): 317–41.

58. Rebecca Bedell and Margaret Samu, "The Butter Sculpture of Caroline Shawk Brooks," in Maureen Daly Goggin and Beth Fowkes Tobin, eds., *Women and Things, 1750–1950* (Burlington, VT: Ashgate, 2009). See also Pamela H. Simpson, "A Vernacular Recipe for Sculpture: Butter, Sugar, and Corn," *American Art* 24, no. 1 (Spring 2010): 23–26; and Pamela H. Simpson, *Corn Palaces and Butter Queens:*

A History of Crop Art and Dairy Sculpture (Minneapolis: University of Minnesota Press, 2012).

59. Quoted in Giberti, *Designing the Centennial,* 53. See also Tony Bennett, "The Exhibitionary Complex," *New Formations* 4 (Spring 1988): 73–102.

60. Philip Foner, "Black Participation in the Centennial of 1876," *Phylon* 34, no. 4 (Winter 1978): 289.

61. Shari Michelle Huhndorf, *Going Native: Indians in the American Cultural Imagination* (Ithaca, NY: Cornell University Press, 2001), 30.

62. "The Centennial Exposition: US Government Building," *Pennsylvania School Journal* 25, no. 1 (July 1876): 4.

63. "The Centennial Exposition: Exhibit of the Bureau of Education," *Pennsylvania School Journal* 25, no. 6 (December 1876): 239.

64. Quoted in John Ehle, *Trail of Tears: The Rise and Fall of the Cherokee Nation* (New York: Doubleday, 1988), 254.

65. "Letter from Sarah Winnemucca, an Educated Pah-ute Woman," in Helen Hunt Jackson, *A Century of Dishonor* (New York: Harper and Brothers, 1881).

66. Sarah Winnemucca, *Life Among the Paiutes: Their Wrongs and Claims* (Boston: Cupples, Upham and Co., 1883), 48.

67. "Princess Winnemucca on the Treatment of the Indians," *Evening Transcript,* May 3, 1883, 2; quoted in Carolyn Sorisio, "Playing the Indian Princess? Sarah Winnemucca's Newspaper Career and Performance of American Indian Identities," *Studies in American Indian Literatures* 23, no. 1 (Spring 2011): 3.

68. Cari M. Carpenter and Carolyn Sorisio, eds., *The Newspaper Warrior: Sarah Winnemucca Hopkins's Campaign for American Indian Rights* (Lincoln: University of Nebraska Press, 2015).

69. "An Indian School," *Silver State,* October 22, 1885, 3; reprinted in Carpenter and Sorisio, *The Newspaper Warrior,* 256.

70. Richard H. Pratt, *Battlefield and Classroom: Four Decades with the American Indian, 1867–1904* (New Haven, CT: Yale University Press, 1964), 335. See also Hayes Peter Mauro, *The Art of Americanization at the Carlisle Indian School* (Albuquerque: University of New Mexico Press, 2011).

71. Merrill Gates, "Land and Law as Agents in Educating Indians," address delivered at the American Social Science Association, Saratoga, NY, September 11, 1885; Gates, address to the Thirteenth Annual Meeting of the Lake Mohonk Conference of Friends of the Indian, 1895.

72. This passage is indebted to conversations with the Denver Art Museum curator John Lukavic and the Native American artist Gregg Deal, whose satirical artworks include a performance piece called *The Last American Indian on Earth*.

73. Luther Standing Bear, *Land of the Spotted Eagle* (New York: Houghton Mifflin, 1933).

Chapter 4: A MORE PERFECT UNION

1. Chris Jennings, *Paradise Now: The Story of American Utopianism* (New York: Random House, 2016).

2. Quoted in Glendyne R. Wergland, *One Shaker Life: Isaac Newton Youngs, 1793–1865* (Amherst: University of Massachusetts Press, 2006).

3. Henry Daily, journal entry, March 16, 1883; quoted in David Marisch, "And Shall Thy Flowers Cease to Bloom? The Shakers' Struggle to Preserve Pleasant Hill, 1862–1910," *Register of the Kentucky Historical Society* 109, no. 1 (Winter 2011): 14.

4. Janneken Smucker, *Amish Quilts: Crafting an American Icon* (Baltimore: Johns Hopkins University Press, 2013).

5. "The Inspirationists," *San Francisco Chronicle*, August 5, 1888, 2.

6. "Communism in Iowa: Life in the Colony of True Inspirationists," *Chicago Daily Tribune*, May 2, 1891.

7. Bertha M. H. Shambaugh, *Amana: The Community of True Inspiration* (Iowa City: State Historical Society of Iowa, 1908), 178, 180, 187. See also Abigail Foerstner, *Picturing Utopia: Bertha Shambaugh and the Amana Photographers* (Iowa City: University of Iowa Press, 2000).

8. Wendy Kaplan, *The Arts and Crafts Movement in Europe and America, 1880–1920: Design for the Modern World* (Los Angeles: Los Angeles County Museum of Art, 2004); Karen Livingstone and Linda Parry, eds., *International Arts and Crafts* (London: Victoria and Albert Museum, 2005).

9. William Morris, "The Revival of Handicraft," *Fortnightly Review*, November 1888.

10. Irene Sargent, "John Ruskin," *Craftsman* 1, no. 2 (November 1901): 9.

11. Oscar Lovell Triggs, "The Workshop and School," *Craftsman* 3, no. 1 (October 1, 1902): 30.

12. Nancy Owen, "Marketing Rookwood Pottery: Culture and Consumption," *Studies in the Decorative Arts* 4, no. 2 (Spring/Summer 1997): 2, 8.

13. Quoted in Paul Evans, ed., *Adelaide Alsop Robineau: Glory in Porcelain* (Syracuse, NY: Syracuse University Press, 1981), 107. See also Thomas Piché Jr. and Julia A. Monti, eds., *Only an Artist: Adelaide Alsop Robineau, American Studio Potter* (Syracuse, NY: Everson Museum of Art, 2006).

14. Charles Fergus Binns, "Pottery in America," *American Magazine of Art* 7, no. 4 (February 1916): 137.

15. Adelaide Alsop Robineau, editorial, *Keramic Studio* 18, no. 11 (March 1917): 175.

16. Quoted in Amelia Peck and Carol Irish, *Candace Wheeler: The Art and Enterprise of American Design, 1875–1900* (New York: Metropolitan Museum of Art, 2001), 6.

17. Quoted in Virginia Gunn, "The Art Needlework Movement: An Experiment in Self-Help for Middle-Class Women, 1870–1900," *Clothing and Textiles Research Journal* 10, no. 3 (Spring 1992): 54–63; Peck and Irish, *Candace Wheeler*, 26.

18. Quoted in Randy Kennedy, "The Gilded Age Glows Again at the Park Avenue Armory's Veterans Room," *New York Times*, March 6, 2016.

19. Gunn, "The Art Needlework Movement," 58.

20. Gunn, "The Art Needlework Movement," 58; Jeanne Madeline Weimann, *The Fair Women: The Story of the Women's Building at the World's Columbian Exposition* (Chicago: Chicago Reader, 1981).

21. Candace Wheeler, *How to Make Rugs* (New York: Doubleday, 1900).

22. Madeline Yale Wynne, "How to Make Rugs," review, *House Beautiful* 14 (1903): 162.

23. Candace Wheeler, *Principles of Home Decoration* (New York: Doubleday, 1903), 8.

24. Quoted in Mark Alan Hewitt, *Gustav Stickley's Craftsman Farms: The Quest for an Arts and Crafts Utopia* (Syracuse, NY: Syracuse University Press, 2001), 30.

25. A[lgie] M. Simons, "The Economic Foundation of the Arts," *Craftsman* 1 (March 1902): 41.

26. Gustav Stickley, "Thoughts Occasioned by an Anniversary: A Plea for a Democratic Art," *Craftsman* 7, no. 1 (October 1904): 43.

27. Gustav Stickley, "Als Ik Kan," *Craftsman* 11, no. 1 (October 1906): 128.

28. Eileen Boris, *Art and Labor: Ruskin, Morris, and the Craftsman Ideal in America* (Philadelphia: Temple University Press, 1986), 76.

29. Quoted in Barry Sanders, *A Complex Fate: Gustav Stickley and the Craftsman Movement* (New York: John Wiley and Sons, 2006).

30. Raymond Riordan, "A New Idea in State Schools A New Idea in State Schools that Will Build up Character and Body as well as Brain: A Suggestion for California," *Craftsman* 24, no. 1 (April 1913): 52–60.

31. Emily Marshall Orr, "The Craftsman Building: Gustav Stickley's 'Home' in New York City," *Journal of Modern Craft* 10, no. 3 (November 2017): 273–91.

32. Quoted in Eileen Boris, "Dreams of Brotherhood and Beauty: The Social Ideas of the Arts and Crafts Movement," in Wendy Kaplan, ed., *The Art that Is Life: The Arts and Crafts Movement in America, 1875–1920* (Boston: Museum of Fine Arts, 1987), 219.

33. Kaplan, *The Art that Is Life*, page 316.

34. Elbert Hubbard, "A Little Journey to Tuskegee," *Philistine*, July 1904, 44.

35. Edward S. Cooke Jr., "Scandinavian Modern Furniture in the Arts and Crafts Period: The Collaboration of the Greenes and the Halls," *American Furniture* (Chipstone Foundation) (1993).

36. Nancy Green, *Byrdcliffe: An American Arts and Crafts Colony* (Ithaca, NY: Herbert F. Johnson Museum, 2004).

37. Mary Ware Dennett, "The Arts and Crafts: An Outlook," *Handicraft* 2 (April 1903): 5–8; Mary Ware Dennett, "Aesthetics and Ethics," *Handicraft* 1, no. 2 (May 1902): 29–33. Dennett's *The Sex Side of Life* (1915) is little known today but was, for its time, a remarkably frank and progressive exploration of social issues affecting women. She continued her activism into the 1920s and was eventually brought up on charges of obscenity; the satirical writer H. L. Mencken defended her, dismissing her conservative critics as "the Smut-Snufflers."

38. Thorstein Veblen, "Arts and Crafts," in Veblen, *Essays in Our Changing Order* (Piscataway, NJ: Transaction Publishers, 1954).

39. Mary Harris Jones, *Autobiography of Mother Jones* (Chicago: Charles Kerr, 1925); Elliot Gorn, *Mother Jones: The Most Dangerous Woman in America* (New York: Hill and Wang, 2001).

40. Jones, *Autobiography of Mother Jones.*

41. Walter Licht, *Industrializing America: The Nineteenth Century* (Baltimore: Johns Hopkins University Press, 1995), 173.

42. Ileen A. DeVault, *United Apart: Gender and the Rise of Craft Unionism* (Ithaca, NY: Cornell University Press, 2004); Mark Walker, "Aristocracies of Labor: Craft Unionism, Immigration, and Working-Class Households in West Oakland, California," *Historical Archaeology* 42, no. 1 (2008): 108–32.

43. Samuel Gompers, *Seventy Years of Life and Labor* (New York: E. P. Dutton, 1925), 17

44. Eugene Debs, "The Call" (speech, delivered in Canton, OH, June 16, 1918).

45. Frederick Winslow Taylor, *Shop Management* (1903), reprinted in Taylor, *Scientific Management* (New York: Harper and Row, 2011), 63. See also Joshua B. Freeman, *Behemoth: A History of the Factory and the Making of the Modern World* (New York: W. W. Norton, 2018), 90, 107.

46. Jill Lepore, "Not So Fast," *New Yorker*, October 12, 2009.

47. Quoted in Martha Banta, *Taylored Lives: Narrative Productions in the Age of Taylor, Veblen, and Ford* (Chicago: University of Chicago Press, 1993), 118.

48. Harry Braverman, *Labor and Monopoly Capitalism: The Degradation of Work in the Twentieth Century* (New York: Monthly Review Press, 1974), 67.

49. Braverman, *Labor and Monopoly Capitalism*, 318.

50. Julian Street, *Abroad at Home* (New York: The Century Co., 1914), 93.

51. Thorstein Veblen, *The Instinct of Workmanship* (New York: Macmillan, 1914), 270.

52. Henry Ford, *My Life and Work* (New York: Doubleday, Page and Company, 1923), 24.

53. Quoted in David Montgomery, *The Fall of the House of Labor: The Workplace, the State, and American Labor Activism, 1865–1925* (Cambridge, UK: Cambridge University Press 1987), 14.

54. Jennifer Gilley and Stephen Burnett, "Deconstructing and Reconstructing Pittsburgh's Man of Steel," *Journal of American Folklore* 111, no. 442 (Autumn 1998): 392–408.

55. Jane Addams, *Twenty Years at Hull-House* (1910; repr., New York: Signet, 1999), 65.

56. Addams, *Twenty Years at Hull-House*, 39.

57. Rick A. Lopez, "Forging a Mexican National Identity in Chicago: Mexican Migrants and Hull-House," in Cheryl R. Ganz and Margaret Strobel, eds., *Pots of Promise: Mexicans and Pottery at Hull-House, 1920–40* (Urbana and Chicago: University of Illinois Press, 2004).

58. Ellen Gates Starr, "Art and Labor," in Starr, *Hull-House Maps and Papers* (Boston: Thomas Y. Crowell and Co., 1895).

59. Nonie Gadsden, *Art and Reform: Sara Galner, the Saturday Evening Girls, and the Paul Revere Pottery* (Boston: Museum of Fine Arts, 2007).

60. Quoted in Kaplan, *The Art that Is Life*, 247.

61. *Amana Visitor's Guide 2018* (Amana, Iowa: Amana Colonies, 2018); Whirlpool Corporation Employee Reviews for Assembler in Amana, IA, indeed.com.

Chapter 5: AMERICANA

1. "Literary Clubland: The Cliff Dwellers of Chicago," *Bookman* 28 (1909): 542–48. The group had first met in 1907 as the Attic Club and formally adopted the name of the Cliff Dwellers in 1909. Women were not admitted until 1984. See also Judith Barter and Andrew Walker, *Window on the West: Chicago and the Art of the New Frontier 1890–1940* (Chicago: Art Institute of Chicago, 2003).

2. Van Wyck Brooks, "On Creating a Usable Past," *The Dial*, April 11, 1918, 337–41.

3. "Indian Blankets, Baskets and Bowls The Product of the Original Craftworkers of This Continent," *Craftsman* 17, no. 5 (February 1910): 588–90; Gustav Stickley, "The Colorado Desert and California," *Craftsman* 6, no. 3 (June 1904): 234–59.

4. Charles Eastman (Ohiyesa), *Indian Boyhood* (New York: McClure Phillips, 1902), v.

5. Laura Graves, *Thomas Varker Keam: Indian Trader* (Norman: University of Oklahoma Press, 1998).

6. Zena Pearlstone, "Hopi Doll Look-Alikes: An Extended Definition of Inauthenticity," *American Indian Quarterly* 35, no. 4 (Fall 2011): 579–608.

7. Quoted in Robert Fay Schrader, *The Indian Arts and Crafts Board: An Aspect of New Deal Indian Policy* (Albuquerque: University of New Mexico Press, 1983), 4.

8. Edwin L. Wade, *The Arts of the North American Indian: Native Traditions in Evolution* (New York: Hudson Hills Press/Philbrook Art Center, 1986), 180–84; Barbara Kramer, *Nampeyo and Her Pottery* (Albuquerque: University of New Mexico Press, 1996).

9. Otis Mason, *Women's Share in Primitive Culture* (New York: D. Appleton and Company, 1899), 92.

10. Lea McChesney, "Producing Generations in Clay: Kinship, Markets, and Hopi Pottery," *Expedition* 36, no. 1 (1994).

11. Gail Tremblay, "Cultural Survival and Innovation: Native American Aesthetics," in Janet Kardon, ed., *Revivals: Diverse Traditions* (New York: American Craft Museum, 1994).

12. Wade, *The Arts of the North American Indian*, 251.

13. Alice Lee Mariott, *María: The Potter of San Ildefonso* (Norman: University of Oklahoma Press, 1948). The review is quoted in Barbara Babcock, "Mudwomen and Whitemen: A Meditation on Pueblo Potteries and the Politics of Representation," in Katharine Martinez and Kenneth Ames, eds., *The Material Culture of Gender, The Gender of Material Culture* (Winterthur, DE: Winterthur Museum/University Press of New England, 1997).

14. Susan Peterson, *The Living Tradition of Maria Martinez* (Tokyo: Kodansha, 1977), 71, 99.

15. Charles Frederick Harder, "Some Queer Laborers," *Craftsman* 10, no. 6 (September 1906): 752; Henrietta Lidchi, *Surviving Desires: Making and Selling Native Jewellery in the American Southwest* (Norman: University of Oklahoma Press, 2015), 19. Though Slender Maker of Silver's image has been used to represent the ancestral origin of Navajo silverwork, he, too, was at the receiving end of a lineage. He is thought to have been trained by his older brother, Atsidii Sáni ("Old Smith"), a blacksmith who in turn learned his skills from a Mexican metalworker.

16. *Low Country Gullah Culture* (Atlanta, GA: National Park Service, Southeast Regional Office, 2005), 64. The highway marker was placed in 1997.

17. Wilbur Cross, *Gullah Culture in America* (Westport, CT: Prager, 2008).

18. John Michael Vlach, "Keeping on Keeping On: African American Craft During the Era of Revivals," in Kardon, *Revivals*.

19. Quoted in Laura E. Weber, "The House That Bullard Built," *Minnesota History* 59, no. 2 (Summer 2004): 62–71.

20. Andrew Nelson Lytle, "The Hind Tit," in *I'll Take My Stand: The South and the Agrarian Tradition, by Twelve Southerners* (1930; repr., Baton Rouge: Louisiana State University Press, 2006), 234.

21. John Gould Fletcher, "Education, Past and Present," in *I'll Take My Stand*, 121, 93.

22. Frank Lawrence Owsley, "The Irrepressible Conflict," in *I'll Take My Stand*, 62.

23. Susan V. Donaldson, introduction to *I'll Take My Stand*, xl.

24. Horace Kephart, *Our Southern Highlanders* (New York: Outing Publishing Company, 1913), chap. 1.

25. Frances Goodrich, *Allanstand Cottage Industries* (New York: Woman's Board of Home Missions, 1909), 11.

26. Frances Goodrich, *Mountain Homespun* (New Haven, CT: Yale University Press, 1931).

27. William G. Frost, "Berea College," *Berea Quarterly* 1 (May 1895): 24. See Shannon Wilson, "Lincoln's Sons and Daughters," in Wilson and Kenneth Noe, eds., *The Civil War in Appalachia: Collected Essays* (Knoxville: University of Tennessee Press, 1997).

28. Quoted in Philis Alvic, *Weavers of the Southern Highlands* (Louisville: University of Kentucky Press, 2003), 5.

29. Quoted in Garry Barker, *The Handcraft Revival in Southern Appalachia, 1930–1990* (Knoxville: University of Tennessee Press, 1991), 5.

30. John C. Campbell, *The Southern Highlander and His Homelander* (New York: Russell Sage Foundation, 1921), xxi, 129.

31. David Whisnant, *All That Is Native and Fine: The Politics of Culture in an American Region* (Chapel Hill: University of North Carolina Press, 1983).

32. Lucy Morgan, *A Gift from the Hills* (Chapel Hill: University of North Carolina Press, 1971), chap. 9. Morgan had studied weaving techniques with Worst in Chicago prior to this visit; he would return to Penland to teach annually until his death in 1949. Woody was a skilled weaver and dyer who had also sold her work through Allanstand Industries.

33. Allen H. Eaton, "Mountain Handicrafts: What They Mean to Our Home Life and to the Life of Our Country," *Mountain Life and Work*, July 1926.

34. Allen H. Eaton, *Handicrafts of the Southern Highlands* (1937; repr., New York: Dover, 1973), 123.

35. Eaton, *Handicrafts of the Southern Highlands*, 115, 133.

36. Eaton, *Handicrafts of the Southern Highlands*, 21.

37. Henry Chapman Mercer, *The Tools of the Nation-Maker: A Descriptive Catalogue of Objects in the Museum of the Historical Society of Bucks County, Penna* (Doylestown, PA: Historical Society of Bucks County, 1897), 1.

38. Mercer, *The Tools of the Nation-Maker*, 1, 6, 25.

39. Quoted in Linda F. Dyke, *Henry Chapman Mercer: An Annotated Chronology* (Doylestown, PA: Bucks County Historical Society, 2009), 17.

40. Benjamin H. Barnes, *The Moravian Pottery: Memories of Forty-Six Years* (Doylestown, PA: Bucks County Historical Society, 1970), 7.

41. Steven Conn, "Henry Chapman Mercer and the Search for American History," *Pennsylvania Magazine of History and Biography* 116, no. 3 (July 1992): 330.

42. Clifford Warren Ashley, "The Blubber Hunters, Part 1," *Harper's Weekly*, May 1906.

43. Quoted in Nicole Jeri Williams, "Whalecraft: Clifford Warren Ashley and Whaling Craft Culture in Industrial New Bedford," *Journal of Modern Craft* 11, no. 3 (November 2018).

44. Quoted in C. B. Hosmer Jr., *Preservation Comes of Age: From Williamsburg to the National Trust* (Charlottesville: University of Virginia Press, 1981), 94. See also Michael Kammen, *Mystic Chords of Memory: The Transformation of Tradition in American Culture* (New York: Alfred A. Knopf, 1991), 353.

45. Quoted in Karen Lucic, "Charles Sheeler and Henry Ford: A Craft Heritage for the Machine Age," *Bulletin of the Detroit Institute of Arts* 65, no. 1 (1989): 42.

46. William Goodwin, "The Restoration of Colonial Williamsburg," *Phi Beta Kappa Key* 7, no. 8 (May 1930): 514–20.

47. Michael Wallace, "Visiting the Past: History Museums in the United States," in Phyllis K. Leffler and Joseph Brent, eds., *Public History Readings* (Malabar, FL: Krieger Publishing, 1992).

48. Thomas Jefferson Wertenbaker, "The Restoring of Colonial Williamsburg," *North Carolina Historical Review* 27, no. 2 (April 1950): 218–32.

49. William De Matteo, *The Silversmith in Eighteenth-Century Williamsburg: An Account of His Life and Times, and of His Craft* (Williamsburg, VA: Colonial Williamsburg, 1956).

50. Mary Scott Rollins, "Furnishings in the Williamsburg Spirit," *Better Homes and Gardens*, September 1937, 30–31, 86–87.

51. Charles Alan Watkins, "The Tea Table's Tale: Authenticity and Colonial Williamsburg's Early Furniture Reproduction Program," *West 86th* 21, no. 2 (Fall/Winter 2014): 155–91.

52. Alfred C. Bossom, "Colonial Williamsburg: How Americans Handle a Restoration," *Journal of the Royal Society of Arts* 90, no. 4621 (September 4, 1942): 634–44.

53. Robert de Forest, "Address on the Opening of the American Wing," *Metropolitan Museum of Art Bulletin* 19, no. 12 (December 1924): 288.

54. Robert de Forest, "The American Wing and the Nation's Business," *American Magazine of Art* 21, no. 9 (September 1930): 537.

55. Thomas Denenberg, *Wallace Nutting and the Invention of Old America* (New Haven, CT: Yale University Press/Wadsworth Atheneum Museum of Art, 2003), 131.

56. Quoted in Gary Gertsle, *American Crucible: Race and Nation in the Twentieth Century* (Princeton, NJ: Princeton University Press, 2001), 51.

57. Quoted in Jeffrey E. Mirel, *Patriotic Pluralism: Americanization, Education and European Immigrants* (Cambridge, MA: Harvard University Press, 2010), 68.

58. Carol Troyen, "The Incomparable Max: Maxim Karolik and the Taste for American Art," *American Art* 7, no. 3 (Summer 1993): 64–87.

59. Albert Sack, *Fine Points of Furniture: Early American* (New York: Crown Publishers, 1950).

60. Erica Lome, "American by Design: Isaac Kaplan's Furniture for the Colonial Revival," *American Furniture* (Chipstone Foundation) (2017).

61. Bruce Hatton Boyer, "Creating the Thorne Rooms," in *Miniature Rooms: The Thorne Rooms at the Art Institute of Chicago* (Chicago: Art Institute of Chicago, 1983), 19.

62. Kate White, "The Pageant Is the Thing: The Contradictions of Women's Clubs and Civic Education During the Americanization Era," *College English* 77, no. 6 (July 2015): 512–29.

63. Annelise K. Madsen, "Columbia and Her Foot Soldiers: Civic Art and the Demand for Change at the 1913 Suffrage Pageant-Procession," *Winterthur Portfolio* 48, no. 4 (Winter 2014): 283–310.

64. "The Women's Party and the Press," *Suffragist* 7, no. 37 (September 13, 1919): 7.

65. Marc Leepson, *Flag: An American Biography* (New York: Macmillan, 1907).

66. Quoted in Mary Simonson, *Body Knowledge: Performance, Intermediality, and American Entertainment at the Turn of the Twentieth Century* (Oxford: Oxford University Press, 2013), 52.

67. Rose Moss Scott, *Illinois State History: Daughters of the American Revolution* (Danville: Illinois Printing Company, 1929), 152.

68. Ernest Thomson Seton, *The Birch-Bark Roll of the Woodcraft Indians* (New York: Doubleday, Page and Co., 1907).

69. *Scouting for Girls* (New York: Girl Scouts, 1920), 284. See also Philip Deloria, *Playing Indian* (New Haven, CT: Yale University Press, 1998), 109.

70. Quoted in Ginger Wadsworth, *First Girl Scout: The Life of Juliette Gordon Low* (New York: Clarion Books, 2012), 104.

71. Rebekah E. Revzin, "American Girlhood in the Early Twentieth Century: The Ideology of Girl Scout Literature, 1913–1930," *Library Quarterly* 68, no. 3 (July 1998): 261–75.

72. Juliette Gordon Low, *How Girls Can Help Their Country* (New York: Girl Scouts Inc., 1917), 9–10.

73. Quoted in Wendy A. Cooper, "A Historic Event: The 1929 Girl Scouts Loan Exhibition," *American Art Journal* 12, no. 1 (Winter 1980): 30.

Chapter 6: MAKING WAR

1. Press caption for *New Horizons in American Art*, Museum of Modern Art, New York, 1936.

2. Russell Vernon Hunter, "Concerning Patrocinio Barela," in Francis V. O'Connor, ed., *Art for the Millions: Essays from the 1930s by Artists and Administrators of the WPA Federal Art Project* (Greenwich, CT: New York Graphic Society, 1973), 96.

3. Quoted in Stephanie Lewthwaite, *A Contested Art: Modernity and Mestizaje in New Mexico* (Norman: University of Oklahoma Press, 2015), 103; Edward Gonzales and David L. Witt, *Spirit Ascendant: The Art and Life of Patrociño Barela* (Santa Fe, NM: Red Crane Books, 1996); Tey Marianna Nunn, *Sin Nombre: Hispana and Hispano Artists of the New Deal Era* (Albuquerque: University of New Mexico Press, 2001).

4. Lois Palken Rudnick, *Mabel Dodge Luhan: New Woman, New Worlds* (Albuquerque: University of New Mexico Press, 1984), 182.

5. "A Tastemaker and Her Rediscovered Treasures," *Antiques*, April 17, 2017; Lois Palken Rudnick, *Utopian Vistas: The Mabel Dodge Luhan House and the American Counterculture* (Albuquerque: University of New Mexico Press, 1996).

6. Mary Austin, *The Basket Woman: A Book of Indian Tales for Children* (Boston: Houghton Mifflin, 1904), 47.

7. Quoted in Rudnick, *Mabel Dodge Luhan*, 180.

8. Mary Austin, *Everyman's Genius* (Indianapolis, IN: Bobbs-Merrill, 1923), 12, 23.

9. Stuart Chase, *Mexico: A Study of Two Americas* (New York: Macmillan, 1931). See also Wendy Kaplan, *Found in Translation: Design in California and Mexico, 1915–1985* (Los Angeles: Los Angeles County Museum of Art/Prestel, 2018).

10. The term *significant form* was coined by Clive Bell and then developed by Roger Fry, both members of the Bloomsbury Group. See Bell, *Art* (New York: Frederick A. Stokes, 1914); and Christopher Reed, ed., *A Roger Fry Reader* (Chicago: University of Chicago Press, 1996). See also Glenn Adamson, Martina Droth, and Simon Olding, eds., *Things of Beauty Growing: British Studio Pottery* (New Haven, CT: Yale University Press, 2017); and Kim Brandt, *Kingdom of Beauty: Mingei and the Politics of Folk Art in Imperial Japan* (Chapel Hill, NC: Duke University Press, 2007).

11. Quoted in Wendy Jeffers, "Holger Cahill and American Art," *Archives of American Art Journal* 31, no. 4 (1991): 5.

12. John Cotton Dana, "The Gloom of the Museum," *Newarker* 2, no. 12 (October 1913): 392.

13. Ezra Shales, *Made in Newark: Cultivating Industrial Arts and Civic Identity in the Progressive Era* (New Brunswick, NJ: Rivergate/Rutgers University Press, 2010), 181; Ezra Shales, "Mass Production as an Academic Imaginary," *Journal of Modern Craft* 6, no. 3 (November 2013): 267–74.

14. Holger Cahill, introduction to *New Horizons in American Art* (New York: Museum of Modern Art, 1936), 19.

15. Dana, "The Gloom of the Museum," 399.

16. Alfred H. Barr Jr., letter to the editor, *College Art Journal* 10, no. 11 (Autumn 1950): 57.

17. Gordon Mackintosh Smith, quoted in Stephen Bowe and Peter Richmond, *Selling Shaker: The Commodification of Shaker Design in the Twentieth Century* (Liverpool: Liverpool University Press, 2007), 11.

18. Cahill, introduction to *New Horizons in American Art*, 24. The watercolors are now in the collection of the National Gallery of Art. See Virginia Tuttle Clayton, ed., *Drawing on America's Past: Folk Art, Modernism, and the Index of American Design* (Washington, D.C.: National Gallery of Art, 2002).

19. Holger Cahill, *The Shadow of My Hand* (New York: Harcourt, Brace and Company, 1956), 48.

20. The airport never materialized because after the attack on Pearl Harbor, Treasure Island was converted into a military base.

21. Paul Conant, "The Golden Gate Exposition," *ALA Bulletin* 33, no. 3 (March 1939): 190; Robert W. Rydell, *World of Fairs: The Century-of-Progress Expositions* (Chicago: University of Chicago Press, 1993), 130.

22. Wallace's prominence was ironic. Though he was a traditionally trained carver, he had converted to Christianity and had actually participated in the destruction of totem poles in Alaska before government funding motivated him to return to the art form. Alison K. Hoagland, "Totem Poles and Plank Houses: Reconstructing Native Culture in Southeast Alaska," *Perspectives in Vernacular Architecture* 6 (1997): 181.

23. Robert Fay Schrader, *The Indian Arts and Crafts Board: An Aspect of New Deal Indian Policy* (Albuquerque: University of New Mexico Press, 1983), 190.

24. D'Harnoncourt, paraphrased in Kathleen McLaughlin, "Coast Fair Draws More Than Chicago," *New York Times*, February 22, 1939.

25. Quoted in Emily Navratil, "Native American Chic: The Marketing of Native Americans in New York Between the World Wars," doctoral diss., City University of New York, 2015, 192.

26. *Official Guide Book, Golden Gate International Exposition* (1939), 57, 62.

27. Alexa Winton, "Color and Personality: Dorothy Liebes and American Design," *Archives of American Art Journal* 48, no. 1–2 (Spring 2009): 4–17.

28. Dorothy Liebes, "Weaving Materials, Old and New," *Craft Horizons* 2, no. 1 (May 1942): 5.

29. Dorothy Liebes, "Tomorrow's Weaving," *Woman's Day*, April 1944, 32.

30. Maurice Sterne, "Workshops," in *Official Catalogue: Golden Gate Exposition* (San Francisco: Golden Gate International Exposition, 1939), 23.

31. Alexa Winton, "None of Us Is Sentimental About the Hand: Dorothy Liebes, Handweaving, and Design for Industry," *Journal of Modern Craft* 4, no. 3 (November 2011): 251–68. See also Virginia G. Troy, "Textiles as the Face of Modernity: Artistry and Industry in Mid-Century America," *Textile History* 50, no. 1 (2019): 23–40.

32. Navratil, "Native American Chic," 213.

33. René d'Harnoncourt and Frederic H. Douglas, *Indian Art of the United States* (New York: Museum of Modern Art, 1941), 8, 9, 197.

34. *Fred Kabotie, Hopi Indian Artist* (Flagstaff: Museum of Northern Arizona, 1977), 71; quoted in Navratil, "Native American Chic," 228.

35. My thanks to the historian Anya Montiel for sharing her research on this aspect of the Indian Court.

36. Quoted in *Booming Out: Mohawk Ironworkers Build New York* (Washington, D.C.: National Museum of the American Indian, 2002).

37. Oliver La Farge, "The Indian as Artist," *New York Times*, January 26, 1941.

38. "The Museum of Modern Art Appoints René d'Harnoncourt Director of a New Department," press release, 1944.

39. Eliot Noyes, *Organic Design in Home Furnishings* (New York: Museum of Modern Art, 1941), 4, 5.

40. James C. Kimble and Lester C. Olson, "Visual Rhetoric Representing Rosie the Riveter," *Rhetoric and Public Affairs* 9, no. 4 (Winter 2006): 533–69.

41. The original painting, now in the Crystal Bridges Museum of American Art, Bentonville, Arkansas, was at one time owned by the Chicago Pneumatic Tool Company and displayed in its New York offices next to examples of the riveting gun shown in the image.

42. Sherna Gluck, *Rosie the Riveter Revisited* (Boston: Twayne Publishers, 1987), 12.

43. Maureen Honey, *Creating Rosie the Riveter* (Amherst: University of Massachusetts Press, 1985), 128, 129; Winifred Raushenbush, *How to Dress in Wartime* (New York: Coward-McCann, 1942), xi.

44. Kazuhiro Mishina, "Learning by New Experiences: Revisiting the Flying Fortress Learning Curve," in Naomi Lamoreaux, Daniel M. G. Raff, and Peter Temin, eds., *Learning by Doing in Markets, Firms, and Countries* (Chicago: University of Chicago Press, 1999), 168.

45. Lola Weixel, interviewed in *The Life and Times of Rosie the Riveter*, dir. Connie Field (1980).

46. Quoted in Gluck, *Rosie the Riveter Revisited*, 22–49.

47. Philip W. Nyden, "Evolution of Black Political Influence in American Trade Unions," *Journal of Black Studies* 13, no. 4 (June 1983): 385; Robert J. Norell, "Caste in Steel: Jim Crow Careers in Birmingham, Alabama," *Journal of American History* 73, no. 3 (December 1986): 669–94.

48. Josh Sides, "Battle on the Home Front: African American Shipyard Workers in World War II Los Angeles," *California History* 75, no. 3 (Fall 1996): 251.

49. Elizabeth McDougal, "Negro Youth Plans Its Future," *Journal of Negro Education* 10, no. 2 (April 1941): 223–29.

50. *American Negro Exposition, 1863–1940: Official Program and Guide Book* (Chicago, 1940).

51. Quoted in Margalit Fox, obituary for Ruth Clement Bond, *New York Times*, November 13, 2005.

52. April Kingsley, "Ruth Clement Bond and the TVA Quilts," in Kardon, *Revivals*; Angelik Vizcarrondo-Laboy, "Fabric of Change: The Quilt Art of Ruth Clement Bond," in *Views* (New York: Museum of Arts and Design, 2017).

53. Philip Scranton and Walter Licht, *Work Sights: Industrial Philadelphia, 1850–1950* (Philadelphia: Temple University Press, 1986), 244.

54. Robert C. Weaver, "The Employment of the Negro in War Industries," *Journal of Negro Education* 12, no. 3 (Summer 1943): 386–96.

55. Quoted in Rawn James Jr., *Double V: How Wars, Protest and Harry Truman Desegregated America's Military* (New York: Bloomsbury, 2013), 148–49.

56. Philip Scranton and Walter Licht, *Work Sights: Industrial Philadelphia, 1850–1950* (Philadelphia: Temple University Press, 1986).

57. Robert C. Weaver, "Negro Employment in the Aircraft Industry," *Quarterly Journal of Economics* 59, no. 4 (August 1945): 623.

58. Quoted in Sides, "Battle on the Home Front," 263.

59. Quintard Taylor, "The Great Migration: The Afro-American Communities of Seattle and Portland During the 1940s," *Arizona and the West* 23, no. 2 (Summer 1981): 109–26.

60. Maya Angelou, *I Know Why the Caged Bird Sings* (New York: Random House, 1969), chap. 27.

61. Allen H. Eaton, *Handicrafts of New England* (New York: Harper and Brothers, 1949).

62. Allen H. Eaton, *Beauty Behind Barbed Wire* (New York: Harper and Brothers, 1952).

63. Eaton, *Beauty Behind Barbed Wire*. See also Delphine Hirasuna, *The Art of Gaman: Arts and Crafts from the Japanese American Internment Camps, 1942–46* (Berkeley, CA: Ten Speed Press, 2005).

64. Quoted in Robert J. Maeda, "Isamu Noguchi: 5-7-A, Poston, Arizona," in Erica Harth, ed., *Last Witnesses: Reflections on the Wartime Internment of Japanese Americans* (New York: Palgrave MacMillan, 2003), 154, 158.

65. Isamu Noguchi, "I Become a Nisei," unpublished manuscript, 1942.

66. Oral history interview with Mira Nakashima, March 11, 2010, Archives of American Art, Smithsonian Institution, Washington, D.C.; "Gentaro Kenneth Hikogawa," *Densho Encyclopedia* (online resource).

67. Quoted in Jane E. Dusselier, *Artifacts of Loss: Crafting Survival in Japanese American Concentration Camps* (New Brunswick, NJ: Rutgers University Press, 2008).

68. Richard Rhodes, *The Making of the Atomic Bomb* (New York: Simon and Schuster, 1986).

69. Maj. Nathaniel Saltonstall, "Why Crafts in the Army," *Craft Horizons* 4, no. 11 (November 1945): 8.

70. "Do It Yourself!" *Good Housekeeping* 116, no. 4 (April 1943): 116.

71. "Craftsmen and the War," *Craft Horizons* 2, no. 2 (May 1943): 12.

72. Press release for *Occupational Therapy: Its Function and Purpose*, Museum of Modern Art, New York, 1943.

73. "Vanderbilt Webb Weds Miss Osborn," *New York Times*, September 12, 1942.

74. Aileen Osborn Webb, *Almost a Century: Memoirs of Aileen Osborn Webb*, typescript c. 1977 (Archives of American Art, Smithsonian Institution, Washington, D.C., and Archives of American Craft Council, Minneapolis), 73. See Ellen Paul Denker, "Aileen Osborn Webb and the Origins of Craft's Infrastructure," *Journal of Modern Craft* 6, no. 1 (March 2013): 11–34.

75. "Do You Know Our Name?" [*Craft Horizons*] 1, no. 1 (1941): 4.

76. Holger Cahill, "Unity," [*Craft Horizons*] 1, no. 1 (1941): 25.

77. Quoted in Suzanne Mettler, *Soldiers to Citizens: The G.I. Bill and the Making of the Greatest Generation* (Oxford: Oxford University Press, 2005), 7.

78. Mettler, *Soldiers to Citizens*, 11.

79. Ira Katznelson, *When Affirmative Action Was White* (New York: W. W. Norton, 2006).

80. See Jennifer Scanlan and Ezra Shales, "Pathmakers: Women in Art, Craft and Design, Mid-Century and Today," special issue, *Journal of Modern Craft* 8, no. 2 (July 2015).

81. *Textiles U.S.A.* (New York: Museum of Modern Art, 1956), 4, 6.

82. Dorothy Giles, "The Craftsman in America," in *Designer Craftsmen U.S.A.* (Brooklyn, NY: Brooklyn Museum and the American Craftsmen's Educational Council, 1953), 13.

83. Ed Rossbach, oral history interview (Berkeley: Bancroft Library, University of California at Berkeley, 1983), 57.

84. Arthur Hald, "Half Truths About American Design," *Design Quarterly* 29 (1954): 5–6.

Chapter 7: DECLARATIONS OF INDEPENDENCE

1. Quoted in Oren Arnold and Eleanor Gianelli, "Their Hobbies Built a Home," *Better Homes and Gardens*, February 1950, 41–42, 142–45. Wilbur Hoff went on to

become a successful psychiatrist, while Ida Lucille is recorded as a graduation speaker at the local high school; she spoke on the theme "The World Is Unfinished."

2. Albert Roland, "Do-It-Yourself: A Walden for the Millions?" *American Quarterly* 10, no. 2 (Summer 1958): 154.

3. Amy Bix, "Creating 'Chicks Who Fix': Women, Tool Knowledge, and Home Repair, 1920–2007," *Women's Studies Quarterly* 37, no. 1–2 (Spring/Summer 2009): 38–60; Carolyn Goldstein, *Do It Yourself: Home Improvement in 20th Century America* (New York: Princeton Architectural Press, 1998).

4. "The Home that Millions Want: The Popular Mechanics Build-It-Yourself House," *Popular Mechanics*, April 1947, 105–11.

5. Stephen Knott, *Amateur Craft: History and Theory* (London: Bloomsbury, 2015).

6. Richard Harris, *Building a Market: The Rise of the Home Improvement Industry, 1914–1960* (Chicago: University of Chicago Press, 2012), 319, 321, 326.

7. Roland, "Do-It-Yourself: A Walden for the Millions," 155; Sarah A. Lichtman, "Do-It-Yourself Security: Safety, Gender, and the Home Fallout Shelter in Cold War America," *Journal of Design History* 19, no. 1 (Spring 2006): 39–55.

8. Oliver J. Curtis, "Nominal Versus Actual: A History of the 2x4," *Harvard Design Magazine* 45 (Spring/Summer 2018).

9. Ronald E. Spreng, "They Didn't Just Grow There: Building Water Towers in the Postwar Era," *Minnesota History* 53, no. 4 (Winter 1992): 130–41.

10. Lee Loevinger, "Handicraft and Handcuffs: The Anatomy of an Industry," *Law and Contemporary Problems* 12, no. 1 (Winter 1947): 49.

11. Margaret Mead, "The Pattern of Leisure in Contemporary American Culture," *Annals of the American Academy of Political and Social Science* 313 (September 1957): 11–15. See also Margaret Mead, "Work, Leisure, and Creativity," *Daedalus* 89, no. 1 (Winter 1960): 13–23.

12. Patrick D. Hazard, "Leisure for What?" *Clearing House* 32, no. 9 (May 1958): 565.

13. Theodor W. Adorno, "Free Time," in *The Culture Industry* (New York: Routledge Classics, 2001).

14. David Riesman, with Nathan Glazer and Reuel Denney, *The Lonely Crowd: A Study of the Changing American Character* (New Haven, CT: Yale University Press, 1950).

15. Edward Throm, ed., *Fifty Years of Popular Mechanics, 1902–1952* (New York: Simon and Schuster, 1952).

16. Donald P. Costello, "The Language of 'The Catcher in the Rye,'" *American Speech* 34, no. 3 (October 1959): 173.

17. June Diemer, "Good Buy, Mr. Chips?" *High School Journal* 42, no. 2 (November 1958): 46.

18. H. H. Remmers and D. H. Radler, "Teenage Attitudes," *Scientific American* 198, no. 6 (June 1958): 25, 26.

19. Kelly Schrum, *Some Wore Bobby Sox: The Emergence of Teenage Girls' Culture, 1920–1945* (New York: Palgrave Macmillan, 2004).

20. Quoted in Eileen Margerum, "The Sewing Needle as Magic Wand: Selling Sewing Lessons to American Girls After the Second World War," in Barbara Burman, ed., *The Culture of Sewing: Gender, Consumption and Home Dressmaking* (Oxford: Berg Publishers, 1999).

21. Meyer Berger, "Zoot Suit Originated in Georgia," *New York Times*, June 11, 1943.

22. Stuart Cosgrove, "The Zoot Suit and Style Warfare," in Angela McRobbie, ed., *Zoot Suits and Second-Hand Dresses* (London: Macmillan, 1989).

23. "Girl Who Couldn't Sew Booms Into Business with Circle Skirt," *Toledo Blade*, February 23, 1953, 26.

24. "How to dress as if money were no object," *Ebony*, ad copy, December 1959, 158.

25. Jennifer Le Zotte, *From Goodwill to Grunge Book: A History of Secondhand Styles and Alternative Economies* (Durham: University of North Carolina Press, 2017), 134.

26. Ronald Green, *Innovation, Imitation, and Resisting Manipulation: The First Twenty Years of American Teenagers, 1941–1961* (PhD diss., University of Oklahoma, 1988), 162–63.

27. Quoted in Gene Balsley, "The Hot-Rod Culture," *American Quarterly* 2, no. 4 (Winter 1950): 356.

28. H. F. Moorhouse, *Driving Ambition: Social Analysis of the American Hot Rod Enthusiasm* (Manchester, UK: Manchester University Press, 1991), 38.

29. David N. Lucsko, *The Business of Speed: The Hot Rod Industry in America, 1915–1990* (Baltimore: Johns Hopkins University Press, 2008). A turbocharger injects compressed air into the engine, increasing efficiency and power.

30. Thomas K. Wolfe, "There Goes (Varoom! Varoom!) That Kandy Kolored (Thphhhhhh!) Tangerine-Flake Streamline Baby (Rahghhh!) Around the Bend (Brummmmmmmmmmmmmmmmmm. . .)," *Esquire*, November 1, 1963.

31. William White, "Problems of a Hot-Rod Lexicographer," *American Speech* 30, no. 3 (October 1955): 239.

32. Quoted in Janicemarie Allard Holtz, "The Low-Riders: Portrait of an Urban Youth Subculture," *Youth and Society* (June 1, 1975): 497.

33. David William Foster, *Picturing the Barrio* (Pittsburgh, PA: University of Pittsburgh Press, 2017), 117.

34. Eric Avila, *The Folklore of the Freeway: Race and Revolt in the Modernist City* (Minneapolis: University of Minnesota Press, 2014).

35. See Janet Koplos and Bruce Metcalf, *Makers: A History of the Studio Craft Movement* (Chapel Hill: University of North Carolina Press, 2010).

36. Jade Snow Wong, *Fifth Chinese Daughter* (1945; repr., Seattle: University of Washington Press, 1989), 582.

37. Quoted in Barry Harwood, *From the Village to Vogue: The Modernist Jewelry of Art Smith* (Brooklyn, NY: Brooklyn Museum, 2008), 5.

38. Quoted in Jayne Linderman, "Loloma: Stone, Bone, Silver, and Gold," *Craft Horizons* 34, no. 1 (February 1974): 24.

39. Marguerite Wildenhain, "The Socio-Economic Outlook," *Asilomar Conference Proceedings* (American Craftsmen's Council, Asilomar, CA) (1957): 18.

40. Rose Slivka, "The New Ceramic Presence," *Craft Horizons* 21, no. 4 (July/ August 1961): 31–37.

41. Barbara Rose, "Crafts Ain't What They Used to Be," *New York Magazine*, June 19, 1972, 72–73.

42. Lee Nordness and Margaret Phillips, performance lecture, 1971, Lee Nordness Papers, Archives of American Art, Smithsonian Institution.

43. Louise Bourgeois, "The Fabric of Construction," *Craft Horizons* 29, no. 2 (March/April 1969): 32. See also Elissa Auther, *String, Felt, Thread: The Hierarchy of Art and Craft in American Art* (Minneapolis: University of Minnesota Press, 2009).

44. F. Carlton Ball, "The Socio-Economic Outlook" *Asilomar Conference Proceedings*, 14.

45. Aileen Osborn Webb, "Craftsmen Today," *Asilomar Conference Proceedings*, 5.

46. "The Relation of the Past to the Demands of the Present" panel discussion, *World Craft Council Proceedings* World Crafts Council, New York, 1964); reprinted in Glenn Adamson, ed., *The Craft Reader* (Oxford: Berg, 2010), 203.

47. Rosa Parks, *My Story* (New York: Dial Books, 1992).

48. Quoted in Donnie Williams and Wayne Greenhaw, *The Thunder of Angels: The Montgomery Bus Boycott and the People Who Broke the Back of Jim Crow* (Chicago: Chicago Review Press, 2005), 48.

49. Quoted in Kenneth Torquil MacLean, "Origins of the Southern Civil Rights Movement: Myles Horton and the Highlander Folk School," *Phi Beta Kappan* 47, no. 9 (May 1966): 487.

50. Martin Luther King Jr., "A Look to the Future," 1957, in *Papers of Martin Luther King, Jr.,* vol. 4 (Berkeley: University of California Press, 2000).

51. James B. Jacobs and Ellen Peters, "Labor Racketeering: The Mafia and the Unions," *Crime and Justice* 30 (2003): 229–82.

52. Barbara S. Griffith, *The Crisis of American Labor: Operation Dixie and the Defeat of the CIO* (Philadelphia: Temple University Press, 1988).

53. Michelle Haberland, *Striking Beauties: Women Apparel Workers in the U.S. South, 1930–2000* (Athens: University of Georgia Press, 2015).

54. Quoted in Jack Barbash, "Union Interests in Apprenticeship and Other Training Forms," *Journal of Human Resources* 3, no. 1 (Winter 1968): 82, 84.

55. James Baldwin, "Interview on Race in America," *Esquire*, July 1968.

56. Quoted in Philip W. Nyden, "Evolution of Black Political Influence in American Trade Unions," *Journal of Black Studies* 13, no. 4 (June 1983): 379–98.

57. Aldo A. Lauria-Santiago, "Puerto Rican Workers and the Struggle for Decent Lives in New York City," in Joshua Freeman, ed., *City of Workers, City of Struggle* (New York: Columbia University Press, 2019).

58. Quoted in Nancy Callahan, *The Freedom Quilting Bee: Folk Art and the Civil Rights Movement* (Tuscaloosa: University of Alabama Press, 2005).

59. Rita Reif, "The Freedom Quilting Bee: A Cooperative Step Out of Poverty," *New York Times*, July 9, 1968, 34.

60. Quoted in William Arnett et al., *Gee's Bend: The Women and Their Quilts* (Atlanta, GA: Tinwood Books, 2003), 366. See also Anna Chave, "Dis/Cover/Ing the Quilt's of Gee's Bend, Alabama," *Journal of Modern Craft* 1, no. 2 (July 2008): 221–53.

61. Paul Fryman, *Black and Blue: African Americans, the Labor Movement, and the Decline of the Democratic Party* (Princeton, NJ: Princeton University Press, 2008), 1, 5.

62. John P. Hoerr, *And the Wolf Finally Came: The Decline of the American Steel Industry* (Pittsburgh, PA: University of Pittsburgh Press, 1988).

63. Jack Barbash, "Union Interests in Apprenticeship and Other Training Forms," *Journal of Human Resources* 3, no. 1 (Winter, 1968): 73.

64. Joshua B. Freeman, "Hard Hats: Construction Workers, Manliness, and the 1970 Pro-war Demonstrations," *Journal of Social History* 26 (1993): 725–45; Julia Bryan-Wilson, *Art Workers: Radical Practice in the Vietnam War Era* (Berkeley: University of California Press, 2009), 111; Woden Teachout, *Capture the Flag: A Political History of American Patriotism* (New York: Basic Books, 2009), 195–96.

65. Rachel Carson, *Silent Spring* (Boston: Houghton Mifflin, 1962).

66. Edith Fowke and Joe Glazer, *Songs of Work and Protest* (New York: Dover Publications, 1973). The book was a re-edition of an earlier collection entitled *Songs of Work and Freedom*, published in 1960.

67. Art Boericke and Barry Shapiro, *Handmade Houses: A Guide to the Woodbutcher's Art* (San Francisco: Scrimshaw Press, 1973).

68. Peter Rabbit [Peter Douthit], *Drop City* (New York: Olympia Press, 1971), 20.

69. Lloyd Kahn, *Domebook One* (Los Gatos, CA: Pacific Domes, 1970), 15.

70. Amy Azzarito, "Libre, Colorado, and the Hand-Built Home," in Elissa Auther and Adam Lerner, eds., *West of Center: Art and the Countercultural Experiment in America, 1965–1977* (Minneapolis: University of Minnesota Press, 2012), 99.

71. Robert M. Pirsig, *Zen and the Art of Motorcycle Maintenance* (New York: Bantam, 1974); John Jerome, *Truck: On Rebuilding a Pickup, and Other Post-Technological Adventures* (Boston: Houghton Mifflin, 1977), 1.

72. Peter Schumann, quoted on the Bread and Puppet Theater website. See also John Bell, "The End of 'Our Domestic Resurrection Circus': Bread and Puppet Theater and Counterculture Performance in the 1990s," *The Drama Review* 43, no. 3 (Autumn 1999): 62–80.

73. Judson Jerome, *Families of Eden: Communes and the New Anarchism* (New York: Seabury Press, 1974).

74. Paul H. Wild, "Flower Power: A Student's Guide to Pre-Hippie Transcendentalism," *English Journal* 58, no. 1 (January 1969): 62. Wild also wrote that "Thoreau, like the hippie, knew how to blow his mind, only for Thoreau, pure air was sufficient intoxicant."

75. Jared M. Phillips, "Hipbillies and Hillbillies: Back-to-the-Landers in the Arkansas Ozarks during the 1970s," *Arkansas Historical Quarterly* 75, no. 2 (Summer 2016): 91.

76. Eliot Wigginton, ed., *The Foxfire Book* (Garden City, NY: Doubleday, 1972), 12.

77. Pamela Wood, ed., *The Salt Book* (Garden City, NY: Doubleday, 1977), ix.

78. Paul Berensohn, "Finding One's Way with Clay," *Studio Potter* 1, no. 1 (1972): 18; Gerry Williams, "Editorial: Reading the Entrails," *Studio Potter* 3, no. 2 (Winter 1974/75): 4.

79. Quoted in Glenn Adamson, "Seeker," in Karen Patterson, ed., *Lenore Tawney: Mirror of the Universe* (Sheboygan, WI: John Michael Kohler Art Center/University of Chicago Press, 2019).

80. Alexandra Jacopetti, *Native Funk and Flash: An Emerging Folk Art* (San Francisco, CA: Scrimshaw Press, 1974), 12.

81. M. C. Richards, *Centering in Pottery, Poetry and the Person* (Wesleyan, CT: Wesleyan University Press, 1962), 15. See also Jenni Sorkin, *Live Form: Women, Ceramics, and Community* (Chicago: University of Chicago Press, 2016).

82. Ram Dass [Richard Alpert], *Be Here Now* (San Cristobal, NM: Lama Foundation, 1971), 5, 54.

83. Jacopetti, *Native Funk and Flash*, 5; Julia Bryan Wilson, *Fray: Art and Textile Politics* (Chicago: University of Chicago Press, 2017), 54.

84. Sherry L. Smith, *Hippies, Indians, and the Fight for Red Power* (Oxford: Oxford University Press, 2012), 5, 143. See also Philip Deloria, *Playing Indian* (New Haven, CT: Yale University Press, 1998).

85. Quoted in Fred Turner, *From Counterculture to Cyberculture: Stewart Brand, the Whole Earth Network, and the Rise of Digital Utopianism* (Chicago: University of Chicago Press, 2006), 59.

86. Tom Wolfe, *The Electric Kool-Aid Acid Test* (New York: Farrar, Straus and Giroux, 1968), 4.

87. "A Sculptor's Manual," *Whole Earth Catalog*, Fall 1968, 30. See also Andrew Kirk, *Counterculture Green: The* Whole Earth Catalog *and American Environmentalism* (Lawrence: University Press of Kansas, 2007); and Caroline Maniaque-Benton, ed., *Whole Earth Field Guide* (Cambridge, MA: MIT Press, 2016).

88. Turner, *From Counterculture to Cyberculture.*

89. Simon Sadler, "Design's Ecological Operating Environments," in Kjetil Fallan, ed., *The Culture of Nature in the History of Design* (London: Routledge, 2019), 20.

90. *Whole Earth Catalog: Production in the Desert* (1971), cover. The slogan is attributed to the *Catalog* editor Fred Richardson.

91. *The Last Whole Earth Catalog* (1972), 14.

Chapter 8: CUT AND PASTE

1. Georgina Garcia interviewed by Judy Silberstein, *Heresies* 1, no. 4 (Winter 1977/78): 73.

2. Howardena Pindell, "Afro-Carolinian Gullah Basket Making," *Heresies* 1, no. 4 (Winter 1977/78): 22.

3. Melissa Meyer and Miriam Schapiro, "Waste Not/Want Not: Femmage," *Heresies* 1, no. 4 (Winter 1977/78): 66–69. The term is a portmanteau of *feminine, homage,* and *collage.*

4. Madeleine Burnside, "Weaving," *Heresies* 1, no. 4 (Winter 1977/78): 27.

5. Lucy Lippard, "Making Something from Nothing," *Heresies* 1, no. 4 (Winter 1977/78): 64.

6. Amelia Jones, *Sexual Politics: Judy Chicago's Dinner Party in Feminist Art History* (Los Angeles: Armand Hammer Museum of Art/University of California Press, 1996).

7. Anna Katz, ed., *With Pleasure: Pattern and Decoration in American Art, 1972–1985* (Los Angeles: Museum of Contemporary Art/Yale University Press, 2019).

8. Joyce Kozloff, "Thoughts on My Art," in *Name Book 1* (Chicago: N.A.M.E. Gallery, 1977), 68.

9. Smucker, *Amish Quilts*, 105–12.

10. To make them, Ringgold at first collaborated with her mother, a self-made couturier who had been a labor activist with the ILGWU in her youth. Melanee Harvey, "Faith Ringgold, Who I Am and Why," *International Review of African American Art* (2013), online resource.

11. Elaine Hedges, "Quilts and Women's Culture," *Radical Teacher* 4 (March 1977): 7–10; Melody Graulich and Mara Witzling, "The Freedom to Say What She Pleases: A Conversation with Faith Ringgold," *NWSA Journal* (National Women's Studies Association) 6, no. 1 (Spring 1994): 14. See also Patricia Mainardi, *Quilts, the Great American Art* (San Pedro, CA: Miles and Weir, 1978).

12. Ruby Nell Sales oral history interview, conducted by Joseph Mosnier in Atlanta, Georgia, April 25, 2011, Civil Rights History Project, Library of Congress, Washington, D.C. On women in the counterculture, see Gretchen Lemke-Santangelo, *Daughters of Aquarius: Women of the Sixties Counterculture* (Lawrence: University of Kansas Press, 2009).

13. Cindy Decker, quoted in Rebecca E. Klatch, "The Formation of Feminist Consciousness Among Left- and Right-Wing Activists of the 1960s," *Gender and Society* 15, no. 6 (December 2001): 798. See also Robin Morgan's essay "Goodbye to All That," first published in 1970 and widely reprinted.

14. Patricia Mainardi, "The Politics of Housework," in *Sisterhood Is Powerful: An Anthology of Writings from the Women's Liberation Movement* (New York: Random House, 1970).

15. Pat Sweeney, "Wages for Housework: The Strategy for Women's Liberation," *Heresies* 1 (1977): 4.

16. Dorothy Sue Cobble, "A Spontaneous Loss of Enthusiasm: Workplace Feminism and the Transformation of Women's Service Jobs in the 1970s," *International Labor and Working-Class History* 56 (Fall 1999): 23–44.

17. Studs Terkel, *Working* (New York: Pantheon Books, 1974), xiv, 222, 717.

18. Quoted in Hoerr, *And the Wolf Finally Came*. See also Ruth Milkman, *Farewell to the Factory: Auto Workers in the Late Twentieth Century* (Berkeley: University of California Press, 2008).

19. Barry Bluestone and Bennett Harrison, *The Deindustrialization of America: Plant Closings, Community Abandonment, and the Dismantling of Basic Industry* (New York: Basic Books, 1982). See also Joshua B. Freeman, *Behemoth: A History of the Factory and the Making of the Modern World* (New York: W. W. Norton, 2018).

20. R. Buckminster Fuller, "Accommodating Human Unsettlement," *Town Planning Review* 49, no. 1 (January 1978): 53.

21. Jack Metzgar, *Striking Steel: Solidarity Remembered* (Philadelphia: Temple University Press, 2011), 119.

22. Irwin M. Marcus, "The Deindustrialization of America: Homestead, a Case Study," *Pennsylvania History* 52, no. 3 (July 1985): 173.

23. Barry Bluestone, "Deindustrialization and Unemployment," *Review of Black Political Economy* 12, no. 3 (March 1983): 27.

24. Quoted in Jefferson Cowie and Joseph Heathcott, eds., *Beyond the Ruins: The Meanings of Deindustrialization* (Ithaca, NY: Industrial Labor Relations Press, 2003), 2.

25. Steven High, "Beyond Aesthetics: Visibility and Invisibility in the Aftermath of Deindustrialization," *International Labor and Working-Class History* 84 (Fall 2013): 140–53.

26. Mike Wallace, "Industrial Museums and the History of Deindustrialization," *Public Historian* 9, no. 1 (Winter 1987): 9–19.

27. Ezra Shales, *The Shape of Craft* (London: Reaktion, 2017), 74.

28. Tom Wolfe, *Bonfire of the Vanities* (New York: Farrar, Straus and Giroux, 1987), 58.

29. Garth Clark, "Voulkos's Dilemma: Toward a Ceramic Canon," in John Pagliaro, ed., *Shards: Garth Clark on Ceramic Art* (New York: D.A.P./Ceramic Arts Foundation, 2003).

30. Edward S. Cooke Jr., "Wood in the 1980s: Expansion or Commodification?" in Davira Taragin et al., *Contemporary Crafts and the Saxe Collection* (New York: Hudson Hills, 1993), 148–61.

31. Quoted in Tina Oldknow, *Pilchuck: A Glass School* (Seattle: Pilchuck Glass School/ University of Washington Press, 1996), 105.

32. Janet Koplos and Bruce Metcalf, *Makers: A History of the Studio Craft Movement* (Chapel Hill: University of North Carolina Press, 2010), 411.

33. David Green with Dean Merrill, *More than a Hobby* (Nashville: Nelson Business, 1995), 5, 7, 13.

34. Green and Merrill, *More than a Hobby*, 18.

35. Green and Merrill, *More than a Hobby*, 24.

36. Quoted in Barbara Lippert, "Our Martha, Ourselves," *New York Magazine*, May 15, 1995.

37. Carol A. Stabile, "Getting What She Deserved: The News Media, Martha Stewart, and Masculine Domination," *Feminist Media Studies* 4, no. 3 (2004): 315–32. As part of her comeback, Stewart hosted her own spinoff version of *The Apprentice*.

38. Lippert, "Our Martha, Ourselves."

39. Karal Ann Marling, "The Revenge of Mrs. Santa Claus, or, Martha Stewart Does Christmas," *American Studies* 42, no. 2 (Summer 2001): 135.

40. Sarah A. Leavitt, *From Catharine Beecher to Martha Stewart: A Cultural History of Domestic Advice* (Chapel Hill: University of North Carolina Press, 2002).

41. Shirley Teresa Wajda, "Kmartha," *American Studies* 42, no. 2 (Summer 2001): 73.

42. Martha Stewart interviewed by Charlie Rose, PBS, July 26, 1995.

43. Michael Frisch, "American History and the Structures of Collective Memory: A Modest Exercise in Empirical Iconography," *Journal of American History* 75 (March 1989): 1130–55.

44. David Lowenthal, "The Bicentennial Landscape: A Mirror Held Up to the Past," *Geographical Review* 67, no. 3 (July 1977): 253–67. See also M. J. Rymsza-Pawloska, *History Comes Alive: Public History and Popular Culture in the 1970s* (Chapel Hill: University of North Carolina Press, 2017), chap. 5.

45. R. Lee Hadden, *Reliving the Civil War: A Reenactor's Handbook* (Mechanicsburg, PA: Stackpole Books, 1996), 36.

46. Tony Horwitz, *Confederates in the Attic: Dispatches from the Unfinished Civil War* (New York: Vintage, 1998), 143.

47. Southern Pride Flag Company website.

48. Quoted in Bryn Stole, "The Decline of the Civil War Re-enactor," *New York Times*, July 28, 2018.

49. Jeremy Dupertuis Bangs, "The Hypothetical Nature of Architecture in Plimoth Plantation's Pilgrim Village," *Museum History Journal* 8, no. 2 (July 2015): 119–46.

50. Scott Magelssen, "Recreation and Re-Creation: On-Site Historical Reenactment as Historiographic Operation at Plimoth Plantation," *Journal of Dramatic Theory and Criticism* (Fall 2002): 107–26.

51. In fact, the Wampanoag language was destroyed through forced assimilation, though it has recently been revived by a woman named Jessie Little Doe Baird. She has won a MacArthur Foundation "Genius Grant" for her work, a highly unusual example of a dead language being restored to everyday use. See Jessie Little Doe Baird and Jason Baird, "Statement of Practice," *Journal of Modern Craft* 13, no. 1 (March 2020).

52. Quoted in Lisa Blee and Jean O'Brien, *Monumental Mobility: The Memory Work of Massasoit* (Chapel Hill: University of North Carolina Press, 2019), 147.

53. Michael Hare, "Hard Times at Plimoth Plantation," *Outline*, November 21, 2017.

54. Rep. Robert Kastenmeier, quoted in Jon Keith Parsley, "Regulation of Counterfeit Indian Arts and Crafts: An Analysis of the Indian Arts and Crafts Act of 1990," *American Indian Law Review* 18, no. 2 (1993): 497.

55. Hulleah Tsinhnahjinnie, "Proving Nothing," *Crossroads* 5 (August 1993): 13.

56. William J. Hapiuk Jr., "Of Kitsch and Kachinas: A Critical Analysis of the Indian Arts and Crafts Act of 1990," *Stanford Law Review* 53, no. 4 (April 2001): 1011, 1013. See also Gail Sheffield, *The Arbitrary Indian: The Indian Arts and Crafts Act of 1990* (Norman: University of Oklahoma Press, 1997).

57. Emily Moore, "The Silver Hand: Authenticating the Alaska Native Art, Craft, and Body," *Journal of Modern Craft* 1, no. 2 (July 2008): 199.

58. Steve Fraser, "Abolish Sweatshops Now!" *New Labor Forum* 4 (Spring/Summer 1999): 33.

59. Sydney Schanberg, "Six Cents an Hour," *Life*, March 28, 1996.

60. Peter Dreier, "The Campus Anti-Sweatshop Movement," *American Prospect* (September/October 1999); Naomi Wolf, *No Logo: Taking Aim at the Brand Bullies* (New York: Picador, 1999), 487.

61. Paul Krugman, "In Praise of Cheap Labor," *Slate*, March 21, 1997.

62. Tim Connor, "Time to Scale Up Cooperation: Trade Unions, NGOs, and the International Anti-Sweatshop Movement," *Development in Practice* 14 (2004): 61–70.

63. Andrew Ross, "Sweated Labor in Cyberspace," *New Labor Forum* 4 (Spring/Summer 1999): 51.

64. Louis Hyman, *Temp: The Real Story of What Happened to Your Salary, Benefits, and Job Security* (New York: Penguin, 2019), 213.

65. Julia Bryan-Wilson, *Fray: Art + Textile Politics* (Chicago: University of Chicago Press, 2017).

66. Bryan-Wilson, *Fray*, 201.

67. Betsy Greer et al., "The Craftivism Manifesto," craftivism.com.

68. Cat Mazza, "Little Tools, Big Tools," *microRevolt* (blog), January 18, 2006.

69. Alla Myzelev, "Creating Digital Materiality: Third-Wave Feminism, Public Art, and Yarn Bombing," *Material Culture* 47, no. 1 (Spring 2015): 58–78.

70. Sadie Plant, *Zeroes + Ones* (New York: Doubleday, 2007).

71. "The Politics of Craft, a Roundtable," *Modern Painters*, February 2008; reprinted in Glenn Adamson, *The Craft Reader* (Oxford: Berg Publishers, 2010), 625.

72. Laurie Henzel and Debbie Stoller, *The Bust DIY Guide to Life* (New York: Stewart, Tabori and Chang, 2011), 16. See also Jack Bratich and Heidi Brush, "Fabricating Activism: Craft-Work, Popular Culture, and Gender," *Utopian Studies* 22, no. 2 (2011): 241.

73. Tina Kelley, "Of Spindles and Spirituality," *New York Times*, September 20, 2003.

74. Grace Dobush, "How Etsy Alienated Its Crafters and Lost Its Soul," *Wired*, February 19, 2015. See also Faythe Levine, *Handmade Nation: The Rise of DIY, Art, Craft and Design* (New York: Princeton Architectural Press, 2008).

75. Leonardo Bonanni and Amanda Parkes, "Virtual Guilds: Collective Intelligence and the Future of Craft," *Journal of Modern Craft* 3, no. 2 (July 2010): 179–90.

76. Neil Gershenfeld, *Fab: The Coming Revolution on Your Desktop* (New York: Basic Books, 2005), 12.

77. Neil Gershenfeld, "How to Make Almost Anything," *Foreign Affairs* 91, no. 6 (November/December 2016): 44.

78. Debbie Chachra, "Why I Am Not a Maker," *Atlantic*, January 23, 2015.

Chapter 9: CAN CRAFT SAVE AMERICA?

1. The master's program in critical and historical craft studies is at Warren Wilson College, North Carolina, and is headed by Namita Wiggers. The quoted list was collectively compiled by these students and faculty: Pheonix Booth, Darrah Bowden, Nick Falduto, Samantha Gale, Michael Hatch, Matt Haugh, Lisa Jarrett, Sarah Kelly, Matt Lambert, Ben Lignel, Kelly Malec-Kosak, Sydney Maresca, Kat St. Aubin, Linda Sandino, and Namita Wiggers.

2. Frederick Douglass, "What to the Slave is the Fourth of July?" (speech, first delivered at Corinthian Hall, Rochester, New York, July 5, 1852).

3. Richard Ocejo, *Masters of Craft: Old Jobs in the New Urban Economy* (Princeton, NJ: Princeton University Press, 2017).

4. Victor Lytvinenko, "Made in North Carolina: Skill Versus Scale in a Modern Jeans Workshop," *Journal of Modern Craft* 4, no. 3 (November 2011): 317–26.

5. Matthew Crawford, *Shop Class as Soulcraft* (New York: Penguin, 2009), 53; Eric Gorges, *A Craftsman's Legacy: Why Working with Our Hands Gives Us Meaning* (Chapel Hill, NC: Algonquin Books, 2019), 5, 7. Gorges also describes his own house as a "boot camp for learning how to build and fix things" (18).

6. Michelle Millar Fisher, "Making Space(s) for Craft," in Glenn Adamson, ed., *Craft Capital: Philadelphia's Cultures of Making* (Philadelphia: CraftNOW/Schiffer, 2019).

7. Roberta Naas, "FTC Rules Shinola Can No Longer Claim Watches Are 'Made in America,'" *Forbes*, June 20, 2016.

8. Simon Bronner, *Making Tradition: On Craft in American Consciousness* (Lexington: University Press of Kentucky, 2011), 150. See also Anthea Black and Nicole Burisch,

"From Craftivism to Craftwashing," in Black and Burisch, eds., *The New Politics of the Handmade: Craft, Art and Design* (London: Bloomsbury, 2020).

9. These quotations are taken from comments posted on Glassdoor in 2018, by employees of the John Deere plant in Ottumwa.

10. Nicolás Medina Mora and Rebecca Zweig, "Socialism Comes to Iowa," *The Nation*, December 20, 2017.

11. Glenn Adamson, *Fewer Better Things: The Hidden Wisdom of Objects* (New York: Bloomsbury, 2018).

12. Tim Jackson, *Prosperity Without Growth: Economics for a Finite Planet* (London: Earthscan, 2009), 130–31.

13. Quoted in Paul Adams, "100-Mile Suit Wears Its Origins on Its Sleeve," *Wired*, April 2, 2007.

14. Dana Thomas, *Fashionopolis: The Price of Fast Fashion and the Future of Clothes* (New York: Penguin, 2019).

15. Terkel, *Working*, 671.

INDEX

Note: Italic page numbers refer to illustrations.

A NOTE ON THE AUTHOR

GLENN ADAMSON's books include *Fewer, Better Things*, *The Invention of Craft*, and *The Craft Reader*. His writings have also been published in museum catalogues and in *Art in America*, *Antiques*, *frieze*, and other periodicals. He was previously director of the Museum of Arts and Design, New York, and has held appointments as senior scholar at the Yale Center for British Art and as head of research at the Victoria and Albert Museum, London. He lives in the Hudson Valley, New York.